MAKING ANOTHER WORLD POSSIBLE

Making Another World Possible offers a broad look at an array of socially engaged cultural practices that have become increasingly visible in the past decade, across diverse fields such as visual art, performance, theater, activism, architecture, urban planning, pedagogy, and ecology.

Part I of the book introduces the reader to the field of socially engaged art and cultural practice, spanning the past ten years of dynamism and development. Part II presents a visually striking summary of key events from 1945 to the present, offering an expansive view of socially engaged art throughout history, and Part III offers an overview of the current state of the field, elucidating some of the key issues facing practitioners and communities. Finally, Part IV identifies ten global issues and, in turn, documents 100 key artistic projects from around the world to illustrate the various critical, aesthetic and political modes in which artists, cultural workers, and communities are responding to these issues from their specific local contexts. This is a much needed and timely archive that broadens and deepens the conversation on socially engaged art and culture. It includes commissioned essays from noted critics, practitioners, and theorists in the field, as well as key examples that allow insights into methodologies, contextualize the conditions of sites, and broaden the range of what constitutes an engaged culture.

Of interest to a wide range of readers, from practitioners and scholars of performance to curators and historians, *Making Another World Possible* offers both breadth and depth, spanning history and individual works, to offer a unique insight into the field of socially engaged art.

Corina L. Apostol is the curator of Tallinn Art Hall and previously served as the Andrew W. Mellon Fellow at Creative Time. She is the cofounder of the activist publishing collective ArtLeaks and editor in chief of the *ArtLeaks Gazette*. Her recent publications include the book *Theories and Methodologies of Art History: A Guide* (2016), as well as numerous essays for volumes, textbooks, and catalogues.

Nato Thompson is the Sueyun and Gene Locks Artistic Director at Philadelphia Contemporary. He served as the curator of the Creative Time Summit from 2009 to 2017 and has written two books of cultural criticism: *Seeing Power: Art and Activism in the 21st Century* (2015) and *Culture as Weapon: The Art of Influence in Everyday Life* (2017). He has also edited *Living as Form: Socially Engaged Art from 1991–2011*, *Experimental Geography*, *Ahistoric Occasion*, *Becoming Animal*, and *The Interventionists*.

MAKING ANOTHER WORLD POSSIBLE

10 Creative Time Summits, 10 Global Issues, 100 Art Projects

Edited by Corina L. Apostol and Nato Thompson

Routledge
Taylor & Francis Group

LONDON AND NEW YORK

First published 2020
by Routledge
2 Park Square, Milton Park, Abingdon, Oxon OX14 4RN

and by Routledge
52 Vanderbilt Avenue, New York, NY 10017

Routledge is an imprint of the Taylor & Francis Group, an informa business

British Library Cataloguing-in-Publication Data
A catalogue record for this book is available from the British Library

Library of Congress Cataloging-in-Publication Data
A catalog record has been requested for this book

ISBN: 978-1-138-60353-0 (hbk)
ISBN: 978-1-138-60354-7 (pbk)
ISBN: 978-0-429-46898-8 (ebk)

Typeset in Bembo
by Apex CoVantage, LLC

CREATIVETIMEBOOKS

CONTENTS

BIOGRAPHIES

Corina L. Apostol is the curator of Tallinn Art Hall and previously served as the Andrew W. Mellon Fellow at Creative Time. She is the cofounder of the activist publishing collective ArtLeaks and editor in chief of the *ArtLeaks Gazette*. Her recent publications include the book *Theories and Methodologies of Art History: A Guide* (2016), as well as numerous essays for volumes, textbooks, and catalogues.

Mari Bastashevski Bastashevski is an artist, writer, researcher, and a visiting fellow at the Data & Society Institute. Her past work, usually resulting from extensive online and field investigations, are samples of information, photographs, and texts that explore the role of the mediated image in sustaining state-corporate power. She is involved in a number of collaborative art projects and divides her time between inventing technology that misuses social media platforms and researching the history of postnatural animals. She is also prototyping a mediascape for collective play through which artists, academics, journalists, and technologists can foster a media practice that aims to counter the algorithmically driven production of networked content. She has previously exhibited with Bonnier Konsthall, MAST foundation, Musée de l'Elysée, HKW Berlin, and Art Souterrain, and she has published her work with *Le Monde*, *Time Magazine*, *The New York Times*, *Prix Pictet*, *Courrier International*, and *VICE*, among others.

Tega Brain Brain is an artist and environmental engineer making eccentric engineering. Her work intersects art, ecology, and engineering, addressing the scope and politics of emerging technologies. It takes the form of online interventions, site-specific public works, experimental infrastructures, and poetic information systems. Tega is an assistant professor of integrated digital media, New York University. She is an affiliate at the Data & Society Institute and works with the Processing Foundation on the Learning to Teach conference series and p5js project.

Rashida Bumbray Bumbray is senior program manager of the Arts Exchange, the Open Society Foundations' global arts for social justice initiative. Since joining in 2015, Bumbray has organized the Arts Forum: Art, Public Space, and Closing Societies and launched the Soros Arts Fellowship. Bumbray began her curatorial career in 2001 at the Studio Museum in Harlem, where she coordinated major exhibitions, including *Freestyle and Frequency*. As an associate curator at The Kitchen, Bumbray organized critically acclaimed exhibitions and commissions featuring work by Leslie Hewitt, Simone Leigh, and Kyle Abraham, among others.

Corinne Butta Butta is an editor and writer based between Washington, D.C., and Brooklyn, New York. She is an editorial associate with the Terreform Center for Advanced Urban Research, where she is assisting with the forthcoming essay collections *Open Gaza* (UR Books, 2019) and *Syria Unsettled* (UR Books, 2019). She is the editorial coordinator for Wendy's Subway, an independent library and small press, and a graduate of the School of the Art Institute of Chicago's Visual and Critical Studies program.

Thanom Chapakdee Chapakdee is an art critic, curator, and art activist based in Bangkok. He teaches art criticism, art history, political art, and contemporary art at Srinakharinwirot University, Bangkok. Working as an art writer for the past three decades, Chapakdee cofounded the Bangkok Performance artists Group, UK-Kabat (Bonfire,1995). He curated local and regional performance art festivals, Asiatopia, since the late 1990s. He also worked with the Bru ethic group community in Baan Tha-Long, on the border of Laos and Thailand based (2000). Chapakdee served on the Southeast Asia Cultural Committee to the Ministry of Culture, Taiwan (2015). Recently, he organized the (art) Manifesto project, Khonkaen Manifesto, in the Northeast of Thailand (Isan region). The (art) Manifesto will carry on every two years in Northeast Thailand in order to endorse the values and the idea of aesthetics of resistance through artistic and cultural approaches, working closely with marginalized communities.

Chto Delat? Chto Delat? (*What is to be done?*) is a collective of Russian artists, critics, philosophers, and writers from St. Petersburg and Moscow. Responding to a sense of urgency on the need to merge political theory, art, and activism, the collective was founded in St. Petersburg in 2003. Chto Delat? produces art projects, theatrical plays, videos, radio programs, educational seminars, public murals, and political campaigns. It also publishes a newspaper named *Chto Delat?*, which covers culture and politics from around the world, printed in Russian and English. In 2013, the collective founded The School of Engaged Art in St. Petersburg and runs a space called Rosa's House of Culture.

Maja Fowkes is an art historian, curator, and codirector of the Translocal Institute for Contemporary Art, an independent research center focusing on the art history of Central Europe and contemporary ecological practices. Curatorial projects include the *Anthropocene Experimental Reading Room*, the Danube River School, the conference Vegetal Mediations, as well as the exhibition *Walking Without Footprints*. Recent and forthcoming publications include *The Green Bloc: Neo-Avant-Garde and Ecology under Socialism*, a book on Central and Eastern European Art Since 1950, as well as numerous chapters and journal articles on topics such as performative reenactments, deschooling the art curriculum and the ecological entanglements of deviant democracy.

Reuben Fowkes is an art historian, curator, and codirector of the Translocal Institute for Contemporary Art, an independent research center focusing on the art history of Central Europe and contemporary ecological practices. Curatorial projects include the *Anthropocene Experimental Reading Room*, the Danube River School, the conference Vegetal Mediations, as well as the exhibition *Walking Without Footprints*. He is also an editor of *Third Text*, and is a regular contributor to magazines and artist publications.

Gridthiya Gaweewong Her curatorial projects have addressed issues of social transformation confronting contemporary artists from Southeast Asia and beyond since the Cold War.

Gaweewong has curated numerous exhibitions including *Politics of Fun* at the Haus der Kulturen der Welt, Berlin (2005, with Ong Ken Seng), the *Saigon Open City* in Ho Chi Minh City, Vietnam (2006–2007, with Rirkrit Tiravanija) and *Unreal Asia*, Oberhausen International Short Film Festival, Germany (2009, with David Teh), *Between Utopia and Dystopia*, MUAC, Mexico City (2011), and *The Serenity of Madness*, Apichatpong Weerasethakul survey show, produced by Independent Curators International (ICI), New York & MAIIAM Contemporary Art Museum, Chiangmai. She recently served on the curatorial team of the 12th Gwangju Biennale, South Korea. Currently, Gaweewong is the artistic director at Jim Thompson Art Center in Bangkok.

Pascal Gielen Gielen is professor of sociology of culture and politics at the Antwerp Research Institute for the Arts (Antwerp University - Belgium) where he leads the Culture Commons Quest Office (CCQO). Gielen is editor of the international book series *Antennae - Arts in Society* (Valiz). In 2016 he became laureate of the Odysseus grant for excellent international scientific research of the Fund for Scientific Research Flanders in Belgium. His research focuses on creative labour, the common, urban and cultural politics.

Núria Güell Güell's artistic practice focuses on the analysis of how power affects our subjectivity by submitting it to hegemonic law and morality. Her main methodologies include flirting with the established powers, acting as an accomplice to different partners, and using the privileges granted by institutional art—as well as those socially granted to her—for being a white, Spanish, European woman. These tactics, distilled into her own life, are developed in specific contexts with the intention to disrupt power relationships.

Kinana Issa Issa utilizes her writing and art as a form of loyalty to humanity. She has produced more than ten experimental audiovisual works and authored the script for *Gardens Speak*, an interactive sound installation containing the oral histories of ten people buried in Syrian gardens. She has also sat on the committee of the Syrian Film Festival in Toronto and has written for *Associated Press* and *Al Jazeera Children*. Issa is currently an honorary fellow of the International Writing Program at Iowa University.

Athi Mongezeleli Joja Joja is an art critic based in Johannesburg, South Africa. A member of the art collective Gugulective, he is currently pursuing his MFA at the University of the Witwatersrand on the critical practice of late art critic Prof. Colin Richards. His writing has appeared in publications such as *The Mail & Guardian*, *Art Throb*, *Contemporary And (C&)*, *Chimurenga Chronic*, and *Africanah*. Joja is also a Predoctoral Fellow in the Mellon-Funded Critical Theory Cluster at Northwestern University, Evanston, Illinois.

Shimrit Lee Dr. Lee graduated from the Middle Eastern studies program at New York University. Her research resides at the intersection of several disciplines: visual culture, political economy, cultural studies, performance, and critical security studies. She has a background in international human rights law and the politics of witnessing, with a regional focus on contemporary Israel/Palestine. She also writes on photography, film theory, and contemporary visual arts and is a currently serving as a curator at Residency Unlimited in Brooklyn, New York.

Miguel A. López López is a writer, researcher, and chief curator of TEOR/éTica in San José, Costa Rica. His work investigates collaborative dynamics and transformations in the understanding of and engagement with politics in Latin America in recent decades. His work also focuses on queer rearticulations of history from a Southern perspective. He has recently curated

Equilibrio y Colapso. Obras de Patricia Belli, 1986–2016 at the Fundación Ortiz Gurdian, Managua (2017) and *Teresa Burga. Structures of Air* (with Agustín Pérez Rubio) at the MALBA, Buenos Aires (2015).

Justine Ludwig Ludwig is the executive director of Creative Time. She has curated projects with many artists including Shilpa Gupta, Nadia Kaabi-Linke, Pedro Reyes, Laercio Rendondo, Paola Pivi, and Pia Camil. Her research interests include the intersections of aesthetics and architecture, violence, economics, and globalization.

Wanda Nanibush Nanibush is an Anishinaabe-kwe curator, image and word warrior, and community organizer. Currently she is the inaugural curator of Canadian & Indigenous Art at the Art Gallery of Ontario. She holds a master's in visual studies from the University of Toronto, where she has taught graduate courses. Her curatorial projects include *Rita Letendre: Fire & Light* (AGO, 2017), *Toronto: Tributes + Tributaries, 1971–1989* (AGO, 2016), *Sovereign Acts II* (Leonard & Bina Ellen Art Gallery, 2017), *The Fifth World* (Mendel Art Gallery, 2015) and the award-winning *KWE: The Work of Rebecca Belmore* (Justina M. Barnicke Gallery, 2014).

Hanka Otte Dr. Otte is a postdoctoral researcher in the Culture Commons Quest Office (Antwerp Research Institute of the Arts—ARIA). The central question of this research group is how creative workers may contribute to the urban environment and what has been called "the commons" and how creative biotopes arise. Hanka's focus is on how these creative biotopes can be maintained in a sustainable manner by city policies.

Grace Samboh Samboh is in search of what comprises curatorial work within her surrounding scene. She jigs within the existing elements of the arts scene around her, for she considers the claim that Indonesia is lacking arts infrastructure—especially the state-owned or state-run—as something outdated. She believes that curating is about understanding and making at the same time. In 2011, she cofounded Hyphen, a closed-door discussion group that seeks to sew together bit by bit the fragmented Indonesian art history by (re)reading Indonesian contemporaneity and by putting it into its own historical context. With Hyphen, her concern is to encourage Indonesian arts and artistic research projects and publications.

Thasnai Sethaseree With a background in philosophy, social science, and art, Sethasaree works as an artist, activist and lecturer at the Media Art and Design, Graduate School, Chiangmai University. His recurrent themes in his artistic practice have included issues of memory, migration, and a philosophical questioning of the nature of knowing. He participated in both local and international exhibitions including the solo exhibition *What You Don't See Will Hurt You* (VER Gallery, Bangkok, 2016); international group shows such as Safe Place in the Future (?) (Jim Thompson Art Center, Bangkok), and Museum of Contemporary Art and Design (Manila, Philippines, 2013); The Way Things Go (Yerba Buena Center for the Arts in San Francisco, 2015). Recently he received Jurors' Choice Awards from Signature Art Prize, Singapore Art Museum, 2018.

A.L. Steiner Steiner utilizes constructions of photography, video, installation, collage, collaboration, performance, writing, and curatorial work as seductive tropes are channeled through the sensibility of a skeptical queer ecofeminist androgyne. Steiner is cocurator of Ridykeulous, cofounder of Working Artists and the Greater Economy (W.A.G.E.), and collaborates with numerous writers, performers, designers, activists, and artists. Steiner is based in Los Angeles and New York and is the recipient of the 2015 Tiffany Foundation Biennial Award, 2015–2016

Berlin Prize, Foundation for Contemporary Arts 2017 Grants to Artists Award, and the 2018 Yale University Presidential Fellowship in the School of Art.

Nato Thompson is the Sueyun & Gene Locks Artistic Director at Philadelphia Contemporary. He served as the curator of the Creative Time Summit from 2009 to 2017 and has written two books of cultural criticism: *Seeing Power: Art and Activism in the 21st Century* (2015) and *Culture as Weapon: The Art of Influence in Everyday Life* (2017). He has also edited *Living as Form: Socially Engaged Art from 1991–2011, Experimental Geography, A historical Occasion, Becoming Animal,* and *The Interventionists.*

Jasmina Tumbas Dr. Tumbas is an Assistant Professor of Contemporary Art History and Performance Studies in the Department of Global Gender and Sexuality Studies at the University at Buffalo, SUNY. Tumbas curated Selma Selman's first U.S. solo show at Dreamland in Buffalo, an exhibition that traveled to Vienna, Austria, and she serves on the board of directors of Squeaky Wheel. She is currently finishing her first book, *The Erotics of Dictatorship: Art, Sex, and Politics under Yugoslav Socialism,* and serves as coeditor for the anthology *Radical Art in Transition: Counter-Culture, Protest, Resistance and Contemporary Art in the Balkans since 1968.* Her research has appeared in *ArtMargins, Camera Obscura: Feminism, Culture, Media Studies,* and *Sztuka i Dokumentacja (Art and Documentation), Performing Arts in the Second Public Sphere* (2016), and in the forthcoming anthologies *BODIES THAT MATTER AGAIN.*

Syrus Marcus Ware Ware is a Vanier Scholar, a visual artist, community mobilizer, educator, and researcher pursuing his PhD studies in the Faculty of Environmental Studies at York University. Syrus holds degrees in art history, visual studies (University of Toronto), and sociology and equity studies (OISE). In 2014, he was awarded the Slyff Fellowship/Graduate Fellowship for Academic Distinction by York University. Syrus has authored book chapters, journal articles, and peer-reviewed publications about disability, the diversification of museums, transparenting, and sexual health for trans MSM. In 2009, Syrus coedited the *Journal of Museum Education* issue *Building Diversity in Museums* with Gillian McIntyre. Syrus was voted Best Queer Activist by *Now Magazine* (2005), was awarded the Steinert and Ferreiro Award (2012) for LGBT community leadership and activism, and was awarded the TD Diversity Award from the Toronto Arts Foundation in 2017.

Ala Younis Younis uses archivally found materials in research-based projects that combine personal narratives with collective and national histories of the Middle East. Younis has participated in the Iran Biennial: *Art in the Contemporary Islamic World* (2005), Asian Art Biennial Dhaka 2006), New Museum Triennial: *The Ungovernables* (New York 2012), Gwangju Biennale (2012), and the Venice Biennale: *All the World's Futures* (2015). As a curator, she has organized several international exhibitions including the first Kuwaiti Pavilion at the Venice Biennale (2013).

What, How and for Whom/WHW WHW is a curatorial collective formed in 1999 and based in Zagreb and Berlin. Its members are curators Ivet Ćurlin, Ana Dević, Nataša Ilić, and Sabina Sabolović and designer and publicist Dejan Kršić. WHW organizes a range of productions, exhibitions, and publishing projects and directs Gallery Nova in Zagreb. WHW has been intensively developing a model based on a collective way of working, a collaboration between partners of different backgrounds and an involvement with local advocacy platforms. WHW curated numerous international projects, among which are *Collective Creativity, Kunsthalle* Fridericianum (Kassel, 2005), the 11th Istanbul Biennial *What Keeps Mankind Alive?* (Istanbul, 2009), and *One Needs to Live Self-Confidently ... Watching* (Croatian pavilion at the 54th Venice Biennial, 2011).

CONTRIBUTORS

Kunlé Adeyemi
Luis Manuel Otero Alcántara
Morehshin Allahyari
Nabil Al-Raee
Halil Altindere
Corina L. Apostol
Lara Baladi
Fredman Barahona
Mari Bastashevski
Richard Bell
Josh Begley
Zach Blas
Xu Bing
Tega Brain
James Bridle
Nut Brother
Rashida Bumbray
Corinne Butta
Campus in Camps
Giuseppe Campuzano
Cassils
Melanie Cervantes
Tings Chak
Thanom Chapakdee
Zuleikha Chaudhari
Benvenuto Chavajay
Chen Chieh-Jen
Paolo Cirio
Molly Crabapple
Krudas Cubensi

CUDS (Colectivo Universitario de
 Disidencia Sexual)
Chto Delat?
Maksaens Denis
Pablo DeSoto
Brigada Puerta de Tierra
Hasan Elahi
Electronic Disturbance Theater
Etcétera
Yevgeniy Fiks
Maja Fowkes
Reuben Fowkes
Futurefarmers
Regina José Galindo
Gridthiya Gaweewong
Pascal Gielen
Hope Ginsburg
Núria Güell
Lawrence Abu Hamdan
Sharon Hayes
Khaled Hourani
Trampoline House
Evan Ifekoya
Illuminator
Kinana Issa
Khaled Jarrar
Athi Mongezeleli Joja
Vladan Jeremić
Yao Jui-chung
Amar Kanwar

Conflict Kitchen
KUNCI Cultural Studies Center
Agung Kurniawan
Shimrit Lee
Simone Leigh
Yanelys Núñez Leyva
Li Liao
Victoria Lomasko
Miguel A. López
Lucy + Jorge Orta
Justine Ludwig
Cannupa Hanska Luger
Mary Maggic
Jill Magid
Ibrahim Mahama
Leónidas Martín
Lauren McCarthy
Metahaven
Joanna Moll
Molleindustria
Nástio Mosquito
Carlos Motta
Rabih Mroué
Sethembile Msezane
Wanda Nanibush
Otobong Nkanga
Jenny Odell
Ahmet Öğüt
Pepón Osorio
Tanja Ostojić
Otabenga Jones & Associates
Hanka Otte
Trevor Paglen
Dan Perjovschi
Lia Perjovschi
Alexandra Pirici

Laura Poitras
Pope.L
Postcommodity
Oda Projesi
Mujeres Públicas
Bhenji Ra
Rena Rädle
Tomáš Rafa
Journal Rappé
Urban Reactor
Oliver Ressler
Atiz Rezistans
Pussy Riot
Mika Rottenberg
Grace Samboh
Marika Schmiedt
Stiev Selapak
Marinella Senatore
Thasnai Sethaseree
Huhana Smith
Karolina Sobecka
Jonas Staal
A.L. Steiner
Hito Steyerl
TanzLaboratorium
Slavs and Tatars
The Fire Theory
Nato Thompson
Daniel Tucker
Jasmina Tumbas
Kara Walker
Syrus Marcus Ware
Joshua Wong
Ala Younis
What, How and for
 Whom/WHW

ACKNOWLEDGMENTS

Why this book? Why now? A great deal has changed since 2009 when Creative Time organized its first Summit to discuss the field of socially engaged art and contemporary political issues. Since then, socially engaged art has moved from the margins of the art world to, if not quite its center, then certainly to a central part of the discussion on contemporary art and politics. This shift has taken place against the backdrop of a changing world, one defined by a growing global consciousness or awareness of a shared environmental, political, and economic fate and by a shared perception of crisis. With the occasion of the ten-year anniversary of the Summit, *Making Another World Possible* brings these two strands of art activism and global politics together.

In light of these urgent issues and the growing interest in socially engaged art, the editors have taken on the challenge of organizing this book. Rather than attempting an encyclopedic historical survey, the editors conceived of this publication in order to raise fundamental questions that ignite conversation and contribute to the understanding of socially engaged art in an ever changing field. In this pursuit, we turned to a group of advisors who have diligently guided our understanding of the field and introduced us to new artists and practices. We would especially like to thank Ala Younis, A.L. Steiner, Athi Mongezeleli Joja, Chto Delat?, Elvira Dyangani Ose, Grace Samboh, Gridthiya Gaweewong, Hanka Otte, Jasmina Tumbas, Justine Ludwig, Kinana Issa, Mari Bastashevski, Miguel A. López, Núria Güell, Pascal Gielen, Rashida Bumbray, Sally Szwed, Syrus Marcus Ware, Tega Brain, Thanom Chapakdee, Thasnai Sethaseree, Wanda Nanibush, and What, How and for Whom/WHW. Not only was their contribution critical, but, more, the book features essays by some of these renowned theorists, curators, and practitioners, each of whom approached the field and major social topics from their own unique critical and globally diverse perspectives.

Nato Thompson's introduction retrospectively reviews the Creative Time Summit from its inception in 2009 until 2017. His essay discusses the formation, evolution, and the major topics of the Summit under the global political environment. Next, for "On Arts, Politics, and Engagement: A Selected Timeline 1945 to Present" (Part II) section, we commissioned the Russian collective Chto Delat? to create an original chronology setting the Creative Time Summits against the background of major world events and highlighting diverse major projects of public art, key publications, and political initiatives, spanning from the end of World War II to the present.

Opening our Major Issues in the Field of Socially Engaged Art section (Part III), Pascal Gielen and Hanka Otte's essay includes two parallel shifts signalized and analyzed: one is the

transition from community art to so-called commoning art; the other is the transition from cultural policy to a politics of culture. Next, artist, writer, and architect Ala Younis discusses trust between people, technology, and the Internet in the context of the Zaatari refugee camp in Jordan and in the aftermath of the Persian Gulf War and former dictatorship in Iraq and Jordan. Curator and author Miguel A. López analyzes recent projects in Latin America that have generated important intersections between feminist and queer activism, pedagogy, and artistic practice. Taking Black collectivity as an ethical medium, or strategy, for public commentary, artist and writer Athi Mongezeleli Joja focuses comparatively on three prominent South African collectives—namely, Gugulective, Burning Museum, and iQhiya—and how their visual worlds shed light on history, archival knowledge, and exclusionary practices. Grace Samboh explores the practices of three Indonesian artists that began at the end of the 1970s: Gendut Riyanto (1955–2004), Semsar Siahaan (1952–2005), and Moelyono (b. 1947) who based their artistic practices in the city centers of Indonesia and who critically engaged with the New Order under Muhammad Suharto (1967–1998). In her discussion with artist Thasnai Sethaseree and fine arts professor Thanom Chapakdee, curator Gridthiya Gaweewong brings into focus examples of socially engaged art in Thailand's recent history that responded directly to the political situation, especially the collapse of democracy in the country. Next, curatorial collective What, How and for Whom/WHW's essay analyzes artist Victoria Lomasko's illustrated chronicles of hidden political conflict in contemporary Russia and the creation of new civic spaces through Sandi Hilal and Alessandro Petti's project Campus in Camps.

For the next major section of the book, "Dialogue: 10 Global Issues, 100 Art Projects" Part IV), we ask what roles has art played in the tumultuous last decade of social and political struggles around the world and how have practitioners used art as a tool with which to shape the world. In this section, we identified ten key issues and 100 projects that describe different strategies and tactics, mapping the broad field of contemporary political art and art activism. Justine Ludwig frames the "State of Siege" section, addressing methodological issues in analyzing the condition of cultural production in relation to the militarization of society and the violence and siege mentality related to the ongoing wars on terror, both domestic and foreign. For "Surveillance" (Section 2), artist and theorist Mari Bastashevski seeks to address the following question: can artists and art institutions devise a collective praxis that suspends normative production in favor of deliberate algorithmic stumbling within a negative space of surveillance apparatuses? Framing "Confronting Inequity" (Section 3), Núria Güell's essay is based in the press conference that Güell gave around her project *Aphrodite* (2017), investigating the conditions of labor as they apply to artists—and specifically to female artists. At the beginning of "The Uprising," Rashida Bumbray looks to the underground as a space of strength and revolutionary reimagining given the global turn towards fascism. Introducing "Exodus" (Section 5), Kinana Issa reflects on one woman's exile journey and the struggle to bring invisible narratives from self-identified women to light through art. Next, for "Cosmopolitics" (Section 6), Maja and Reuben Fowkes discuss how contemporary artists are responding to the unfolding planetary drama, against the backdrop of a virulent cocktail of climate change, species extinction, and toxic pollution. Thinking about how "Race Matters" (Section 7), Syrus Marcus Ware wrote a text exploring a world set in a time just after an apocalyptic set of events where the survivorship of this postapocalyptic moment depends on artists of colors. In her introduction to "Classroom in Crisis" (Section 8), Jasmina Tumbas addresses the contemporary state of higher education and art projects that push for a response to various global and local crises, including war, pollution, immigrant and refugee rights, as well as racism, sexism, economic inequalities, and gentrification. Opening the "Queer and Now" discussion in Section 9, A.L. Steiner wrote a poetic text, diagnosing human-centric freedom and catastrophe and examining how practices of queering may enlighten us in regard

to the future. Last, but not least, "The Device" (Section 10) is framed by Tega Brain, who discusses art practices that blend strategies from modern art, tactical media, and civil disobedience to adapt, repurpose, and bend these technologies to breaking points in ways that reveal their blind spots and biases, as well as question technological narratives. The "Epilogue", written by Justine Ludwig, brings us to some of the Summit's responsibilities and aspirations for the future. Closing the book, our "Glossary of Terms," written by Corina L. Apostol, explores the meanings behind key concepts in the field: "social engagement" in culture, "gentrification," "art education," and more. Her contribution addresses the necessity of developing a terminology to make theoretical articulations more clear and accessible to our readers. In addition, the section discusses key terms used frequently by contributors to our book.

Working with our editor Ben Piggott and Laura Soppelsa, editorial assistant at Taylor and Francis/Routledge, has been a great pleasure, and we are grateful for their commitment to making this book a reality. We are deeply appreciative to our talented editorial assistant Corinne Butta who led the research for this project, helped us to bring the manuscript together, and contributed brief texts on artists who engaged with timely issues by expanding their practice into public space. She was joined by our research assistants, Shimrit Lee, who also authored project descriptions, and Julia Hernandez, who played a key role in the initial research for this book. Special thanks also go to our intern, Tianyu Guo, who assisted us in completing this research, for her diligence in the crucial moments of manuscript delivery. We would also like to acknowledge artist Nikolay Oleynikov of the artistic collective Chto Delat?, one of our longtime collaborators, who created our elegant and engaging cover, inspired by a banner he created together with the Shvemy Sewing Cooperative.

We cannot express enough how grateful we are to all the donors and funders who recognized the importance of artists as global agents for change and generously invested in this project, as well as the history of the Creative Time Summit. We'd particularly like to thank the Andrew W. Mellon Foundation for their support of an Editorial Fellowship, without which this publication would not have been possible.

We are also grateful to the Creative Time Team members who have played an instrumental role in the success of the Summit over the years, especially Anne Pasternak, Katie Hollander, Laura Raicovich, Sally Szwed, Carolina Alvarez-Mathies, Teal Baskerville, Alex Winters, and Ben Bromley. Sincere gratitude also goes to Creative Time's Board of Trustees who have supported us in making this book a reality and who continue to champion artists' dreams to create meaningful change. Finally, we are deeply thankful to all the artists who are represented in this book, for generously answering our queries during the writing process, sharing their works with us, and for their inspiration in making a profound impact on our world. It is our strong belief that this publication will inspire even more vibrant socially engaged art projects and generate enthusiasm in the field.

PART I

A precarious assembly
Ten years of art and activism

Nato Thompson

The Summit, a conference that tracks political art across the globe, has been transformed over the past decade, its form and content shaped by the contours of political events abroad and on U.S. soil and by the changing genre of socially engaged art practice. What started as a gathering to make the case for the relevance of art and politics in the main circuits of contemporary art evolved into an urgent coming together of disparate and politically telling artistic practices. Looking back over the last decade, the texture and content of this gathering reflect the mood, spirit, and political urgencies of this wild decade.

This book is an opportunity to reflect on the condition of both tendencies—political and artistic—across the vast geography of the globe and how they inform each other. The essays and projects contained herein offer a lens into a series of practices that could be inspiring to practitioners in a wide array of regions, while also possessing a specificity germane to their location. They tell a tale of the complex forces that give rise to and foreclose moments of aesthetic political action. The urgencies of political moments, coupled with the condition of support for the arts and the various intersectional dynamics within a given region, set the groundwork for specific manifestations of creative protest, resistance, community building, institutional critique, and more.

While art fairs and biennials offer a glimpse into different regional art scenes, much of what constitutes political art remains outside these networks. While the commercial world had, over the course of the 1990s and into the 2000s, begun to embrace a fever of globalism, the political art sphere still required much more conversation and spaces of international connection. At its inception, the Creative Time Summit also lagged behind in providing a global lens on these practices. While the Summit has always attempted to connect diverse practices across the globe, the reach and understanding of these practices and practitioners would take time to develop.

Over the course of the next decade, the Summit would take place annually (if not biannually), and each iteration would reflect tendencies happening both in political art and in the urgencies of the political moment. Reflecting on its modalities over time, the Summit provided a clear snapshot of the forces and events that would come to occupy the center of current political concerns. If political art exists at the fringes, then it is the fringes that usher in an emerging social landscape.

The return of political art

On public memory:

> [T]hose various types of distributed memories [collective memory, communicative memory, and cultural memory] reinforce the concept of memory as shared process, as a condition that takes us out of our immediate reality and allows for an awareness of connections and contingencies. Public memory resides precisely in that transitional realm of individual awareness and collectively scripted narrative of self-expression and context. To activate public memory, that is to render it an agent of the moment. We need to work in that ambiguous realm and to bring our audiences to it.
>
> Carin Kuoni, *Creative Time Summit: Revolutions in Public Practice*, 2009

We shaped the Summit in order to uplift political art and to make the case for its relevance to the community of artists, scholars, and cultural workers that form not only the art world but also the world beyond. We, at Creative Time, wanted the Summit to introduce audiences to the vast world of political art production and to make a case for the power of art to transform society. That said, the first important task was to make the case to the art world itself.

The methodology and content of the Summit built upon a number of important precursors. One of the more significant conferences in New York history that guided our vision for the Summit was the *Town Hall* series at the DIA Art Foundation that took place in 1980. The first half of the project consisted of an installation by Martha Rosler titled *If You Lived Here*, which responded to questions of gentrification and housing. The second discursive exhibition and platform was by the collective Group Material, titled *Democracy*. Both featured a series of conversations on topics that would not only continue to be urgent at the time of the first Summit—including gentrification, intersections of class, race, and cultural production, AIDS activism, and strategies to resist capitalism—but also put forth a politically progressive agenda by way of an art institution.

In addition to these seminal projects at DIA, we at Creative Time (which, most importantly, included then Executive Director Anne Pasternak) found inspiration in the work of Okwui Enwezor, the artistic director of documenta 11. The 2002 edition highlighted art from the global South and brought colonialism front and center as an important rupture in the production of culture. In addition, Enwezor produced a series of discursive "platforms" that emerged in major port cities across the globe. These platforms, as they were called, featured philosophical and political voices from across the cultural spectrum. Urgent and necessary conversations on subjects ranging from truth and reconciliation in South Africa, to the concept of creolization, to the rise of neoliberalism were being addressed by the world's sharpest minds. And what else could bring them together than art itself? It was within the field of art where these conversations that seemed both urgent and, strangely, beyond the bounds of contemporary political discourse could emerge.

It is also helpful to note that Creative Time itself had a history of organizing around art and politics. In 2006, Creative Time organized three roundtable dinners asking artists, curators, and academics about the state of art and politics. Many of these artists would continue to play a role in Summits to come, including Doug Ashford, Julie Ault, Hans Haacke, Emily Jacir, Lucy Lippard, Daniel Martinez, Marlene McCarty, Helen Molesworth, Anne Pasternak, Paul Pfeiffer, Michael Rakowitz, Martha Rosler, Ralph Rugoff, Amy Sillman, Allison Smith, Kiki Smith, and David Levi Strauss.

Just a year previous to the first Summit in 2009, Creative Time organized a large-scale project at the Park Avenue Armory titled *Democracy in America: The National Campaign*. It could be considered, in some manner, a test case for what would become the Summit. With its cavernous hall, the Armory was transformed into an ad hoc hub for social politics, which brought

together voices ranging from David Harvey to the Guerrilla Girls, the Yes Men, Critical Art Ensemble, Brian Holmes, and Karen Finlay, among others. As part of *Democracy in America*, curator Daniel Tucker and I went to five cities—New York, Baltimore, Los Angeles, New Orleans, and Chicago—to initiate in-depth conversations with artists and activists. It became evident, in 2008, that, rather than only fighting the Bush administration's role in Iraq or the Patriot Act, an issue that evidently had captured the imagination and work of many artists was a topic that would come to be a critical part of the Summits for the decade to come: gentrification.

The Summit also emerged out of a recognition of an ever shifting vast landscape of political art. The broad array of approaches provided an opportunity for a conference where these regional and aesthetic specificities could be explored, from the community-based work of Appalshop in Appalachia to the social practice art coming out of Portland and San Francisco, to the politically engaged social practice out of Chicago in spaces like Mess Hall, to the discursively rigorous work inspired by or in connection with the Whitney Independent Study Program in New York City. More directly activist work like the agitprop activities of the Guerrilla Girls or the Yes Men expanded this landscape even further. And that was just in the United States.

Admittedly, our knowledge of art making outside of our immediate, United States–based context would take some time to come into sharper relief. We began by highlighting the work of cultural workers and artists already familiar to us: the work of curators such as Lars Bang Larsen, Okwui Enwezor, Chus Martinez, Maria Lind, Bisi Silva, Gridthiya Gaweewong, and the Croatian collective What, How and for Whom, as well as the work of artists such as Dinh Q. Le (Vietnam), Etcétera (Argentina), Regina José Galindo (Guatemala), Chto Delat? (Russia), Minerva Cuevas (Mexico), and Yael Bartana (Israel). Many of these artists and curators are well-known in the arts circuits of biennales, major exhibitions, and art fairs. The Summit's network of international artists would expand over time as we continued to have conversations and grew our network and knowledge of practitioners.

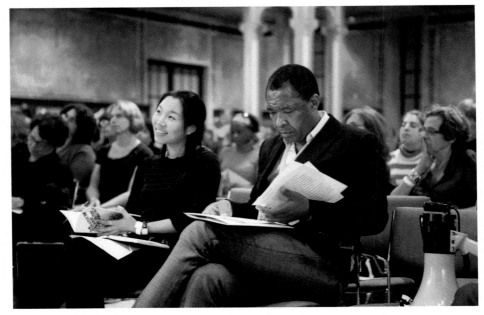

Courtesy Creative Time.

Presenter Okwui Enwezor at the first Creative Time Summit: Revolutions in Public Practice, 2009.

The first Creative Time Summit took place in 2009, one year into the Barack Obama presidency, and in partnership with the New York Public Library. It was seemingly the dawn of a new era. Eight years of George W. Bush as president and the so-called War on Terror had somewhat come to a close; the country had clawed its way out of the big bank bailout of the subprime mortgage crisis. Obama rode into office with promises of closing Guantanamo Bay, and, after eight years of Donald Rumsfeld and Dick Cheney, the new presidency sent an electric shock that history was in the making.

The 2009 and 2010 Summits made a case for political art. We aimed to acknowledge its history and to make space for those artists and collectives that possessed active disdain for the mainstream art world and capitalism in general. Established contemporary global curators and artists such as Okwui Enwezor, Maria Lind, Thomas Hirschhorn, Carin Kuoni, and Alfredo Jaar presented alongside historically important art activists and social practice creators such as Gregory Sholette, Suzanne Lacy, Harrell Fletcher, and Mel Chin and off-the-circuit contemporary activists such as Baltimore Development Cooperative. This would be an evolving formula that would become more global and interdisciplinary as time went on

Leveraging the social capital available from established artists and curators, we put forth a platform that was consciously resistant to power. We were cognizant of the world of conferences that were beginning to emerge in the media landscape. The dot-com–supporting blockbuster innovator conference TED haunted us with its flashy motivational speeches, solid embrace of popular education, and adoration for the rising world of technology. We wanted to keep the conference grounded by speaking truth to power and to simultaneously play a spotlight on many projects that remained hidden. In doing so, we walked the tightrope in the inevitable contradiction of being a resistant program at the center of global capitalism. This contradiction would become more apparent in years to come.

2011: take to the squares

So, 42 years later, this manifesto is a world vision and a call for revolution for the workers of maintenance. For these are the workers of survival and sustainability. Look around, that's most of the people in the whole world. Together, if organized and in coalition, we could reshape the world.
Mierle Laderman Ukeles, Creative Time Summit: Living as Form, 2011

In 2011, the world erupted in a wave of protest and vast political transformation. The year of 2011 would come to be known for the Arab uprisings, the European Summer, and Occupy Wall Street—a domino effect of historic popular uprisings that took over the planet and rocked political establishments worldwide.

It was during this period that Creative Time launched *Living as Form* and the accompanying Summit of the same title. A sprawling exhibition that took place at the Essex Street Market surveying socially engaged art across the globe from 1991–2011, *Living as Form* placed into the conversation a diverse set of artistic practices that utilized the form of everyday life as their artistic medium. As artist Paul Ramírez Jonas said, "The public has a form and any form can be art." The exhibition and Summit itself would coincide with the dawn of Occupy Wall Street located in Zuccotti Park in downtown New York's Wall Street.

Three years after the financial crisis and related big bank bailouts, activists and artists camped out in the park and regularly held protests that demanded accountability from the financial sector. With adages such as "We are the 99%," the movement—which continued

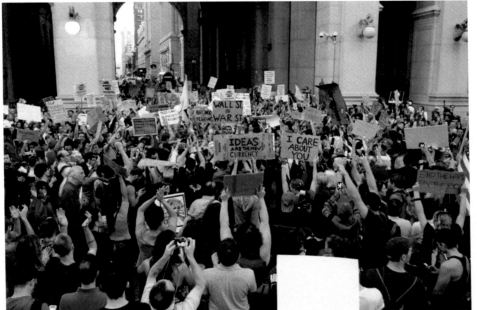

The Occupy Wall Street movement erupts, 2011.

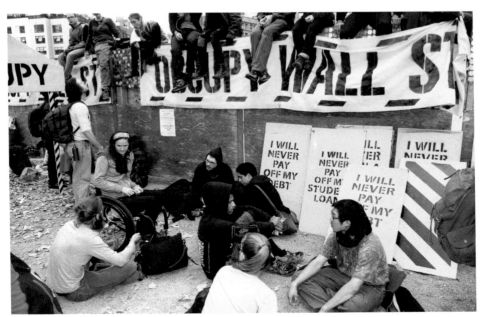

Protesters occupy Zuccotti Park in New York's Wall Street.

to grow and to spring up across squares throughout the country—brought a much needed conversation about neoliberalism and class to television screens, newspapers, and plazas across the United States.

The occupation of the squares had first begun in the Arab world, kicked off in Tunisia with the self-immolation of the fruit seller Mohamed Bouazizi. After having his wares confiscated by the police, Bouazizi set himself on fire, unleashing a wave of protest in Tunisia. The scale of the pushback would not go unnoticed in neighboring Egypt, where youth organized to gather in Tahrir Square on January 25, 2011, to protest the Mubarak regime. As is well-known, the protests in Tunisia would unleash a wave of resistance in Libya, Iraq, Bahrain, Yemen, Syria, Sudan, Jordan, Morocco, and elsewhere. In Tunisia and Egypt, the governments would be overthrown; in other countries such as Syria and Yemen, events would lead to bloody and ongoing civil wars. But in the early days of the Arab uprisings, it felt like anything was possible. The horizon of political possibility remained open.

This movement spread to the shores of Europe where the Indignados movement erupted in Spain in May 2011 and took over Madrid's Puerta del Sol Plaza. As for the events of the Arab uprisings, the use of social media outlets like Twitter and Facebook provided tremendous power for social organizing. Using a Facebook page, the Indignados movement called for people to gather on May 15, stating, "We are not goods in the hands of politicians and bankers."

For the field of art and activism, the year 2011 would set the stage for all events to come. A certain urgency took over in political art. Rather than a desire to blend art and life, suddenly the point was to use art to transform life itself. Art was no longer a passive reflection but an active engagement and challenge to structures of power—from banking to the art world itself.

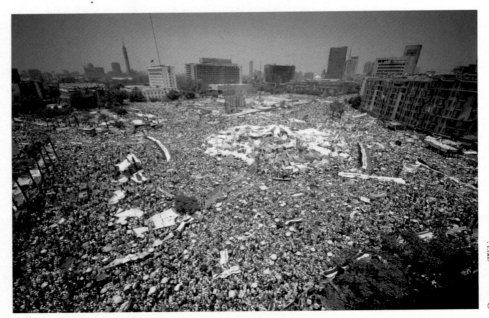

Protesters gather in Tahrir Square, Cairo, Egypt in January, 2011.

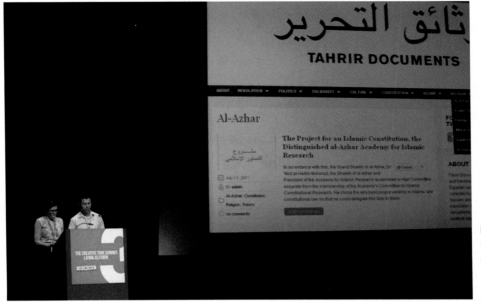

Founders of the Tahrir Documents Project Emily Drumsta and Levi Thompson present at the 2011 Creative Time Summit: Living As Form.

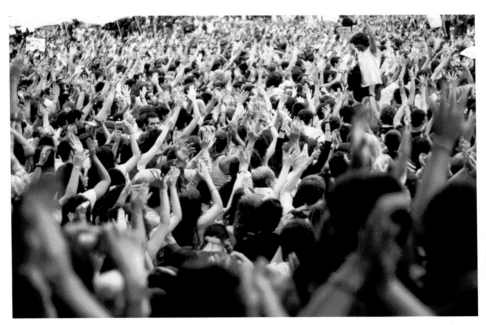

The Indignados movement sweeps over Madrid's Puerta del Sol Plaza.

2012: of critiques and boycotts

We occupy museums to reclaim space for meaningful culture by and for the 99%. Art and culture are the soul of the commons. Art is not a luxury!

Occupy Museums, 2011

If the Arab Uprisings began with the youth challenging the powers that be, the next phase ushered in armed coalitions ready to seize upon a power vacuum. Syria would descend into a complex interregional conflict that evolved into a proxy war between larger powers. The sheer brutality of the pushback from regimes would attempt to stifle the forces of solidarity that had unleashed the Arab uprisings.

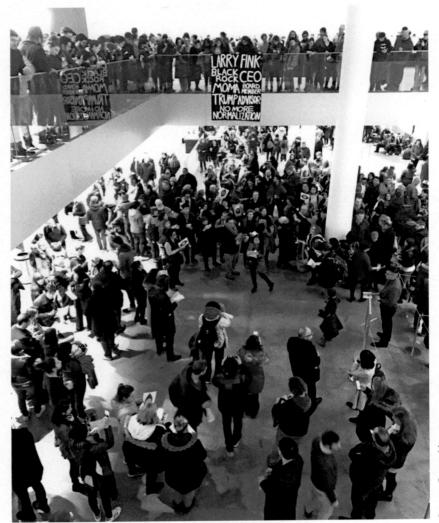

Occupy Museums protest against MoMA board member Larry Fink, 2017.

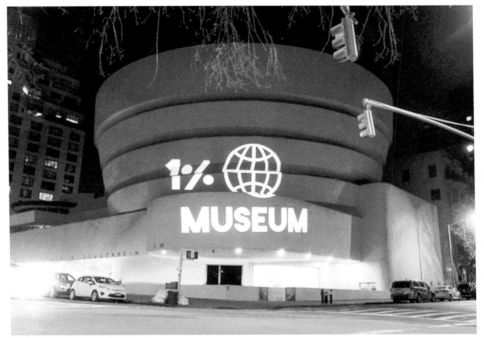

Courtesy Occupy Museums.

Occupy Museums, as part of G.U.L.F. (Gulf Ultra Luxury Faction), protests Guggenheim Abu Dhabi's labor practices.

In the United States, the post–Occupy movement in art and activism would turn its attention toward the forces of neoliberalism in the art world itself. In 2011, Occupy Museums would challenge board members of the Museum of Modern Art (MoMA) for their antiunion policies with staged group discussions and readings in front of Diego Rivera murals. Through the action, the group promised to occupy the MoMA each week in order to open a meaningful conversation about economic injustice and the abuse of the public for the gain of the 1% in cultural institutions. They followed in the footsteps of a collective formed several years prior, a group called GULF Labor, which took to task the labor conditions in the construction of the Guggenheim Abu Dhabi.

A galvanized online and in-person movement, which set out to critique and hopefully reconstruct institutions central to the art world, began to emerge. In 2011, the Sharjah Biennale found itself in the crosshairs of a viral petition that castigated the organization for censoring Maportaliche/*It Has No Importance* (2011), an installation by Algerian artist, writer, and journalist Mustapha Benfodil. The petition was just the beginning of many more biennials to face artist backlash. The 2014 iteration of Manifesta, the roving European Biennial of Contemporary Art set to take place at the Hermitage Museum in St. Petersburg faced boycotts after many found the partnership with the homophobic government of Russia irredeemable. The 2014 iteration of the Sao Paolo Biennale likewise faced protests from participating artists demanding the institution return the financial support it received from the government of Israel.

In 2012, the Creative Time Summit found itself in the crosshairs of a boycott due to a partnership with an Israeli organization. The artist petition, originally circulated by the Cairo-based media collective duo Mosireen, gained widespread attention. With claims that such a partnership

violated the boycott divestment and sanctions movement against the state of Israel, the incident sparked reflection within Creative Time and provoked a deeper understanding of how to navigate such complex political dynamics in our work ahead.

Things fall apart: of dictators and gentrification

> The research I do for my work is a single one: It doesn't happen around themes or subjects, but it represents the way I have decided to live and do as a political actor in any given context—taking art as the profession to do so, and interventions as the strategy.
> *Minerva Cuevas, Creative Time Summit: Revolutions in Public Practice, 2010*

The period post–Arab uprisings fell into a tailspin of neoliberal and populist forces. The backend of the Internet revolution would be the rise of right-wing movements and in the world of art and politics, the overwhelming whiteness of art and activist forces would inevitably be confronted. Conversations began to circulate back to the spaces of privilege where the lines of race quickly became evident. Gentrification was a nexus of these issues and became a focus worldwide. The battles over gentrification may not be anything new, but the speed at which urban development took advantage of the financial crisis kicked in the teeth of activists and the poor alike.

In Syria, artist groups like Abounadarra documented the violence that plagued the cities of Halfaya and Damascus. With guerrilla-style clips, the reality of the war found its way to viewers globally across YouTube. The 2013 Istanbul biennale curated by Fulya Edremci, originally intended to work in public spaces across the city to celebrate the gains of the public protests in Taksim Square in Gezi Park, would be confronted with the increasingly fascist leadership of President Recep Tayyip Erdogan. Taking place in a rapidly developing urban metropolis, the Istanbul protests were as much about the privatization of public space as much as they were about asserting class equity and civil liberties.

In Spain, artist Leonidas Martin worked with other members of the Indignados, developing the protest, "You will never own a house in your whole fucking life!" Pushing back on the widespread foreclosures, the left-wing Spanish political party Podemos made gains in Barcelona and Madrid. The Occupy Movement would also spread to Hong Kong, with citizens demanding a form of self-governance. Under the so-called Umbrella Movement, activists pushed back against electoral reforms that would make it easier for the Chinese Communist Party to control the electoral system of Hong Kong.

In the United States, the phenomenon of collective placemaking would bring to the fore issues of race and class., with gentrification making startlingly clear the vast differences in privilege between communities. At the 2014 Summit, critic and author Rebecca Solnit recounted how the overwhelming takeover of San Francisco by supposed "do-gooder" tech companies like Google and Facebook have displaced economically vulnerable communities. Architect Alfredo Brillembourg said of the squatting community in the high-rise known as Torre de David in the center of Caracas, "It doesn't look good, but it has the seed of a very interesting dream of how to organize life."

In addition to gentrification, the conversation turned toward that of surveillance. On May 20, 2013, NSA-subcontracted employee Edward Snowden fled to Hong Kong to meet with documentary filmmaker Laura Poitras and journalists Glenn Greenwald and Ewan MacAskill. Snowden would leak myriad files to the press revealing a vast level of surveillance by the U.S. government on its own citizens, its allies, and the world. While the United States wrestled with its own fears of the Obama deep-state, the Syrian War tore the Middle East apart and sparked the

largest refugee crisis of our time. Lebanese artist Tony Chakar asked Summit audiences—Where was the compassion? Where was the assistance? The fate of urban life and civil rights seemed very much in limbo. After the promise of liberation through the Arab uprisings and the Occupy movement, the fallout felt more bleak than ever.

Be careful what you wish for

On the image of the Anonymous Accordion Player during the Gezi Park Protests in Istanbul, Turkey:

> The supposition is that every era, every epoch, dreams of the next one and the dreams come in the form of these dream-images or image-texts. This one is from Ankara in Turkey that happened recently. . . . The promise that it is giving us about a life that is not possible now, but that can be possible again . . . about a life of Carnivale, like when we used to dream that everything was possible, that life could be inverted, could be viewed upside down. He is dancing in the street and behind him you have all this destruction, because no new life will come without the destruction of the old ways.
>
> Tony Chakar, Creative Time Summit: Art, Place,
> and Dislocation in the 21st Century City, 2013

If the Summit began as an effort to prove the importance of political art to the art world denizens of NYC, then by 2014 the point had most certainly been made. That year marked a flourishing of political art. In New York City, Queens Museum director and advocate for socially engaged art, Tom Finkelpearl, became the Cultural Commissioner for the city under the De Blasio Administration. Community and social sculpture artist Rick Lowe won the Macarthur Prize. And Theaster Gates, the wunderkind of Chicago's South Side, took his art world largess and developed an intentional community arts center within a restored bank building. Suddenly, the "outsider" world of socially engaged art had become very much a central part of art discourse.

It wasn't just the museums that caught on. It was also the foundations. Foundations like Art Place, a placemaking foundation originally in the Richard Florida vein, had reshaped itself, looking toward the arts as a space for community development. Large amounts of money were being directed toward socially engaged art projects. Conferences began to proliferate as well. In the United States, social justice conferences and organizations had begun to gain traction, such as Hand in Glove, Open Engagement, the Vera List Center for Art and Politics, Blade of Grass, and the Queens Museum. These conferences helped to bring these discussions that were for so long limited to the periphery of the art discourse to wider audiences. They also expanded the conversation and communication among practitioners, allowing for the sharing of resources and the advancement of conversation.

In that year, Creative Time partnered with curator Magdalena Malm to bring the first international Summit to Stockholm. The following year, 2015, curator Okwui Enwezor invited the Creative Time Summit to participate in the Venice Biennale. As the Summit gained currency within the art world, new questions arose as to how resistance movements were being co-opted into the halls of power.

The 2014 Summit in Stockholm focused on the rise of the global right wing. As populism gave rise to xenophobic movements that were further heightened by the growing migration of people displaced by crises in the Syria and Yemen crises. The Summit aimed to provide a platform with which to respond to such destabilizing politics. Political candidates like Birgitta Jonsdatter spoke about the pirate party in Iceland; Prime Minister of Albania Edi Rama spoke

Simone Leigh presents at the 2015 Creative Time Summit: The Curriculum NYC.

Keynote speaker Antonio Negri presents at the 2015 Creative Time Summit: The Curriculum at the Biennale Arte 2015.

about the power of art to change the lived experience of cities; and artists including Ahmet Ögüt warned about the dangers of tyranny being confronted in Turkey while also discussing his project, The Silent University, a university taught by and for refugees.

In Venice, the 2015 Summit continued to be a space to hear from those on the run from increasingly right-wing governments. Amar Kanwar spoke about his film and community development project *The Sovereign Forest* and the rise of the Modi regime in India. Activist Joshua Wong gave an impassioned speech regarding the right to self-determination in Hong Kong. While the platform's presence of the Venice Bienale can be interpreted as socially engaged art making some progress in the halls of art world power, the political reality on the ground couldn't be further from the truth. As more politicians, artists, activists, and academics presented, a picture emerged of a world where art and life had merged, but life itself was politically destabilized, violent, and precarious.

Hands up, don't shoot

There are many in America that feel, every day, what it means to be under siege.
Alicia Garza, Creative Time Summit DC: Occupy the Future, 2016

The 2016 Summit took place auspiciously in D.C. on the eve of the United States election that brought Donald Trump to the presidency. A bellwether of the arriving political horizon, the Summit made clear that the antipathy for the right-wing agenda of Trump found an equal match with the disdain for the neoliberal policies of the Democratic Party. Political commentator Thomas Frank spoke to the corrupt nature of the election and focused on the rise of the Movement for Black Lives.

The keynote speaker was Alicia Garza, one of the founders of the #BlackLivesMatter movement that swept across the country as America's Black citizens were routinely gunned down by law.enforcement. Spawned in the aftermath of the acquittal of white security guard George Zimmerman after shooting of Black 17-year-old Trayvon Martin, the hashtag would go viral, and so too would the campaign as it moved from tragedy to tragedy in a list of names that grows to this day: Eric Garner (NYC), Michael Brown (Ferguson), Tamir Rice (Cleveland), Dontre Hamilton (Milwaukee), Freddie Gray (Baltimore), Sandra Bland (Waller County, Texas) and so many more. Garza stated with force, "There are many in America that feel, every day, what it means to be under siege." Artist Sheila Pree Bright showed gripping documentary photographs from the protests in Chicago, New Orleans, and Baltimore. Filmmakers Arthur Jaffa and Elissa Blount Moorehead talked about Black cinema and the sadistic relationship between Black bodies and the silver screen. Finally, Carrie Mae Weems spoke to an enraptured audience on the need for grace in the face of racism and violence.

Historically, the Summit had hosted various collectives from Russia who faced persecution, from Voina to Pussy Riot. In 2016, each presentation and performance pointed to the ruins of democracy within the United States.

Artist Shuddabratta Sengupta of the India-based Raqs Media Collective spoke about the vast sculptural project, Coronation Park, which featured nine denuded statues recreated from the coronation of King George V and Queen Mary as emperor and empress of India in 1911, which investigate the ongoing impact of colonialism in India and globally.

It was the 100th anniversary of the birth of the avant-garde movement Dada, and perhaps that same sense of political absurdity had begun to well up. While the United States' news media would soon enough simply become a series of reactions to the tragicomic behavior of Donald Trump, on the eve of the election, the conversation lingered on the tragedy of the electoral

Journal Rappe presents at the 2016 Creative Time Summit: Occupy the Future.

system itself. A sinister picture of the future was certainly in place and, politically, attention began to shift toward the longer journey of injustice that had made such a system possible.

Unlearning

> What is my relationship to land? It is hard to think of it as something separate from myself, as something separate from the way I think about community, the way I think about love, the way I think about caring.
> —*Wanda Nanibush, Creative Time Summit: Of Homelands and Revolution, 2017*

In April of 2016, LaDonna Brave Bull Allard, a Lacota Nation activist and Standing Rock Sioux elder, initiated a camp for cultural and spiritual resistance to the proposed Dakota Access Pipeline in North Dakota. The camp would quickly gain widespread attention and attract activists from across the country. This historic flashpoint would become known as Standing Rock and would become a site of conversation and active political resistance tying together many political concerns at the intersection of indigenous rights, activism, and environmentalism.

On the heels of Standing Rock, curator Adam Szymczyk put together a two-part documenta titled *Learning from Athens* that took place in 2017, half the exhibition and programming based in the historic German home of documenta, Kassel, and the other in Athens, Greece—the location of a deep financial crisis and battle for the fate of the European left. At the opening press conference, as Hili Perlson reports, Szymczyk stated, "We believe that unlearning everything we believe to know is the best beginning. The great lesson is that there are no lessons." As an integral part of that unlearning, documenta featured a number of indigenous culture makers, including Rebecca Belmore, Beau Dick, Máret Ánne Sara, Britta Marakatt-Labba, Synnøve Persen,

Keviselie (Hans Ragnar Mathisen), Mette Henriette, Iver Jåks, Niillas Somby, and Joar Nango. If unlearning was part of the program, it was part of a larger discussion in academic, activist, and artistic circles described as "decolonial" practices.

That same year, Creative Time presented two Summits: one described as a "dispatch" in Athens, as well as a full Summit in Toronto. The Athens dispatch, presented in partnership with the Onassis Cultural Center, took place in the aftermath of the failed Greek election and in the midst of the Syrian refugee crisis and rising unemployment among Greek youth. Creative Time took a different approach to this Summit, inviting participants to be "delegates" and to present three artists, activists, or academics at the gathering.

Many indigenous and global south participants expressed skepticism toward claims of solidarity from Western nations. At the same time, U.S. artist Simone Leigh argued for the need for white progressive communities to get practical about politics (in a way, she asserted, that Black communities had long been). Artists and curators from Europe—including Adam Kleinman, Dephne Ayes, and Iiana Fokianaki—spoke to the dual forces of a rising left and right across the continent.

In Toronto, the Creative Time Summit took place in partnership with the Power Plant Gallery. This iteration, titled *Of Homelands and Revolutions*, would take into account the 100th anniversary of the Russian Revolution as an entry point into the history of colonialism and indigenous resistance. The Summit highlighted the voices of indigenous artists and scholars, including Standing Rock artist Canupa Hanska Luger, Maori artist and curator Dr. Huhana Smith, Sami artist Máret Ánne Sara, Crees Canadian painter and performance artist Kent Monkman, and curator Wanda Nanibush. In addition, a talk by Srecko Horvat, an advisor to Yanis Varoufakis and the growing Democracy Movement in Europe (labeled DiEm25), spoke about the desperate need to take the electoral system seriously and for all social movements to focus on changing governmental structures.

Photo by Candace Nyaomi. Courtesy Creative Time.

Gary Sault leads a land acknowledgement at the 2017 Creative Time Summit: Of Homelands and Revolutions.

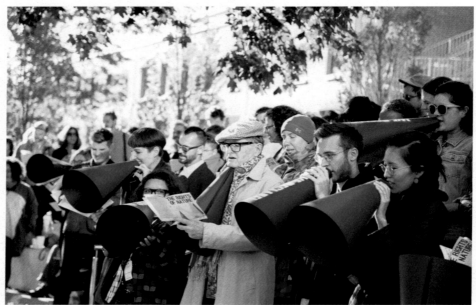

Photo by Candace Nyaomi. Courtesy Creative Time.

"The Rights of Nature" closing ceremony for the 2017 Creative Time Summit: Of Homelands and Revolutions. In collaboration with Public Studio, Hiba Abdallah, Haida lawyer Terri-Lynn Williams Davidson.

So much more to do and learn

> I remind the ruling class: Today you are depriving us of our future, but the day will come when we decide your future. No matter what happens to the protest movement, we will reclaim the democracy that belongs to us, because time is on our side.
> *Joshua Wong, Creative Time Summit: The Curriculum, 2015*

Looking back over ten years of this conference of art and activism, we can glean much. The Summit has offered an artistic snapshot, blurry yet prescient, of the major events in social activism and world events over the past decade. Rather than disparate moments, these histories are interwoven; they inform and incite future events, with art at their core. Whether Occupy or the Indignados movement, the Snowden revelations, or the growing resistance of Occupy Hong Kong, the post-Apartheid landscape or the rise of post–civil war in Medellin, these events are intimately tied up with cultural spaces and artist-organizers on the ground. Just a cursory glance at the last ten years reveals something very simple and mesmerizing: artists were center stage in many of history's most groundbreaking social movements and events.

But this is not meant to be an essay of boosterism. With humility, the Summit over the years revealed just how much further we had to go than how far we had come. It is certainly telling that only toward the end of the past ten years did the conversation around indigenous resistance take center stage. To take a broader look at history allows one to see beyond hot button political events and instead to focus on ongoing structural oppressions and inequalities and on the longue durée of colonialism. In doing so, ongoing questions of what constitutes art, what constitutes resistance, and what constitutes a subject and community suddenly appear with more force and with more relevance.

The Summit in Athens also pointed toward a different methodology in providing space for local actors to bring their agendas and constituencies to the table. In so doing, productive debate emerged, questioning the assumptions of the term "solidarity" on the Left, including different ideas around race, activism, and the meaning of solidarity.

But these failures, so to speak, in providing solidarity, also hinted at just how urgent it remains to provide a space for various cultural agents from across the globe to come together. Exposing difference, while also finding a creative space to share work, ideas, dreams, and concepts, allows for new forms of social cohesion and play. By presenting a complex ecology of resistance instead of conventional blue chip artists, the Summit hoped to avoid the pitfalls of the commercial and press-hungry vectors of art world alienation.

It also required no small amount of adaptability. Acting as a focal point for the resisters across the globe to come together means no small amount of patience and openness to critique. The Summit certainly found itself in the crosshairs of both boycotts and critiques and during these times had to wrestle with its values and how it could operate within a space of both political and activist discussions. As an organization operating in New York City (the belly of global capitalism no less), the Summit required both finesse and constant (self)evaluation of the contradictions and ironies of presenting political art and global resistance.

The value of cultural practices invested in social change remains more dynamic and urgent than ever. With a vast ecology of intersectional issues coming to the fore—from climate change to capitalism, gender equity and decolonialism (and the list goes on and on)—the creative approach to tackling these issues and speaking publicly about them will forever have value. In an era where the consolidation of power defines politics globally, those that speak truth to power will need sanctuary, support, and a platform. A glimpse at the last decade should provide ample evidence that art activists from across the globe are opening conversations, spaces, and new ways of thinking that make another future possible.

Works cited

"About." *Occupy Museums*, www.occupymuseums.org/index.php/about. Accessed 13 November 2018.

Brillembourg, Alfredo. "Creative Time Summit | Built From the Ground Up: Alfredo Brillembourg." *YouTube*, uploaded by Creative Time, 13 November 2013, www.youtube.com/watch?list=SPxlntVxQCi56 BCzMiQ7KLHThyb-YukqIB&v=UALqRO7GP2M. Accessed 29 July 2019.

Chakar, Tony. "Creative Time Summit | Flaneurs: Tony Chakar." *YouTube*, uploaded by Creative Time, 13 November 2013, www.youtube.com/watch?list=SPxlntVxQCi56BCzMiQ7KLHThyb-YukqIB&v= CF-bRD2TF_E. Accessed 29 July 2019.

Cuevas, Minerva. "Creative Time Summit | Minerva Cuevas." *YouTube*, uploaded by Creative Time, 25 January 2010, www.youtube.com/watch?v=tJhQjUK-f3A. Accessed 29 July 2019.

"First Action at Museum of Modern Art." *Occupy Museums*, 20 October 2011, www.occupymuseums.org/ index.php/actions/18-first-action-at-museum-of-modern-art. Accessed 13 November 2018.

Garza, Alicia. "Creative Time Summit DC | Under Siege—Keynote: Alicia Garza." *YouTube*, uploaded by Creative Time, 26 October 2016, www.youtube.com/watch?v=NUNzJ-DKmrE. Accessed 29 July 2019.

Kuoni, Carin. "Creative Time Summit | Carin Kuoni." *YouTube*, uploaded by Creative Time, 25 January 2010, www.youtube.com/watch?time_continue=59&v=PgAaDb4ECTE.

Laderman Ukeles, Mierle. "Creative Time Summit | Mierle Laderman Ukeles." *YouTube*, uploaded by Creative Time, 24 August 2012, www.youtube.com/watch?v=Y38PjCYSaqM. Accessed 29 July 2019.

Martin, Leonidas. "Spain: The Nameless Force behind the Protests." *Creative Time Reports*, 30 November 2012, http://creativetimereports.org/2012/11/30/spain-the-nameless-force-behind-the-protests/. Accessed 29 July 2019.

Nanibush, Wanda. "Creative Time Summit Toronto | Land—Wanda Nanibush." *YouTube*, uploaded by Creative Time, 18 October 2017, www.youtube.com/watch?v=kaAeSq-CeuU. Accessed 29 July 2019.

Perlson, Hili. "The Tao of Szymczyk: documenta 14 Curator Says to Understand His Show, Forget Every-thing You Know." *artnet News*, 6 April 2017, https://news.artnet.com/art-world/adam-szymczyk-press-conference-documenta-14-916991. Accessed 14 November 2018.

Ramírez Jonas, Paul. "Creative Time Summit 2015 | The Art of Pedagogy: Paul Ramírez Jonas." *You-Tube*, uploaded by Creative Time, 2 September 2015, www.youtube.com/watch?v=HcT3Cxo_3aU. Accessed 29 July 2019.

Wong, Joshua. "Creative Time Summit 2015 | Statement: Joshua Wong." *YouTube*, uploaded by Creative Time, 2 September 2015, www.youtube.com/watch?v=4_xwjPPBf7Y. Accessed 29 July 2019.

PART II

On arts, politics, and engagement
A selected timeline 1945 to present

Chto Delat? with an introduction by Corina L. Apostol and Nato Thompson

on Arts, Politics, and Engagement:
a Selected Timeline
1945 to Present

A paradox exists in the effort to chronologically organize politically and socially engaged art from around the world. First, the two concepts "art" and "politics" shift meanings so dramatically across time and geography, that the terms themselves nearly collapse. Yet, secondly, in an age of already profound and only increasing regional retrenchment, it appears more urgent than ever for a spirit of internationalism to be embraced historically by political art.

We elected to present this timeline as a starting point for inquiry, reflecting the collective interests of our editorial team and our contributors, which range from activism to aesthetics, from the historical to happenings, and from the local to the global. Our selection includes landmark events that shaped and guided the practice of socially engaged art, including dramatic political changes and far-reaching social movements. This timeline recognizes the principal role of socially engaged art as part and parcel of art history, as well as everyday socio-cultural geographies.

key:

■ arts\culture\knowledge
■ peoples' life
■ geopolitics
▢ economics
■ time ▢ space

★ = zvezdá = very inspiring event
🐾 = red kónnitsa = movements
✖ = grobý = deadly disasters
⚡ = mólnia or vnezápno = no one would expect this

The projects that we highlight critically deconstruct traditional, academic art history; they shift the focus from art-related texts and images to a consideration of the cultural construction of those artistic practices and works and their relationship to seminal social and political events. Our timeline extends the aspirations of a global art history by positioning key art projects not as objects of history within a predetermined Western canon, but as a set of active inquiries into historical processes, engaging propositions to imagine other scenarios for a changing world.

This collective timeline presents compelling socially engaged art histories from around the world in different ways, based on a selection of key projects, actions, initiatives, thinkers, and artists working in the rapidly-changing socio-political environments of their localities. The specific atmosphere in their respective working environments impacted the direction each work took as artists sought diverse responses to these pressures. Each project was both a reaction to, as well as a product of, the changing social times of which these protagonists were an integral part. Their engagements, aspirations, and propositions to a volatile and confusing era of complex struggles provide much needed inspiration for the challenges ahead Corina L. Apostol and Nato Thompson

ized by **Chto Delat** research unit members: **Corina L. Apostol, Corinne Butta, Dmitry Vilensky, Julia Hernandez, Nato Thompson, Nikolay Oleynikov, Shimrit Lee, Tianyu Guo**

graphic work: **Nikolay Oleynikov**
inspired by **La Charge de la Cavalerie Rouge** [Skachet Krasnaya Konnitsa] by **Kazimir Malevich**, 1928-1932 (see image above)

Paris, France: **Maurice Merleau-Ponty** publishes **Phenomenology of Perception**, introducing a paradigm shift in the humanities and social sciences towards acknowledging an embodied understanding of everyday life

Paris, France: Artists **Isidor Isou** and **Gabriel Pomerand** disrupt a performance of **Tristan Tzara's La Fuite** at the **Vieux-Colombier**

FINIS LES PIEDS PLATS

Publication of **The Letterist Dictatorship: notebooks of a new artistic regime.** The subtitle proudly boasts that **Lettrism** is *'the only contemporary movement of the artistic avant-garde'*

Bombay, India: **Bombay Progressive Artists' Group** forms following the partition. Artists break with the revivalist nationalism of the modernist **Bengal School** to encourage an Indian avant-garde

Paris, France: Northern European avant-garde internatio art collective **CoBrA** fo focusing on spontaneity experimentation rather formalism in their wo

End of World War II (1939—1945) 70 to 85,000,000 victims

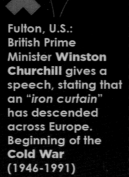

Nagasaki

Osaka

Hiroshima Tokyo

U.S. bombs **Hiroshima** and **Nagasaki** in **Japan**, over **100,000** people are killed

UN General Assembly passes a partition plan to separate **Palestine** into t states: **Palestine** and **Isra**

RED SCARE intensifies in the U.S.; the **House Committee on Un-American Activities** (HUAC) arrests 10 Hollywood writers and directors for affiliations with the Communist Party. The playwright and theatre practitioner **Bertolt Brecht** is among those blacklisted

Fulton, U.S.: British Prime Minister **Winston Churchill** gives a speech, stating that an *"iron curtain"* has descended across Europe. Beginning of the **Cold War** (1946-1991)

Apartheid system of rac segregation is implemer in South Africa

North Atlantic Treaty Organization (NATO) is established, composed of signatories including the countries of the Western European Union, the U.S., Canada, Iceland, and Norway.

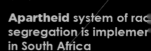

Berlin, Germany: **Bertolt Brecht** establishes his theatre company, the **Berliner Ensemble**

FINIS LES PIEDS PLATS

Kassel, Germany: **Arnold Bode** founds **documenta**, an exhibition of contemporary art which takes place every 5 years

FINIS LES PIEDS PLATS

Berlin, Germany: The **Soviet War Memorial** is built in **Treptower Park**, designed by Soviet architect **Yakov Belopolsky**. It commemorates **7,000** of the **80,000** Soviet soldiers who fell in the **Battle of Berlin** in April–May, 1945

Tokyo, Japan: Jikken Kōbo (Experimental Workshop), a self-taught collective of artists, musicians, and writers, is founded in Japan within the context of the Hiroshima and Nagasaki bombs

Paris, France: **Frantz Fanon** publishes **Black Skin, White Masks**, a theoretical work critiquing colonialism and Western hegemony

FINIS LES PIEDS PLATS

Paris, France: **Picasso's** first **Dove of Peace** is chosen as the emblem for the **First International Peace Conference**

The **20th Congress** of the Communist Party of the Soviet Union takes place, introducing *de-Stalinization*

NIS LES PIEDS PLATS

People's Republic of China forms headed by **Mao Zedong**

Osaka, Japan: **Jiro Yoshihara** founds the Gutai group, who explore boundaries through audience participation

Bandung Asian-African Conference brings together the first generation of post-colonial leaders from both continents to formulate an international relations policy

FINIS LES PIEDS PLATS

György Lukács, a Marxist philosopher, is appointed Minister of the brief communist revolutionary government in **Hungary**

...ginning of **McCarthyism** in the U.S.

New York City, U. S.:
Allan Kaprow presents
**18 Happenings
in 6 Parts** at
Reuben Gallery

**I
HAVE
A
DREAM**

Bengal, In[...]
Bengali poets f[...]
the **Hungry** a[...]
Movement
anti-colonial [...]
anti-canon[...]
group
sha[...]
the lite[...]
establishm[...]

Yuri Gagarin, a Soviet pilot and cosmonau[...]
becomes the first human to journey into
outer space when his **Vostok** spacecraft
completes one orbit of the Earth

Belgrade, Jugoslavia:
Non-aligned Movement (NAM[...]
a group of organizations resist[...]
alignment with any world
superpower, is established

The Situationist International (SI) is formed.

Paris, France:

The SI incorporate influences from Dada, Surrealism, and **Lettrism**
with anti-authoritarian Marxism to critique mid-20th century capitalism

Paris, France: **Yves Klein**'s The Void is displayed at **Galerie Iris Clert**

Havana, Cuba:
Fidel Castro and
**Ernesto "Che"
Guevara** lead
a rebel army into
Havana during
the **Cuban
Revolution**,
initiating
a revolutionary
government.
Decolonization
reaches its peak
when **16 African
countries**
achieve
independence
from European
colonial
powers

Berlin, Germany:
Supported by Soviet leaders,
East German authorities
build **a wall**
between East and West Berlin.

WEST WEST WEST WEST WEST WEST WEST WEST

**I
HAVE
A
DREAM**

George Maciunas initiates
The Fluxus International Festival.
Fluxus denotes a movement of
international concerts and events,
manifestos and editions

Tokyo, Japan:
Radical art collective
Hi-Red Center is founded;
the group creates happenings
and events, using their urban
environment to generate works
that are socially reflexive,
anti-establishment, and
anti-commercial

New York City, U. S.:
Andy Warhol establishes
The Factory, which has three
different locations between
1962 and 1984

New York City, U. S.:
The **Judson Memorial Church**
(known for the **Judson Poets'**
Theater and **Judson Art Gallery**)
becomes a hub for vanguard
dance activity

I
HAVE
A
DREAM

The Cuban Missile Crisis
begins, bringing the world
to the edge of nuclear war

EAST

Washington, D.C., U. S.:
200,000 people march and
demonstrate for African
American civil and
economic rights.
Martin Luther King Jr.
delivers his
"I have a dream" speech
addressing civil rights march
at Lincoln Memorial

The Civil Rights Act of 1964 is passed in the United States
outlawing discrimination based on race, color, religion, sex, or national origin

Moscow, USSR:
Mikhail Bakhtin publishes his highly influential study *Rabelais and Folk Culture of the Middle Ages and Renaissance*

Los Angeles, U. S.:
The Artists' Protest Committee creates the Artists' Tower of Protest designed by sculptor Mark di Suvero.
It becomes a focal point for hundreds of artworks installed around it in protest of U.S. involvement in Vietnam

Paris, France:
Guy Debord publishes **Society of the Spectacle**

London, U. K.:
The **Artist Placement Group** (APG) is organized by **Barbara Steveni** as an artist-run group seeking to refocus art outside the gallery

San Francisco, U. S.:
The **San Francisco Mime Troupe**, an anarchist group and theater troupe known for their practice of guerilla theater, stage a spectacle after their permit is revoked by the San Francisco Park and Recreation Commission, resulting in the arrest of member **Ron G. Davis**

Łazy, Poland:
Tadeusz Kantor organizes the **Panoramiczny happeni morski** (*Panoramic Sea Happening*), which involvec over **1,600 people** from the artistic community as well a tourists on the beach

Düsseldorf, Germany:
Joseph Beuys performs **How to Explain Pictures to a Dead Hare**

LAND BREAD HOUSING
EDUCATION CLOTHING
JUSTICE PEACE LAN
BREAD HOUSING PEACE
CLOTHING JUSTICE LAN
BREAD

Oakland, U. S.:
The Black Panthers is founded to combat police violence against African-American people

Quezon City, Philippine
The **Philippine Educati
Theater Association** (I
is established to train
critical, cultural worker
in social transformatior

LAND BREAD HOUSING
EDUCATION CLOTHING
JUSTICE PEACE LAND
BREAD HOUSING PEACE
CLOTHING JUSTICE LAND
BREAD HOUSING PE
CLOTHING
LAND B.
EDUCAT
JUSTIC

Emory Douglas
becomes Minister of C
of the **Black Panther F**

Indonesia:
After a failed military coup, an anti-communist purge, supported by the U.S. and other Western countries, results in the death of nearly 1 million people

China's **Cultural Revolution** begins, headed by **Mao Zedong**, and ends with his death in 1976

he **Tropicália** artistic movement emerges in Brazil. Hélio **Oiticica** creates environments for viewer interaction, fusing aesthetics and social organization

Tucuman, Argentina: **Vanguard Artist's Group** protests the closure of sugar mills and farms in the Tucuman region by staging an exhibition called **Tucuman Arde** (Tucuman Burns) at their self-created First Biennial of Avant-Garde Art

Venice, Italy: student and anti-war protests take place on the opening day of the **34th Venice Biennale**

Paris, France: Student-led **Atelier Populaire** produces graphic posters and protest materials for demonstrations and public display during the **May Protests**. The **Situationist International** plays a key role in student councils and protest activities

Havana, Cuba: **Del Tercer Mundo** —a cinematic and pedagogical exhibition— opens to address North American imperialism and colonialism

New York City, U. S.: Soviet dissident **Andrei Sakharov** publishes the pamphlet **Reflections on Progress, Peaceful Coexistence, and Intellectual Freedom**, a key text of dissident movements

Image below: **Chto Delat** (after the **Newspaper Boy** by **Emory Douglas**) **1968 Through Continents: Oakland, Paris and eswhere** (fragment of installation) for **100 Years of Revolutions**, Toronto, 2017

Bogotá, Colombia: **Paulo Freire** publishes **Pedagogy of the Oppressed**

Prague, Czechoslovakia: Headed by **Alexander Dubcek**, the new leadership of the Republic launches political reforms under the slogan *"socialism with a human face"* during the **Prague Spring**

1968

New York City, U. S.:
The **Art Workers' Coalition** (AWC) is formed with the goal of pressuring museums into implementing economic and political reforms

Neil Armstrong, an American astronaut, becomes the first man to walk on the moon

New York City, U. S.:
Stonewall riots begin, leading to the gay liberation movement and the fight for LGBT rights in the U.S.

Toronto, Canada:
Three Canadian conceptual artists establish the collective **General Idea**

Amsterdam, Netherlands:
As the Vietnam War escalates, **John Lennon** and Yoko Ono hold two-week-long Bed-ins For Peace at the Hilton Hotel

GIVE PEACE A CHANCE
GIVE PEACE A CHANCE
GIVE PEACE A CHANCE
GIVE PEACE A CHANCE
GIVE PEACE A CHANCE
GIVE PEACE A CHANCE
GIVE PEACE A CHANCE
GIVE PEACE A CHANCE
GIVE PEACE A CHANCE

Robert Smithson constructs the groundbreaking earthwork sculpture **Spiral Jetty**

Nigeria:
Musician and activist **Fela Kuti** forms the **Kalakuta Republic**, a commune, recording studio, and home for people connected to his band, **Afrika 70**, which he declares as independent from the Nigerian State

New York City, U. S.:
The first issue of **Radical Software**, a magazine focusing on revolutionary communication in media and the burgeoning video art community, is published

Santiago, Chile:
The artist collective **Brigada Ramona Parra** (BRP) propels Socialist candidate **Salvador Allende** into the presidency

Brazilian director and activist **Augusto Boal** establishes **The Theater of the Oppressed** as a form of popular theater for and of people struggling for liberation

Petrova-Gora, Croatia:
Vojin Bakić begins construction of **Monument to the Uprising of the People of Kordun and Banija** (1971-1981)

New York City, U. S.:
Ivan Illich, a Croatian-Austrian philosopher, publishes **Deschooling Society**, a critical discourse on the ineffectual nature of institutionalized education

IVAN ILLIC

DESCHOOLIN
SOCIETY

World Perspectives

Edited by Ruth Nanda Anshen

Taranto, Italy:
Environmental activists' gr **Italia Nostra** together with scholars and students of the visual art department local **University** organize series of happenings to confront heavy metallurgi industry responsible for the high rate of cancer among workers in the are

the anti-war fervor and civil and queer rights movements

in building visual culture

Hollywood, United States:
Judy Chicago and Miriam Schapiro organize Womanhouse, a home where they install site-specific art environments surrounding women's reclamation of domestic space

Buenos Aires, Argentina:
The Centro de Arte y Comunicacion hosts the exhibition Art Systems in Latin America

Canberra, Australia:
Four Aboriginal activists construct the Aboriginal Embassy on the lawn opposite Parliament House in protest to the McMahon government's disregard of Indigenous rights

 Dakar, Senegal:
The **Laboratoire Agit'Art** is established with the goal of revitalizing artistic production and critiquing institutional frameworks and the philosophy of *Négritude*

New York City, United States:
Creative Time is founded as a platform for experimental art interventions in the city

 Paris, France:
Henri Lefebvre publishes **The Production of Space**, in which he discusses the socially constructed nature of space, as well as the more complex social realities of everyday life

Paris, France:
Members of the **Arab Workers Movement** (MTA) start a theater company called **Al Assif** (The Storm) to draw attention to the situations of immigrant workers in France

 New Delhi, India:
Jana Natya Manch (People's Theatre Front), a Delhi-based amateur theater company specializing in left-wing street theatre, is established

Belyayevo, Russia:
The **Bulldozer Exhibition** takes place on a vacant lot featuring the work of avant-garde artists from Moscow and Leningrad. The exhibition is forcefully broken-up by a large police force with bulldozers and water cannons, hence the name

London, United Kingdom:
The **Greenwich Mural Workshop** is founded as a service to council estates. They paint murals to highlight their labor as a proper working day

 The **Middle East Oil Crisis** begins

A U.S.-backed coup in **Chile** ousts the **Allende** socialist government. The new **Pinochet** regime forces **Brigada Ramona Parra**, a Communist muralist collective, into hiding

VIETNAM WAR IS OVER
1,353,000 victims
(1955-1975)

Milan, Italy:
The **Festival of the Proletarian Youth** is organized in the city park by **Ré Nudo**, a group of politicized artist and intellectuals

New York City, U.S.:
Jean-Michel Basquiat and friend **Al Diaz** spray paint graffiti on buildings in Lower Manhattan working under the acronym **SAMO**

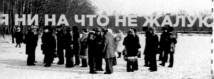

Moscow, U.S.S.R.:
The group **Collective Actions** is formed. Artists invite audiences to take part in minimal, outdoor actions in the fields and forests surrounding the city

Los Angeles, United States:
Artist **Judy Baca** initiates the project **The Great Wall of L.A.**, working together with over 400 community members, historians, ethnologists, and artists to recount an ethnically diverse history of the city

New York City, United States:
Rosalind E. Krauss and **Annette Michelson** found the journal **October**. It is influential to the adoption of French postmodernist theory in American art-historical and critical discourse

Canberra, Australia:
The **Australian Federal Parliament** passes the **Aboriginal Land Rights Act**, the first legislation in the country allowing Indigenous people to claim land rights for heritage lands

Venice, Italy:
The **Venice Biennale** is devoted to unofficial and banned art from *Eastern Europe*; artists from the U.S.S.R. are pressured into refusing to participate

New York City, U.S.:
The **Heresies Collective** launch **Heresies: A Feminist Publication on Arts and Politics**

Gaborone, South Africa:
Molefe Pheto and **Thami Mnyele** establish the cultural organization **Medu Art Ensemble**, whose goal is to promote art that speaks to the immediate community

Munster, Germany:
The first **Skulptur Projekte Munster** (Sculpture Project Munster) is held, exhibiting public works by a number of international artists throughout the city. It is to be held every 10 years since

Istanbul, Turkey:
On the first of May, **International Workers' Day,** agents open fire on the crowd of protesters, **killing over 30 people** and **injuring over 100** more. The demonstration and the Taksim square are decorated with many socially engaged works by Turkish artists

London, U.K.:
Su Braden publishes **Artists and People**, a key study of self-organized community arts projects and a critique of *"parachuting in"* artists to solve social problems

The **Iranian Revolution** begins with the strong participation of Leftist and union forces, which are later repressed

Budapest, Hungary:
Artists **György Galántai** and **Julia Klaniczay** initiate the **Artpool Archive** as an alternative institution for the conservation of materials concerning non-conventional art forms from the 1970s onwards

New York City, U.S.:
Jenny Holzer displays posters with polemical language that contains polemical language that provoke awareness of the need for ideas that passersby and provoke awareness of the need for ideas that encourage social change

New York City, U.S.: **Tim Rollins** and **Kids of Survival** (K.O.S.) initiate a project to integrate art into an after school literacy program in the South Bronx

London, U.K.: **Peter Dunn** and **Loraine Leeson** initiate the **Docklands Community Poster Project**, a ten year initiative to combat the proposed redevelop-ment of the **London Docklands** under **Margaret Thatcher**

Kassel, West Germany: **Joseph Beuys** proposes a plan to plant **7,000 oak trees** in the city of Kassel as his contribution to **documenta 7**

The political art collective **Neue Slowenische Kunst** (NSK) is established in Yugoslavia with the aim of creating an arm of cultural determination for Slovenians

New York City, U.S.: **Creative Time** presents **Mierle Laderman Ukeles'** performance **Touch Sanitation Show: Part 1,** in which she visits each district of the N.Y. Department of Sanitation to shake hands with every worker who would accept the gesture

Moscow, U.S.S.R.: Artist **Nikita Alekseev** launches the **APTART** (Apartment Art) social art movement, involving critical and playful exhibits of artworks in residential apartments

Karachi, Pakistan: **Women's Action Forum** is established. Using posters and artwork as a critical tool in mobilization, the forum becomes one of the most significant platforms for women's rights and feminisms of the global South

Gaborone, South Africa: The **Medu Art Ensemble** organize the **Gaborone Culture and Resistance Festival**

Los Angeles, U.S.: **HIV/AIDS** epidemic begins with the U.S. **Center for Disease Control and Prevention** issuing a warning about rare case of pneumonia within a small group of gay men

The South African photographers' collective **Afrapix** is established. They document conditions of life under Apartheid and oppose its institution

New York City, U.S.: The collective **Group Material** organizes **Timeline: The Chronicle of U.S, Intervention in Central and Latin America** at the alternative venue **P.S.1**

(vertical text, left margin) becoming one of the alternatives ... exhibitions by placing emphasis on the juncture between art and the nature

(vertical text, lower left margin) workers' movement, advancing the causes of workers' rights and social change

The **Public Art Forum** is established in the U.K. as a think tank to conduct research, provide training and support networking events in public spaces

Ghent, Belgium:
Jan Hoet curates the exhibition **Chambres D'Amis**, which features art by fifty international artists displayed in fifty eight private homes across the city

Detroit, U. S.:
Artist **Tyree Guyton** initiates **The Heidelberg Project** to transform his neighborhood into a *living indoor-outdoor art gallery*

Bruno Latour

Science in Action

How to Follow Scientists and Engineers through Society

Cambridge, U. S.:
Bruno Latour publishes **Science in Action: How to Follow Scientists and Engineers Through Society**, in which he lays the foundation of the *Actor-Network* theory

THIRD TEXT

THIRD WORLD PERSPECTIVES ON CONTEMPORARY ART & CULTURE

AUTUMN 1987 £3.50/$6

London, U. K.:
Third Text, a bimonthly journal focusing on the impact of globalization and colonial histories on discourses within contemporary art, is founded by **Rasheed Araeen**

Johannesburg, South Africa:
Tributaries: A View of Contemporary South African Art opens at the **Africana Museum** in Johannesburg. The exhibition incorporates work from both urban and rural African artists and explores the role of "*transitional*" art in the mediation between South African and Western aesthetics

Hamburg, Germany:
Esther Shalev-Gerz and **Jochen Gerz** install the participatory disappearing monument **The Monument Against Fascism** with help from the city's residents

Margaret Thatcher wins against U.K. miners' strike

The Polish surrealist dissident group ORANGE ALTERNATIVE organizes the REVOLUTION OF DWARVES, a series of anti-government protests across Poland marked by its 10,000 participants wearing orange "dwarf hats"

New York City, U. S.:

★ ★

New York City, U. S.:
The activist group **Gran Fury** suspends the banner **All people with AIDS are Innocent** in Manhattan as part of the exhibition **Images and Words: Artists Respond to AIDS** at the Henry Street Settlement Cultural Center

New York City, U. S.:
Crystal and **Lottie LaBeija** present the **First Annual House of LaBeija Ball**, specifically for queens of color. The **House of Latex** forms in the same year to draw **attention to the crisis and struggle against HIV/AIDS**

New York City, U. S.: The **Keith Haring Foundation** is established to provide support to non-profit organizations assisting children and providing educational and care-based resources related to AIDS

★ ★

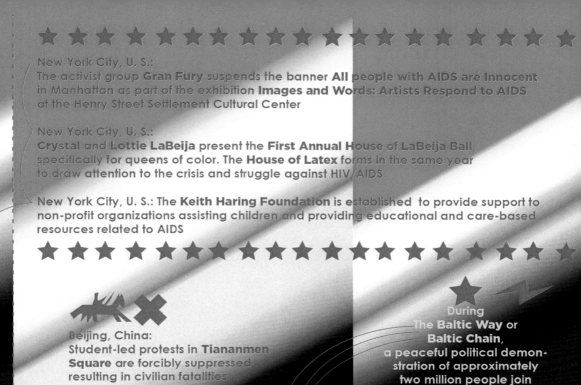

Beijing, China:
Student-led protests in **Tiananmen Square** are forcibly suppressed resulting in civilian fatalities

During
The **Baltic Way** or **Baltic Chain**, a peaceful political demonstration of approximately two million people join hands to form a chain spanning **675.5 kilometres (419.7 mi)** across the three Baltic states

Berlin, Germany:
At midnight on November 9th, citizens of the **GDR** are free to cross the country's borders. East and West Berliners freely cross the checkpoints at the **Berlin Wall**

ESTONIA

LATVIA

LITHUANIA

Warsaw, Poland:
The **Polish People's Republic** democratically transition to the **Third Polish Republic**, becoming the first non-Communist government in the **Eastern Bloc** in over 40 years

POLAND

EAST GERMANY

Timisoara, Romania:
Protests erupt on behalf of a pastor facing deportation due to his criticisms of dictator **Nicolae Ceausescu**. Ceausescu's government responds violently, striking down hundreds of dissenting Romanians and beginning the **Romanian Revolution**

CHECHOSLOVAKIA

HUNGARY

ROMANIA

On January 22, during **Operation Desert Storm**, **ACT UP** activist **John Weir** and two other activists enter the studio of the **CBS Evening News** at the beginning of the broadcast. They shout **AIDS is news. Fight AIDS, not Arabs!**

ART AND THE PUBLIC SPHERE

EDITED BY W. J. T. MITCHELL

Chicago, U. S.: W.J.T. **Mitchell** publishes **Art and the Public Sphere**, providing critical thought on art in public spaces and its audiences in the context of mass communication technologies

Houston, U. S.: **RICK LOWE** initiate **PROJECT ROW HOUSES**, working with a team of artists to renovate abandoned houses in **HOUSTON'S THIRD WARD**

London, U. K.: **Fredric Jameson** publishes **Postmodernism, or, The Cultural Logic of Late Capitalism**, applying a Marxist lens to social and cultural life and objects in late capitalism

Irvine, U. S.: **Coco Fusco** and **Guillermo Gómez-Peña** organize the performance **The Year of the White Bear and Two Undiscovered Amerindians Visit the West**, a counter-quincentennial **Christopher Columbus**

Chicago, U. S.: As part of MARY JA JACOB'S CULTURE ACTION INITIATIVE, artist MARK DION organizes The CHIC URBAN ECOLOGY ACTION GROUP, a project engaging hi school students wit renovation of a build from which to provi neighborhood clean work and ecologica education for the p

San Francisco, U. S.: **Suzanne Lacy** organizes **Mapping the Terrain**, a public performance gathering artists, curators, writers, and theorists to explore the histories and experiences of public art

New Delhi, India: **Raqs Media Collective**, whose multi-disciplinary projects explore power and resistance through writing, curation, and art-making

Zócalo, Mexico City: Around **20,000 Mexicans** fill the central plaza to mourn the deaths of **millions of indigenous people** in the **500 years** since Spanish colonizers arrived in the New World

The Soviet Union collapses

FIGHT AIDS NOT ARABS FIGHT AIDS NOT ARABS FIGHT AIDS NOT ARABS FIGHT AIDS NOT ARABS FIGHT AIDS NOT ARABS

Hamburg, Germany:
Park Fiction is initiated by the local residents' association in Hamburg. Artist **Christoph Schäfer** rallies residents to take control of the urban planning process to use the park for exhibitions, talks, and festivals

, Austria:
ENKLAUSUR
zes a free mobile
or homeless
, operating out
n equipped to
te basic medical
ent

FIGHT AIDS
NOT ARABS
FIGHT AIDS
NOT ARABS
FIGHT AIDS
NOT ARABS
FIGHT AIDS
NOT ARABS
FIGHT AIDS

San Francisco, U. S.:
Amy Franceschini fou
Futurefarmers, an interna
collective of artists, activ
researchers, farmers, and a
who propose alternatives
social, political, and enviro
organization of spac

Chiapas, Mexico:
An armed **Zapatista** uprising
led by **ELZN** takes over the
15 cities in **Chiapas.** This event
starts the history of **Zapatista**
autonomous indigenous
communities

TRABAJO PAN SALUD EDUCACIÓN INDEPENDENCIA DEMOCRACIA NOSOTROS N... PARA TODXS TODO ... TODO PARA NOSOTROS ... TODO PARA TODXS ...

Iwakura, Japan:
Artist **Michihiro Shimab**
presents the installatio
Memory of Future, in w
he fills an empty plaza
intentionally incongrue
objects meant to prov
passersby to stop, enter
space, and reflect on t
relationship with the c

FIGHT AIDS
NOT ARABS
FIGHT AIDS
NOT ARABS
FIGHT AIDS
NOT ARABS
FIGHT AIDS

New York City, U. S.
Critical Art Ensemb
publishes **Electronic C**
Disobedience and Ot
Unpopular Ideas to exp
the concept and poter
of nomadic and eve
un-organized resistan

London, U.K.:
bell hooks publishes
Teaching to Transgress:
Education as the Practice
of Freedom

ut, Lebanon:
KAL ALWAN is
blished as an
anization
mitted to the
duction, facilitation,
circulation of
tive endeavors
ebanon

FIGHT AIDS
NOT ARABS
FIGHT AIDS

Moscow, Russia:
Oleg Kulik, along with
Alexander Brener, performs
The **Mad Dog Performance**

Argentina:
H.I.J.O.S. (Children f
Identity and Justice Ag
Forgetting and Silence)
the escrache practice
public interventions as a
of showing the communi
presence of unpunish
criminals of the dictator
(1976-1983)

Apartheid ends in South Africa

Amsterdam, Netherlands:
Russian artist **Alexander Brenner** sprays a dollar sign over a **Malevich** painting at the **Stedelijk Museum** in protest of the commodification of art

The Labour party comes to power in the U.K. under the 'New Labour' manifesto, triggering policy shifts to establish the **Social Exclusion Unit** for remedying economic and social issues; among other activities, they fund participatory projects

New Delhi, India:
Khoj International Artists' Association is established

In the name of **CIHABAPAI**, the Argentinian artist **León Ferrari** sends a petition addressed to God's representative on earth, **Pope John Paul II**, asking him to abolish Hell

Paris, France:
Curator **Nicolas Bourriaud** publishes **Relational Aesthetics**, an extended essay exploring emerging social practices exhibited within gallery and museum contexts

Mexico City, Mexico:
Minerva Cuevas creates the **Mejor Vida Corp.** (Better life Corp.), a web-based non-profit which distributes free products and services for a "better life"

Bogotá, Colombia:
The Colectivo Cambalache (Barter Collective) organizes El Museo de la Calle (The Museum of the Street), where people exchange or donate used objects as part of an alternative economy

Vienna, Austria:
Christoph Schlingensief organizes Please Love Austria, a public examination into immigration in Austria that draws thousands of people into a large-scale participatory project that exposes difference and conflict

Colombo, Sri Lanka:
Theertha Artists Collective is founded

London, U. K.:
Alex Coles publishes **Site-specificity: The Ethnographic Turn**, a historical discussion on public art, anthropological fieldwork, and audience participation from 1920 to 2000

London, U. K.:
Chantal Mouffe publishes **The Democratic Paradox** expanding on the notion of radical democracy by arguing that agony, rather than consensus, is part and parcel of a democratic process

Chantal Mouffe *The Democratic Paradox*

Radical Thinkers V

Tijuana \ San Diego Border:
For **The Cloud, Alfredo Jaar** suspends a bag of balloons over the U.S./Mexico border in memory of those whose deaths have taken place along and because of it. For 45 minutes, music is played, poetry is read and the balloons are released, drifting over the border into Mexico

Genoa, Italy:
Carlo Giuliani, a protester o[f] globalization[,] outside the [G] summit, is sh[ot] dead by riot police

Belgrade, Se[rbia]:
The art group[s] **Škart** initiate[s] **HORKESKA[RT]**, a choir who perform Yug[oslav] socialist son[gs] and punk in markets, refu[gee] camps, and schools

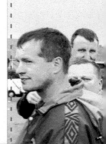

a coordinated attacks by
aueda. **Killed = 3000 people,**
ed = 6000 others.
e died of 9/11-related cancer
respiratory diseases in
nonths and years following

U.S. invades
Afghanistan as part
of the **War on Terror**

Lima, Peru:
**Five hundred
volunteers** with
shovels gather at a
huge sand dune on
the outskirts of the city
and over the course
of a day move it by
several inches for the
Belgian artist **Francis
Alÿs'** project, **When
Faith Moves
Mountains**

:ontroversial **War on Terror**
ns following the **9/11** attacks.
:ampaign states the elimination
ernational terrorism as its aim,
: critics believe that the
iterterrorism campaign has an
rialist geopolitical agenda

La Paz, Bolivia:
Maria Galindo
co-founds **Mujeres
Creando**, a collective
and social movement
confronting homophobia
and sexism

**Taller Popular de
Serigrafía**
(Popular Silkscreen
Workshop) forms
during protests
following
Argentina's
economic collapse
to create protest
materials for political
events

ı, Italy:
Theis initiates the **Isola Art**
:ct, transforming a squatted
ling into a public space for local
re. The project transforms into
is now the **Isola Art Center**

nen on Waves is established as a
en's healthcare advocacy group
:d at providing abortion services in
tries where the procedure is illegal

> Alegre, Brazil:
naugural **World Social Forum**
), an annual meeting of civil
:ty organizations, is held to
brate counter-hegemonic
alism and develop alternatives

Orgreave, U. K.:
Jeremy Deller organizes **Battle
of Orgreave**, working with
reenactment societies from
across the U.K. to re-stage
the clash between the miners
nd the police that occurred
Sheffield in 1984

Kassel, Germany:
Thomas Hirschhorn realizes his participatory
Bataille Monument at documenta 11

Ntone Edjabe founds **Chimurenga**, a pan-African
platform for writings, art, and politics

Nikola-Lenivets, Russia:
Artist **Nikolay Polissky** cooperates with local residents to produce
numerous public art works and events which attracts other artists
and the attention of the public to the village

2002

image above:
Maria Galindo of MUJERES CREANDO perorms at the
Creative Time Summit, Venice, 2015

St. Petersburg, Russia:
The collective **Chto Delat** is formed after members organize **We leave the city**, a protest against the celebration of 300 years of St. Petersburg which marked an openly conservative turn in Russian politics

Kyiv, Ukraine:
An artist group **Revolutionary Experimental Space** (R.E.P.) was founded during the **Orange Revolution** in Ukraine. **R.E.P.**'s developed actions and performances called **Interventions**, in reaction to the politicized public space of *'post-orange'* Ukraine

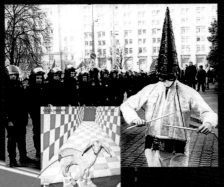

Buenos Aires, Argentina:
The exhibition **La Normalidad** is organized by the German artists and curators **Alice Creisher** and **Andreas Siekmann** and mounted at the **Palais de Glace**

Julian Assange founds **WikiLeaks**, a media organization specializing in the analysis and publication of restricted material on war, espionage, and corruption

Venice, Italy:
Utopia Station is curated by **Molly Nesbit**, **Hans Ulrich Obrist** and **Rirkrit Tiravanija** for the **50th Venice Biennale**

Beijing, China:
Conceptual artists **Sun Yuan** and **Peng Yu**'s **Dogs that Cannot Touch Each Other** is performed at the **Today Art Museum** in Beijing. The performance places eight bull terriers on treadmills; while the artwork examines and critiques systems of power and control, the performance is widely criticized by animal-rights activists

Bidoun, a publication and online archive with a focus on contemporary art and culture in the Middle East, is founded by **Lisa Farjam**

Rugerero, Rwanda:
Barefoot Artists initiate the **Rwanda Healing Project**, a program of cultural activities, economic and environmental development efforts, operated by and for the Survivors' Village residents

Amsterdam, Netherlands:
Artist **Jeanne van Heeswijk** initiates **The Blue House**, a durational project negotiating for a large villa in a housing block to be taken off the market and transformed into a space for community research, artistic production, and cultural activities

New Orleans, U. S.:
Mel Chin develops **Operation Paydirt/Fundred Dollar Bill Project** to engage communities with imagining creative solutions for the lead-contamination crisis in the U.S.

2003 2004 2005 2006 200

New York City, U. S.:
The first **Creative Time Summit**, entitled Revolutions in Public Practice, takes place. The **Summit** explores burgeoning socially engaged art practice, inviting practitioners to share ideas, learn to create communities, and discover collaborative methodologies and strategies

..acun, Mexico:
For the project **Palas por Pistolas, Pedro Reyes** collects firearms from residents of the city in order to recast them as shovels; residents use them to plant trees

Kyiv, Ukraine:
The first actions of **FEMEN,** a radical feminist activist group, take place

Tehran, Iran:
The Iranian **Green Movement** protests against the presidential election results, despite the fact that authorities closed universities, shut down websites, and banned rallies

w Orleans, U. S.:
.eative Time presents **Paul** .an's project **Waiting for Godot** New Orleans**, drawing attention he realities of the city st-Hurricane Katrina

.am, U. S.:
.icia Clough and Jean ..ey publish **The Affective Turn: .orizing the Social**, analyzing .ole of feelings and emotions .osocial research in the .anities and social sciences

.dhoven, Netherlands:
.Van Abbemuseum mounts . exhibition **Forms of .sistance: Artists and the .ire for Social Change .m 1871 to the Present,** .ompanied by the .lication **Art and Social .ange: A Critical Reader**

.os, Nigeria:
.i Silva opens the **Center for .temporary Art**, providing a .tform for the presentation .d discussion of art and .ture in Nigeria

**Chicago, United States:
TEMPORARY SERVICES begins the publishing INITIATIVE HALF LETTER PRESS to publish documents of socially engaged works and explore independent publishing as a form of social practice**

Chiapas, Mexico:
Over **100 displaced Indigenous community members** occupy the **United Nations (UN)** offices in San Cristobal de las Casas. The **UN** changes offices in response and their former building becomes **EDELO** (*En donde la era ONU / Where the United Nations used to be*), an artist residency and workspace run by **Caleb Duarte** and **Mia Rollow**

Nizhny Novgorod, Russia:
Over 30 participants in the **24-hours** autonomous pedagogical event "Leftist Poetry, Leftist History, Leftist Philosophy, Leftist Art" were arrested (including children), signaling harsher measures in Putin's Russia against cultural workers' engaging with street politics

Istanbul, Turkey:
Feminist antifascist collective **WHW** from Zagreb curates **What Keeps Mankind Alive: The 11th Istanbul Biennial**, politicizing the rotation of resources in the Western art world as a mirror of global extractivist tendencies

West Bank, Palestine:
Banksy paints a dove in a sniper's crosshairs on the wall separating the **West Bank** from Israel

The U.S. subprime MORTGAGE CRISIS spirals into an INTERNATIONAL BANKING CRISIS following the collapse of the LEHMEN BROTHERS INVESTMENT BANK

2008 2009

Pittsburgh, U. S.: **Jon Rubin** and **Dawn Weleski** launch **Conflict Kitchen**, serving food from countries the U.S. is in conflict with, as a means to understand complex perspectives from diverse cultures

Pablo Helguera initiates the project **The School of Panamerican Unrest**, involving performances, discussions, and screenings to seek connections between regions of the Americas

New York City, U. S.: **Creative Time** organizes **Living as Form**, the first ever survey of socially engaged art in a global context, presented at the **Essex Street Market**

Artist **Tania Bruguera** presents **Immigrant Movement International,** a project focusing on political representation and conditions facing migrants

London, U. K.: **Jacques Rancière** publishes **The Emancipated Spectator**, viewing the visual arts as a co-pedagogical intervention in everyday life

Karachi, Pakistan: **Tentative Collective** is founded by artists, curators, teachers, architects and collaborators from different backgrounds including fishermen, housewives and domestic workers. Navigating precarious urban geographies, the group creates poetic and ephemeral moments in conversation with the city's infrastructures, making connections to its complex ecological and geological histories

St. Petersburg, Russia: The artist collective **Voina** paints a 213 ft. high **penis** on the Liteiny Bridge, directly across from the **FSB headquarters**

Rome, Italy: A group of cultural workers occupy the **Teatro Valle**, a historic opera house and theater. The building remains occupied for three years with different activities

The **Arab Spring**, a revolutionary wave of protests and civil wars across **North Africa** and the **Middle East**, begins

ArtLeaks, an international collective of art workers was founded to publish cases of abuse, censorship, infraction of labor rights, and resist the appropriation of socially engaged art by capital and power

The OCCUPY MOVEMENT takes place in cities around the world, protesting against social and economic inequality and lack of real democracy

ARTIFIC
HEL

CLAIRE BISHOP

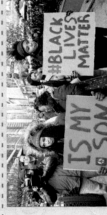

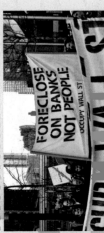

2010 2011 2012

ISIS begins looting libraries, universities, and cultural institutions, and destroying cultural heritage sites in **Mosul, Iraq, Palmyra, Syria,** and other occupied areas

Moscow, Russia:
The feminist protest punk group **Pussy Riot** stages a performance inside Moscow's **Cathedral of Christ the Savior**, which results in two of the members' incarceration after a public trial, and international solidarity campaign

New York City, U. S.
Claire Bishop publishes **Artificial Hells: Participatory Art and the Politics of Spectatorship**, a history of socially engaged art practices and an ethical critique of the role of the spectator

Graz, Austria:
Truth is Concrete, a 24/7 marathon camp on artistic strategies in politics and political strategies in art, takes place. It bring **300 artists and cultural workers** together

The **#BlackLivesMatter movement** is formed in response to racism and is rooted in highlighting the lived experiences of Black people in the U.S. who actively resist oppression

Dubai, United Arab Emirates:
GCC artist collective is founded in Dubai. to examine contemporary Gulf culture

New York City, U. S.:
Hito Steyerl publishes **The Wretched of the Screen**, examining the politics of the composition, circulation, and collection of images

Istanbul, Turkey:
The program of the **13th annual Istanbul Biennial** focusing on issues of public space in the context of the **Gezi Park** protests is cancelled as a result of the protest action and repressions

Rome, Italy:
Marinella Senatore founds the The **School of Narrative Dance**, a long-term pedagogical project concerned with storytelling through choreography and self-training

Leninopad begins. Lenin monuments fall across Ukraine after the changing of power which declare de-communization as the priority politics

Berlin, Germany:
The **Center for Political Beauty** organizes operation **First Fall of the European Wall**, taking white crosses from the city's governmental quarters on the **25th anniversary of the fall of the Berlin Wall** to the European Union's borders to commemorate those lost trying to cross them

The annexation of **Crimea** by **Russia** and subsequent war with **East Ukraine** strains the relationship between Russia and the NATO member countries

Vienna, Austria:
Russian collective **Chto Delat** realizes **Face to Face with the Monument** during the city's **Into the City** festival. The project tackles a new world situation in a moment of danger of new cold war analyzing the performative monumentality of our time

Hamburg, Germany:
Schwabbinggrad Ballett begins their collaboration with musicians and non-musicians refugee-activists. Their musical performances and street actions address themes of free movements and immigrants' rights

 Berlin, Germany:
Ai Weiwei wraps the columns of the **Konzerthaus** with 14,000 salvaged refugee life vests left by migrants on Greek beaches

Moscow, Russia:
Artist **Pyotr Pavlensky** sets the wooden door of the **Lubyanka**—the headquarters of the **Federal Security Bureau**—on fire as part of the performance **Threat: Lubyanka's Burning Door**. Pavlensky is arrested

 Bogotá, Colombia:
For **Sumando Ausencias** (Adding Absence), **Doris Salcedo** fills a public square with the names of civil war victims across 7,000 meters of white fabric

The **European Commission**, **International Monetary Fund**, and **European Central Bank** initiate a referendum to decide if Greece is to accept the bailout conditions for the debt crisis. After a **NO** vote, a 3-year bailout plan with higher austerity conditions than the first is implemented

London, U. K.:
Boris Groys publishes **In The Flow**, examining the social and performative turn of art in regard to the institutions that these works circulate within

 The feminist movement **Ni Una Menos** emerges in **Argentina** to tackle gender-based violence

Awami Art Collective is formed as a reaction to the reduction of cultural spaces in **Pakistan**

Chiapas, Mexico:
The **Zapatista movement** organizes the **Festival CompARTE por la Humanidad** at **CIDECI/Universidad de la tierra Chiapas** and Zapatista Caracoles

 The European **"refugee crisis"** reaches its height with **over 1.4 million** applications for asylum received by EU member countries from people displaced by conflicts in areas of the **Middle East** and **Africa**

 Standing Rock Sioux Reservation, U. S.:
Protests begin over the **Dakota Access Pipeline** which poses a threat to the reservation's water and land. **Cannupa Hanska Luger** initiates The **Mirror Shield project**, inviting people to create mirror shields for water protectors onsite at camps in **Standing Rock**

 Douglas\Agua Prieta, U.S.\Mexico Border:
Artist collective **Postcommodity** installs **Repellent Fence**, a 2-mile long stretch of 26 balloons featuring Indigenous medicinal colors and symbolism, tethered to the ground across the U.S./Mexico border
→

 Athens, Greece:
Jonas Staal creates a set for **New Unions: DiEM25** (Democracy in Europe Movement 2025). Initiated by economist **Yanis Varoufakis**, the project is aimed at conceiving new assemblist designs for the movement's pan-European politics

 Washington, DC, U. S.:
The Women's March takes place the day after the

2015 | **2016**

Revelations that
Facebook- Cambridge Analytica
harvested the personal data of millions
of **Facebook** users without consent and
used it for political purposes raises
public awareness on ethical questions
of data usage and surveillance

Moscow, Russia:
Members of **Pussy Riot** interrupt
the final match of the **World Cup**,
running onto the field of **Luzhniki
Stadium**, to stage a protest
against illegal detentions at
political rallies and the policing of
social media, while campaigning
for a more transparent political
process

Miami, United States:
The **Creative Time Summit**,
**Of Archipelagoes and Other
 Imaginaries** takes place,
focusing on the Caribbean as
a site of international migrations
and depopulation, queer cultures,
indigenous ways of being, and
ecological resistance

Washington, D.C., U. S.:
March for Our Lives, a student-led
demonstration in support of tighter
gun control, takes place along with
over **800 sibling events** around the
world

France:
Les **Gilets Jeunes** (Yellow
vests movement) erupted.
The grassroots movement for
economic justice originated
with French motorists protesting
against an increase in fuel taxes,
wearing the yellow vests that,
under the law, all motorists are
required have and to wear in
case of emergency

2018

PART III

Major issues in the field of socially engaged art

COMMONING ART IN EUROPE – ON THE PLAY BETWEEN ART AND POLITICS

Hanka Otte and Pascal Gielen

A community art policy could be the perfect legitimization for public support of the arts, especially in times of austerity. After all, due to the direct involvement of citizens in the design, production, and/or performance of the artwork, such support directly and visibly benefits the population (the taxpayers), particularly those members of the population who would normally not be confronted with art. In European countries—where most states and cities have a tradition of subsidizing culture—the revival of community art since the 1990s was very much related to an official cultural policy. For example, in Belgium, it followed a governmental report on poverty in 1994, emphasizing the importance of art participation for social inclusion and leading to a variety of funding opportunities for participatory art initiatives up until today (Van Erven 45). In the United Kingdom, the Arts Impact Fund and in the Netherlands, the two-year program Kunst van Impact are examples of cultural policies providing subsidies for social-artistic projects or stimulating the private sector to support such projects in and with society through all kinds of provisions. For Europe, this all started in the UK where the artistic practice of the 1960s and 1970s was embraced and turned into a policy instrument (Merli 112–113). Strongly influenced by the famous but meanwhile also notorious report "Use or Ornament?" by François Matarasso, the British government adopted his claim that art contributes to a stable, secure, and creative society. However, according to Merli, this is diametrically opposed to the aims of the community art of the 1960s and 1970s, which was also called "countercultural art" for a reason.

> While the [latter] was directed to the expression of conflicts, Matarasso's vision is directed to social stability obtained by means of "peaceful" popular consensus, the underlying inspiration seemingly being that whereas the rich are doing the "right" things, the poor should be soothed through "therapeutic" artistic activities. While in the seventies the aim was emancipation and liberation from any form of social control, also (and above all) by means of artistic creativity, in the revival of interest in participatory arts advocated by Matarasso the aim is the restoration of social control using the same tools, although otherwise directed.
>
> *(Merli 114)*

According to the art historian Claire Bishop, community art in fact never got full recognition or the kind of support needed to fulfill its original goal, which could be described as to

47

empower (marginalized) people through the democratization of cultural production (Bishop 188). With the impetus to make dehierarchized participatory art, community art already faced major problems in the 1980s, which were mainly but not exclusively the result of Margaret Thatcher's conservative government controlling the purse strings. The community art movement had failed to give a clear definition of its aesthetic quality, which in the early 1970s gave the Arts Council carte blanche in deciding how to assess community art, placing emphasis on the social process and attitude rather than on artistic criteria (189). The question of how to evaluate these processes and attitudes remained unanswered and by "avoiding questions of artistic criteria, the community arts movement unwittingly perpetuated the impression that it was full of good intentions and compassion, but ultimately not talented enough to be of broader interest" (190). Apparently it was not made clear how important visual methods of negation, disruption, and antagonism, as mentioned by Bishop, were to questioning the existing order and helping to build new communities. Consequently, community art projects were assessed by criteria the Arts Council thought were appropriate in the field of social work. Already in the 1980s, this had turned community art into a more or less "soft" and harmless branch, which was easy to embrace and turn into a policy instrument for "social provision" as New Labour did in the 1990s, followed by other European governments.

The European Union, which has been subsidizing participatory art projects, and national and local governments that finance community art, mainly have high expectations of its social effect on individuals and communities. As Merli already suggested, these effects seem to be moving in only one direction, though. Makers of community art may be sincerely concerned about social deprivation, social inequality, and other societal injustices, and it is for that very reason that they are asked to reinforce the social fabric with their art—that is, as long as they use appropriate methods. This approach is indeed sometimes hardly distinguishable from that of the social worker. Earlier reflections on the phenomenon of community art stated that in the worst case it is "guilty" of what Michel Foucault called "pastoral power"[1] (Gielen 27–32). Social workers can be deployed as helpers of the state or even the police insofar as they detect, document, and try to correct behavior that is not in line with prevailing values and norms in a society. They not only help the long-term unemployed, drug addicts, or rebellious teenagers with their daily social and mental problems, but they also try to bring them back to the straight and narrow by checking on them; for example, they might count the number of toothbrushes or beds that were slept in at the homes of singles who receive benefits. In that sense, social workers also contribute to the normalizing and disciplinary principles that are supposed to keep society running as it has always run. This is not an unimportant aspect as, in this respect, social work affirms the existing social order without questioning it. Something similar occurs in the working process of community artists, when they hand out video cameras in a disadvantaged neighborhood and attempt to strengthen social cohesion by having "antisocial" figures and families interview and film one another or by producing a stage play together. The result of this "process-like" approach is usually presented at a festive public screening or performance attended by local politicians and civil servants involved and by the local press. This also means that the intimate details of private lives, including sometimes profound misery and impoverished living conditions, are thrown out into the open. Whereas social workers still treat the individual clients' files with professional confidentiality, community artists organize them in public confessions.

Obviously, not all community artists and not all social workers participate in this machinery of social control. One cannot fail to notice, though, that nowadays their practices—orchestrated or not but subsidized by local and national governments in Europe—manifest themselves in neighborhoods and regions where in a more or less distant past a local medical center or a primary school provided social cohesion. Under the influence of public management and efficiency

thinking, such local social services have been closed, merged, and centralized. Coincidence or not, a few years after such austerity operations, community artists show up in the same location, sometimes hired with funding by local politicians or civil servants. These artists can then try to put together the broken pieces that are the result of the earlier policy of tearing down the local social fabric. The project-like mode of operation of the artist is, at any rate, cost-efficient, as it is only temporary and thus cheaper than maintaining a school building or a medical center with a permanent staff. In addition, at the conclusion of their project, the artists often produce a positive public story about the resilience of a neighborhood or an unexpectedly creative and colorful community. Such a positive outlook is always a bonus in times of elections, but in fact the community artists help to fill the holes that politics themselves created in the European welfare states at an earlier stage.

Again, a growing number of artists and community artists are quite aware of the pitfalls accompanying these government commissions. However, politics are left inexplicit, as it is hard to adopt a critical attitude toward the hand that feeds you. Whether the commission comes from a government or private entity, neither of them looks favorably on artists who concern themselves with politics.

Bonding versus bridging

From this point of view, it is not strange that in former socialist countries in Eastern Europe, the term "community" art has a negative overtone, especially when it is supported or initiated by governments. It is for the very same reason that in (West)European countries, since World War II, policy makers have been very cautious in connecting cultural practices to any community, as a too narrow connection between culture and a collective from 1930 onward evolved into a cruel nationalism. However, according to cultural scientist Christiaan de Beukelaer, the connection between a certain community and cultural practices is still being made, although often not explicitly. Even within contemporary hyper diverse societies where the white middle-class became itself a minority (Rosanvallon 9–46), this minority goes on wielding power as if it is the majority. In doing so, it is holding on to an imagined monocultural nation, which expresses itself in a so-called methodological-nationalistic cultural policy (De Beukelaer 6). This is a policy that may not always explicitly hold a party-political or ideological nationalistic discourse but certainly nurtures it in the core of and throughout its entire administrative organization. Besides, it can hardly be denied that all over Europe, an explicit nationalism is on the rise again today. The revival of nationalist cultural policies in various Eastern European countries but also the revaluation of popular culture including national anthems in the official cultural policy of various Western European nations (such as the Netherlands) point to a tendency of allowing culture to serve nationalist aims again.

Deploying community art in this context contributes mainly to social integration based on socialization within a dominant cultural order. Nowadays, more and more governments display a sometimes nostalgic longing for forms of internal social cohesion or a "we" feeling. This is a form of cohesion that is based on the recognition of similarities among the individuals who make up a group or community, as was once the hallmark of thriving social life in many local communities. However, clinging to a consensus model constantly sweeps the diversity, dissensus, and tensions under the carpet while upholding an artificial "we" feeling or, in more scientific jargon, an *internal* social cohesion.[2] As said earlier, community art can play a rewarding role in this. It is, in any case, one of the reasons why this artistic revival is frequently embraced and supported by politicians.

The social reality of a minorities society requires radically different politics, however. Such politics can still be aimed at social cohesion, albeit one that learns how to cope with fundamental

differences. It is a social cohesion that is not based on consensus but, paradoxically, on shared dissensus. Not bonding but bridging differences—literally like a bridge links two different sides without merging them into sameness—then becomes the focus: not glossing over contradictions and tensions but learning to acknowledge the Other and learning to live with and next to the Other and that which is radically different. Neither the methodological nor the recent explicit nationalism on which cultural policies in Europe are now based helps to transcend huge contrasts between "us" and "them." Therefore, De Beukelaer advocates a "methodological cosmopolitan" politics—for simplicity's sake we will call it "cosmopolitics"—that takes as its starting point our obligations with regard to our fellow men, regardless of their national identity (De Beukelaer 10). Cultural policy and art that are in line with this can then no longer aim for socialization and bonding cohesive behavior but must find a way of dealing with fundamental differences. Social cohesion is then no longer aimed at the internal community or the homogenization of that community but is consistently aimed at the outside world, which, paradoxically, has become more and more part of our "inner" world or our "own" community. This evolution requires the effectuation of a different form of cohesive behavior. It is not the "we" feeling or internal social cohesion that has to be encouraged but rather external social cohesion. Previous research (Otte 32) has shown that it is not confirmative art—art that confirms existing values and norms—but art that challenges the prevailing culture that can contribute to such a bridging social cohesion. Whereas community art mainly contributes to the first form of cohesion—especially when it is part of a top-down cultural policy as has been implemented in various European countries since the 1990s—today, artists are looking for more challenging forms and strategies to arrive at the second form of cohesion.

Political play

Everywhere in Europe artistic initiatives are emerging that want to do things differently because they either do not fit within the current cultural political doxa or because they simply *have* to do things differently due to austerity measures or lack of private interest. Those artists often ignore the regulated and therefore official frameworks of engaging with the realm of politics. Community artists who not only concern themselves with the social domain but also with politics are soon deprived of sponsors, subsidies, or institutional support. Their twofold course on the social and the political level often makes it necessary for them to look for alternative working methods, including ways of funding. It is a search that drives cultural initiatives such as Culture 2 Commons in Zagreb (Croatia), Recetas Urbanas in Seville (Spain), and l'Asilo in Naples (Italy), to name but a few, more and more toward the domain of the commons, a social space where they may find free, albeit not unconditional support for their work. Culture 2 Commons is a cluster of three cultural activist organizations. By their jointly set up denominated framework of shared values, teaming up for tactical reasons and carrying out an initiative of shared strategic interests, they do form such a social space. A space in which cultural projects and events are organized, but even more importantly joint public actions, policy initiatives, and new institutional structures can be and are being developed. L'Asilo can be described as an independent, self-governed cultural laboratory. The building, housing a theater, cinema, and several kinds of laboratories, is at the disposal of all citizens of Naples. Using the space also means contributing to the life of l'Asilo, by publicly presenting and/or exchanging goods and/or keeping the building clean.

Architectural studio Recetas Urbanas designs and builds projects in urban spaces with the aim of helping its inhabitants in shaping their social lives themselves. With their work, they try to open up urban spaces as commons: spaces and buildings that are managed by the users or the inhabitants of those spaces and buildings. But what exactly are commons?

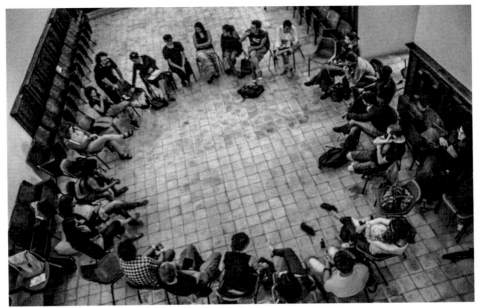

Photo and courtesy Sabrina Merolla.

L'Asilo community assembly in Naples, Italy.

According to the political economist Massimo De Angelis, the commons is supported by a social system that has three constituent elements (De Angelis, *Omnia Sunt Communia* 119): (1) pooled material or immaterial *resources*, (2) *commoners* willing to share, pool, and reproduce these resources, and finally (3) *commoning* practices or social processes in which, by the autonomous generation of operational and regulatory frameworks, commoning practices can be extended to other resources and social domains (De Angelis, "Grounding Social Revolution" 218–230). For example, whereas the pooled sources of Culture 2 Commons and l'Asilo consist mainly of logistical infrastructure and buildings, Recetas Urbanas builds meeting places and schools at the request of communities and shares building materials and legal advice within a European network (the Group for the Reuse and Redistribution of Resources).

As to the second constituent element, Culture 2 Commons and l'Asilo organize assemblies for the collective management and shared use of financial and logistical means or buildings. Recetas Urbanas puts much effort in the follow-up of their projects and support for the collective self-management of the communities that requested intervention by Recetas in the first place. Finally, we see how Culture 2 Commons and Recetas Urbanas also generate rules (for example, for subsidies) and legal precedents that are then also used by others. In the case of l'Asilo, it is even a city government that recognizes and adopts common rights, thereby continuing a process of commoning by which the commons reappropriate more and more ground from the government and the markets. However, it is also this last constituent element by which commoning artistic practices inevitably become political. Not only do they shape communities through these practices, they also do so in a nonconfirmative and not purely integrative or socializing way. Specifically, commoners propose a social use of resources that is alien to markets and governments, drawing the attention of administrators to alternative regulations and forms of organization. It is no coincidence that Recetas Urbanas often call their own practices "a-legal."

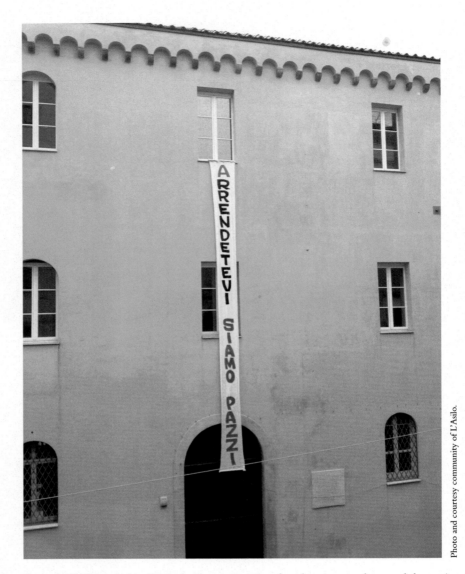

Photo and courtesy community of L'Asilo.

Photo taken of Asilo Filangieri in Naples by the community of workers in art, culture, and theater in self-government (2013). Banner reads: "Surrender We Are Crazy."

Commoning artists operate, after all, mostly in a civil, not or not yet regulated space for which the legal frameworks have not yet been conceived or where a government refrains from outlining such frameworks, either on purpose or not. It is precisely in this gray area between creativity and criminality that the artistic component emerges. Just like community artists, commoning artists often use play as an artistic form. Singing or making theater together may, for instance, enhance the internal social cohesion, but it can also do this with its external variant. It is characteristic of play that the players determine the rules of the game, thereby generating a fictive but really experienced (although enacted) space (Huizinga 3–13). Both community and commoning artists apply this skill to intervene in social reality, but, as stated earlier, community

Recetas Urbanas, Free Phone Booth, 2007. Constructed in downtown Madrid, Spain.

art mostly uses society-confirming strategies and methods that lead to or are aimed at social integration or socialization. Commoning artists utilize play as well but tend to use more challenging methods that subvert the prevailing social order and sometimes even legal frameworks. In other words: the differently applied rules serve to stretch or change existing rules and legislative frameworks. Recetas Urbanas often literally plays with the law by presenting, for example, the building of a school as a creative workshop for children or as an educational project with students in order to circumvent building permits and other legal restrictions. Or they make clever use of the constitutionally guaranteed right to education to renovate a school building or create a playground where this is in fact against existing laws. Commoning artists frequently perform a balancing act between fiction and nonfiction, between imagination and reality, thereby challenging existing social practices and fixed habits, including legal frameworks. The challenge this type of art poses is therefore not limited to the prevailing rules of art as upheld by, for example, a professional art world. Commoning art breaks through the walls of the museum or theater by challenging the social rules of the actually lived game. Commoning artists don't derive the inspiration for their artistic or daring moves from the art world or from art history but rather from the cultural context in which they operate. After all, their challenge is primarily expressed in the imaginary space of people's wishes, longings, and dreams. Legal and illegal citizens both long for better social contacts, more solidarity, or, quite practically, they wish to have a safe playground, a school, a community center in the neighborhood. The artist's mission is then to detect, distill, catalyze, and materialize these communal wishes and dreams. The challenge of commoning art thus consists of encouraging people and communities to chase their own dreams, wishes, and desires, often against traditional customs, legal frameworks, or market rules. Artists who guide and coach this collective longing toward social reality not only frequently clash with bureaucracy and jurisdiction themselves but also challenge the community in which—and with which—they work to venture into this insecure, "a-legal" territory. It doesn't come as a surprise

Photo and courtesy Recetas Urbanas.

Recetas Urbanas, Insect House, 2001. Occupying a tree in Seville, Spain.

therefore that governments are not really rejoicing in commoning artists and citizens who are out to undermine administrative and legal frameworks.

The 7th design principle

What the attitude of a government toward such a commoning artist might be can be gathered from the 7th design principle for the commons as defined by Nobel Prize winner Elinor Ostrom. In *Governing the Commons*, this economist poses that one condition for having a commons organization is that higher authorities recognize the self-determination of communities (90).

Building on this, De Angelis states that in fact a policy for the commons cannot be launched legally in a top-down manner but that only bottom-up self-regulations can be recursively legalized. After all, a commoning practice is itself constitutive. This means that the rules for its functioning and sanctioning are generated self-autonomously in practice. Only a government can reject or recognize them (De Angelis, "Grounding Social Revolution" 221). If a government wishes to tolerate and encourage commoning practices at all, it can do so only through an inductive policy. This means that the government makes room for bottom-up and grassroots practices, not by directing them as initiator or regulator but by acting as partner (Bauwens & Onzi 30). This is not the same as regionalizing or decentralizing government policy by relegating it to lower administrative bodies, like the Cultural Council in the Netherlands now proposes to do in order to change the current system of cultural subsidies. After all, a reshuffle of duties among the various governments does not change anything about the relationship between government and cultural organizations, which may be top-down at a local level just as well. An inductive policy would mean that the government creates room for tailor-made conditions, thereby creating a "free" playing field—not according to the rules of one specific culture or specific social order but according to new rules that can be codefined by anyone who is part of a community or has recently arrived in it. According to researchers of peer-to-peer networks Michel Bauwens and Yurek Onzi, this requires a "cooperative" government that is open to the contributive logic of the commons and links this logic to the classical liberal-representative democracy "of all" (Bauwens & Onzi 19). The contribution of art (to the commons) lies in its use value, its performative power to change perspectives, even to change ordinary habits and attitudes by showing people other possible horizons. Recognizing this value would open the road toward a culture of politics, a culture that recognizes the possibilities of the self-governance of citizens.

Notes

1 See Foucault (165) for the origin of the term.
2 On the use of this term, see Dijkstra et al. (131), Forrest and Kearns (2142), Schnabel and Hart (15), and Otte (32, 72, 255).

Work cited

Bauwens, Michel and Yurek Onzia. "A Commons Transition Plan for the City of Gent." *Commons Transition*, 8 September 2017, http://commonstransition.org/2017/09/08/. Accessed 18 July 2018.

Bishop, Claire. *Artificial Hells. Participatory Arts and the Politics of Spectatorship.* Verso, 2012.

De Angelis, Massimo. *Omnia Sunt Communia. On the Commons and the Transformation to Postcapitalism.* ZED Books, 2017.

De Angelis, Massimo. "Grounding Social Revolution: Elements for a Systems Theory of Commoning." *Perspectives on Commoning: Autonomist Principles and Practices*, edited by Guido Ruivenkamp and Andy Hilton. ZED Books, 2017.

De Beukelaer, Christiaan (2017) "Ordinary Culture in a World of Strangers: Toward Cosmopolitan Cultural Policy." *International Journal of Cultural Policy*, 23 October 2017, www.tandfonline.com/doi/abs/10.1080/10286632.2017.1389913. Accessed 26 December 2018.

Dijkstra, Anne Bert, Jacomijn Hofstra, Jan Pieter van Oudenhoven, Jules Peschar, and Marieke van der Wal. *Oud gedaan, jong geleerd? Een studie naar de relaties tussen hechtingsstijlen, competenties, evln-intenties en sociale cohesie.* Aksant Academic Publishers, 2004.

Forrest, Ray and Ade Kearns. "Social Cohesion, Social Capital and the Neighborhood." *Urban Studies*, vol. 38, no. 12, 2001, pp. 2125–2143.

Foucault, Michel. *Security, Territory, Population: Lectures at the Collège de France, 1977–1978.* Trans. Graham Burchell. Palgrave Macmillan, 1978.

Gielen, Pascal. "Mapping Community Art." *Community Art. The Politics of Trespassing*, edited by P. De Bruyne and Pascal Gielen. Valiz Books, 2011.

Gielen, Pascal, and Philipp Dietachmair. "Public, Civil and Civic Spaces." *The Art of Civil Action. Political Space and Cultural Dissent*, edited by P. Dietachmair and P. Gielen. Valiz Books, 2017.

Gielen, Pascal, and Thijs Lijster. "Culture: The Substructure for a European Common." *No Culture No Europe, On the Foundation of Politics*, edited by P. Gielen. Valiz Books, 2015.

Huizinga, Johan. *Homo Ludens: proeve eener bepaling van het spel-element der cultuur*. Erven J. Huizinga c/o Amsterdam University Press, 2008 [1950].

Matarasso, François. *Use or Ornament? The Social Impact of Participation in the Arts*. Commedia, 1997.

Merli, Paola. "Evaluating the Social Impact of Participation in Arts Activities." *International Journal of Cultural Policy*, vol. 8, no. 1, 2001, pp. 107–118.

Ostrom, Elinor. *Governing the Commons: The Evolution of Institutions for Collective Action*. Cambridge University Press, 1990.

Otte, Hanka. *Binden of Overbruggen? Over de relatie tussen kunst, cultuurbeleid en sociale cohesie*. Rijksuniversiteit Groningen, PhD dissertation, 2015.

Rosanvallon, Pierre. *Democratie en tegendemocratie*. Boom, 2012.

Schnabel, Paul, and Joep de Hart. "Sociale cohesie: het thema van dit Sociaal en Cultureel Rapport." *Betrekkelijke Betrokkenheid. Studies in Sociale Cohesie. Sociaal en Cultureel Rapport 2008*, edited by Joep de Hart. Sociaal en Cultureel Planbureau, 2008.

Van Erven, Eugène. *ICAF in the Picture*. Rotterdams Wijktheater, 2015.

BETWEEN ART AND CULTURE

Performing First Nations sovereignty

Wanda Nanibush

Over the last 20 years, I have noticed a blurring of the lines between political action, performance art, and cultural ceremony in ways that are exciting and challenging to the divisions between these often separated spheres of creating social change. My main goal in this section is to analyze at this shift and its relationship with a concomitant shift in Indigenous politics toward performing sovereignty, rather than seeking political recognition from settler governments.[1]

When I begin to discuss the notion of "performing sovereignty,"[2] I often turn to its opposite in visual culture: that is, images of First Nations children in what I call "assimilation diptychs." The first photo is of a First Nations child in traditional clothing and hairstyle, and the second photo shows the same child after attending a residential school with a Western-style suit and short hair.[3] These before-and-after photos were meant to advertise the success of the schools in civilizing and assimilating First Nations into American and/or British culture. The purpose of the schools was described by the first Prime Minister of Canada John A. Macdonald:

> When the school is on the reserve, the child lives with its parents, who are savages, and though he may learn to read and write, his habits and training mode of thought are Indian. He is simply a savage who can read and write. It has been strongly impressed upon myself, as head of the Department, that Indian children should be withdrawn as much as possible from the parental influence, and the only way to do that would be to put them in central training industrial schools where they will acquire the habits and modes of thought of white men.
>
> *(1107–1108)*

The schools forced Christianity, English or French, and European, Euro-American, or Euro-Canadian culture onto the children, often through extremely coercive means. Survivors of the schools often speak about them as if they were prisons for children. Despite the rampant abuse and cultural genocide that the schools represent, many First Nations people were able to survive and become leaders in their communities. The schools created deep identity crises because many no longer felt at home in any culture or space, but, at the same time, many became fiercely committed to holding onto their cultures because of the violence of its attempted removal in the schools.

Courtesy Provincial Archives of Saskatchewan.

Thomas Moore before his entrance into the Regina Indian Residential School in Saskatchewan in 1897.

In the diptych of Thomas Moore, the fault lines of cultural genocide hiding behind the discourse of assimilation, inclusion, advancement, and education become clear. Moore is Anishinaabe from the Muscowpetung Saulteaux First Nation in Saskatchewan, Canada. He became a student of Regina Indian Residential School in 1891 at the age of eight. Four years later, he was sent home with tuberculosis (a common occurrence in the schools). He was named number 22 in the school because he was the 22nd student enrolled. Moore died at the age of 12, one of over 3,000 children known to have died because of the poor care and conditions at the schools. It is important to start thinking about performing sovereignty from the position of attempted cultural genocide that included schools, but also policies like the Indian Act and laws that banned

Courtesy Provincial Archives of Saskatchewan.

Thomas Moore after his entrance into the Regina Indian Residential School in Saskatchewan in 1897.

cultural expression until 1951. The last school closed in 1996 (Joseph; Milloy). The act of dressing up and performing "whiteness" in this photo belies the very real tenacity of First Nations people to hold onto their cultural practices. Artists coming out of the schools—artists including Alex Janvier, Norval Morrisseau, and Robert Houle—were part of a cultural renaissance that sought to have First Nations cultures survive for future generations, while also innovating and adapting new modes of creation, in particular painting on canvas and installation art.

The most recent political movement called Idle No More,[4] or the Round Dance Revolution, swept across Canada in 2012 in the form of a cultural response to a series of new laws that deregulated environmental protection of waters and challenged First Nations sovereignty over

education and more. In my own involvement, I had decided to work with an amazing group of women: Charm Logan, Tannis Nielsen, Crystal Sinclair, Rebecca Tobabadung, and Grand-mother Pauline Shirt. We worked together for three years and eventually were joined by Tori Cress, Shiri Pasternak, and many more. Organizing groups like ours were in most cities and First Nation reserves across Canada. A host of Round Dances hit malls across the nation, which inspired United States–based groups to join the movement, as well as sparking international round dances from Siberia to Croatia. This was one of the first times a ceremony was used as the symbol and main action of a sustained political movement asserting First Nations' sovereignty. In order to perform round dances in Toronto, we asked permission from Prairie Elders whose culture developed and performed the Round Dance. We received permission to perform them in the winter, which is not the regular season for them. We needed permission to break the cultural protocols of the ceremony. The dance itself, the story goes, came about to heal a young woman who could not stop grieving the death of her mother (The Kino-nda-niimi Collective 21–27). It made perfect sense that a healing dance to turn mourning into celebration became the performance of protest in the streets to the continued assimilation policies of the Canadian government. It was a secularization of a ceremony but also the sacralization of public protest. The ceremony and the revival of Indigenous cultures was the basis for the movement and what continues to drive it today, as a result. Instead of knocking on the government's door for recognition, Indigenous people and their allies in the street were enacting cultural sovereignty through their daily actions. These actions of doing ceremony but also of building houses on tra-ditional territories and teaching their children their languages, all form a network of performing sovereignty that ensures cultural genocide fails.

Two years before Idle No More, in 2010, I curated the exhibition *Mapping Resistance*, for which invited performance artists Rebecca Belmore, James Luna, Tanya Lukin Linklater, and Archer Pechawis, as well as storytellers Leanne Simpson and Doug Williams, to respond to the

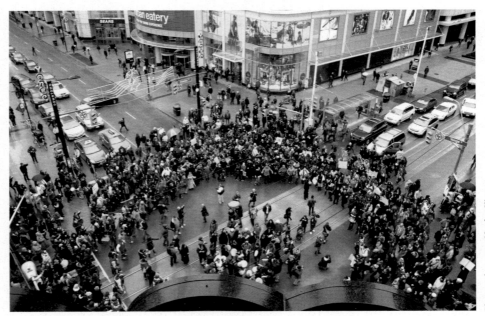

Idle No More Round Dance for Indigenous Rights in Toronto's Dundas Square, 2012.

Photo and courtesy Hayden King.

twentieth anniversary of the Kanehsatà:ke resistance, also called the Oka Crisis of 1990. The Mohawk community of Kanehsatà:ke went head-to-head with the Quebec police and then with the Canadian army for 78 days in order to protect their burial and ceremonial grounds from becoming a golf course for the town of Oka. This standoff created a sense of unity among Indigenous nations, which in turn triggered actions of support and solidarity across the country. A lasting outcome was the devastating reality that the Canadian government would send in the army after its supposed citizens. On the twentieth anniversary of the Kanehsatà:ke resistance, I wanted to bring together a range of artists from North America to make site-specific work in public spaces as a way of physically claiming space for Indigenous bodies that are normally unseen or removed.

The late, great James Luna decided to use a World War II memorial site for his piece. He chose this site in part because it marks a war, and none of our wars are marked on our lands in this way. He began by talking to the crowd, performing a healing ceremony, before he changed into clothing that signified the Native warrior. A Native person in camo clothing, sporting a bandana over his face and holding a gun, became the new stereotype of a Native warrior after 1990 (Smyth). Once dressed, he performs a scene from Abenaki filmmaker Alanis Obomsawin's film *270 Years of Resistance*. Obomsawin was the only filmmaker to stay behind the barricades with the Mohawk community and film their perspective for the whole 78 days. Luna suddenly yelled, "Everyone get down," and the audience dropped to their stomachs. With three words, Luna shifted the audience perspective. We were now lying on the ground with the Mohawk community getting shot at by the Canadian army. Suddenly our sympathy was with the Mohawks—with the people who are most vulnerable and precarious. Afterward, he burned the warrior clothing. The Kanehsatà:ke community still has to deal with the aftermath of the standoff of 1990—they live with it daily in their families. On top of that, the land issue is still unresolved. The burning of the warrior outfit was a way to cathartically release that pain and

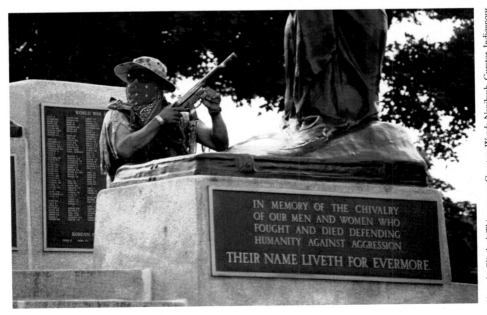

James Luna, Untitled performance for Maping Resistances curated by Wanda Nanibush, 2010.

Photo by Elizabeth Thippawong. Courtesy Wanda Nanibush, Curator, Indigenous Art, Art Gallery of Ontario.

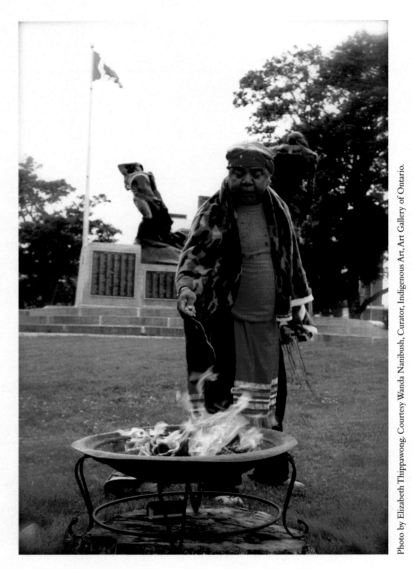

James Luna, Untitled performance for Maping Resistances curated by Wanda Nanibush, 2010.

experience of violence. All the anger, pain, loss was released momentarily in a small ceremony with fire. Often these artists walk this line when they are ceremonially engaged in the world: it bleeds over into their art practice. Ceremony and art join in the mode of healing. Luna offered a prayer at the end. He believes in the power of art to affect and to effect people. It is not mere commentary but an active agent in our hearts, minds, bodies, and spirits. We are acted upon by the work. Luna demonstrated the transformative potential of art.

I curated a second performance art exhibition in 2012 called *House of Wayward Spirits*, which was dedicated to the idea of cultural change. It was a house made for the wayward, the contrary, and the transformative. A series of performance art works were created by Adrian Stimson, Rebecca Belmore, Archer Pechawis, Lori Blondeau, The Contrary Collective, and James Luna.

Courtesy Adrian Stimson.

Adrian Stimson as Buffalo Boy, Buffalo Boy's Coal Jubilee, 2012. Photo documentation.

Two performances took place in Queens Park (the park of Ontario's provincial government) the day before and the day of Canada Day (Monday, July 1). The idea was to not ask permission, much as the Idle No More flash mob round dances occurred without permits as a way to acknowledge that all land is Indigenous and all restrictions to its use are by foreign law.

Adrian Stimson's *Buffalo Boy's Coal Jubilee* played with the structure of the Queen's Silver Jubilee.[5] Buffalo Boy is a persona Stimson deploys to challenge outmoded stereotypes, to invert colonial values, to parody power structures, to queer history, and to tap spiritual and cultural legacies of the Blackfoot peoples to whom he belongs. Stimson chose a bronze monument in the park that featured an oversized horse ridden by King Edward VII. On the walkway to the statues, in coal, Stimson wrote, "We shall all serve Buffalo Boy." Buffalo Boy, as Shaman Exterminator (Buffalo Boy dressed as a shaman), strolled to the tune of "Pomp and Circumstance" with his Buffalo Robe and fishnets, while images of the Queen's Diamond Jubilee flash by on a large screen. He disrobed and laid his Buffalo Robe over audience member Rebecca Belmore in honor of all the dead who have suffered from the power struggles of colonial governments and settlers. Donning pearls, a buffalo corset, and G-string, Buffalo Boy saunters over to the King Edward II statue. The phallic nature of the statue is brought to the fore by the way he plays erotically with the horse, swinging suggestively between its legs. He uses eroticism both to point out colonial desire and to displace its power. The performance showed that kings and queens are no match for Buffalo Boy. However, he did not just assume monarchic power; his was s a Coal Jubilee. Buffalo Boy buried himself in a huge pile of coal in a state of mourning for the loss of health and of land to the coal industry. The coal fueled the trains that allowed for settlement of Blackfoot territory and ultimately allowed for the extermination of the Buffalo, the animal most necessary to Blackfoot survival. Buffalo Boy linked the extermination of the Buffalo to the attempted genocide of Blackfoot people. The performance is connected to contemporary political protests against the extraction economy. Stimson was performing the dirty side of development. It is Indigenous land and bodies that suffer the consequences of the extraction economy.

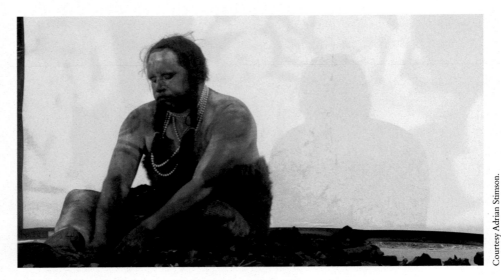

Courtesy Adrian Stimson.

Adrian Stimson as Buffalo Boy, Buffalo Boy's Coal Jubilee, 2012. Photo documentation.

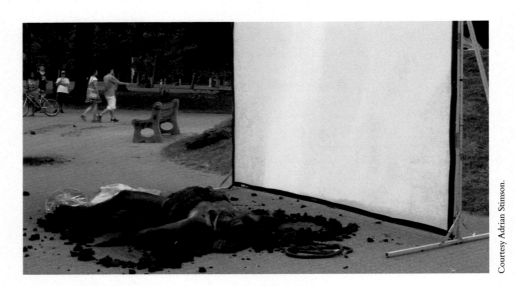

Courtesy Adrian Stimson.

Adrian Stimson as Buffalo Boy, Buffalo Boy's Coal Jubilee, 2012. Photo documentation.

Artists also used performance within political events themselves to bring new connections among art, ceremony, and protest. Artist and hereditary Chief Beau Dick, following the lead of his daughter's involvement, wanted to connect his practice to the Idle No More movement or at least make his practice useful to it. As a result, he created *Cutting the Copper* in 2014. Dick decided to take a Kwakwaka'wakw ceremony that had not been performed for decades and recreate it on Parliament Hill in Ottawa—the site of the Parliament of Canada—in order to transform the tradition for today's challenges. The original ceremony involved the breaking

of a copper—a metal plaque traditionally used to measure the status, wealth, and power of Kwakwaka'wakw chiefs—in order to signify the breaking of agreements and promises. The breaking of the copper meant shame for the receiver of the broken copper. Dick was actively saying the Canadian government had broken its promises, agreements, and treaties to the Earth and to the Indigenous people and should be ashamed of itself. What struck me most about the ceremony—artwork—protest was the sound the men made as they tried to break the copper, which is a very difficult and physically demanding process. Their yells sounded like anger but also like sadness. The physical act itself was a visualization and enactment of the trauma of colonialism and the struggle against it. This ceremony is a governance structure that shows an understanding of how broken political agreements or oppressive laws physically affect the body and how a value system that does not acknowledge the importance of the Earth should bring about a feeling of shame. The work also questions political movements that do not act according to the values of the society that one is fighting for. In other words, if I am fighting for an Anishinaabe existence, then my own actions must be Anishinaabe in their values and effects. It is also a meaningful gesture illustrating how our traditions can be adapted for here and now.

Similarly but in a gallery context, Ursula Johnson created the work *We Are Indian* (*L'nuwelti'k*) in 2012. She toured Canada asking for volunteers to sit for her in a live performance. Johnson would weave a black ash bust around your head and shoulders. When I participated, she explained everything she was going to do and said to tell her if I was uncomfortable at all. As the black ash strips were woven to the point of covering my face, she made sure I was still comfortable. She has created over 200 busts so far. She attaches a tag to your bust with your name and Indian status. In Canada, a person needs to be registered as an Indian under the law to be considered a First Nations person legally (Vowel). Johnson draws attention to how the law divides us, but in actuality when we travel around, meeting one another, our acceptance is not based on a legal technicality. The law is meant to eventually get rid of Indian status by slowly using

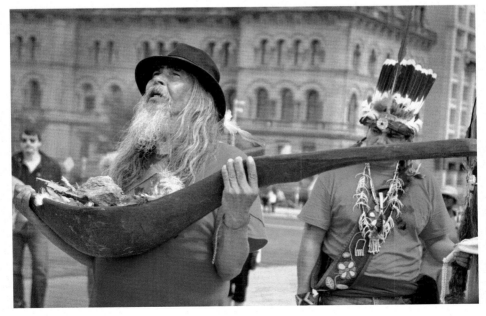

Beau Dick, Cutting the Copper performance, 2014.

Courtesy Franziska Heinze.

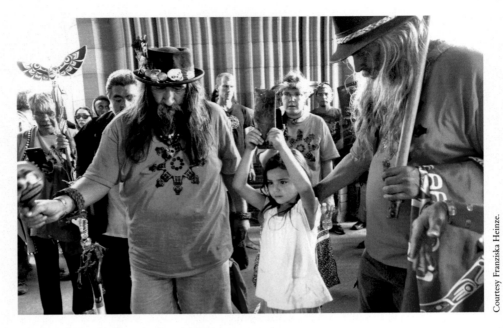

Courtesy Franziska Heinze.

Beau Dick, Cutting the Copper performance, 2014.

blood quantum to remove people's status. Johnson uses the traditional medium of Mi'kmaw black ash basketry ("History—Wisqoq") that she learned from her great grandmother but in a new contemporary way. The medium allows her to show cultural continuity and the relevance of ancestral knowledge while also accounting for change. *We Are All Indian* performs this "radical inclusivity" (L'Hirondelle) both through the act of its creation and when the busts are all exhibited together (Johnson "L'nuwelti'k [We Are Indian]").

The Anishinaabe artist Rebecca Belmore, like James Luna, has birthed contemporary Indigenous performance art as a site-specific, public, embodied, affective, political art practice. As part of both the performance art exhibitions previously discussed, she created works that brought out Anishinaabe ways of being, seeing, and doing in highly aesthetic, beautiful works that also challenged societal commitments and acts. In *X*, her response to the 20th anniversary of the Kanehsatà:ke resistance of 1990, she painted more than 10-feet-tall "Xs" on a public wall, while her assistant constantly erased them. The performance had many facets, but the main thrust was this action of continually marking and erasing, a colonial condition most First Nations people find themselves in. Many of our ancestors signed treaties with an "X" because they did not write English. Those documents became broken promises and allowed for a considerable theft of land to the point where, now, First Nations have only 2% of all the land in Canada (Pasternak "Arthur Manuel's Battle").

For *House of Wayward Spirits*, Belmore created *Facing the Monumental*. Belmore thought that Anishinaabe would not build monuments and that, instead, our monument is the 150-year-old Indigenous tree in Queen's Park that stands witness to colonialism but still survives. Belmore wrapped the tree in craft paper, which made it look like it was wearing a gown, and in the process created a temporary monument to Mother Earth. Near the end of the performance, she placed an Indigenous woman in the tree, making woman and tree seem as one, and then sits contemplatively in front. As an ending twist, gunshots start to ring out in the park as the speakers

play the 21-gun salute. Many of us started to weep, thinking of all the violence our women face, that the Earth faces, in the name of nationalism, capitalism, and colonialism. The affective relationship created in her durational, quiet, and beautiful works allow an audience to experience loss, celebration, freedom, oppression, and much more that can be cathartic, transformational, futurist, challenging, confrontational, and emotional. It allows me to ask how change happens in people's bodies and hearts and how that is taken into a political realm.

During Idle No More (2012–present), many actions were deployed that mirrored ceremonial structures or artistic practices. We held candlelight marches to honor the global resistance fighters, our ancestors, and those we have lost to oppression. We conducted water ceremonies led by Grandmother Pauline Shirt to heal the water but also to help people develop an affective relationship with the water: to feel its spirit and our relationship to it. I am convinced that people need to physically experience relationships in order to develop the value system that sees the Earth, animals, and all of creation as a web of relations. The bleeding of boundaries between art, protest, and ceremony is the consequence of an Indigenous worldview becoming more mainstream, even if it remains largely unacknowledged. The Indigenous worldview could be called post-Cartesian, but it existed before Descartes was born. The system we live in is based on valuing reason, rationalism, and the Enlightenment project. We are still engaged in this project, especially institutionally. This includes a mistaken connection of vision with the location of knowledge. We value what we can see and know with reason and facts. I have been taught by many knowledge keepers that Anishinaabe believe the human is made up of the mind, body, and spirit. Part of living a good life is learning to keep them in balance.[6] When we think of knowledge, we bring all three of these aspects together under the notion of *debwewin*, or truth. Truth,

Rebecca Belmore, Facing the Monumental, 2012. Photo documentation.

Courtesy Wanda Nanibush, Curator, Indigenous Art, Art Gallery of Ontario.

in Anishinaabe teachings, can be arrived at only if you engage the mind, body, and spirit. It is the heart knowledge that connects everything together. Emotion, truth, intuition, and the unconscious are central. In the West, the spirit is externalized as a substantive being—a substance—a being up there, for me. Spirit, for Anishinaabe, connects us to all of creation. It connects my body to my mother's body to the Earth's body. Colonial trauma breaks the connections between these bodies but also has developed new pathways to rebuilding those same connections. So much art practice already works in the area of heart knowledge. Artists often work from a place of intuition and experimentation. As a beginning, all I am able to do is connect the relationship of the body to ceremony, the relationship of the body to politics, and the relationship of the body to art, and examine how the interpenetrations of each into one another can transform us into beings with an ethic of care. This worldview understands the role of heart knowledge in linking the mind, body, and spirit together. How is this truth creating real possibilities for a future that honors life, in itself?

Notes

1 Settler colonialism is a form of colonialism whereby indigenous populations are replaced by a settler government, which, over time, develops a distinctive identity and sovereignty. Settler colonial states include Canada, the United States, Australia, and South Africa. Settler colonial theory has been productively used to analyze conflicts in Israel, Kenya, and Argentina and in tracing the colonial legacies of empires that founded settlement colonies.
2 I started using this phrase 18 years ago to speak to the notion that sovereignty is an embodied practice that has to continually be created through this very embodiment of culture in daily practice. It is my effort to grapple with Judith Butler's notion of performativity in the context of Indigenous sovereignty. I wrote about it in my MVS thesis and exhibition called *Sovereign Acts* (2012, University of Toronto).
3 In 1837, the British government decided that assimilation was the forward strategy for indigenous residents of the colonies. In Canada, the United States, Australia, and New Zealand, the Indian Residential School system was created as means to forcibly assimilate indigenous children into Western culture. Attendance was mandatory; therefore Indian Agents regularly removed children from aboriginal communities. Many of them never saw their families again. As a rule, students were punished for speaking their native languages or keeping any indigenous traditions, and some were subjected to medical experimentation and sterilization. The last residential school in Canada didn't close until 1996 (Feir 433–480).
4 Idle No More has become one of the largest Indigenous mass movements in Canadian history, organizing hundreds of teach-ins, rallies, and protests that have changed the social and political landscape of Canada. The movement was initiated by activists Nina Wilson, Sheelah Mclean, Sylvia McAdam, and Jessica Gordon in November 2012, during a teach-in at Station 20 West in Saskatoon called "Idle No More." It was held in response to the Harper government's introduction of Bill C-45, implementing numerous measures, many of which weaken environmental protection laws (Kino-nda-niimi Collective).
5 The Silver Jubilee of Queen Elizabeth II was held in 1977 and celebrated with a series of parades, parties, and religious ceremonies. In honor of the occasion, rose gardens were planted in Ontario's Queen's Park.
6 Our cultural knowledge is passed on orally and is learned in relationship. Some people have written some of it down. I have learned from my grandfather Howard McCue, my mother Caroline McCue, my 17 brothers and sisters, and Grandmothers Shirley Williams, Edna Manitowabi, and Pauline Shirt, to name a small number of all the knowledge keepers of many nations who have taught me so much.

Works cited

Feir, Donna L. "The Long-term Effects of Forcible Assimilation Policy: The Case of Indian Boarding Schools." *Canadian Journal of Economics*, vol. 49, no. 2, May 2016, pp. 433–480.
Fine, Sean. "Chief Justice Says Canada Attempted 'Cultural Genocide' on Aboriginals." *Daily Mail*, 28 May 2015, www.theglobeandmail.com/news/national/chief-justice-says-canada-attempted-cultural-genocide-on-aboriginals/article24688854/. Accessed 20 December 2018.

"History—Wisqoq." *Wisqoq*, http://wisqoq.ca/black-ash/history/. Accessed 14 January 2019.

Idle No More, www.idlenomore.ca/. Accessed 20 December 2018.

Johnson, Ursula. "L'nuwelti'k (We Are Indian)." *Ursula Johnson*, https://ursulajohnson.ca/portfolio/2012-ongoing-lnuweltik-we-are-indian/. Accessed 29 July 2019.

Joseph, Bob. *21 Things You May Not Know about the Indian Act: Helping Canadians Make Reconciliation with Indigenous People a Reality*. Indigenous Relations Press, 2018.

The Kino-nda-niimi Collective. "Idle No More: The Winter We Danced." *The Winter We Danced: Voices from the Past, the Future, and the Idle No More Movement*, edited by The Kino-nda-niimi Collective. ARP Books, 2014, pp. 21–27.

The Kino-nda-niimi Collective. *The Winter We Danced: Voices from the Past, the Future, and the Idle No More Movement*. ARP Books, 2014.

L'Hirondelle, Cheryl. *Why the Caged Bird Sings: Radical Inclusivity, Sonic Survivance, and the Collective Ownership of Freedom Songs*. 2015, OCAD University, MA thesis, http://openresearch.ocadu.ca/id/eprint/287/. Accessed 29 July 2019.

Macdonald, Sir John A., Prime Minister. "Official Report of the Debates of the House of Commons of the Dominion of Canada." National Archives of Canada. 9 May 1883, 1107–1108.

Milloy, John. "Indian Act Colonialism: A Century of Dishonour, 1869–1969." National Centre for First Nations Governance, 2008, http://fngovernance.org/ncfng_research/milloy.pdf. Accessed 14 January 2019.

Obomsawin, Alanis. "Kanehsatake: 270 Years of Resistance." *YouTube*, uploaded by NFB, 20 September 2011, www.youtube.com/watch?v=7yP3srFvhKs. Accessed 29 July 2019.

Pasternak, Shiri. "Arthur Manuel's Battle against the 0.2 Per Cent Indigenous Economy." *Canadian Dimension*, 6 July 2017, https://canadiandimension.com/articles/view/arthur-manuels-battle-against-the-0.2-per-cent-indigenous-economy. Accessed 29 July 2019.

Smyth, Heather. "The Mohawk Warrior: Reappropriating the Colonial Stereotype." *TOPIA: Canadian Journal of Cultural Studies*, vol. 3, 2018, pp. 58–80. https://doi.org/10.3138/topia.3.58.

Vowel, Chelsea. "Got Status? Indian Status in Canada, Sort of Explained." *âpihtawikosisân*, 14 December 2011, https://apihtawikosisan.com/2011/12/got-status-indian-status-in-canada-sort-of-explained/. 14 January 2019.

TRUST OR THE WORKS
WERE LIMITED

Ala Younis

This text focuses on the truth spoken by the defeated in eras that follow euphoric, nationalistic escalations. As in the United States, we are witnessing change in the aftermath of the 2011 uprisings—shifts in friendships, in trust, in styles of governance, and in accessible geography—while, at the same time, the virtual space of the Internet expands massively in its scope, effect, and (often misleading) content. This text focuses on searching for knowledge that resides, remains, and can be detected even despite the interrupted, ambiguous, and distrusting retelling of these histories. These "retellings" are the space where personal histories plug into shared ones and are experienced or verified through the Internet and personal encounters.

In a street leading to one of the community center schools in the Zaatari camp, north of Jordan, a teenager kneeled very close to the fence around one of the mission's headquarters. He wrapped around his phone with his body, seeking the shade that would allow him to read his screen.

The camp is in the middle of the desert. Or it seems to be because the sand colors everything. The other color is United Nations' blue. The camp's landmarks are bus stops, street names, falafel shops, and community centers. There are no trees except for those painted on the corrugated walls of the temporary living units: caravans given to a hundred thousand Syrian refugees. The camp is divided into zones cut with streets whose names are handwritten on the caravan that begins it. The names are necessary to locate any disorder when it happens, said the driver. The architecture is a mix of tents, caravans, and repurposed wood, some of which still carries the logo of the relief mission that brought it to the camp for other uses.

On one bus stop, high-rise buildings were painted, each on a panel of the corrugated structure. On another, a sky with clouds. I was thinking about these and the other illustrations that we could spot on the caravans and could imagine that they were the work of artists brought to do community work here. I was not sure whether that was something I would support or challenge; regardless, these paintings were not only colorful spots that served as landmarks in the arid landscape—or cityscape—of the camp but also shaped the perception of art in this less exposed context.

Those who were not from the camp but had work to do there had to go straight to where they would work. They were not allowed to tour the camp. I was with a group whose work was in the library of one of the community centers. The library was in a caravan too. It had tables on which sat an exhibition of older creative-educational projects illustrating linguistic, cosmic,

scientific, natural, or geographic lessons. One featured a volcano, made of melted wax resembling lava. It was a gift from a teacher who taught geography to the children of the adjacent school. The team I entered with presented a scientific show on the weaker bonds that bring gas molecules together, and so the last bit of the show blew thin paper sheets above the heads of the children, causing an enthusiastic disorder among the young crowd. The team's supervisors asked the crowd to quiet down and sit back on their chairs. This happened in both presentations we did: the first for girls and the other for boys. I needed a quiet spot between the two presentations, and so I was offered a corner in a computer programming class. There were girls there discussing typing, programming codes, web design, and the fact that there was no Internet with their teacher, who was very close to their age.

On our way back from the school-community center at the edge of the Zaatari camp, I saw two other teenagers kneeling close to the same outer fence of the first institution we had passed. They were also pressing their bodies against the fence with their hands extended into the shade, cradling their phones. The car drove faster, and, as I turned my head to continue looking, I realized they were there for the Internet.

Mobile phone screens, like those of the teenagers from the Zaatari camp, carry news from geographies rendered inaccessible after 2011.

Facebook is also dominantly blue, and a vast number of its pages could save or serve information seekers some hassle. These screens have delivered very violent images in the past six years. They also offer users information on deaths, locations of those they know but whose traces were lost, solutions for crossing borders, maps, and contacts. If I want to know which pages brought this teenager to the fence to seek Internet, it is because I want to imagine what knowledge, pleasure, or need could shape his body this way under the sun. What is in these technological

Photo and courtesy Ala Younis.

High rise buildings illustrated on corrugated sheets at bus stops in Zaatari Camp, Jordan, 2018.

offerings that he builds trust with and what breaks down in his reading? What news does he encounter, how can he verify plans he wants to pursue, and what impressions does he carry of the events that he is part of? As I think of his age, I do not rule out that maybe he is there keeping up a relationship with someone.

In her article on cyberculture in Lebanon's Palestinian refugee camps, Laleh Khalili describes the intimacy that was allowed by the communication over chat pages among the younger generation of refugees. How they could find foreign language easier and safer to confess their feelings to others. How anonymity and distance offered a safe zone that encouraged the expressions of feelings or the use of statements that were usually harder to break in person or in a mother language, statements like "I love u." This analysis of safe space is not by any means limited to people who live in the camp, but perhaps their easiest (virtual) way out:

> In the early evening hours, the Web café in the Burj el-Barajneh camp in Beirut is filled with young Palestinians. The walls of the center are decorated with calendars and posters in Palestinian national colors downloaded from the Internet and reproduced on ordinary printer paper. A few older customers use the centrale telephones to contact relatives and friends; the youth, however, use the computers.
>
> *(Khalili 126)*

Khalili's analysis is focused on Palestinians from Lebanon conversing with Palestinians from the West Bank. They were as if cousins, meeting again for the first time after a long separation and admiring each other in accents, traditions, and notions of Palestinian-ness. The dynamics of the Internet and its profiling of users today is very different from Khalili's fieldwork undertaken between 2001 and 2003, a decade before the events of 2011. Not only would Arab geography change but also its online social and political representation, including who trusts what of it. The computers are now smartphones. Cybercafes are 3G sim-cards. The network coverage in the camp is not strong enough, and, most importantly, the wars—their fighting parties and their supporters—are still strongly present on social media.

With every call for a demonstration in Cairo following 2011, analyses spread across the Facebook newsfeed. People ask questions on their walls. Who is calling for this demonstration? Who participates in it? What was the future of past events with similar tones? The people split after each call to action into smaller and smaller groups.

This feed is also activated during elections and referendums, particularly in 2013, with the circulation of images of women breaking into dance at the entrances of the voting centers in Cairo. They danced as they had put their trust in the referendum for a new constitution or an elected president. They performed putting their future quest to rest in the hands of a trusted authority. Their performance of this trust was illustrated to the camera and then it moved virally across the web.

Viral circulation becomes a prompt for a breakdown of political and social positions. A world that exaggerates in exposing its loyalties becomes an unbearable space to live in.

My work on architectural projects in Baghdad brought me into contact with Iraqi architects who worked closely with key political figures on the construction of high-rise buildings, as well as the accompanying infrastructures of power. Most of them had lived in Amman before they moved on to settle in far countries, after the First or Second Gulf War (1990–1991 and 2003–2011). They could twist their accents to make their words more understandable to us, people of the Levant. I was to extract information on architectural practice from their stories—stories told after the influences of a lifetime of hard work, of exuberant national sentiments, of a draining war followed by more wars, of professional careers under dictatorships, embargo, multiple exits, and transits. One could imagine how a conversation of this sort might sound: tremulous.

When I spoke to these architects over the phone or over the Internet, I felt a high wall between us. In the unspoken code of these conversations, I could ask only about the past, not the present. Further, the past I should be interested in must be professional, not political. If it has to be political, then I should not mention Saddam Hussein or inquire about his character, the shape of his rule, or the interviewee's possible professional relationship to him. This is not to say that the architects in question worked with or supported Saddam Hussein but to say that they did not want to be the pen that writes the pages of anyone's version of that history.

When she walked into *Plan for Feminist Greater Baghdad*[1] in London, the Iraqi architect, Wijdan Maher, did not need me to explain to her the history that I laid out on the wall. But, gesturing to one of the figurines I had created, I asked her, "Do you recognize this woman?" She didn't. I said, "Not even the hairstyle?" She seemed to be shocked. I said, "I asked, but you never gave me photos. I had to work from the only photo that I found of you." Her friend intervened: "Yes, you had your hair cut like this once." When I started the project, I had not been sure that, if I could reproduce a miniature of a living person, this person would allow it, much less like it. I relied on an old image of her, self-published in a magazine, reproduced yet again on the Internet. While I hope I captured her image, I recognize that I, still, reproduced only a digital image.

Maher was carrying a black folder. I said, "It would be absolutely fantastic if your time allows and we could meet in person." She said, "No time, let's speak on the phone." I said, "But, since we already spoke on the phone, this is a great chance to meet in person." She said, "My house is far and the time is tight." She said, "Call me on Sunday." What I wanted from this encounter was to build a space of trust in my person, to extend her the ability to judge my voice and choice of words in a way not available over a Skype call, to a more genuine access of my personality. I did not want the safe zone offered by the Internet, a zone that any of us were allowed to retreat into. I wanted this encounter, hopefully a future contribution to my research on female Iraqi

Ala Younis, Plan for Feminist Greater Baghdad exhibition installation view, 2018. Photo Anna Shtraus.

architects (whose diaries are not written and their works hidden in less prominent files), to be built on the faith of personal encounters.

We would finally meet after we shuffled between the two exits of one of London's tube stations, me from outside the station and her from within.

"Your research is rich indeed," she said, "but there are, nevertheless, some parts where you are wrong. I normally would let this go, but since you have insisted on this meeting I might as well explain to you some of the misleading points in your project." She opened the same black folder and brought out some photos of herself, in different stages of her life, mostly shaking hands with other women. There were some printouts of drawings for a resort in Habbaniyah, in central Iraq. These were low resolution and printed on a color laser printer; she forwarded me scans of some other plans, also low resolution. It was obvious that she herself had received them through the Internet.

I was told by an Iraqi scholar in Amman that she designed Saddam Hussein's palace in Habbaniyah. I did not dare to ask if these were her same project but assumed they were and that the scholar's comment was one of those given by people to tease researchers and send them in certain directions. After all, the only photo I found of her—and from which I built her resemblance into a 3D figure—was on the scholar's Facebook page. Maher allowed me to take photos with my phone for everything.

She asked, "Why center your research on the work of an international architect in Iraq and not the avant-gardes of the local architects who studied and worked there?" I felt her question was one out of trust. She felt proud of her practice, while I had felt—at earlier stages of my project—that a Gymnasium designed by Le Corbusier and named after Saddam Hussein in Baghdad was something bigger than my imagination. I spent a long while linking the two men together through architectural projects that illustrated the shift of power. Some viewers of my work on this Gymnasium equally expressed their shock upon learning this history. Do we (all) like the work of the famous, the foreign, the conspicuous? This Iraqi architect expressed that she had already lived a life shaped by similar preferences, friendships, and fame of others: "When we graduated from school, sons of so-and-so had just come back from their studies abroad, established their offices, and took all the work." She said, "By the time we graduated, we had to work in their offices, because they had taken all the jobs; the works were limited." For once, the discourse on the Iraqi architectural boom in its modern era was described as limited from the viewpoint of a female architect who could be a senior employee at a consulting office but was not convinced there was work enough to have for her own, should she establish her own office.

Among the photos she presented to me was a set of her portraits at the Iraq Consult office where she worked as a senior architect. She looked different in each photo and, in each, different from the photo that I had of her. This evidence of change was perhaps a metaphor of the different levels of imagination—or of understanding—of Maher's role in this yet-to-be-written history and thus, in this way, restored my confidence in the portrait I myself had made of her. Iraq Consult is an architectural consultants' office cofounded by Rifat Chadirji; he and his office were the local consultants for Le Corbusier's commission in Baghdad, and he worked after Le Corbusier's death with his contractors. Between 1978 and 1980, Iraq Consult supervised the construction of the Gymnasium, the only element finally built from Le Corbusier's commission. As Chadirji was serving a life sentence in Abu Ghraib prison, Saddam Hussein was becoming a president, and so the building (designed by Le Corbusier, who had passed away in 1965) took the name of the new president.

The Gymnasium metamorphosed through numerous iterations of plans over 25 years before it was inaugurated in 1980. Until then, the commission for the Gymnasium passed through five military coups; six heads of state; four master plans (each with its own town planner); a

Ala Younis, Glimpses of History of Architecture, part of Plan (fem.) for Greater Baghdad project, 2018. Inkjet prints, 14" x 11".

Development Board that became a ministry and then a state commission; a modern starchitect among a constellation of many others with their associated architects, draftsmen, contractors, agents, and lawyers; local architects accompanied by similar personnel structures from their own consulting firms, from government departments, and from parallel commissions; more than one local artist; eager competitors; and other monuments that simultaneously appeared and disappeared as a result of these same configurations. To produce a work on this history meant that I needed to navigate these political and rival events, all, of course, composed in written

or spoken words, uttered through choices of temporal, emotional, and political context. The authors, publishers, and governments through which these words were channeled made their choices of what to share of this history.

I found out about the existence of this Gymnasium from photos taken by Chadirji himself at the end of 2010. I reproduced a two-layered timeline that pits developments in the Gymnasium's story against those in Baghdad's, using materials found in archives, books, or documents and through the stories of the main protagonists. I spent a great deal of my time roaming Facebook and YouTube posts that reproduced fragments of low-resolution images attached to misinformed captions. I also relied on (autobiographical) books,[2] correspondence found in archives,[3] and the content of artworks from the period (most importantly Jewad Selim's *Liberty Monument.*) The written documents not only enjoyed a stability of content (which cannot be guaranteed for online posts) but also revealed the ways in which they were the product of the architectural firms that led the projects. The trust that was bestowed on these architects (and their offices) to build these monuments in the past carved larger and deeper ripples in what we build on in our present. In simpler words, those who had offices of their own managed to write books of their own. These power relations dominated the first version of my *Plan for Greater Baghdad* and left women outside this first presentation. I did not want to give only nominal or cursory mention of their work or of the positions they worked from.

We were exchanging stories on Iraqi singer Kathem Al-Saher when Iman Mersal told me how, in 1992, she went on a solidarity trip with a group of Arab feminists to Baghdad. She told me of how their group was redirected, without prior notice, to meet Saddam Hussein himself. She said that other Arab women who lived in Baghdad were brought to the meeting too. She said, "Saddam surprised us with a very liberal feminist speech." Since *Plan for Greater Baghdad* was heavily based on materials from archives and the dominant narratives recorded by them, I wanted now to reproduce the whole timeline through a female perspective, and so Iman's description of his speech—as well as the group photo with Saddam Hussein—became part of an extension of my original project. She did not want the image to roam the Internet, accumulating a wealth of fake stories around their encounter. We agreed that I could reproduce the image only if it were to be accompanied by the knowledge that would ensure any circulation of it would stick to its original context.

I discovered a video recording of a concert that Kathem Al-Saher did in Le Corbusier's Gymnasium in 1992. The recording is very low in quality, and when I pause the video for a still image, Al-Saher's face has no features. So was the case for another video of his concert at the Gymnasium from 1990. In the latter, a man wears a Mickey Mouse costume, dancing to the tunes of popular music in celebration of the New Year. There is a girl who puts on an exaggerated dance performance whenever she sees the camera coming close to her, particularly when certain national songs are playing. She continuously looks at the camera as she dances, and so a young man sitting next to her starts to perform for the camera too when he sees its long attentive presence.

For a long time, I thought this character would definitely be one of the seven women that I would finally feature as a 3D print in my new iteration of the *Plan for Greater Baghdad* project. But it was impossible to reproduce her resemblance as she moved, and, when she paused, her features would disappear too, lost to the poor quality of the footage. Yet the gesture in her arms looked like those of a woman leading a protest, itself an image that seemed recurrent in prominent Iraqi films from 1978–1980.[4] I needed a paradoxical character with hybridity of two contrary sides, a character who performed support to authoritarian politics while also objecting to it by the same means of performance.

The image of this revolutionary woman seems to last longer on paper than the milliseconds it took in the film itself. This elongated dimension is also present in artist Jewad Selim's *Liberty*

Monument (1961), where the first woman included in the narrative of his mural is one among the revolutionaries or revolution frequenters. She is raising her arms beside a group of men, all of whom are carrying banners. Chadirji, who designed the base of the monument to look like Baghdad's revolutionary banners, installed the pieces with the help of Selim's assistants, as Selim passed away upon finishing the sculptures. Distrustful of the eyes of fellow artists, who would report the content of the mural to the prime minister, Chadirji covered each newly installed piece with gypsum until the day of the inauguration, the third anniversary of the July Revolution that overthrew the monarchy and announced the Iraqi Republic.

Dissidents. Friends. Friends who became dissidents. Their friends who blocked them on their Facebook pages. Neighbors who reported exhibitions and cultural events. Police who came to take down the shows in the neighborhood and to lock up at least one employee for at least one night. Friends of the cultural spaces came to see him in prison. Friends of the cultural spaces deactivated their accounts after raids. Cultural spaces sent private invitations to their close network of friends for events that followed raids. Cultural spaces cracked down in the aftermath of the events of 2011.

When I called Chadirji in 2011, he asked me to read all his books before I came to meet him in Beirut. I managed to find them and had read all but one. I was influenced by the informative style of his publication *Al Ukhaidir and the Crystal Palace*, the way he wove a narrative of architectural practice in relationship to individuals, whose short biographies and photos were featured on the side of the page where they were first mentioned. This extended research into the profiles of the mentioned names served both as a form of tagging and as windows, opening insights into those mentioned. It served as an older version of informatics, replaced by the Internet in our time.

Chadirji authored this book in Abu Ghraib prison between 1978 and 1980, and this experience was reproduced in detail in *A Wall between Two Darknesses* (2004), coauthored with his wife, Balkis Sharara. This book that I did not read before meeting Chadirji consisted of alternating chapters written separately by the couple on the prison experience, him from inside and her from outside. She details how she moved photocopies of 160 books and over 120 other miscellaneous materials—including maps, drawings, and photos of homemade meals—for her husband to use during his time in prison. This flood of information, of images that lost quality (and, consequently, information) through reproduction, and of the wide variety of materials that Sharara carried into the prison provides a precedent to the way content would start to move across geographies using the Internet, to and between Iraqis and others, soon after Saddam Hussein's regime toppled in 2003. Published in the next year, *A Wall between Two Darknesses* linked two worlds together, an imprisoned one that was eager to bring the world into to this confinement and the other just as eager to represent the variety of available content back to the imprisoned. What instigated this systematic flow of content was that Chadirji was serving a life sentence; he was encouraged to use this time to put in writing his own knowledge of architectural practice. His writing described a world that he was not part of anymore but a certain part of whose history he knew much about. When I reread his words, describing how he curled his body as he wrote, sitting on his mattress in prison, I remembered the boys from the camp, warping their bodies in the limited shade to read and write online.

In her last chapter, Sharara mentions architect Wijdan Maher. Maher helped her organize maps and papers from Iraq Consult, visited Chadirji in prison, and brought him cake on his birthday. She writes that two fellow architects told Maher that Chadirji would be brought out of prison by Saddam Hussein himself to supervise a great development project that would reshape Baghdad, and, indeed, this happened the next morning. By end of 1982, Chadirji and Sharara left Baghdad, but Chadirji did not publish his seminal book until 1991, when Saddam Hussein had

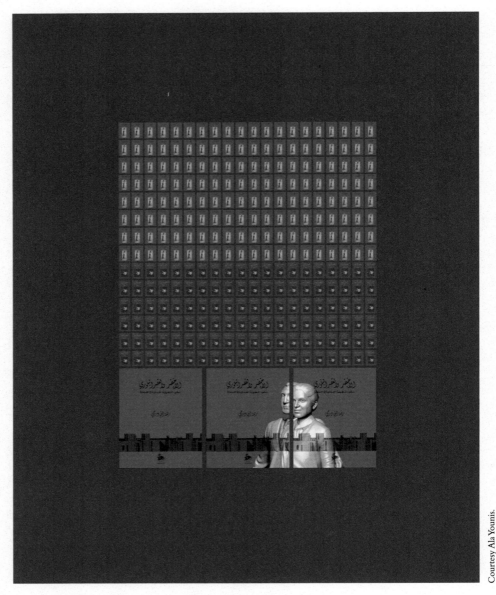

Ala Younis, Balks transfers to/from Abu Ghraib, part of Plan (fem.) for Greater Baghdad project, 2018. Inkjet prints, 14" x 11".

lost another war. Chadirji did not mention Saddam Hussein even once in this book, although he had spoken of previous presidents and particularly of the pressures on artist Jewad Selim to include a depiction of the late prime minister Abdel Karim Kassem (overthrown and killed in 1963) among the sculptures of *Liberty Monument*.

Wijdan Maher was traveling when the fourth issue of her publishing project, a magazine titled *Imara*, was stuck at printers as a result of the Iraqi army invasion of Kuwait in 1990.

Baghdad never saw this or another *Imara* issue, nor did Maher return. I met Maher for the first time in person when she walked into my show in London.

An Iraqi scholar once warned me that Chadirji writes his own view of things. I tried not to worry because my work is presented as art and, thus, trusting the historical events presented in it is thwarted by (the possible inclusion of) elements of fiction. I felt more assured that Chadirji's narrative, over Jewad Selim's, was correct when I found the same story mentioned in the Baghdad-based Palestinian critic Jabra Ibrahim Jabra's book on the monument. But what shook my trust in the written narratives was my meeting with Wijdan Maher in London. Have I given a bigger, larger life to the written word? How should I navigate the feelings of mistrust that result from detecting a gap, no matter how small, in this composed narrative? Have I fostered issues of class, gender, and perhaps an egoistic or exoticized presentation of a complex history?

Wijdan Maher said she is a good writer but has chosen not to write. She has decided to instead look at content and comment only if she trusts that her comment will make a difference. And so she said, "I will help you by introducing you to my circle of architects." I came to them through her, a person they trust. But how do we bring any of the unspoken, the invisible back to writing, if events insist to be locked inside the memory of their beholders? Or if the effort is great to get inside (or outside) the borders of where they remain? Or when the information that you are entrusted with will mostly move across, be consumed, and reproduced online—if not added to—by circles of those you do or do not trust?

Notes

1 Solo exhibition by Ala Younis held simultaneously in London and Dubai from February 2018 to June 2018.
2 See *The Ukhaidir and the Crystal Palace*, Rifat Chadirji's book on architectural practice in Iraq.
3 Particularly correspondence found in the Fondation Le Corbusier in Paris, which I consulted in person in 2011, 2015, and 2018.
4 Particularly *Al-ayyam al- tawilah* (*The Long Days*, 1980) directed by Tewfik Saleh and *Al Aswar* (*The Walls,* 1979) by Mohamed Shukri Jameel.

Works cited

Al-aswar (*The Walls*). Directed by Mohamed Shukri Jameel, performances by Ibrahim Jalai and Sami Abdul Hameed, 1979.
Al-ayyam al-tawilah (*The Long Days*). Directed by Tewfik Saleh, performances by Saddam Kamel and Nada Siham, 1980.
Chadirji, Rifat. *The Ukhaidir and the Crystal Palace*. CRC, 1991.
Chadirji, Rifat, and Balkis Sharara. *A Wall between Two Darknesses*. Dar al-Saqi, 2004.
Khalili, Laleh. "Virtual Nation: Palestinian Cyberculture in Lebanese Camps." *Palestine, Israel, and the Politics of Popular Culture*, edited by Rebecca L. Stein. Duke University, 2005, p. 126.
Younis, Ala. *Plan for Feminist Greater Baghdad*. 1 February 2018–2 June 2018, Delfina Foundation, London and Art Jameel, Dubai.

MAKING LATIN AMERICA TREMBLE

Feminist imagination against the pedagogy of cruelty

Miguel A. López

On Tuesday, July 31, 2018, hundreds of feminist activists from the #NiUnaMenos movement occupied the city of Buenos Aires's underground transportation. This intervention took place on the eve of the debate of the Law of Interruption of Pregnancy (IVE) in the Argentine Senate (August 8, 2018). The activists' intention was to press for a favorable vote to guarantee the right to legal, safe, and free abortion in Argentina, taking advantage of the political climate brought about by a first victory of the law in the Chamber of Deputies two months prior.

This massive intervention had a pedagogical dimension. By taking the subway lines, the activists had the opportunity to share their own personal stories and experiences, emphasizing that pregnancies were not a personal problem but a social one, not a so-called family issue but a health issue for millions of women. With the complicity of the workers and delegates of the underground unions, in each train the same text was read over a loudspeaker. "Attention passengers! At this moment, interventions are being carried out on this metroline and all the others. Do not be scared. The train will continue its usual route," the message began. "We want to tell you that from the underground city we are weaving networks like spiders, making the earth tremble. We demand that on August 8 the right to legal, safe, and free abortion becomes law" (Romero).[1]

Together with poets, actresses, singers, and various other public figures, the activists turned the subways into small itinerant galleries. They mounted posters, drawings, and stencils; handed out leaflets; and knotted green ribbons along the handrails into a powerful and poetic spider-web. On the A metroline, activists initiated conversations on abortion from the perspective of human rights; on the B metroline, the politics of the pregnant body and the social mandate of motherhood were discussed; on the C, activists emphasized the right to decide on their bodies and the struggles for self-determination; on the D, activists demanded comprehensive sexual education; on the E, misinformation strategies and conservative discourses were examined; and on the H, the importance of understanding the discussion of abortion as a public health issue was highlighted. In all cases, activists stressed that the deaths of tens of thousands of women due to clandestine abortion practices should be considered state-sanctioned femicide.

The action, titled *Operation Spider: The Earth Trembles from Below*, sought to build an analogy between the fabric of the city and the web of violence that crosses the lives of women. "The feminist city is a collective body that we activate among all of us and that allows us to reappropriate our bodies that are our territories," read their manifesto (Romero). The intervention

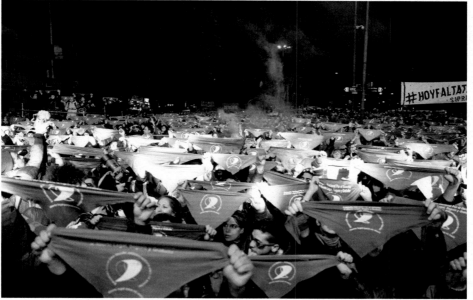

Courtesy Julieta Ferrario/ZUMA Wire/ Alamy Live News.

9th Aug, 2018. 2018, August 8, City of Buenos Aires, Argentina. Senators reject the Legalization of Abortion Project at the National Congress. Thousands of people remain in vigil outside the Parliament. Outside the Parliament, thousands of people manifestate in favor (green handkerchief) and against (blue) the project. On 2018 June 14 Lawmakers (Deputies) approved the original project. Credit: Julieta Ferrario/ZUMA Wire/Alamy Live News.

ended in Plaza de Mayo with a massive congregation and a *pañuelazo*: thousands of women holding the green handkerchiefs that became the main symbol of their struggle. Even though the Law of Interruption of Pregnancy was not approved by the Senate on August 8, the impact of the mobilization strengthened similar campaigns that were carried out in Mexico, Chile, Peru, Paraguay, Costa Rica, and Brazil.

Similar to many other actions realized in different cities on the continent, *Operation Spider* transformed public spaces into places for public education. These interventions challenged the information monopoly formed by the alliance between conservative economic groups, right-wing populism, and religious discourses maintained in many countries of the region. These public actions also pointed to the complicity of the media in maintaining this patriarchal social structure. As anthropologist Rita Segato observes, crimes against women and the conversion of the violence against their bodies into a media spectacle continue to be some of the most effective methods of imparting a "pedagogy of cruelty"—that is, the collective training of how to exercise domination over others and "all the acts and practices that teach, accustom, and program subjects to turn forms of life into things" ("A Manifesto"). For Segato, it is clear that this is not only a matter of gendered violence but also the way in which social relations are produced at a time when the project of economic exploitation driving the social elite—the concentration of the planet's wealth among the population's 1%—is the dominating worldview (*La guerra contra las mujeres*).

While the effectiveness of the pedagogy of cruelty lies in its enmeshment with capitalism's logic of extreme productivity and the social obedience to the rule of masculinity (what

Segato calls the *masculine mandate*) ("A Manifesto"), the possibility of a response dwells in the mobilization of feminist imagination, the regeneration of the social fabric, and the creation of strong networks of counter-education. Many of the feminist creative strategies that have arisen in recent years can be thought of as spaces for collective learning and destabilizing institutional "certainties" held under the guise of misogyny, homophobia, and discrimination. These coun
tereducational experiences contribute to the reconstruction of solidarity and empathy through gestures, songs, images, and actions that have been introduced into the vocabulary, routine, and daily lives of millions of people. The result has been the cracking of the patriarchal, political, and religious nexus that seeks to perpetuate the subordination experienced by many cisgender women, trans women, and queer and feminized bodies in society.

Regression and repression

The cultural and political landscape of Latin America has drastically been transformed in the last decade. Recent electoral results have seen the victory of right-wing governments in countries including Argentina (Mauricio Macri, 2015), Peru (Pedro Pablo Kuczynski, 2016), Honduras (Juan Orlando Hernández, 2017), Chile (Sebastián Piñera, 2017), and Colombia (Iván Duque, 2018); the interruption of democratic governments by parliamentary setbacks in Honduras (Manuel Zelaya, 2009) and Paraguay (Fernando Lugo, 2012); and the abrupt removal of President Dilma Rousseff in Brazil in 2016, followed by the recent election of the misogynistic, far-right former military officer Jair Bolsonaro as the new president. These changes contribute to a deeply regressive map drawing. Furthermore, the victory of Donald Trump in the 2016 United States presidential elections has prompted dehumanizing attacks on the Latino community and caused the displacement of thousands of undocumented and migrant families.

The resurgence of ultraconservative discourses in Latin America, supported by neoliberal economic policies, has had an influence on censorship and control on culture and education. A few key examples include the dismissal of the Place of Memory's director in Peru due to pressure from political groups seeking to erase the memory of the crimes of the dictatorship of Alberto Fujimori (August 2017), the shutdown of the queer art exhibition *Queermuseu* at the Santander Cultural space in Brazil due to pressure from religious groups (September 2017) (Londoño A4; Wouk Almino),[2] and the recent elimination of the Ministry of Culture in Argentina due to economic cutbacks (September 2018). The constant threat to artistic and intellectual freedom is modeled on a perception of culture as a sphere of financial investment. Similarly, the banner of "defense of the family" was another strategy of the right wing and of fundamentalist religious groups. It has proven to be effective, as evidenced in many countries, tilting the electoral balance toward conservative candidates.

The political left has also entered into a new crisis due to corruption scandals associated with the Brazilian company Odebrecht and the deleterious public effects of the authoritarian direction of some governments—such as Nicolás Maduro in Venezuela or Daniel Ortega in Nicaragua—that have forced the diaspora of thousands of people, who now seek refuge or asylum. Even when several progressive and leftist governments in the region succeeded in promoting important social justice measures—such as human rights policies and reparation for the victims of violence, the reduction of poverty, educational programs, and a more equitable participation of the State in the national economy—these have consistently failed to protect women's rights and those of the queer community.

These are some of the many obstacles feminist and queer groups face today. It means going beyond state structures—without abandoning them altogether—and questioning the narrow limits of institutionalized left politics. As a result of their struggle, such groups have created

spaces for organizations and collectives to converge—migrant communities, indigenous people, workers, and various sectors of civil society—where the use of symbols has been decisive in coalescing anger and rage against normalized misogyny and homophobia. As writer and activist Cecilia Palmeiro recognizes:

> The horrifying and escalating number of femicides and transfemicides at a continental scale, the murder of local anti-extractivist female leaders, the wave of redundancies, and the current and future austerity measures, thanks to the return of the IMF to the arena of decision-making over our everyday lives, the economic crises delivered from above as a form of discipline, find in feminism their most vital form of resistance.
>
> *(Palmeiro)*

Handkerchiefs, skirts, and shawls

The proliferation of the green handkerchief in Argentina as the main symbol for the National Campaign for Abortion is exemplary of the role that representation plays in shaping social demands. The ability of this symbol to enter people's daily lives, becoming an accessory to hang around one's neck, on purses and bags—as well as to multiply across different countries with variations in color—has indicated the affirmation of a community of complicity and support and the creation of safe spaces for women in public. They have been used by tens of thousands of women assembled in squares, parks, universities, and legislatures throughout Argentina, accompanied by dances and chants, signs, stickers, green paint glittering on faces, and banners making visible the demand for legal abortions.

The handkerchief continues a tradition initiated by the Mothers and Grandmothers of Plaza de Mayo, who wore white handkerchiefs to demand the safe and sound return of those detained and disappeared during the Argentine military dictatorship (1976–1983).[3] The historical connection between both symbols highlights the role of women in the struggle for human rights but also their continuity: the claim made by young women for control over their bodies and their reproductive rights is another way of opposing the same project of cruelty and terror that robbed these mothers and grandmothers of the possibility of raising their children and grandchildren during the seventies and eighties.[4] The refrain, "We are daughters of white handkerchiefs and mothers of green handkerchiefs," was heard constantly during the demonstrations.

The need to acknowledge a legacy of struggle and resistance is also present in other contexts crossed by situations of war and extreme violence. In Peru, a number of social mobilizations have fought for the judicialization of sexual crimes committed by the armed forces during the years of armed conflict between subversive organizations and the Peruvian State (1980–2000). This include the prosecution of nearly 300,000 forced sterilizations committed against peasant, indigenous, and poor women between 1996 and 2000, during the dictatorship of Alberto Fujimori.[5]

One of the most powerful actions related to that case was "My body is not your battlefield" by the feminist collective NoSINmiPERMISO, originally presented in 2011 in the public streets and squares of Lima.[6] In their performance, the five members emulated the ways in which attempts were made to convince and coerce peasant women to enroll in the program that would sterilize them without their consent. "Sterilization is the goal; to prevent the birth of the poor!" shouted one of them in a direct reference to racial discrimination and abuse committed by medical authorities and military forces. The performance ended with each of them raising their Andean skirts to unveil drawings of bleeding uteruses and phrases written on their legs: "My body is not your battlefield," "No one can touch your body," and "Not without my permission," explicitly signaled this impunity. This action, which was even featured on the front pages

NoSINmiPERMISO, *Mi cuerpo no es tu campo de batalla [My Body Is Not Your Battleground]*, 2011. Public intervention in the demonstration "With Hope and Dignity, Fujimori Never More" in Lima on May 26th. From left to right: Analucía Riveros, Eliana Solórzano, Carol Fernández, Alejandra Castro e Inés Jáuregui Vásquez.

of newspapers, has since been appropriated and repeated by hundreds of women in innumerable social mobilizations in recent years. A telling phrase has even been used by the youngest genera-tion: "We are the daughters of the peasants who they could not sterilize."

Underlining the racist and misogynistic logic, as well as the economic objectives that drove the creation of a sterilization program within the framework of a neoliberal economy, is crucial to understanding the instrumental role of women within the discourses of national progress and growth. As Christina Ewig observed, "Women were perceived as vessels whose reproductive capacities had to be controlled in order to serve the cause of economic development" (49–69), which meant, in many cases, reducing the growth of indigenous, Afro-descendent populations and that of people with low economic resources. This reminds us that the jurisdiction over bod-ies, in particular of the wombs of women, is in constant dispute by governmental, religious, legal, or economic entities (Preciado).

The interdependence between models of economic dispossession and sexual aggression is also evident when analyzing the history of Guatemala. Two years ago, 14 Q'eqchie women who were kidnapped and enslaved in the 1980s won a trial against former military officers for crimes committed in the Sepur Zarco's military detachment during the armed conflict. The verdict (February 26, 2016) marked a historic milestone: for the first time, a national court judged and condemned sexual slavery as a war crime in addition to the crimes of domestic slavery, the intentional disappearance of husbands, and others.[7]

One of the most impactful images during the trial was the presence of women with their heads and faces covered with Mayan *perrajes* due to fear of retaliation for their testimonies.[8] The aesthetic strength of their partially wrapped bodies, sitting side by side in court, was a power-ful affirmation of a communal fabric that had not been broken despite the violence enacted against them. Wrapping their bodies and faces with blankets can be interpreted, on the one hand, as a refusal to become figures of a public spectacle, indirectly affirming that grief is not

only individual but collective. On the other, covering their faces with Mayan blankets also meant taking shelter in the legacy, experience, and shared memory of the affections, energies, ties, and indigenous social relationships that colonial logics wanted to see disappear. As Maya K'iche' activist and sociologist Gladys Tzul rightly points out, "Being indigenous means that the Nation-State project did not succeed. . . . [I]f the nation-state does not succeed, this means that the territory is not unique, that the language is not unique and that there is not a single citizenship" ("Ser mujer y ser indígena").

In all three cases, humble symbols and everyday objects such as handkerchiefs, Andean skirts, or Mayan shawls served as markers of the history of political communities. The aesthetic potency of these elements lies in their capacity to activate memory and build spaces of recognition and empathy, emphasizing the history of bodies and populations that are constantly exposed to the colonial and patriarchal violence sustaining the modern national project.

Infiltrations

Some artistic research and feminist activist groups have dedicated their work to demonstrating how certain social disciplines have been built according to normative principles and have been looking for strategies to subvert their ways of functioning. For more than a decade, lawyer Elizabeth Vásquez has developed a "legal alternativisim" (or what she considers "alternative uses of law"), that is, the tactical use of law to find fissures, gaps, contradictions, and paradoxes in the legal system that allow one to challenge its oppressive structures ("Alternativismo").

Vásquez has developed various forms of infiltration and "subversive redesign" of the law in Ecuador. In 2004, she used the legal concept of the commercial contract to draw up a document

Photograph Ana Almeida. Courtesy Elizabeth Vásquez.

Hugo Vera and Joey Hateley (contracting parties) and Verónica Ormaza (judge) after celebrating the "First Gay Marriage" in Ecuador, 2010. An "alternative use of law" project conceived of by Elizabeth Vásquez, in collaboration with Ana Almeida, Proyecto Transgénero, and TransAction Theatre.

in which the stated "business" was a joint life and the common heritage between two people of the same sex. "From now on, and for the purposes of this contract, Messrs. Alex Carrillo and David Bermeo will be called the bride and groom," stated the first clause of the contract that she filed before a notary. Using the formal structure of commercial law, Vásquez introduced issues including inheritance, mutual assistance, and other aspects derived from the marital commitment. The final effect was to recognize the coexistence of both people, hack the protocols of the conservative familial institution, and subvert the exclusionary dimension of conventional law.

In another project titled *Legal Micro-Pluralism*, inspired by indigenous legal pluralism, Vásquez generated a parallel system of citizen identification. In 2009, in collaboration with the community of transgender sex workers in Quito, she put a "street citizenship card" into circulation—one that recognized gender and not sex, the preferred name and not the legal one—competing with official documents.[9] This document compelled there to be a different dialogue between gender nonbinary individuals and the representatives of the law, reducing the use of force, and introducing other ways of considering the attributions of name and identity.

This strategy was accompanied shortly after by a legislative reform project titled My Gender in My Identification Card (2012) that sought to substitute sex with gender in the Ecuadorian citizenship card.[10] The audiovisual spot campaign stirred up a broad public discussion about the right to self-determination for transgender communities. The media impact even caused the leftist president Rafael Correa to speak out against "gender ideology" in defense of the family. One of the results of the reform campaign was nevertheless the approval of the Organic Law on Identity and Civil Data Management in 2016, with which the transgender population in Ecuador can register their gender on their identification cards.

Subverting authority by using elements from various disciplines and institutions has also promoted projects such as the creation of the *Transvestite Museum of Peru*, founded in 2003 by the philosopher, drag queen, and activist Giuseppe Campuzano (1969–2013). This museum, created halfway between performance and historical research project, appropriates the languages of museology to propose a promiscuous rewriting of history from the strategic perspective of a fictional identity that Campuzano called the indigenous androgyne/mestizo transvestite (Campuzano 90–99).

One of their most ambitious projects was *Life Line* (2009–2013), a didactic counternarrative of transgender bodies through objects, images, texts, documents, press clippings, and appropriated works of art. The installation displayed reproductions of drawings by the indigenous chronicler Guamán Poma de Ayala made in the seventeenth century, depictions of Moche ceramics (S. V–VII CE), nineteenthcentury photographs of queer people, and androgynous masks from traditional Andean dances, among many other elements. The project aimed not only to collect these representations in order to reorganize the political genealogy of urban and indigenous sexual struggles but also to dramatize and stage the museum through actions and performances where all the characters of the exhibition come back to life to build new social choreographies.[11]

Following Gregg Bordowitz's critical reflections, the queer reenactment of the past "means the act of taking control of history by becoming its subject through repetition. Rather than producing a revolutionary break with history, the artist repeats moments of queer liberation over and over to the point where the past becomes an ever-present tense" (Bordowitz 25) These historical citations go beyond simply showcasing unclassifiable or nonnormative bodies; they "seek out the possibilities of 'becoming' within these experiences of inequality. It attests to the fact that these possibilities have not been completely colonized by the experience of violence and disempowerment" (Lorenz 56). Campuzano's *Transvestite Museum* resignifies official culture through a process in which those bodies that had been denied their human status acquire the possibility of being subjects of political enunciation and agents of knowledge production.

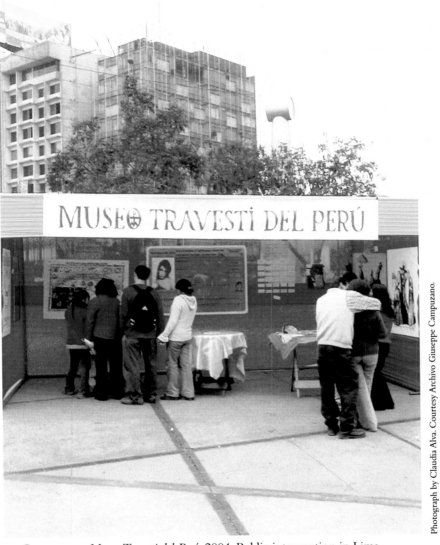

Photograph by Claudia Alva. Courtesy Archivo Giuseppe Campuzano.

Giuseppe Campuzano, *Museo Travesti del Perú*, 2004. Public intervention in Lima.

Using a similar strategy, the University Coordinator for Sexual Dissidence (CUDS) in Chile confronted the weaponizing of scientific discourse by making a series of interventions that critically explored biological conceptions of the fetus and its translation into images. In 2012, CUDS launched the fictional campaign For a Better Life: Donate for an Illegal Abortion, which consisted of videos on social networks, workshops, and public actions where the debate about abortion was parodied, along with the scientific language and representations employed by religious and "pro-life" groups. The fetus (and its nominal allusion as "a person" or "human being") has been one of the most recurrent images in conservative group marches, constructing a false analogy between abortion and murder. Thus the most controversial action of CUDS was a 2014

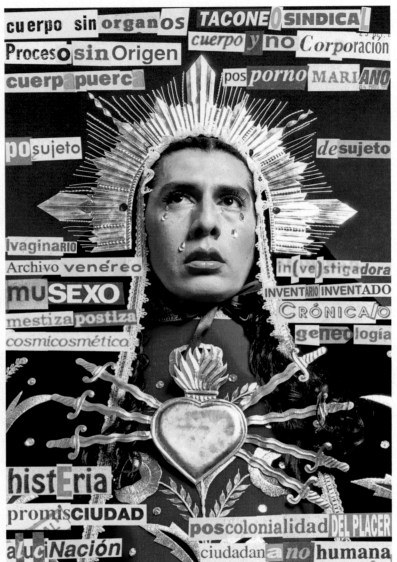

Giuseppe Campuzano, *Letanía*, 2012. Digital collage and screen print on paper, 50 x 30 cm.

Print Taller ÁÁ. Courtesy Archivo Giuseppe Campuzano.

intervention into precisely this visual imaginary: the group put up a series of posters in which the allegorical image of a fetus was accompanied by the phrase, "This is not a human being."

This intervention—for which they were later accused in the justice courts of "illicit association"—provocatively explored the intersections between scientific rhetoric, public policies, and the social perception of pregnant bodies. As the transfeminist biologist and member of CUDS Jorge Díaz pointed out, what was at stake was "a question of a philosophical nature: of life itself and the limits of humanity" (Díaz "Fetos falseados"). What relationship exists between the images that are presumed and affirmed as scientific and a heterosexual matrix that

Courtesy CUDS.

CUDS's *Dona por un aborto ilegal [Donate for an Illegal Abortion]*, Public intervention, Santiago de Chile, 2012.

is presented as unquestionable? When exactly does a set of cells receive the status of a life-form, and at what moment is it placed above the lives of women?

Several of these interventions have sought to introduce supplementary information to critically understand the construction of history and the implications of inhabiting a specific time and place within it. Commemorating International Women's Day (March 8, 2018) in Costa Rica, the collective Acá Estamos intervened on all the public statues of female figures in San José to share local data evidencing inequality and institutionalized violence.[12] "Less than 1% of all cases of street harassment are reported," "Of the 60% of women who graduate from university, only 30% are employed," "Three out of 4 women would prefer to work instead of being housewives," and "On average, one girl under 15 years gets pregnant every day," read some of the posters. Their appearance disputed the conservative common sense and the stereotyped view of Costa Rica as the "happiest country in the world." The collective used the monuments as a way to show a public sphere still under strict patriarchal control, especially considering that the few sculptures of women in the streets are anonymous, unlike the victorious images of heroic men who are clearly named (Soto Campos "Mujeres artistas").[13]

However, to agitate for women's lives and rights in public spaces is often unbearable for the patriarchal order. On September 30, 2018, Rodrigo Amorim and Daniel Silveira, two candidates for PSL (Social Liberal Party)—a conservative and far-right party in Brazil—removed a plaque in homage to sociologist and feminist activist Marielle Franco who was shot dead after attending a debate about empowering Black women in Brazil, titled "Young Black Women Moving Structures." On the eve of her killing, Franco had denounced that the death of artist and trans activist Matheusa Passareli earlier that week had again been a case of police brutality. The plaque,

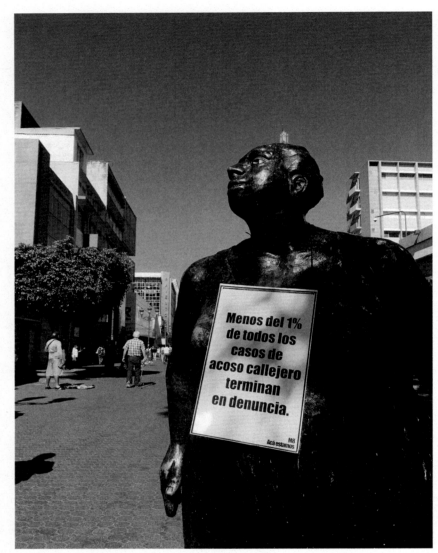

Photo and courtesy Sara Mata.

Acá Estamos (Marcela Araya, Gala Berger, Esteffany Carvajal, Longina León, Sara Mata, y Albertine Stahl), *La revolución será feminista o no será [The revolution willbe feminist or it will not be]*, Intervention in all public statues of female figures in San José, Costa Rica, 2018.

installed at the center of Rio de Janeiro, read "Marielle Franco Street (1979–2018). Councilor, defender of Human Rights and of minorities, cowardly murdered on March 14, 2018." The removal of the plaque of this Afro-Brazilian feminist councilor was an exhibitive gesture of the aforementioned "pedagogy of cruelty." Destroying the public homage to Franco's legacy made by activists and several of her sympathizers, once again removing her name from the public eye, was an attempt to determine for her and for many queer and Black bodies the condition of being doubly dead: the life that was taken away is also erased from public visibility, dispossessed of its right to be named and to generate spaces for mourning.

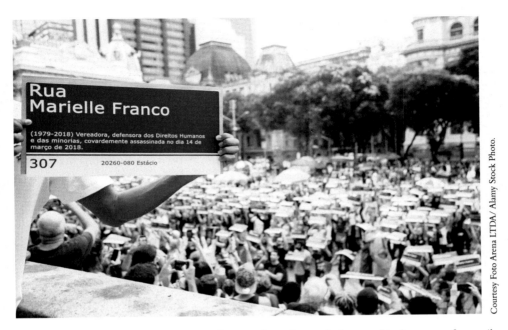

Rio De Janeiro, Brazil. 14th Oct, 2018. Distribution of one thousand plaques with the name of council woman Marielle Franco held at Cinelândia in Rio de Janeiro. Credit: PauloFernandes/FotoArena/Alamy Live News.

Two weeks later, on October 14, as a response to the inscription's destruction, a thousand ⸳commemorative plaques for "Marielle Franco Street" were distributed by demonstrators at Cinelândia in Rio de Janeiro. Those involved were also demanding answers from authorities about Franco's death, after seven months of investigations carried out in secrecy. Her assassination is interpreted by many human rights activists and organizations as "carefully planned, executed by people with professional/specialized training," and involving "some level of participation of state agents" (Medley).

Antagonistic forces

The creative strategies, public actions, representations, and visual formulations implement methodologies that interrupt the misogynist logic of contemporary society. They create bridges between activism and art, broadening the ways of understanding the horizon of an engaged culture. The actions have also put pressure on the administration of museums and cultural institutions in Latin America. The politicization of cultural debate driven by feminists has forced a critical revision of the patriarchal structures and power relations that dominate the art world and perpetuate inequality and abuse, demanding that they be made visible and publicly discussed. This was clearly stated by the Permanent Assembly of Women Art Workers from Argentina with the "We Propose" manifesto, a piercing declaration of commitment to feminist practices in art launched in November 2017. The intensification of queer activism and feminist art in recent years is growing from the margins of mainstream, institutional, artistic, and economic discourses. Queer activism and feminist art are revitalizing the possibilities of linking practices that sometimes are described as isolated and disconnected flashes. To contribute to building a transfeminist

genealogy of visual culture is to connect these episodes in order to claim art history as a haven of sorority, where powerful instances of listening and collective production trigger new antagonistic forces. Such an exercise demands, on the one hand, fracturing the privileged place of heterosexual, white, masculine subjectivity in the construction of history. On the other, it demands challenging the conventional patriarchal filters that sanction what is considered exemplary, valuable, and transcendent in cultural terms, in order to create new structures of valorization contrary to those of the normative, elite art world.

Against the threat of the privatization of life under the neoliberal-capitalist logic, the politics of feminism imagine new acts of disobedience and a pedagogy of emancipation. Their infiltration into public squares, school curriculums, museum displays, legal systems, and scientific spheres disrupts the movements of normalizing life and social practice. Their creative grammars are mobilizing spaces of experimentation, collective learning, and new aesthetic fictions that have the capacity of affecting, shifting, and even undoing the boundaries that set the norms that, in turn, produce subjectivities and regulate the social body.

Notes

1 This intervention was organized by Ni Una Menos, the National Campaign for Legal, Safe and Free Abortion, and more than 70 popular organizations (Trabajadoras del área de educación del Museo Nacional de Bellas Artes, Taller de Serigrafía Colectiva, Serigrafistas Queer, Poetas por el aborto legal, Mujeres Públicas, Mujeres de Artes Tomar (MAT), Mantera Feminista, Grupo de Arte Callejero (GAC), Colectiva Gráfica, among many others).

2 *Queermuseum. Cartografías da Diferença na Arte Brasileira*, one of the largest recent queer art exhibitions of Brazilian art, was unilaterally shut down by Santander Cultural in Porto Alegre, Brazil, after religious conservative critics accused it of promoting blasphemy and pedophilia. In their censorship statement, Santander Cultural accused the show of being disrespectful to "symbols, beliefs, and people" and not "generating positive reflection." The exhibition was curated by Gaudêncio Fidelis and featured 85 artists from the mid-twentieth century to today. A year later, the show was reopened in the galleries of Parque Lage in Rio de Janeiro, Brazil. For a critical analysis on the advance of right-wing groups in Brazil and recent censorship cases, see Duarte (ed. Londoño and Wouk Almino).

3 The Mothers of Plaza de Mayo initially wore cloth diapers that later became white handkerchiefs and headscarves. For a reflection about the productions of symbols by the Mothers of Plaza de Mayo, see Longoni.

4 One of the common military regime's practice regarding pregnant women detained by the dictatorship was kidnapping their newborn infants for adoption into Catholic families. To this day, the Grandmothers of Plaza de Mayo continue to search for their disappeared grandchildren, many of whom are unaware of their biological heritage.

5 The official name of this forced sterilization program was the National Reproductive Health and Family Planning Program. To this day, state authorities have remained indifferent and have not prosecuted this crime, which has contributed to the perpetuation of the impunity of the aggressors.

6 The Colectivo NoSINmiPERMISO consisted of Alejandra Castro, Carol Fernández, Inés Jáuregui, Analucía Riveros, and Eliana Solórzano. The march "With Hope and Dignity Fujimori Nevermore" was convened by the National Coordinator of Human Rights and various social and civic organizations in May 2011.

7 The sentences were of 120 and 240 years in prison for Francisco Reyes and Heriberto Valdéz, respectively.

8 The *perrajes* are also called rebozos, shawls, or blankets and are an important element in Mayan clothing.

9 This identity card also included a synthesis of constitutional articles that protect the rights of transgender sex workers. Related to this work, the photographic exhibition *Trans Civitas: From the Code of Street Families* intervened in the text of the Ecuadorian Civil Code, made in Quito in 2013.

10 This reform was promoted by the Ecuadorian Confederation of Trans and Intersex Communities (CONFETRANS), the Silhouette X Association, and the Transgender Project and was drafted by Elizabeth Vásquez.

11 For a more extensive analysis on this, see López.

12 The Acá Estamos collective is a community of women artists who have joined forces to generate a public debate on the problems of exclusion in their professional practices. It was founded by Marcela Araya, Gala Berger, Estefanny Carvajal Muñoz, Longina León, Albertine Stahl, and Sara Mata.

13 See Soto Campos.

Works cited

Almino, Elisa Wouk. "Far-Right Criticism Shuts Down Brazil's Largest Ever Queer Art Exhibition." *Hyperallergic*, 11 September 2017, https://hyperallergic.com/399883/far-right-santander-shuts-down-brazil-queer-art-exhibition/. Accessed 15 November 2018.

Bordowitz, Gregg. "Repetition and Change: The Film Installations of Pauline Boudry and Renate Lorenz." *Afterall*, no. 31, 2012, pp. 12–25.

Campuzano, Giuseppe. "De engendro fabuloso a performatividad creadora." *Saturday Night Thriller y otros escritos, 1998–2013*, edited by Miguel A. López. Estruendomudo, 2013, pp. 90–99.

Díaz, Jorge. "Fetos falseados y fetos emancipados: ciencia ficción feminista en la lucha por el aborto desde activismos queer en Chile." *Actuel Marx Intervenciones*, No. 24, 2018, pp. 57–73.

Duarte, Luisa, editor. *Arte censura liberdade. Reflexões à luz do presente*. Cobogó, 2018.

Londoño, Ernesto. "In Brazil, 'Queer Museum' Is Censored, Then Celebrated." *New York Times*, 26 August 2018, www.nytimes.com/2018/08/26/world/americas/queer-museum-rio-de-janeiro-brazil.html. Accessed 6 December 2018.

López, Miguel A. *Reality Can Suck My Dick, Darling. The Transvestite Museum of Peru and the Histories We Deserve*, edited by Mateo Luchetti and Judith Wielander. Kunsthaus Graz and Visible, 2013.

Ewig, Christina. "La economía política de las esterilizaciones forzadas en el Perú." *Memorias del caso peruano de esterilizaciones forzadas*, edited by Alejandra Ballón. Biblioteca Nacional del Perú, 2014, pp. 49–69.

Longoni, Ana. "Photographs and Silhouettes: Visual Politics in Argentina." *Afterall*, no. 25, Autumn/Winter 2010, pp. 5–17.

Lorenz, Renate. *Queer Art. A Freak Theory*. Transcript, 2012, p. 56.

Medley, Magdalena, "Who Killed Marielle Franco? Speaking Up against Violence and Impunity in Brazil." *Medium*, 27 November 2018, https://medium.com/@amnestyusa/who-killed-marielle-franco-speaking-up-against-violence-and-impunity-in-brazil-5a1d6b7b1e3. Accessed 29 July 2019.

Palmeiro, Cecilia. "The Latin American Green Tide: Desire and Feminist Transversality." *Journal of Latin American Cultural Studies*, 6 August 2018, https://medium.com/@j_lacs/the-latin-american-green-tide-desire-and-feminist-transversality-56e4b85856b2. Accessed 29 July 2019.

Preciado, [Paul] Beatriz. "Huelga de úteros." *Revista Números rojos*, diario *Público*, 29 January 2014., https://blogs.publico.es/numeros-rojos/2014/01/29/huelga-de-uteros/. Accessed 27 September 2018.

Romero, Ivana. "Tejiendo redes." *Página 12*, Buenos Aires, 3 August 2018. https://www.pagina12.com.ar/132545-tejiendo-redes.

Segato, Rita Laura. *La guerra contra las mujeres*. Traficantes de sueños, 2016.

Segato, Rita Laura. "A Manifesto in Four Themes." Trans. Ramsey McGlazer, *Critical Times*, vol. 1, no. 1, 2018, https://ctjournal.org/index.php/criticaltimes/article/view/29/26. Accesseded 16 November 2018.

Soto Campos, Carlos. "Mujeres artistas intervienen esculturas de San José para alzar la voz contra la desigualdad de género." *La Nación*, San José, 9 March 2018.

Tzul Tzul, Gladys. Gloria Muñoz Ramírez, "Ser mujer y ser indígena, un peligro en la Guatemala del despojo" (Interview with Gladys Tzul Tzul), *DesInformémonos*, Guatemala, 3 November 2013, https://desinformemonos.org/ser-mujer-y-ser-indigena-un-peligro-en-la-guatemala-del-despojo/. Accessed 29 September 2018.

Vásquez, Elizabeth. "Alternativismo: cinco conversaciones Arte—Derecho." *Women Out of Joint—Il femminismo è la mia festa*. Galleria Nazionale d'Arte Moderna e Contemporánea and IILA, 2018, pp. 14–15.

"WHEN I SPEAK, I SPEAK AS A COLLECTIVE"

Black collectives and activism in contemporary South African art

Athi Mongezeleli Joja

What are Black art collectivities today? What are their constituent features, political orientations, and aesthetic modes of practice today? Recently there has been cumulative interest, investigation, and research on Black collectives in the visual arts. This interest has been especially noted in shows like *Arte inVisible* (Ose) and the recent art conference Black Collectivities, which later published its proceedings in NKA journal (Copeland and Beckwich). Similarly, we've also seen various artist- and curator-led initiatives and platforms like this in Africa and its diaspora (Kouoh). The efforts explored in this piece are intermittent—not necessarily out of choice but as a recurrent challenge, even suspicion, incurred by anything "Black" in various discursive fields. It is also very rare to come across even the mildest account or relative clarification of what is often meant by the term "Black" in the couplet, Black collectivity. When it is not absented in liberal-leftist denunciations of race, Black collectivity registers as a tautological, if not oxymoronic duo whose "meanings" are always either elusive, co-opted, or expunged.

Such questions are posed with this rough and contradictory background in mind and will be explored by focusing on three recent (i.e., emerging in the last decade) art collectives based in South Africa, namely Gugulective, Burning Museum, and iQhiya Collective. In a country still racially fixed like South Africa, not only are white people the owners of the means of (cultural) production, but they are also the brokers of knowledge, whereby Black production is always either on the auction block or threatened by "the mark of deletion . . . cancelation and defacement" (Oguibe 17). While Black collectivities have remained historically uncharted art territory, the epistemological monopoly that Western theorization has on the concept and practice of collectivity is yet to catch discursive fire. In fact, in their introduction to the recently published volume *Collective Situations*, Bill Kelly Jr. and Grant Kester have observed that:

> The theoretical and methodological inheritances of Latin America are diverse as its people, yet the analysis of these art practices within the intellectual centers of the West has tended to "translate" Western critical theory and apply it to Latin American art without recognizing or investigating local communities, contexts, histories and practices.
>
> *(10)*

The aim of this essay is to introduce contemporary iterations of the historical Black collectivities in contemporary South African visual arts. Collectivism or collaborative practice in

94

South Africa has a considerably extensive genealogy that predates even Apartheid by at least a decade or so. While collectivism, as a term, has had an acceptable political resonance, collaboration, on the other hand, has tended to have a negative one; that is, it has been associated with treachery and cooperation with the police, the state, and so on (Kester 2). Responding to the political negotiations of the 1990s, scholar and anti-Apartheid activist Livingstone Mqotsi read collaboration as being consistent with the "watering down of the fundamental demands of the liberation movement" (5). These distinctions tended to be less emphasized in the art world before the 1970s in South Africa, as collectivism simply boiled down to "working together."

In the 1970s, the Black Consciousness Movement (BCM) began to reject nonracialism as a white ruse, used as a means to maintain an artificial collectivism. For Steve Biko, "hastily arranged integration" was tantamount to "expecting the slave to work together with the slave-master's son to remove all the conditions leading to the former's enslavement" (22). Blackness emerged as an articulation of a political position, as well as an existential condition of the racially oppressed communities.[1] Consequently, they not only deemphasized the binary between politics and art, always maintained as a strategic border within the arts, but they also refused any cooperation with white people. Emerging in the post–Sharpeville massacre era to fill the vacuum left by the imprisonment and forced exile of most Black intellectuals and activists, BCM not only forged a new sensibility built on (and at times against) that of its predecessors, but it also refused to submit to the previous order whereby the arts and cultures played second fiddle to an Anglicized politics. For BCM, "Its tool was culture itself, understood . . . as the ensemble of meaningful practices and uniformities of behavior through which self-defining groups within or across social classes express themselves" (Mzamane 193). Biko would later contest that "there is no place outside that fight for the artist or for the intellectual who is not himself concerned with, and completely at one with the people in the great battle of Africa and of suffering humanity" (35).

Ironically, the legal restraints of the Suppression of Communism Act actually forced cultural memory, echoing the global clamors of Negritude, Black Power militants, and other socialist coconspirators. Historical consciousness reinforced what Aimé Césaire described as to "seize our own past and, through the imaginary, grasp the intermittent flashing of our being" (15). This turn to history not only reinvigorated the systematically obliterated "past" but also brought to bear the unending cycles of racial subjection they too were existentially facing. Although the Black consciousness movement did not mean a reactionary repudiation of Western thought and its influence in Black discourse—or even belay the taking of white people's money—it did mean an exclusion of white participation from all the Black networks. As a retrospective critique of "white trusteeship," it took stock of the hegemonic roles played by white liberals and leftists alike at the psychological and programmatic levels in Black emancipatory politics in the historic instance. Furthermore, it debunked how the social edifice preyed on racially alienated subjects to reinstate the status quo, and, in so doing, Black collectivism in art took on a radical shift. Molefe Pheto, founder-member of Music, Drama, Arts and Literature Institute (MDALI) and Mihloti groups, reflects: "I decried apartheid in the arts, demanded that we Blacks determine our cause, recommended a disassociation from white artists and impresarios as long as the color last, and I spoke out on the exploitation of the Black artist by the white gallery owners" (11).

By virtue of this collective malaise, the relations between art and politics had to change, and solidarities had to be forged. Echoing the words artist Ernest Mancoba uttered decades before, that "art . . . was as urgent as working for political evolution" (Thompson 46), Pheto noted that "the time to stop differentiating between art, culture and politics had come" (17). Pallo Jordan might read this as reflecting a collectivist ethic already foundational to African thought and culture, reaching its apotheosis in anti-Apartheid collaborative art projects (2004). Therefore, it follows that the pursuit of freedom hinged on repurposing rather than jettisoning African thought

and its forms, thereby decolonizing it entirely. Rather than viewing precolonial forms as static, moribund, and ornamental objects—as antagonistic to, while also devoid of, the contemplative reach of high art—they challenged the very presuppositions of autonomy, critical distance, and its high-end aesthetic quietism proffered by the art establishment. They chose neither to relent to the regulated bohemian circumspection for white appeasement nor to resort to melancholic self-primitivizing nostalgia and self-pity. Moreover, this same decision also did not connote that the art object must be reduced to a pure didactic item, split between "formalism on the one side—contentism on the other," as Bertolt Brecht warned (Adorno et al. 71). Presciently writing from the political margins of the late the 1930s to mid-1940s, his "Masses and the Artist" dramatist H.I.E. Dhlomo, already suggested a more dialectical approach that the Black artist "has a social, as well as, an aesthetic responsibility to represent a group as well as personal experience. Great art is more than personal and nebulous aesthetic" (62).

Thus when Black collectivities insist on "self-determination, self-realization and self-support," as the 1975 issue of the *Black Review* noted, they are equally saying *no* to the "system of fragmentation, the tendency towards individualism, exclusiveness and isolation ... divide and rule" (Mnyele 300). As Boris Groys has stated in his take on the interest of activist art in present times, their point isn't simply to criticize art or its condition of possibility, but instead the artists want to change or overhaul the system without having to abandon art, as such. Black collectives in the 1970s had understood this. They introduced an array of unorthodox strategies oriented against the art establishment: like creating alternative sites of exhibiting art and publication, conducting workshops, adjudicating less standardized artistic styles, diverting to metaphysical topics, reintroducing the arts to Black communities, organizing intramural collaborations between various art media, and other self-organized initiatives. As Pheto concedes, these choices became a "sore thumb" both to the Security Branch and to white people equally, as it also meant a high risk for most Black artists.[2] Despite their larger objectives and connection to the larger movement, the functions differed from more administrative (The Culture Committee and MDALI) to education (Jazz Appreciation Society) to creative (Mihloti and Dashiki) collectives. Whether as experimental smaller and often ephemeral groups or formal structures, these initiatives tended to have an inter- and transmedial approach to arts and culture. These interartistic practices elaborated the collaborative ethos beyond dominant Western disciplinary strictures, undermining its individuating obsession with "the artist" and the verticality it induced within the struggle context. These activities went on for less than a decade, reaching their untimely relative demise in the wake of the Student Uprising in the late 1970s, due to imprisonment, banning, and exile. BCM gave in to a new decade and to a different collectivism, which returned to pre-1970s nonracialist politics through groups like Medu, Peace Parks, and others (Gibson). The 1970s art collectivities have remained interlopers in art historiography—an abyss between the 1960s and 1980s—situating them in discourse resonates with what Dhlomo called "literary necromancy" (1939, 37).

Collectivism after 1994

In the words of Brecht, "It will be evident" in the course of this section that we have "merely freed" ourselves "from grammar, not from capitalism" (Adorno et al. 73). Structurally, South Africa hasn't changed its inherited racial asymmetries but has, instead, as critic Lewis Nkosi said, "reconciled" us to the status quo. Needless to say, collaborative approaches have been popular, whether as loosely aligned individuals working together on a project basis, as fixed groups working together over a sustained period, or as more formalized alternative institutions. Hitherto, we have seen various groups and artist-led initiatives like The Trinity Session, Dead Revolutionary Club, Doing It for Daddy, Centre for Historical Reenactment, Tokolos Stencils, and so

on. Equally, a number of shows have been dedicated to collectivism as an artistic concept and socioeconomic imperative. At times, these modes can be indistinguishable in the way they discretely pervade one another (Stimson, 36). Artistically, collectivism remains relativized with its pre-1994 predecessors, while, socially, the attempt is to live up to "freedom dreams." Constitutionally, there's a moratorium against any racially exclusive formations, but despite injunctions on race and because of its omission of structural injustice and continued economic exclusion, racially polarized groupings are recursive (More 32). However, the onomastic monopoly over collectivism is primarily in service of "ruling class" interests and not necessarily of the "ruling party"—from nonracialism to rainbow nation, the patriotic "we" in our national discourse is enunciative of the status quo ante (Barchiesi).

In the West, scholars of collectivism have "periodized" the political flip-flopping as a decisively post World War II turn to the market, while others have challenged its wholesale generalizations (Stimson and Sholette, Sholette, Galimberti). Collectivism in contemporary art, it seems, has largely become an aesthetic mise-en-scene of its antecedent glories, what David Riff has called "the new Proletkult, but one bio-politically advantageous to the elite." Critiquing contemporary collaborative practices, left-wing Russian art group *Chto Delat?* has narrowed the problem not so much into dissolving artist–spectator relations but to a reluctance to problematize "relationality" itself. "Without clarifying what it is exactly that binds us in our relation," they write, "collectivity is easily repurposed for use by the status quo." Thus, they continue, "[W]e can no longer assume a direct link between radical politics and working collectively." In South Africa, an honest historicizing of this needs to start with the return to nonracialism in the 1980s, as the organizing principle of "all" other compromises. Lest we forget, in the late 1980s the debate about readiness for "freedom" not only laid ground for reactionary "ceasefire" postures but also systematic recultivation of the wedge between politics and art. These two moves had laid future grounds for thinking of race and protest arts that, according to Albie Sachs, "corresponds to this current phase in which a new South African nation is emerging" (19). Rather than assuming the revolutionary path that the liberation movement had idealized, Sachs's constitutionalist visions articulated a rights discourse "for every South African, without reference to race, language, ethnic origin or creed" (19). The foreclosure enacted by the collectivizing pronouns and adjectives have remained out of critical reach; "the culture of debate is perhaps more important than the debate of culture" (148). In a few light strokes, the sins of the "past" were not only shoddily addressed but were, as Adorno would say, even removed from memory (Adorno 89). White declarations became dogma!

Art collectives, such as Gugulective, Burning Museum, and iQhiya Collective, are some among a few that have remained "Black" first in terms of their group membership. They have also, in various contexts, drawn the explanatory power of their bewilderment with current realities from the "past," as if it is not past. Thinking simply on the basis of these two constituent elements, we can presumptuously characterize these groups as iterations of Black collectivities. Although there are spatiotemporal differences between the 1970s and now—that is, differences automatically necessitate each generation to think from the contradictory experiences of its loci—there are also echoes of shared larger concerns. Whether these echoes are aesthetic, ideological, strategic, or existential is neither here nor there. Writing about Gugulective, curator Gabi Ngcobo writes:

> What makes this collective relevant during this time is their awareness, not only of the past as a platform from which to engage present realities, but also of the lack of stability that this past affords the formulation of their identities as the younger generation. Any revolution demands an approach that seeks to challenge an overvalued past in order for it to find relevant content within its present realities.

> *(95)*

These words could have easily been written for Burning Museum or iQhiya. Gugulective first burst into the art public in 2007 with its show *Akuchanywa* (*No Pissing*) and *Akuchanywa Apha* (*No Pissing Here*), as part of Cape '07. The names of the show utilized signs from Kwa-Mlamli, a shebeen in the township of Gugulethu, where some of the members (including the author) hailed from and adopted its name. Gugulethu, ironically meaning "our pride," is a township (previously designated as Native Yards) located in the geographic fringes of Cape Town, "founded" in the wake of the 1960s forced removals as a labor reservoir. Created as ultimate repositories of Black labor, in which Black people would, at ungodly hours and in dangerous public transport, travel to the city for jobs, for shopping, and to even see their own art shows. Owing to the violent history of dispossession, exploitation, and alienation inalienable from Apartheid spatial configurations, Gugulective's decision to show exhibitions in the township, aimed at psychogeographically revealing the unthought of racialization of the very routes and itineraries of the art world. Kwa-Mlamli as a shebeen (local beer hole) and an exhibition space played into the historicist narrative of Black spaces, in which shebeens were dismissed off-the-cuff. Gugulective wanted to convey a different spatial consciousness about shebeens as places of cultural and intellectual generativity. The act of hosting exhibits, screenings, talks, book launches, residencies, debates, activist meetings, parties, and so on enlivened the space.

Gugulective consisted of a colorful palette of eight members, who were either visual artists, playwrights, poets, photographers, critics, and so on, namely Unathi Sigenu (late), Kemang Wa Lehulere, Zipho Dayile, Lonwabo Kilani, Khanyisile Mbongwa, Themba Tsotsi, Dathini Mzayiya, and myself. Gugulective went on to be shown in *Titled/Untitled* (2007), *Scratching the Surface* (2008), *Performing South Africa* (2008, Berlin), and many other shows locally and internationally. Its work strategies differed from show to show, depending on various things. In certain shows, members individually contributed pieces and in other instances collectively authored artworks like *Building in the Man* (2008), *Ityala Aliboli/Debt Don't Rot* (2010), or *The Last Supper* (2014). Though individually, Gugulective members make different things, the dominant media in their work has largely included installations, performance, and interventions like staging the symbolic

Members of Gugulective left to right: Lonwabo Kilani, Dathini Mzayiya, Khanyisile Mbongwa, Zipho Dayile, Kemang Wa Lehulere and Athi Mongezeleli Joja.

Courtesy Gugulective.

toppling of a Cecil John Rhodes statue in the Company's Gardens, Cape Town, in 2010 (five years before the student protests). Though space arguably took precedent by its recursive feature in much of its conceptual outlook and works, Gugulective refused to play into the fetishistic obsessions of the art establishment beginning to enjoy the trips to the ghetto.

The anachronistic coarticulation of the past and/in the present is seen in Gugulective's projects, such as in *Building in the Man*, in which an old hostel room of the "migrant laborer" is built on the wall that the viewer sees from an aerial view; or in the series *Ityala Aliboli*, which attempted a critical response to the 2008 economic crush. The series shows figures (and their doubles) standing in queues, and the image is imposed on Apartheid cash notes. The concept Ityala Aliboli is a traditional isiXhosa idiom expressing that "an injustice that endures in the historical memory of the injured is never erased merely because of the passage of time" (Ramose). Following on the frenzy of "the crash," the pieces stage an internal response of how finance capital not only organizes and bails itself out of its failures but also repeatedly, as Chakravartty and da Silva note, "profit from unpayable loans *without* debtors" (367).

The concept of "unplayable debts" isn't necessarily a rationalization of the indebtedness of the racialized subject to capital but rather of the impossibility of paying the debt she or he is owed by centuries of countless acts of exploitation and dispossession. Emerging between two events that symbolically and existentially helped foster a critical public on the cyclic histories of colonial terror—the 2012 massacre of miners in Marikana and the 2013 centenary of the Native Land Act of 1913—Burning Museum's intervention also had much to do with the "past." As a collaborative art group, Burning Museum includes Justin Davy, Jarrett Erasmus, Tazneem Wentzel, Grant Jurius, and Scott Williams, a group consisting of visual artists, curators, DJs, archivists, and others. Its early work was centered on photographic and archival material largely connected to the histories of the dispossession-resistance of District Six from the late 1960s. Later works of the collective have turned into more contemporaneous and topical themes like gentrification, land dispossession, education, and institutionalized racism which have been shown locally and internationally. Contrary to what its name might suggest, Burning Museum's interventions, much like Gugulective, are not dogmatically against institutional participation, redress, or critique.

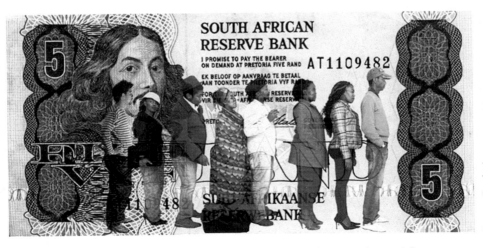

Gugulective, *Half (Ngubo) Tiger* in the series *Ityala Aliboli*, 2010. Digital print in pigment inks on cotton rag paper, 52 x 99 cm, edition of 6.

Historically, the visual appearance of the Black body in museum archives has overwhelmingly comprised problematic forms that have been central to the construction of racist typologies; bodies unceremoniously represented, beheaded, pickled, taunted, and so on, either in the course of colonial expects' attempts at experimenting, researching, or simply enjoying alterity. In an act of creative manumission, Burning Museum returns to the archive—that is, to the museum's fossilization of terror without end or limits—opens it, and publicly forces us to bear witness to the historicity of racial pain, across the city, particularly in the areas designated for "coloureds" by the Apartheid racial classification laws.

However, it is not clear why Burning Museum hasn't either enlarged images of Africans or ventured into the townships to plaster a few posters, as the same people share the same history. The pictures themselves are mainly photocopies of enlarged black-and-white portraits of individuals who once resided in District Six and, at times, written materials that are magnified and placed relatively site specifically. These places in which we encounter these figures, sometimes untitled and nameless, are often daringly public and yet so random: walls of discrete bridges, creased facades of debilitated factories, graffitied exteriors of train carriages, exhibitions, and so on. Despite the simplicity of the materials used (wheat paste and enlarged photostats), their quiet utterances and affective visuality palpably invoke what poet Mxolisi Nyezwa once beautifully described as "the despondent color of wounds." Daniel Hewson and Ashraf Jamal have argued that Burning Museum's plaster technique draws from the 1980s' protest movement to underscore continuing acts of inequality, an observation we can hardly deny. On the other hand, Tim Leibbrandt has associated the group with Chantal Mouffe's concept of "agonism." In the main, both positions are suggestive of the revelatory urges and urgencies of Mouffe's agonistic aesthetics, as it consists in "making visible what the dominant consensus tends to obscure and obliterate, in giving a voice to all those who are silenced within the framework of the existing hegemony" (93).

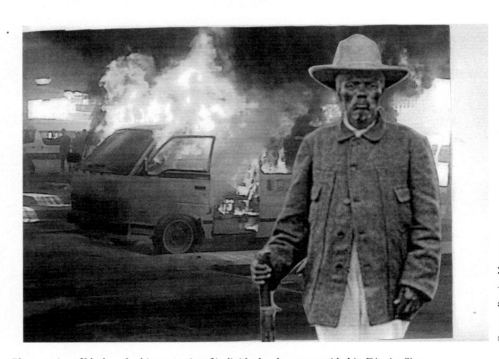

Courtesy Burning Museum.

Photocopies of black and white portraits of individuals who once resided in District Six.

Of course, there's much to be said about inside/outside binary, in which Black people always already occupy what Patricia Hill Collins famously termed an "outsider within" position (S14). In 2014, in a group show titled *Do It!* at Michaelis Gallery, Cape Town, curated by Hans Ulrich Obrist, they were prompted to respond to a brief from Yoko Ono to "make a wish and write it down on a piece of paper." The collective enlarged a fake posthumous honorary doctorate

UNIVERSITY OF CAPE TOWN

we certify that

Peter Clarke

was awarded the degree

Honorary Doctorate in Fine Art

on 4 September 2014

'It's the least we could do!'

Vice-Chancellor Registrar

Burning Museum, as the University of Cape Town, awards Peter Clarke an honorary doctorate as part of the exhibition *Do It!* at the Michaelis Gallery, 2014.

certificate to the artist Peter Clarke, who had recently died. Midway, the certificate credited to University of Cape Town (UCT), read, "It's the least we could do!" The gesture of this intervention, properly agonistic in its interestedness in institutional change, satirized UCT's oversight when it comes to recognizing Black achievers. Equally, being included or even recognized has its own problems.

The call for institutional accounting and change has been similarly central to the all-Black female collective, iQhiya. The originally 11-membered collective emerged in the throes of the #RhodesMustFall student insurgency that began when a few students poured human excrement on the UCT statue of colonial mogul, Cecil John Rhodes. The equally diverse and dynamic ensemble of scholars of the arts, dabbling in arts writing, visual artists, new media, sculpture, performance, and so on is comprised of Thandiwe Msebenzi, Bronwyn Katz, Lungiswa Gqunta, Buhlebezwe Siwani, Bonolo Kavula, Asemahle Ntlonti, Charity Matlhogonolo Kelapile, Pinky Mayeng (late), Sethembile Msezane, Thuli Gamedze, and Sisipho Ngodwana. Iqhiya is an isiXhosa term for the head wrap largely worn by married women in modern South Africa. It has been both an item of patriarchal imposition, as well as one that also conjures images of Black womanhood. Its use of the term is predicated on weaponizing the subject position of Black female existentiality, caught up in the throes of racial, sexual, and institutional exclusionary practices. IQhiya is perhaps the first Black female art collective whose growing prominence isn't symptomatic of a benevolence of the art world but of a relentless, collective feminist chastisement of the status quo.

The art world has, for the longest time, treated Black female artists as personas non grata and as mere artisans lurking in the shadows of cultural production, to be exploited as "crafters" that are undervalorized. iQhiya's forceful burst—with its pervasiveness in the critical discourse of not only "women in art" but in the national discourses on race and landlessness—have become critical disouce and the national discourse. Their works have been shown in various galleries like

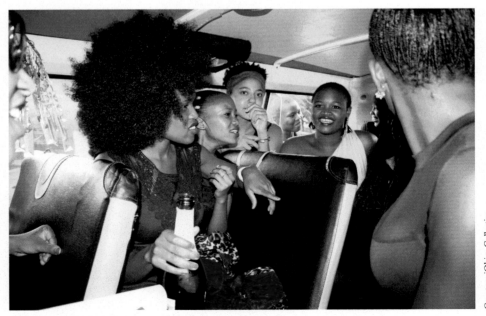

Courtesy iQhiya Collective.

iQhiya Collective, *The Commute (II)*, 2016.

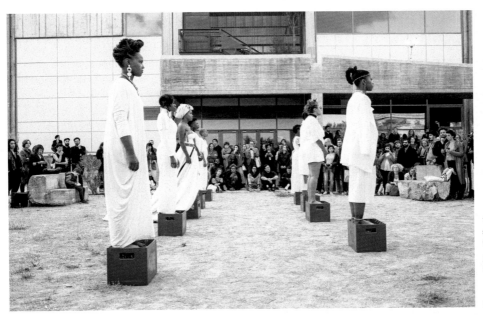

Courtesy iQhiya Collective.

iQhiya Collective, *The Portrait*, 2016.

the Association of Visual Arts (AVA) and have also participated in internationally renowned plat-forms like Documenta 14, Athens. Like the Gugulective and Burning Museum, iQhiya is also preoccupied with the strangulatory ways in which the "past" remains to inform and reform itself in how it treats particular bodies. The concept and realities of the Black female body remain a central locus of critical reflectivity to which their various public interventions and performances repeatedly return. Though the Black female body might appear as irreducible to politics of land dispossession immediately pervading the preceding collectives, if we think historically and criti-cally, the Black female body is the apogee of this dispossession. Historically, as Lauretta Ngcobo has shown, women were not only the missing link in the discourses of dispossession but were, by colonial law, interdicted from owning land and therefore their bodies. Critically, the centrality of the body, whether as female corporeality and/or knowledge production, has therefore been repeatedly turned into a vassal, or genie, that could be roughly conjured at a whim or else. The performance pieces *The Commute (II)* (2016) and *The Portrait* (2016) have articulated these posi-tions with seriousness and creativity, by way of retrospective bringing into our public realms the images unwelcome by our conservative society.

Conclusion

The center of this exercise hinged on recuperating critical iterations of Black collectivities in the current South African art context. By recuperating, I meant how these groups, knowingly or not, were inflected, suggestive or even symptomatic of the historical Black collectives. The absence of a larger political movement to serve as an ideological support system has made the prospects of radical art generally and collectives, in particular, tenuous and easily co-opted. Thus these cursory notes on art collectives served only as an attempt to situate a historical tendency or resonances in contemporary formations by pointing to disregarded features, which in turn are

central to Black radicalism. Mouffe's briefly noted notion of "agonism," as opposed to a full-on anti-Apartheid antagonism, is perhaps conceptually exemplary of flickers of a distant radicalism. Crossing or occupying the lines between criticality and activism have been hard to negotiate in post-1994 artistic space since the latter demanded more than the usual show-face courtesy that tends to do in mass rallies. Thinking of the resultant impact of the institution and institutionalization on art collectives, I want to close this essay with Gerald Raunig's words:

> Critique, and especially institutional critique, is not exhausted in denouncing abuses nor in withdrawing into more or less radical self-questioning. In terms of the art field, this means that neither the belligerent strategies of the institutional critique of the 1970s nor art as a service to the institution in the 1990s promise effective intervention in the governmentality of the present.
>
> *(10)*

As a way out, which is also to say in, Raunig suggests that artists must betray "the rules of the game through the act of flight: 'transforming the arts of governing'" (11). I want to read this betrayal to mean disregarding the injunctions that separate art and the political fields that have become commonplace to South African cultural discourse. "Flight" mustn't be thought of as utopic leaps into a sanctuary elsewhere but as politicization of cultural practice, a means of capturing the cudgels and positioning our collective practices against structural and institutional oppressions.

Notes

1 I use the term "Black" here in its inclusive sense as was used by the Black Consciousness Movement, that is, inclusive of Africans, Coloureds, and Indians.
2 After the security branch had woken up to the idea of politicised actions of the BCM, it had started threatening its members with arrest more frequently. For example, one of its prominent leaders Steve Biko was banned in 1973, restricted only to the confines of the semirural district of Ginsburg. In his autobiography, *And Night Fell*, Pheto opens with his arrest by the security police composed of Black cops, who also doubled as spies. He was picked up, at home, in the middle of the night after they had concluded preparations and planning for the third annual festival of the Black Arts. "This organization," wrote Pheto about Mdali, "had become a sore thumb in the eyes of the police because it exposed the exploitation of Black artists by white impresarios in South Africa. . . . It was Mdali which, for the first time in South Africa, used the words 'Black Arts' aggressively and positively to inspire action towards liberation" (16). For further details on the political precarities of Black artists in South Africa, see Peffer and Hill.

Works cited

Adorno, Theodor. *Critical Models: Interventions and Catchwords*. Columbia University Press, 2005.
Adorno, Theodor, Walter Benjamin, et al. *Aesthetics and Politics*. NLB, 1977. Verso, 2007.
African Noise Foundation, Blues Notes for Bra' Geoff, film, 58', 2009.
Barchiesi, Franco. "The Problem with "We": Affiliation, Political Economy, and the Counterhistory of Non Racialism." *Ties That Bind: Race and the Politics of Friendship in South Africa*, edited by Jon Soske and Shannon Walsh. Wits University Press, 2016, pp. 125–165.
Biko, Steve. *I Write What I Like: Selected Writings*. Picador Africa, 2004.
Césaire, Aimé. "What Is Negritude to Me." *African Presence in the Americas*, edited by Carlos Moore. Africa World Press, 1995.
Chakravartty, Paula, and Denise Ferreira da Silva. "Accumulation, Dispossession, and Debt: The Racial Logic of Global Capitalism—An Introduction." *American Quarterly*, vol. 64, no. 3, September 2012, pp. 361–385.
Chto Delat? *Back to School: A Chto Delat? Reader Performative Education*. Self-published, 2015.
Copeland, Huey, and Bechwich Naomi, editors. *Black Collectivities*. NKA: *Journal of Contemporary African Art*, no. 34, 2014.

Dhlomo, H.I.E. "Masses and the Artist." *English in Africa*, vol. 4, no. 2, September 1977, pp. 61–62.

Dhlomo, H.I.E. "Why Study Tribal Dramatic Forms?" *English in Africa*, vol. 4, no. 2, September 1977, pp. 37–42.

Galimberti, Jacopo. *Individuals against Individualism: Art Collectivism in Western Europe (1956–1969)*. Liverpool University Press, 2017.

Gibson, Nigel. "Black Consciousness after Biko: The Dialectics of Liberation in South Africa, 1977–1987." *Biko Lives! Contesting the Legacies of Steve Biko*, edited by Andile Mngxitama, et al. Palgrave MacMillan, 2008, pp. 129–155.

Groys, Boris. "On Art Activism." *e-flux journal*, no. 56, June 2014, www.e-flux.com/journal/56/60343/on-art-activism/. Accessed 10 December 2018.

Hill, Shannon. *Biko's Ghost: The Iconography of Black Consciousness*. University of Minnesota Press, 2015.

Hill Collins, Patricia. "Learning from the Outsider Within: The Sociological Importance of Black Feminist Thought." *Social Problems*, vol. 33, no. 6, Fall 1986, pp. S14–S32.

Jordan, Pallo. "Foreword." *Tales from Southern Africa*, by A.C. Jordan. University of California Press, 1978.

Kelly, Bill, and Grant Kester. *Collective Situations: Readings in Contemporary Latin American Art, 1995–2000*. Duke University Press, 2017.

Kester, Grant. *The One and the Many: Contemporary Collaborative Art in a Global Context*. Duke University Press, 2011.

Kouoh, Koyo, editor. *Condition Report: Symposium on Building Art Institutions in Africa*. Hatze Cantz, 2012.

Mnyele, Thami. *Thoughts on Bongiwe and the Role of Revolutionary Art. In Tens Years of Staffrider, 1978–1988*, edited by Andries Walter Oliphant and Ivan Vladislavic. Ravan Press, 1988.

More, Mabogo. "Black Solidarity: A Philosophical Defense." *Theoria: A Journal of Social and Political Theory*, vol. 56, no. 120, 2009.

Mpakathi, Geoff. *Blue Notes for Bra' Geoff*. African Noise Foundation, 2009.

Mqotsi, Livingstone. "Non-Collaboration Not Negotiation." *APDUSA Views*, no. 34, 1990.

Mouffe, Chantal. *Agonistics: Thinking the World Politically*. Verso, 2013.

Mzamane, Mbulelo. "The Impact of Black Consciousness on Culture." *Bounds of Possibility: The Legacy of Steve Biko & Black Consciousness*, edited by Barney Pityana et al. Zed Books, 1988.

Ngcobo, Gabi. "I Have Your Back: Notes on Collaborative Strategies in South Africa and Beyond." *Arte Invisible*, edited by Elvira Dyangani Ose. Arco, 2009.

Ngcobo, Lauretta. "African Motherhood—Myth and Reality." *African Literature: An Anthology of Criticism and Theory*, edited by Tejumola Olaniyan and Ato Quayson. John Wiley & Sons, 2007.

Nkosi, Lewis. "The Ideology of Reconciliation: Its Effects in South African Culture." *Writing Home: Lewis Nkosi on South African Writing*, edited by Linda Stiebel and Michael Chapman. UKZN Press, 2016.

Nyezwa, Mxolisi. *Malikhanye*. Deep South Press, 2011.

Oguibe, Olu. "Art, Identity, Boundary: Postmodernism and Contemporary African Art." *Reading the Contemporary: African Art from Theory to the Marketplace*, edited by Olu Oguibe and Okwui Enwezor. inIVA, 1999, pp. 17–29.

Ose, Elvira Dyangani, editor. *Arte in Visible*. Arco, 2009.

Peffer, John. *Art and the End of Apartheid*. University of Minnesota, 2009.

Pheto, Molefe. *And Night Fell: Memoirs of a Political Prisoner in South Africa*. Allison & Busby, 1983.

Ramose, Mogobe B. "An African Perspective on Justice and Race." *Polylog: Forum for Intercultural Philosophy*, no. 2, 2001, pp. 1–27.

Raunig, Gerald. "Instituent Practices: Fleeing, Instituting, Transforming." *Art and Contemporary Critical Practice: Reinventing Institutional Critique*, edited by Gerald Raunig and Gene Ray. Mayflybooks, 2009.

Riff, David. "When Art Once again Becomes Useful." *What Is the Use of Art? Newspaper Chto Delat?*, no. 1–25, March 2009, p. 14.

Sachs, Albie. "Preparing Ourselves for Freedom." *Spring Is Rebellious: Arguments about Cultural Freedom*, by Albie Sachs and Respondents, edited by Ingrid de Kok and Karen Press. Buchu Books, 1990.

Sholette, Gregory. "From Radical Solidarity to "Whatever" Collectivism: Some Thoughts on Political Art and the Rise of Post-Fordist Enterprise Culture." *The Name of Art*, edited by K. Schneller and V. Theodoropoulou. Publications de la Sorbonne, 2013.

Stimson, Blake. "The Form of the Informal." *Black Collectivities*, edited by Huey Copeland and Naomi Beckwich. Duke University Press, 2014.

Stimson, Blake, and Gregory Sholette, editors. *Collectivism after Modernism: The Art of Social Imagination after 1945*. University of Minnesota Press, 2007.

Thompson, Bridget. *In the Name of All Humanity: The African Spiritual Expression of Ernest Mancoba*. Art and Ubuntu Trust, 2006.

BECOMING

In search of the social artists, locating their environments, reorienting the planet

Grace Samboh

How do artists work with people? How do artists work with many people? What do the people who work with these artists think about the work? Does the fact that they are artists matter to these people? What makes being an artist different from other (social) professions? Is the difference acknowledged? Is the difference fundamental? Does it have to be different? For almost a decade, this line of questioning has been in the back of my mind.

When I started reading back in history, it seemed that people were thinking along these same lines throughout different periods of time.

The eighties, in continuation of the seventies, suppressed rebels

Both Semsar and Moelyono[1] were trained in fine arts, the former in sculpture and the latter in painting, and before I move on to a discussion of the eighties, I would like to mark one of Semsar's exhibitions that was held in Cemeti Contemporary Art Gallery in March 1998 titled *The Eco Seeds Action*. I am placing this exhibition here, as it connects deeply to what I will be laying out in the context of the social artists' practices of the eighties rather than to the heat of the *Reformasi* of the 1990s. In his statement released by the gallery, Semsar said that the idea for the piece actually developed in 1987, when he started to randomly pick seeds from plants on the streets and spread them to streets without plants. Not long after, he recognized that the seeds he had thrown had grown. So he started to do this more often and with fruit seeds rather than flowers'. By January 1993, he'd started naming this activity *The Eco Seeds Action*.

Semsar saw how simple it was for plants to grow, how they made themselves sufficient and—even if humans eat them—how they managed to keep growing. However much the population of humans increased, these trees managed to remain. In 1997, Semsar started thinking of the limitations of space in which these trees could grow. He started inviting the people who eat the fruits to throw the seeds into whatever available piece of soil that they encounter. Soon after he started this, he realized that it should not be limited to seeds of plants but should also include seeds of hope for a better future (Siahaan). This understanding of the (living) environment is the best way to connect to what is simply dubbed as *seni lingkungan*, which was never a big movement but had particularly important occurrences during the seventies and eighties. *Seni lingkungan* can literally be translated as "environmental art," but in the practice of the artists I am

speaking about and in the context that they were living in, it also encompasses community art, outdoor art, street art, body art, performance art, process art, conceptual art, land art, and, finally, contemporary art at large. But, more importantly, it addresses and involves the society around which the work was situated, made, and exhibited.[2] The necessity to label them as "environmental artists" at the time was due to be the opposition of the limited kinds of (fine) arts that were exhibited indoor and made under the label "modern art." I again used quotes for the latter term because, in those times, it was used to address the kind of practices that were taught through the existing art institutions that were using the New Order regime's curriculum and directive toward the so-called national identity. The arts and cultural role in this was limited to the creation of the symbolization of that national identity.[3]

In 1980, artist Gendut Riyanto (1955–2003), along with his friends (unfortunately they remain unknown to this date), created an installation on one of the rice fields in the south side of Yogyakarta. An established art critic from Jakarta, Agus Dermawan T., wrote about it in the biggest national newspaper at the time. He wrote:

> Gendut Riyanto and his friends "played" with the (rice) fields. In their aspirations, nature is an aesthetic medium. They hinted upon the necessity of art being functional, especially in our times now. By functional, I meant that [their] art does have immediate function towards nature. . . . Gendut and his friends did make a different kind of art. They really used the natural energies and circumstances to secure the nature itself. This is a high moral standard for the arts. And, this particular is the kind of beauty that the rice field owner can feel once they are harvesting. . . . We shouldn't mark this as the beginning of these kinds of art. But, at least there definitely is the consciousness that art needs to be more than just a social critic, however sharp or deep it is.

Gendut and friends' work did not come out of nowhere. In 1982, there was an exhibition titled *Seni Lingkungan* held by the Nature-Lover Club of the Indonesian Institute of Art of Yogyakarta (ASRI/ISI Yogyakarta). The catalog numbered this exhibition as the sixth. A letter from artist Bonyong Munni Ardhi to painter Nashar, dated September 6, 1979, also mentioned the artist's experimental installation at the Parangtritis Beach.[4] In the Jakarta Arts Center Taman Ismail Marzuki, October 12–15, 1979, there was a performance by dancer-cum-choreographer Sardono W. Kusumo. Titled *Meta Ekologi*, the performance involved 16 trucks of mud that later on would cover all the performers. An experimental film was also made by Gotot Prakosa as an attempt to enter into a dialogue with the ecology of earth and water. The film depicted dancers immersing themselves in a rice paddy field, walking and tangling with one another and wearing the weight and texture of mud on their bodies. Outside of these art instances and happenings, it is also important to note that concerns regarding environmental problems did grow quickly within the decade after Greenpeace was initiated. These and many other cultural instances of the seventies contributed to the growing environmental art movement of the next decade.

By 1980, the very first nongovernmental organization in Indonesia, Wahana Lingkungan Hidup (WALHI, *Means of Environment*), was initiated with the support of Sultan Hamengkubuwono IX, governor of Yogyakarta Special Region and ex–vice president of Indonesia; Emil Salim, minister of environment; Tjokropranolo, governor of Jakarta Special Region; and Erna Witoelar, minister of human settlements and regional development. By 1985, this organization had worked with artists including Gendut, Moelyono, Bonyong Munni Ardi, Haris Purnomo, and FX Harsono on the topic of environmental issues in the exhibition titled *Process 85*. This exhibition was rather an exercise of making works that were not to be seen in an indoor space, in a gallery setting, in a white cube sterile from its environment.

Anusapati's work, for example, was an installation of used zinc cut into the shape of birds and installed with different heights using twigs that were found on site. These zinc birds then generated changing shadows on the sands of the beach, depending on the time of day. Sometimes, their shadows would multiply. To this day, Anusapati is known to work mainly with wood but never with wood that is bought or killed in order to become his work; he uses either used or dying woods, as if he needed to give the wood one last chance to function on this planet, to become beautiful ("PLANTSCAPE"). When asked, why he worked with zinc in the seventies, Anusapati's answer indicated the spirit of experimentation at the time:

> Because there was a budget from the art school! The idea of exhibiting in nature was not thought through! I mean, who were we exhibiting for, anyway? Back then, nobody lives in Parangtritis beach, unlike now. Most likely, we were exhibiting for the hippie tourists or youngsters like us. . . . We were really thinking of what was being said by street food sellers around the beach, at the time.

I mention this example because I want to point out the social aspect of this experimentation. As Anusapati mentioned, these artists had the privilege of time to make their work. With this privilege, they chose to talk to people who may potentially be their audience, and they chose to make something that these people would understand or at least connect to.

Together with FX Harsono and Winardi, Gendut criticized the way their seniors—particularly their lecturers' generation—situated art practice. He quoted the most influential lecturer of the Jogja art school at the time, Fajar Sidik, from a recent discussion session: "Art as an expression is when the artist dare[s] enough to look at the world with their own eyes, with the consciousness of freeing themselves from its social ties and traditions, therefore building their own relationship with their object. Free from the existing traditions and values." For the younger generation, this—art that relieves itself from its social norms and values—could only end up as self-satisfactory or eye-pleasing objects. This kind of art does not consider its audience, let alone the society in which their objects belong. In this case, artworks simply become the substitution of the artists' obsession. They were sure that they did not want the kinds of art that "escapes" its social responsibility. They had created a formula in which art can involve the society, at the very least, where the object/subject came from and those who are looking or interacting with the art. They were the forms of art that assumed equality at least between the artists, the makers, and the audiences, the viewers, as everyone is a part of distinct societies (Harsono et al. 42–45).

In 1983, in a small village called Tulungagung, Moelyono made a work exemplary of these values. On top of a small hill that is mythologized by many different kingdoms of the past—including Majapahit and Mataram—Moelyono installed a *cikrak* (rattan trash basket) upside down. One can see this as a joke that the myths are trash, or one can also forget that it is a *cikrak* and consider it simply as a hat, particularly because the hill is known by the name of a person, *Joko Budeg.* In Moelyono's technical notes, he writes that the *cikrak's* diameter was 11 meters. This means that, had he made it alone, it would have taken months. And had he installed it alone, it would have taken a highly skilled mountaineer to assist.

When Moelyono first had the idea, he approached the elderly man known as the gatekeeper of the hill and asked for his permission to do so, as well as to make the *cikrak* in his garden, closer to the top of the hill. He was allowed, and once he started, the villagers around him helped him whenever they had time, without much questioning. It is part of village life wherein, when you see someone working, you help when you can. Naturally, at some point, you would need their help too. No one was helping with the project for conceptual reasons but for work—and

Courtesy Indonesian Visual Art Archive.

Moelyono's Joko Budeg Project: Legend Dialogue, 1983.

the sharing of work—itself. It took him no longer than a week to finish this. When it came to installing, he asked his mountaineer friend from art school to help. Fully prepared, acting as a professional, the friend came prepared to install it on his own. During the process of raising this *cikrak*, little children started to sit down, clap their hands whenever one big step of the climbing process was done, hold their breaths, and exclaim as if it was a show. I assumed he could have done the installation himself. But some people from another nearby village, who were not part of the making of the *cikrak*, saw this activity from afar and decided that they would use their free time to help. Well, it is, after all, a hill.

From kilometers away, you could also have seen this rather silly activity: trying to put a useless, huge thing on top of a hill. Two men came to help. They literally hopped from one tree to another to reach the top of the hill. The children were laughing as it seemed so effortless in comparison to the mountaineer with so much technology attached to him. Very quickly, the *cikrak* was installed; everybody clapped their hands and went home. In two weeks, Moelyono heard that several villages were hosting festivals to welcome *Joko Budeg*, to celebrate his return. Local newspapers were also spreading speculations on this "hat." To those not involved in making the *cikrak*, it had become a hat. In retrospect, this was the point in time when Moelyono was sure that art does not have to be in galleries or in art schools (Moelyono).[5] This was the point where he learned that his art can affect people. Since then, he had assigned himself to work with the people, as the people. In his words:

> Artists who refuse the dichotomy between Subject and Object, or the gap between the artist (the subject who reveals an issue) and the owner of the issue (the object that is dealt by the revealer) have to be dialogical. Artist and the people (of whom the artist speak for/with) need to be together in facing the same social issue.... The way to do it is (as an artist) by taking the stance as a subject and at the same time treating the people equally as subjects. As subjects, these people too have potentials, aspiration, and their own critical mechanism in facing indifferences. By creating these chances, people can then articulate their own issues through the arts yet with their own ways.
>
> *(Moelyono)*

In 1988, Siti Adiyati wrote a review of Moelyono's exhibition with an intriguing title: "Art (for) Consciousness." She began with questioning the title of the exhibition, *Exhibition of the Dialogical Transformative Art*. "Why is it so unfamiliar, so difficult to understand?" She began with describing the show that brought actual artifacts from the homes of the fishermen community that Moelyono had been working with in Brumbun and Nglanggeran Beach. Surrounding the installation that situated their homes, their domestic lives, were many drawings made by children. These children were, in fact, Moelyono's biggest concern. He introduced himself as someone who could draw; therefore the village announced him as Mr. Drawing Teacher and immediately gave him the chance to teach in their elementary school. The drawings depicted their daily encounters, from particular conversations on fishing gear to neighborhood gossip. The drawings were also full of text, as if the images couldn't tell it all. Siti took this on. It was never about the drawings. It was Moelyono's humanity that brought him there, to the remote villages that are often forgotten by the national narrative and even by activists. Moelyono needed to be there, to be part of the problem, so that he could find some sort of way to navigate this problem together with the people, as the people—not for the people. She was the one that first articulated Moelyono's practice in such a clear manner, that this became Moelyono's manifesto. Any articulations of his practice stem from this line of thinking. Indeed, afterward and until now, Moelyono became known for his *Art (for) Consciousness*. Siti Adiyati postulated yet questioned:

> Where is the limit of what is art and not if social issues are the center of the idea as well as the articulation? For Mr. Drawing Teacher, art is an act of life and he places himself as part of the lower class citizens. Art becomes a tool to dissect social injustices. Art does not remain in the realm of "high" culture. Okay, so, now, would the expected transformation really happen?

The nineties that somehow feel closer to where we are now

It is worth questioning why artists from Indonesia would speak of liberation, freedom, independence, and democracy in 1994, almost 50 years after independence. This was the year Kurt Cobain and Guy Debord killed themselves by gunshot. For us, in Indonesia, this was the year that the authoritarian New Order regime banned *Tempo* and *Editor* magazines, along with the tabloid *DeTik*, because they were reporting on the corruption surrounding the purchase of 39 retired East German warships. The banning of the media triggered many demonstrations not only from the activists and students but also from the citizenry in general. The international media condemned the assault against free speech (Srengenge).

Growing up in a military family, Semsar had always been concerned with the abuse of power. He, who had always been both an activist and an artist, was a field coordinator for one of the demonstrations. He protected his friend, activist Dita Indah Sari, from the violence conducted by the riot police when the crowds rioted after there had been an attempt to break up the demonstration. Semsar was beaten with a rattan stick and rubber baton. Three bones of his feet broke, and pins were installed so that he could walk again (Yatmakan 15–34).

Let us try to look at Semsar's works from this period in order to understand how the socio-political climate informed his work. For the Jakarta Biennale IX 1993, Semsar created a work titled *Penggalian Kembali* (literally *Re-Excavation*, contextually *Re-exhumation*). It was an on-site installation, in what used to be the gallery of Jakarta Art Center's Taman Ismail Marzuki, which was slated to be demolished. When offered to participate in the Biennale, Semsar quickly agreed and chose that site where his solo exhibition was held five years prior—after which, he burned all 250 featured drawings in a work titled *Seni Peristiwa Monumental Menentang Pemi-likan Pribadi atas Karya Seni* (*Monumental Art Event against Individual Ownership of Artworks*). As part of the Biennale, Semsar dug up the center area of the gallery, which used to be a garden-like open space. He did not allow anyone, including the organizers, to enter the building until the opening night. He made everything himself from the sculpted human figures formed from soil, as if they were just exhumed, to the murals on the surrounding walls of the gallery, depicting victims of human rights violations of the New Order regime from 1965 up to the recent Marsinah case. Throughout the exhibition, Semsar was always with his work, whether it was taking visitors on tours or simply spending time with friends. Some say that this was due to his paranoia regarding censorship and a fear that people might add unwanted messages to his installation, particularly to the murals (Wiyanto, *Semsar Siahaan: Art, Liberation*, "Expansion," Hujatnikajennong).

For Indonesians, the 1990s were a period crowded by overt human rights violations enacted by the state. What we call the "1991 Dili Incident" is known worldwide as the Santa Cruz Massacre; a shooting of at least 250 East Timorese proindependence people who were demonstrating against the Indonesian occupation. Along with other human rights activists, such as Roem Topatimasang, Indro Tjahjono, and Saleh Abdullah, Semsar pioneered the Indonesian Front for the Defense of Human Rights (INFIGHT) that managed to get the support of the Netherlands as one of the biggest financial supporters for developmental programs under the New Order.

The Marsinah case mentioned earlier refers to the events of May 5, 1993. Marsinah, a worker and activist from East Java, was found dead by torture and had been raped. Four days earlier, on May 1, she had been the orator for a demonstration demanding higher wages in PT Catur Putra Surya, where she had worked. During this regime, it was common for any businessman to have military backings. As Benjamin Waters highlighted, "The Marsinah case is considered to be the first instance of a wholly premeditated killing of a worker by the military" (12–13). Labeled as Case 1773 by the International Labour Organization, again, this case drew

international attention to the New Order's authoritarianism and suppression of labor. Later that year, Marsinah received the Yap Thiam Hien Human Rights Award. Semsar created the poster for this event.

Coming from East Java, Moelyono was not directly involved with this event. His artistic practice stems from peripheries, and, because Jakarta is the center for governmental and capital activities, Surabaya, East Java—even if it is the second capital of the country—is still considered the periphery. With different wording and in different situations, Moelyono repeatedly stated, "The foundation of my artistic practice is a humane sensibility and conscience upon the sufferings of lower class society—the part of society in which I locate myself and I am morally siding for" ("Seni Rupa Dialogis Transformatif" 4). In the early 1980s, Moelyono began to work with people in remote villages of East Java. As soon as he heard about the Marsinah murder, he began initiating contact with Marsinah's labor friends. He planned an event to commemorate her death, which is a social ritual that we do anyway, usually on the third, seventh, 40th, 100th, and, finally, the 1,000th day. He titled it *Pameran Seni Rupa untuk Marsinah: Mengenang 100 Hari Gugurnya Marsinah* (*Visual Art Exhibition for Marsinah: 100 Days Remembering the Fall of Marsinah*).

Gugur, or "the fall (of)," is an amazing word in the Indonesian language. It is used only for heroes. By using this word in the title, Moelyono elevated Marsinah from a suppressed, silenced second-class citizen—from the periphery—to a national hero. Indeed, Moelyono's practice has always involved society, and, by this, I mean that, instead of representing other people's problems, he would put himself in the shoes of those people so that he would be speaking with them.

With this aesthetic strategy, he approached (and led workshops with) Marsinah's friends and colleagues to create woodcut prints, which were later turned into an exhibition. To one side of the space, there were life-sized human figures made of straw. They held black banners, with one of the figures hung from the ceiling. In the middle of the space were 13 straw figures

Moelyono's exhibition on Marsinah, 1993.

Courtesy Indonesian Visual Art Archive.

Moelyono's exhibition on Marsinah, 1993.

facing two tables, one standing upright and the other one upside down. Central to audiences' eyes was a sculpture of Marsinah cast in cement, installed on a pedestal. As a background to this centerpiece, there were reliefs of fisted hands; surrounding the space were installed the wood-cut prints that recounted a laborer's daily life in the factory, and, mixed with prints, there were many plaques that read "*inggih.*" The word is Javanese for "yes" and is used by the lower class to a higher class, by an employee to the boss, or by a child to the parent. This "traditional" submissive gesture is also a form of critique of the reigning regime, which was militaristic with a taste of Javanese hierarchical culture. Even the international media acknowledged this. Four days before the regime collapsed, *The New York Times* featured this headline: "Suharto, a King of Java Past, Confronts Indonesia's Future" (Kristof). This exhibition for Marsinah was installed in the local arts center, which meant that it needed to be approved by the local arts committee. In the exhibition catalog, the pages began with a clear statement that art needed to side with human rights.

There was a sneering critic of the local scene who seemed to be content with its market stability and lack of commitment to society (Hadjar 2–4). Right before the opening ceremony, when people had started gathering and getting ready for a *tahlilan* (citing the confession of Islamic faith), Aribowo, the head of the Surabaya Arts Committee, announced the exhibition's cancellation ("Dua Kota, Dua Larangan"). Later on, the police insisted that this was not censorship but simply that the organizers of the space did not ask for a permission letter for the exhibition. Though officially the exhibition was canceled, the organizers kept the main door closed, but the works remained installed. For those who asked to see it, they would open the door (gas, rza). Many of the newspapers clearly praised the exhibition. And, indeed, this moment led to the banning of three media outlets the following year.

In the art world, the banning of the Marsinah exhibition became highly significant. Some international catalogs even put brackets next to the announcement of the 1993 Marsinah exhibition to highlight that this exhibition was indeed banned by the police. However, since the

Courtesy Indonesian Visual Art Archive.

Moelyono's exhibition on Marsinah, 1993.

nineties are often celebrated as the turn toward the international, it was only Japan and Australia who started to support Indonesian contemporary art practices. In other fields, with different agendas, there have been other countries closely involved with practices that indirectly impact the artistic field. For example, presumably driven by postcolonizing melancholia, the Netherlands has long invested through developmental and educational aid. Meanwhile, in the realms of economy, state politics, and policy making, the United States has significantly been

Moelyono's exhibition on Marsinah, 1993.

present through their scholars, technocrats, and businesspeople; this relationship has always been convoluted—the CIA's Cold War inheritances, the 1965 genocide, and the consequent banning of the Communist Party of Indonesia (PKI) in 1966 echoed in the relations between the two countries. Like the Netherlands and the United States, Japan was also welcomed by the New Order regime,[6] hence their presence in the Indonesian art world.

The Fukuoka Art Museum in Japan began their regional work in ASEAN countries in the late seventies and started building a collection by early eighties. By 1991, they had changed their name to Fukuoka Asian Art Museum. A little after, Australia decided to regionalize itself, first beginning with the ANZART (Australia and New Zealand Artists Encounter, 1981–1985) series of exhibitions and events, continuing on to ARX (Artists' Regional Exchange, 1987–1999), and finally the APT (Asia-Pacific Triennial, 1993–present.) The latter is an event that is run by Queensland Art Gallery | Gallery of Modern Art, which is also a collecting institution, in Brisbane. The event is known for its rather unique position: they commissioned artists to make new works, but they also acquired works presented at triennials, including new commissions.

At this time, Japanese scholars' take on art practice was more focused on the ruptures of Modernism rather than on the social or the political. Australia showed camaraderie toward artists (and intellectuals) who were more openly political and therefore those who were against the New Order regime. Moelyono was indeed invited to participate in the 1995 ARX. A separate catalog was put together by scholars who had been observing closely (and, to some extent, were involved in), in order to highlight what the artists had called a "Visual Art (for) Consciousness." Even though both the term and the articulation of this concept were both first coined by the artist/writer Siti Adiyati, she is rarely mentioned, let alone acknowledged. In the 1996 APT, Semsar was invited to speak on the panel "Artists and the Social Dimension," and his presentation was titled *Individual Freedom Approaching Creative Society* (Turner and Davenport).

Around this time, Japanese scholars finally caught up with the sociopolitical urgencies within contemporary art practices. In 1997, with the assistance and support of the Japan Foundation, the Tokyo Municipal Museum of Modern Art, and the Hiroshima City Museum of Contemporary Art held the exhibition *Art in Southeast Asia: Glimpses of the Future.* Titled *The Animal Sacrifice of the New Order,* Moelyono's work for the show delivered a harsh critique on the dictator Suharto. He did this through referencing the peaceful demonstration that was conducted by the biggest Islamic organization in Indonesia, Nahdlatul Ulama, that was led by Abdurrahman Wahid (Gusdur), who later on became Indonesia's most tolerant president. At the time, riots and rebellions against the new regime had occurred more and more often across the country, including small towns and villages. Crowds were prone to provocations, and there had been many incidents all over the country; hence Moelyono's reference to sacrifice. Gusdur's way of redirecting the masses was to make them gather and do *istighosah* (chanting prayer.) Later on, in 1999, Moelyono contributed a work to the third Asia-Pacific Triennial that literally demonstrated the riots surrounding the demonstrations toward *Reformasi.*[7] For this generation of artists, humanity has always been the drive of their art practices and their aesthetics. By this time, at end of the nineties, Semsar had moved out of the country. The pain caused by his earlier activism, had made him more prone to stress. Artists and activists in Singapore had organized several months of residency in order for him to work in peace and at the same time have medical checkups and treatments. In 2000, he fled to Canada. Ever since his beating, his works tend to be drawings and paintings rather than happenings, events, or installations.

From an Indonesian governmental perspective, the nineties were the time in which international connections were built. In 1990–1991, the government held an exhibition of traditional, modern, and contemporary art in several university museums in the United States of America. The project was literally titled *Kesenian Indonesia di Amerika Serikat* (KIAS, *Indonesian Art in the USA*), and it was accompanied by a book that tried to historicize the mainstream art practices in Indonesia (Atmadja et al.). Immediately after this, the Jakarta Biennale IX 1993 occurred. Ever since its inception in 1974, the Biennale had another dimension in which it is, at the same time, a competition—there have always been winners of each biennale. Semsar's work I mentioned previously, *Penggalian Kembali,* won the 1993 competition. The reward was supposed to be the inclusion of the work in either the 22nd São Paulo Biennial or 5th Havana Biennial, both held in 1994. I say *supposed,* as that never really happened. Some speculated that it was due to the criticality of one of Semsar's works (Owens). Some indicated that they were sent out as observers of the government instead of participating (Rath 4–15). Two other winners, Andar Manik and Anusapati, said that they had received some money as a reward and that the trip never happened (Anuspati "Personal Interview" 2018). Andar Manik remembered that there was a plan to send them to either of the biennials but could not really be sure why it was canceled: "I was too young to care," he said.

Not long after that, in 1995, the government initiated another exhibition titled *Pameran Seni Rupa Kontemporer Negara-negara Gerakan Non-blok: Mencari Perspektif Selatan?* (*Exhibition of Contemporary Art from the Non-aligned Countries: Seeking a Southern Perspective?*) The *Non-aligned* exhibition was held in the current National Gallery of Indonesia. It was curated by the renowned artist Jim Supangkat, along with an international board of curators consisting of Emmanuel Arinze (Nigeria), Piedad Casas de Ballesteros (Columbia), TK Sabapathy (Singapore), Gulammohammed Sheikh (India), Apinan Poshyananda (Thailand), and AD Pirous (Indonesia). A two-day symposium was held alongside it; speakers included international scholars and practitioners such as David Elliot, Geeta Kapur, Kuroda Raiji, Mary-Jane Jacobs, Apinan Poshyananda, and many more. The directorate general of culture at the time, Edi Sedyowati, mentioned that the event was in remembrance of the Asia–Africa Conference (also known as the Bandung Conference, 1955). This exhibition remains the only one that was officiated by the authoritarian president Suharto.

Courtesy Sonny Siahaan.

Semsar Siahaan, One Way Ticket to Disaster, 1997.

Toward the downfall of the authoritarian New Order regime, Semsar, along with 21 other artists, participated in *Slot in the Box*, a show put together by (and held in) Cemeti Contemporary Art Gallery, Yogyakarta, a month before the presidential election that Suharto and the New Order regime won for the last time.[8] Even though the art world in Indonesia tends to have an acute amnesia, *Slot in the Box* is remembered as one of the most vocal exhibitions that lead up to people's protest against the New Order regime. Semsar's contribution to the exhibition was titled *Tiket Searah Menuju Bencana* (*One-way Ticket to Disaster*, 1997). His painting was full of anger toward the one-sided idea of national development, as well as the depoliticization of citizens through education, health care, and societal neighborhood units. Indeed, the New Order regime has been in power for three decades by then. When *Slot in the Box* was still on exhibit, in the month of the presidential election, Galeri Bentang Yogyakarta—belonging to a rather radical publishing company, Bentang Yogyakarta—launched Moelyono's monograph along with an exhibition titled *Tumpengan Kelapa* (*Coconut Feast*) (Malay 87). Like *Slot in the Box*, and as what people would have had in the back of their minds at the time, this exhibition was also cynical toward the election. Moelyono had chosen coconut as his main material because, in a matter of

days after installation, the fruit would all start to rot and would immediately turn yellow—the color of Golongan Karya, a party that backed the New Order regime.

The students' and citizens' movements' effort in dethroning Suharto from his presidency finally succeeded. The *Reformasi* is (still) considered as the new beginning toward an Indonesian democracy. Yet even before Suharto officially stepped down on May 21, 1998, people had started to question: Indonesia has little experience with democracy. Its institutions have atrophied after three decades of paternalistic rule, and the economy is in shambles. And, unlike elsewhere in Asia, there is no solid middle-class base on which to build a new democratic state (Richburg).

So what comes next? Nobody seemed to be sure. But people were celebrating the moment of freedom. Immediately afterward, in June 1998, Moelyono's installation for Marsinah, which was once banned, was exhibited in Cemeti Contemporary Art Gallery (Fadjri 57–59). For the 3rd APT in Brisbane in 1999, Moelyono contributed a work about the violent riots in which Chinese were targeted, raped, robbed, and even killed (Wicaksono 64). On December 2, 1998, during the fall of President Suharto, Taring Padi declared their existence as an artists' collective that openly stated their leftist references were formed in Yogyakarta (Dahlan 4–15). Taring Padi works to counter imperialism, capitalism, militarism, feudalism, and elitism, connecting politics with artistic practice. They believe in a culture of collective voices, and as a result, their work is often produced communally. Working across media, from kinetic sculptures to techno music, they are perhaps best renowned for their posters carrying social justice messages, which engage with contemporary political issues relevant to Indonesia and the world at large.

In 2000, ruangrupa, an artists' initiative concerned with critical acts of living in the metropolitan Jakarta, was built. Operating on the intersection of an artist collective and an artist-run

Courtesy Taring Padi.

Taring Padi taking part in the Carnival Remembering 4 years of the Lapindo Mud Tragedy, Siring Barat, Porong, Sidoarjo, East Java, 2010.

space, ruangrupa's initial mission was to create a network of activities centered on social engagement within the urban context of Jakarta. The ruangrupa initiative provides alternative autonomous art and workspaces, as well as creating art projects that mainly take place in Jakarta's public areas, fostering collaboration, interaction, and exchange among different groups of people. Their artistic practices are situated in the space between: between formal galleries and street art, between artists and curators, and between artists and the public. All have been contextualized as the products of the new freedom of expression, along with many others groups that came and went after *Reformasi*. Up until now, both Taring Padi and ruangrupa are still active and have reformed in so many ways due to the constantly changing living situations, be it political, economic, social, or ecological.

How did we get here?

During her world travel in the eighties, Siti wrote diligently about her findings and thoughts. The Jakarta Biennale Foundation recently published a compilation of her essays, titled *From Kandinsky to Wianta (1975–1997)*. For a brief time in the early nineties, she worked with Gendut as coeditor for the investigative journal *Dialog* (along with FX Harsono, Hendro Wiyanto, Ugeng T. Moetidjo, and other friends). *Dialog* was published every six months between 1990 and 1993.

On and off, Siti went back to Indonesia. In 1987, Siti, her husband Gendut, critic and historian Sanento Yuliman, artist-cum-curator Jim Supangkat, and other practitioners from filmmaking, advertising, sociology, and behavioral psychology exhibited an art project titled *Pasaraya Dunia Fantasi (Fantasy World Supermarket)* at the Jakarta Arts Center Taman Ismail Marzuki.

All throughout the eighties, Siti traveled the world with her husband and children. Emmanuel Subangun did his masters at Sorbonne University, Paris, and together they conducted research at Kyoto University, Japan. After graduating from the painting department in the Jogja art school, Siti was well-known for her nonconformist practices. She was a part of the so-called avant-garde *Indonesian New Art Movement* (GSRBI, 1975–1989) and had been dealing with social issues within the constraints of traditional—if not conventional—society, as she came from a royal Javanese family background. Subangun was a sociologist and journalist who was working for a very large national newspaper and was active in a number of social research facilities. They grew together.

Indeed, eventually, they became a solid team for agricultural experimentations, particularly different landscapes of Indonesian society. They have a variety of fields, crops, and plantations in Kediri, East Java; Bali; Tomohon, South Sulawesi; and lastly Gunung Kidul, Yogyakarta. It never was about merely agricultural activities for them; it was about learning and earning with what you have and with the people around it. It is not simply about surviving or sustainability but about the advancement of humanities. As for the sites of their work, their choice was driven by their curiosity in the society in which the lands are located. It is never really just farming and neighboring activities: many kinds of courses, workshops, and social experimentations always occur in these places. When asked, why Bali? Her answer was:

> Bali is particularly interesting because it is so difficult to understand their culture. And this is [not] only due to hiding the 1965 genocide, but there are so many layers. Where does their Hinduism stem from? How did they deal with foreigners that came in as traders since hundreds of years ago, and finally the Dutch that occupied the existing palaces? What does it mean to be Balinese amongst what seemed to be a very *international* site?

How could a farmer answer to these questions? "Well, by owning a piece of land, we become their neighbors. We are localized, we are in solidarity. Whatever may happen to them, will happen to us" (Siti "Personal Interview").

For now, Bali is a good place to end this quest. I have to say that, the more I travel, the more I learned that many people do think that it is located near Indonesia. In other words: one, as a place, it is better known than Indonesia as a whole; and, two, it is constantly misunderstood. Ever since moving to Canada, Semsar never really operated solely as an artist and immediately joined the activism for human rights in Canada. Of course, everything was different: the context, the history, the language, and the culture. But for Semsar, all human beings deserve their freedom and therefore their rights. After four lively years in Canada, Semsar decided to move back to Indonesia despite his troubled health. He was welcomed with a solo exhibition in the National Gallery of Indonesia, Jakarta. His return indicated that he wanted to build a new life in a new place. This place was Tabanan, Bali. He had bought a piece of land. For tourists, Bali is a paradise; for many of my friends who now live there, Bali is a home for those who couldn't find one in Indonesia. The world is there, but it is still Indonesia; when you speak the national language, you are mostly understood. I will not psychoanalyze Semsar's final destination. I will say that the people who can afford to choose where to live do have privileges. Being an artist is an option for privileged people. If one remains being an artist, even if one only paints in one's studio, there seems to be no luxury that can ever allow one to be antisocial. Therefore, the next question would be whom does one choose to be one's society? How does one function in it?

Notes

1 In an Indonesian context, people are commonly cited by their first name due to the fact that many cultures do not have the habit passing down family names and, in quite a number of cultures, people have only one name. Look at our first two presidents, for example: Sukarno and Suharto.

2 For the sake of this essay, I could call it social art, but I am far more interested in the people rather than the types or genres of art; hence I am sticking to the terms that these social artists are using/creating themselves.

3 Two remarkable examples demonstrate the regime's need for national identity: in 1973, a group of Bandung-based artists and lecturers, Decenta, were commissioned to fully decorate the interior of the Parliament Hall in Jakarta; in 1975, the amusement park that is dubbed the miniature of Indonesia, namely *Taman Mini Indonesia Indah*, was built.

4 From the personal archive of the artist Bonyong Munni Ardhi. Also accessible in the *Seni Rupa Baru* (GSRBI, Indonesia New Art Movement archive) at the Indonesian Visual Art Archive, Yogyakarta.

5 All the interview materials will be made available in the online archive of Indonesian Visual Art Archive in 2019.

6 In 196, the repressive New Order regime began their reign. During the New Order regime, the Ministry of Trade and Industry, as well as the Ministry of Finance, was led by a number of UC Berkeley graduate military officers who were nicknamed the "Berkeley Mafia." Any international relationships prior to this authoritarian regime were restarted under these new conditions, especially with communist countries where communism was dominant.

7 The Reformasi is both a Malay and Indonesian term for reform or reformation. Through civil disobedience, demonstrations, rioting, occupations, and online activism, thousands across the country protested against Suharto as President in 1998 and the post-Suharto era in Indonesia that began immediately after, and the Barisan Nasional government under the Mahathir Cabinet in Malaysia.

8 Other participating artists were Ade Darmawan, Agung Kurniawan, Andar Manik, Anusapati, Eddi Prabandono, Eddie Hara, Edo Pillu, Firman, FX Harsono, Hanura Hosea, Hedi Hariyanto, Herly Gaya, Iwan Wijono, Marintan Sirait, Ong Harry Wahyu, Pintor Sirait, Rotua Magdalena Pardede, S. Teddy D., Semsar Siahaan, Tisna Sanjaya, Ugo Untoro, Weye Hartanto, Yustoni Volunteero. See "Slot in the Box."

Works cited

Adiyati, Siti. Personal interview with Grace Samboh and Haruko Kumakura for an archive show at Mori Art Museum and for Hyphen's research on GSRBI (Indonesia New Art Movement). 25 April and 6–7 December 2016.

Adiyati, Siti. "Seni Rupa Penyadaran" ["Art (for) Consciousness"]. Translated by Grace Samboh. *Kompas*, 4 September 1988.

Agus Dermawan T. "Seni Rupa Pengusir Burung" ("Art for Driving Out Birds"). Translated by Grace Samboh. *Kompas*, 23 December 1980.

Anusapati. Personal interview with Grace Samboh and Angga Wijaya for EKSTRAKURILAB festival. 3 July 2016.

Anuspati. Personal Interview with Grace Samboh. 4 November 2018.

Atmadja, Mocthar Kusuma, Rahmad Adenan, Kusnadi, Sudarmadji, Soedarso Sp., and Agus Dermawan T, editors. *Perjalanan Seni Rupa Indonesia: Dari Zaman Prasejarah Hingga Masa Kini (Streams of Indonesian Art: From Pre-Historic to Contemporary)*. Direktorat Jenderal Kebudayaan (Directorate General for Culture), 1990.

Dahlan, Muhidin M. 2015. "Seni dan Politik: Yogyakarta sebagai Arena" ("Art and Politics: Yogyakarta as an Arena"). *EQUATOR*, Yogyakarta Biennale Foundation, no. 3, pp. 4–15.

"Dua Kota, Dua Larangan" ("Two Cities, Two Bans"). *Tempo*, 21 August 1993.

"Expansion: Thirteen Years after That Triennale." *Expansion*. National Gallery of Indonesia & SigiArts Gallery, n.d.

Fadjri, Raihul. 1998. "Pameran Instalasi Desa: Dari Marsinah sampai Pemilu" ("An Exhibition of Installation from the Village: From Marsinah to Election"). *Detektif & Romantika*, 27 June 1998, pp. 57–59.

gas, rza. "Pelarangan 'Pameran Seni Rupa untuk Marsinah' Merupakan Keberhasilan" ("The Banning of 'Visual Art Exhibition for Marsinah' Is a Form of Success"). *Surabaya Post*, 16 August 1993.

Hadjar, Saiful. 1993. "Introduction." *Pameran Seni Rupa untuk Marsinah: Mengenang 100 Hari Gugurnya Marsinah (Visual Art Exhibition for Marsinah: 100 Days Remembering the Fall of Marsinah)*. Surabaya, Dewan Kesenian Surabaya, Yayasan Seni Rupa Komunitas & Komite Solidaritas untuk Marsinah, 1993, pp. 2–4.

Harsono, FX, Gendut Riyanto, and Winardi. "Seni Rupa Kembali ke Masyarakat" ("Visual Art's Come Back to the Society"). *Journal SANI*, edited by Hendro Wiyanto and Ong Harry Wahyu. Akademi Seni Rupa Indonesia (ASRI/ISI Yogyakarta), 1983, pp. 42–45.

Hujatnikajennong, Agung. *Perdebatan Posmodernisme dan Biennale Seni Rupa Jakarta IX (1993–1994) [The Debate of Postmodernism and the 9th Jakarta Biennale (1993–1994)]*. 2001. Fakultas Seni Rupa dan Desain ITB, Skripsi Program Sarjana, BA thesis.

Kristof, Nicholas D. "Suharto, a King of Java Past, Confronts Indonesia's Future." *The New York Times*, 17 May 1998, pp. front page–1.

Malay, Afnan. 1997. "Tuan, Terimalah Kepala Kami" ("Sir, Please Accept Our Heads"). *Ummat*, vol. 2, no. 25, 1997, p. 87.

Manik, Andar. Personal interview with Grace Samboh. 4 November 2018.

Miklouho-Maklai, Brita. *Exposing Societies Wounds: Some Aspects of Contemporary Indonesian Art Since 1966*. Flinders University Asian Studies Monograph, Vol. 5. Flinders University, 1991.

Moelyono. Personal interview with Grace Samboh, Ignasius Kendal, Octalyna Puspa Wardany, Pitra Hutomo, Riksa Afiaty, and Syafiatudina. 2016–2018.

Moelyono. "Seni Rupa Dialogis Transformatif: Satu-Proses-Pencarian." *Exhibition of the Dialogical Transformative Art, Lingkar Mitra Budaya Jakarta, August 26–31*. Yayasan API, Lembaga Ilmu Pengetahuan Indonesia (LIPI), and Yayasan Karti Sarana, 1988, p. 4.

"Moelyono; Seni Rupanya Berpihak" ("Moelyono; His Art Practice Takes Side"). Translated by Grace Samboh. *Kompas* 29 April 1994.

Owens, Yvonne. 2002. "The Art of Living Dangerously." *MONDAY* Magazine, vol. 28, no. 30, 2002, www.academia.edu/19988700/The_Art_of_Living_Dangerously_Semsar_Siahaan_1952–2005_. Accessed 4 November 2018.

"PLANTSCAPE." Jakarta, ROH Projects, 2018, www.academia.edu/36616221/_2018_Plantscape_-_Catalogue. Accessed 1 August 2019.

Rath, Amanda K. *Contextualizing 'Contemporary Art': Propositions of Critical Artistic Practice in Seni Rupa Kontemporer Indonesia*. 2011. Faculty of the Graduate School of Cornell University, Ph.D Dissertation, pp. 4–15.

Richburg, Keith B. "Indonesians Ask, After Suharto, Then What? 'Reformasi!' A Common Cry, but What Form Would it Take?" *Washington Post*, 17 May 1998, www.washingtonpost.com/archive/politics/1998/05/17/indonesians-ask-after-suharto-then– what-reformasi-a-common-cry-but-what-form-would-it-take/14f7629d-b029–4458-b9f0–30eb173e6c8b/?noredirect=on&utm_term=.0c37f3ae1704. Accessed 23 September 2018.

Semsar Siahaan: Art, Liberation. Gajah Gallery, Asikin Hasan, 2011.

Siahaan, Semsar. "Press Release." Cemeti Contemporary Art Gallery, 1998.

"Slot in the Box." *Indonesian Visual Art Archive*, http://archive.ivaa-online.org/events/detail/38. Accessed 19 January 2019.

Srengenge, Sitok, editor. *Bredel di Udara: Rekaman Radio ABC, BBC, Nederland, VoA (Banned on Air: Recordings from ABC, BBC, Nederland, VoA Radio)*. Institut Studi Arus Informasi, 1996.

Turner, Caroline, and Rhana Devenport. *The Second Asia-Pacific Triennial of Contemporary Art: Brisbane Australia 1996: Present Encounters—Papers from the Conference*. Queensland Art Gallery, 1997.

Waters, Benjamin. "The Tragedy of Marsinah: Industrialization and workers' rights." *Inside Indonesia*, no. 36, 1993, pp. 12–13.

Wicaksono, Adi. "Moelyono." In *Beyond the Future: The Third Asia—Pacific Triennial of Contemporary Art*, edited by Caroline Turner and Rhana Devenport. Queensland Art Gallery, 1999, pp. 64.

Wiyanto, Hendro, editor. *Semsar Siahaan (1952–2005)*. Yayasan Biennale Jakarta and Penerbit Nyala, 2017, p. 66.

Wright, Astri. *Soul, Spirit and Mountain: Preoccupations of Indonesian Contemporary Artists*. Oxford University Press, 1994, pp. 219–223.

Yatmakan, Yayak. "Art of Liberation and People's Art." In *Semsar Siahaan (1952–2005)*, edited by Hendro Wiyanto. Yayasan Biennale Jakarta & Penerbit Nyala, 2017, pp. 15–34.

ON SOCIALLY ENGAGED ART IN THAILAND

A conversation

Gridthiya Gaweewong, Thanom Chapakdee,
and Thasnai Sethaseree

GRIDTHIYA: I would like to start by asking about socially engaged art in Thailand's recent history that responded directly to the political situation, especially the collapse of our democracy. We have been through multiple bouts of political turbulence, with more than 10 coups d'etat and many disruptions to the democratic process, which resulted in the overthrow of the elected Yingluck Shinawatra government in 2014 by the People's Democratic Reform Committee (PDRC), a yellow-shirt mob made up mainly of the urban middle class and the privileged.[1] This led to the decline of the democratic movement in our country and has permitted the military to stay in power until today.[2] The junta has exercised heavy control over the public, especially in regard to academic and artistic freedom. They have posed a threat to academia and the artist community and have also censored art exhibitions in gallery spaces, for example at Ver Gallery owned by Rirkrit Tiravanija.[3] How have socially engaged artists reacted to this? Have any artists staged resistance? And were you involved in any such projects?

THANOM: My experience with the art movement since the junta seized power has led me to see the increasingly legitimate powers of the State. In fact, the visual arts movement in the Thai context has overwhelmingly emphasized religion, monarchy, and the elite. This is part of the transition to a new reign. These values and beliefs have led to the mythical context related to Buddhism and the Monarchy becoming the institutional fabric of Thai society and to Buddocentricism[4] becoming the mainstream of contemporary Thai artistic, intellectual, and cultural life. That's why art activists are finding it difficult to set up a movement to resist the regime. Political activists, on the other hand, have been more courageous, daring to challenge state power by using art as a platform and employing various art disciplines such as performance art, theater, flash mobs, and community art to manifest and present their ideas of resistance to the public.

THASNAI: I don't trust artists' resistance in Thailand. In other words, I don't buy the utopian idea about artists making art projects to resist political constraint. Art projects allow artists to say things politically only when their political statements benefit themselves to some degree.

For example, when Ai Weiwei was detained by the Chinese authorities in 2011, many Thai artists took part in the "Free Ai Weiwei" campaign. That same year, the number of political prisoners in Thailand charged with lèse-majesté shot up, yet no Thai artists here said a word about the situation of Thai politics. Corrupted minds turned artists into political opportunists in the art world.

To engage in the mobility of political critique, I think artists must consider themselves as ordinary citizens walking on the street, not wandering around an exhibition space. They should be willing to work with people across multiple professions in many forms, not as the sacred form of the art project. I am skeptical about turning an exhibition space into a protest space.

From 2006 to 2014, the years of the last two coups, many social platforms outside exhibition spaces became more powerful as people made critical statements about the status quo of Thai politics. Public and private spaces, both physical and online, became blurred while ideas of governmentality were brought into question. In 2013 and 2014, lighting candles and releasing white balloons became symbolic of people's frustration with absolute authoritarian control and their hope for a better democracy.

In Chiang Mai, people across professions created a series of campaigns against the authoritarian mindset. Those campaigns took the form of talks, seminars, workshops, and site-specific activities such as cooking and eating together at the civic plaza [Tha Pae Gate], or a walk-rally to Chiang Mai City Hall and to the Office of the Election Commission to trade ice cream for a promise to hold a new election after the Yingluck government dissolved parliament at the end of 2013. At the same time, the PDRC initiated the Bangkok Shutdown and Thai artists set up the Art Lane Project, putting their efforts into hindering the election.

Right after the military staged the coup, military checkpoints were everywhere in Chiang Mai city. And, under a military emergency situation, a law prohibiting assembly was announced. A curfew was imposed on the city. It seemed impossible for activists to continue their endeavors. Most were told to report themselves in the military base. Many were

Courtesy Thasnai Sethaseree.

Thasnai Sethaseree, Trading ice cream for your heart: a walk rally to Chiang Mai City Hall and to the Office of the Election Commission.

Courtesy of Political Science Faculty, Thammasart University, Bangkok.

A collective of political activists perform a public exercise during the curfew nights after the Thai junta had staged the recent coup d'état at Tha Pae Gate, Chiang Mai, 2014.

detained. My house was surrounded by troops. However, political mobility continued but in creatively smarter ways. Exercising, informal tea gatherings, sitting around, reading books, standing still, and other forms of trivial activities were turned into political symbols to glue the structure of their sentiment, while other types of activism were prohibited. I am more interested in how people try to mobilize their political or social critiques than what was censored in an art gallery.

GRIDTHIYA: Both your comments—Thanom's on the role of the active citizen and political activists who hijacked the contemporary art scene by using art to manifest their resistance in the public space, and Thasnai's skepticism on the role of artists' resistance in the art spaces— are pertinent. Artists were not part of this movement, were not well-informed, and remained stuck in the art world. Why was that? I am personally interested in how art connected with politics, especially how it was manifested during this crisis. And I would also like to situate the contemporary artists within this landscape, even if they are less active than the political activists and citizens. My question is how do you see the role of socially engaged art practices in the past decade? What made them so sleepy and unable to comprehend the contemporary world? What do you think about artists who were engaged in social change, especially around the early 2000s before the coups, particularly the artists who took part in the yellow shirts movement, who tried to debunk Thaksin and Yinkluck Shinawatra's governments? How can we locate and think about them in today's social-political context?

THANOM: The artists involved in the PDRC were mostly from Silpakorn University.[5] They were lecturers, students, and alumni. Some former art-activists also went over to the PDRC, including Amrit Chusuwan, Sutee Kunavichanon, Manit Sriwanichpoom, and Vasan Sit-thiket.[6] As I said before, the sense of Buddocentricism and Neo-Nationalism constructed by

the elite has been promoted since 1930 and conquered the country decade by decade. They have become the grand pillars of the kingdom. Neither the era of globalization (Thaksinomics) nor neoliberalism could change their domination. In a Postmodernist country like Thailand, changes in the perception of social and cultural values polarize the relationships between people (red shirts and yellow shirts) and cause reality to alter at a faster rate than before. As a precursor to this, we can see Thai society degenerate into imitation, sinister, and unspoken (for example, the plaque remembering the 1932 revolution becoming a happy and fresh-faced citizen plaque in 2017). Society is full of distorted meaning and complicated levels of communication. [T]he ruler used the state apparatus to manipulate and control people and create a culture of fear and conflict. The PDRC art movement was the art of the soft power, of rulers, and it became state propaganda.

THASNAI: I think all criticism through socially engaged art has been abused because of the industrialization of art. These critical vocabularies, whether left or right, have been used without ideological persistence. It is an ideological collapse, and many artists' practices are an integral part of that matrix.

Let me elaborate on how the social and political context has developed in Thai exhibition culture. Thai conservatives established a bureaucratic state in Thailand starting in 1947 during Field Marshal Phibun Songkram's regime. Not until 1955 did Thai capitalists challenge the state-monopolized economic policy. They conspired to subvert the Phibun Regime and supported Field Marshal Sarit Thanarat. From 1958 to 1973, a bureaucratic policy was influenced by the Thai business sector. Thai exhibition culture changed hands, going from bureaucratic to corporate. Works of art during this period not only constituted a monarchical state related to elite culture but also were used as commodities in a display of consumerism. All local ideas—Buddhism, daily life, community life, culture with a capital "C," and culture—were turned into commoditized products. The concepts of "nationalism," as well as "Thainess," were used first by Sarit Thanarat and later Kukrit Pramoj to reconcile conflicts of interest between the bureaucratic and corporate. Actually, Thai nationalism has nothing to do with egalitarianism. And, in addition to Nationalism and Thainess, Buddhism helped unite the Thai ruling classes. The urban upper middle class felt that they also profited from Nationalism, Buddhism, and the imaginary Thainess because their livelihoods evolved around both the bureaucratic and the corporate.

The postcolonial sentiment, which began in the late 1990s, circulated in the region's intellectual circuits to build a protective wall from Western influences. Works of art since then have helped promote ideas of regional solidarity. Endless research has focused on the concept of "reconnecting Asia." Local archives on art and culture have been initiated and exchanged among art organizations in Asia. Correspondingly, postcolonial ideas were discussed for two purposes—first, to disrupt the hegemony of the Western discourse and second, to create a counter perspective to traditional art and its historical confinement in a particular cultural location. Schizophrenia in localism led to an attempt to find new languages of expression in artwork so as to illuminate the self-glorification of a specific culture. Elites, intellectuals, and artists all took part in this postcolonial parade.

On the other side of this postcolonial discourse is the passion for ultranationalism. Bear in mind that the discourse on postcolonialism did not only occur in previously colonized countries. We are not talking about the geo-body of colonization but rather crypto-colonialism where ideas cross borders.

In reality, the languages of postcolonialism helped the authoritarian governments to legitimate their power structures in the international arena. At the same time, the ruling

class used the same vocabulary to colonize the lives of people in the country. The Orientalist stereotype has been created not only by Eurocentrism but by the Thai ruling class's mindset. This becomes a self-colonization that creates a looking-back-to-the-future effect and ultranationalist nostalgia.

From my perspective, the self-colonization by the ruling class in Thailand prevents the use of three things—reason, knowledge, and emotion.

In a society where people cannot use reason, knowledge, and emotion, a melancholy permeates the layers of politics, everyday life, and aesthetics. The body of social melancholy forces those things in which coexistence seems to be firmly integrated. This is perhaps what the Thai ruling class means when they talk about social reconciliation, the unity under melancholy, and the fake social solidarity.

I personally feel sick when people talk about creating a neutral platform, a relational aesthetics project, for instance, where people with different views can meet and talk. You don't talk with people who are involved in or support the killing of your friends, your friends' children, or a member of your family by saying. . . "Okay, forget everything; let's gather and make art together."

GRIDTHIYA: Thasnai brought up an important point about self- or crypto-colonization and postcolonial discourse. In our context, the elites are still in denial of crypto-colonization; therefore the postcolonial and decolonization discourse has not been widely discussed among the mainstream academia. It existed only in the post-Marxist, the forward thinkers, and the intellectual community. So the rejection of the crypto-colonization idea among the Thai elite and rulers translated quite well in the current Junta government. It is backward that they did not accept the democratic society, which they found chaotic and unified, so when the Junta seized the power, they promised to return the happiness to the Thai people and seek a "unified society." Furthermore, the junta's control over the citizens and academia was detrimental to Thai higher education. How did arts and academia deal with this situation? Can you give me some examples?

THANOM: The junta cannot control art activism. Artists can contribute their works and activities throughout political art games. From my experience as an art activist and from running the *Community Art: Participatory Perspective* project since 2000 in the Northeast, I believe that art must be a kind of method of engagement and the provocative grassroots of a movement. We have to break down the barriers of the walls of the museum and gallery in urban society and encourage people to categorize their activities as art. Art is not only an object but activism itself. Since 2000, I have organized the *Community art: Cultural Ecology* project at Ban Tha-Long, Kong-Jiem in Ubon Ratchathani province. Most residents of this village are ethnic Bru. The Bru migrated from southern Laos and crossed the Mekong river to settle in Ban Tha-Long at the end of the Indo-China War, and never knew this land belonged to Siam-Thai. My project aims to find a greater value for the social and cultural contexts of the villagers, and that includes the idea of autonomy and supernatural beliefs. From them, I learned that art is not the objects we are used to but the activism of the self. Since then I have been more serious about the idea of art activism, and my participatory perspective relates to people more than to academics creating art. That's why at the Khon Kaen Manifesto 2018, my priority was to present the concept of art activism and political art.

THASNAI: I don't know how academia should deal with this situation. Part of my work is working in a university, and I don't care about perceived threats but do what I want and say what I want in the classroom, in public, and in my artwork, which is how it should be. If you don't want to be an intellectual or artist serving the state, you must show persistence.

GRIDTHIYA: In my time as a curator working in an art museum, we did many projects with academia. We knew there were limitations in the university, so we offered them space for their platforms and opportunities to share their ideas with the public. We also encouraged artists to work with academia. With this approach, we felt that the museums and art spaces became relevant in playing the "agora" role for society. However, sometimes we were monitored by the Junta. Did this happen to you in the North and Northeast?

THANOM: In the Khon Kaen Manifesto 2018, our aim was to open up spaces in abandoned buildings, warehouses, and local communities for art that used various mediums and engaged with marginalized cultures and communities. We wanted to give voices and provide a platform to those exploited, forgotten, and displaced by mainstream development, whether it was cultural, social, political, and economic. We wanted to encourage them to inherit the rebellious spirit of molam,[7] as well as its potential, and to carry on this spirit and the aesthetics of resistance through artistic and cultural approaches. The Khon Kaen Manifesto became a political art because of the spirit of the grassroots culture. The regional military junta visited the space, and we had to take many artworks out of the exhibition, mostly those that criticized the rulers and the elite. The military also censored the images of Phai Doawdin, one of the political activists jailed in Khon Kaen because of article 112.[8]

THASNAI: Talking about resistance or politics in the context of art exhibitions has become sexy, and we need to be aware that perhaps the language of resistance associated with the history of the oppressed has not yet been narrated. Hal Foster addressed this awareness in his writing "The Artist as Ethnographers,"[9] saying that it was more exploitation of the oppressed that artists turned every marginal new discovery into a form and

Zakariya Amataya, Performance and reading poetry, Khonkaen Manifesto, Khonkaen, 2018.

Courtesy Thanom Chapakdee.

Guerrillar Boys, Junta Connection, Graffiti in Abandoned GF.Building, Khonkaen Manifesto, Khonkaen, 2018.

medium. In addition, many nations utilize the art field as an institutional platform to demonstrate their sovereignty, as well as to reinforce their ruling class mindset and the status quo of power relations.

In the field of cultural production of this sort, art exhibitions in many museums are overcrowded with global conceptualism, archivalism, spectacles of criticism, madness, and severe consumption of intellectual capital. It seems to me that ripping off the significance of things appears everywhere. Jean Baudrillard expressed concern long ago that works of art and their critical tasks would be made and consumed. And that it is—nothing to do with social mobility. Moreover, many authoritarian regimes utilize the art format to embellish their image to promote the tourism industry. This can be seen in the biennale mania in Thailand today.

In conclusion, for an art museum to be functional and serve the people today, its role and content structure need to be reconsidered from the ground up; otherwise, art ideas will be merely a part of the dominant architecture saluting the industry of humanist dream-like charities. And the art field will function just as a discursive exhibiting culture that does not voice any resistance. Therefore, the art space will be just another amusement park and works of art the playthings. As a practicing artist, I can say that I am not making toys. And that I don't mind that undercover police and soldiers sit in front of my house or at my office and keep an eye on me.

GRIDTHIYA: We make sure that art spaces are not amusement parks and are relevant to real life. It seems like we need art more than before in this disrupted and messy world. In the past decades, we felt that we faced similar problems, be it the dark side of globalization, climate change, and the collapse of democracy. As Kader Attia said to me before he left Bangkok last year, "We have to be more creative." Thanks so much for your contributions.

Photo courtesy of Political ScienceFaculty, Thammasart University, Bangkok.

Thanes Panpuan, a multidisciplinary symposium to celebrate 60 years of Professor Thanes Wongyannawa, Araya Hall, Jim Thompson House Museum, 22 June 2019. Photo courtesy of Political ScienceFaculty, Thammasart University, Bangkok.

Notes

1 The yellow shirts, aka the whistle mob, demonstrated against the Yingluck Shinawatra government and successfully ousted the Shinawatra regime in 2014 ("PDRC to Shut Down . . .").
2 This conversation was conducted and completed in January, before the election on 24 March 2019.
3 Thai soldiers and plainclothes officers stormed Gallery Ver where an exhibition by Harit Srikhao was located and took down the works in display on June 15, 2017 (Yu).
4 In a paper presented at the The 12th International Conference on Thai Studies at the University of Sydney, Australia in April, 2014, Thanes Wongyanawa and Thanom Chapakdee used the term "Buddhocentricism" to highlight how Thailand relied heavily on Buddhism as an integral part of its state formation and constitution.
5 Silapakorn University was the first art university in Thailand established officially in 1943. With the endorsement of the Pibun Government, Corrado Ferroci, the Italian sculptor cofounded the Department of Painting and Sculpture. He later became the father of "modern art" in Thailand. Read more on their homepage: www.su.ac.th/en/about.php. Accessed February 1, 2019.
6 Manit Sriwanichpoom and Vasan Sitthiket are Thai artists who have created sociopolitical art since the 1990s. They were actively involved with the artistic activities of the Bangkok Shut Down and PDRC movement. See Chanrochanakit (2016).
7 Molam is the folk music genre from Isan, the northeast region of Thailand near the Laotian border. Lam is a vocal style, generally accompanied with a *khaen*, a bamboo free-reed mouth organ that is the primary musical instrument used in northeastern Thailand. The word *Mo* in Thai means "doctor" and in Lao means "specialist." Thus, Molam means the specialist who sings Lam. This music become an important tool for the Isan resistance movement against the Thai-centric state around the turn of twentieth century. During the Cold War period, Molam was used by both the government as the state propaganda in the anticommunist campaign and to promote democracy, while the Communists Party of Thailand (CPT) used them to criticize the Thai government.

8 Citation 5, article 112 5. Article 112 is a legal provision in Thailand's Panel Code stating: "Whoever defames, insults, or threatens the King, the Queen, the Heir-apparent, or the Regent, shall be punished with imprisonment of three to fifteen years." For the Phai Doawdin case, he was arrested and sent to jail due to his sharing the news about the new king from BBC on his Facebook in 2016. Read more in Kaweewit Kaewjinda (2017).

9 Hal Foster, "The Artist as Ethnographer," *The Return of the Real*. MIT Press, 1996.

Works cited

Chanrochanakit, Pandit. "Reluctant Avant-Garde: Politics and Art in Thailand." *Obieg Magazine* No. 2, 2016, Parallel Contemporaries: The Art from Southeast Asia, https://obieg.u-jazdowski.pl/en/numery/azja/niechetna-awangarda-polityka-i-nbsp-sztuka-w-nbsp-tajlandii-1-. Accessed 1 February 2019.

Foster, Hal. "The Artist as Ethnographer." *The Return of the Real*, edited by Hal Foster. CamMIT Press, 1996, pp. 302–309.

Kaewjinda, Kaweewit. "Thai Activists Get Prison for Posting BBC Story about King." *AP*, 15 August 2017, www.apnews.com/5d394e7dac22401eabf454fc37bed9f5. Accessed 1 February 2019.

"PDRC to Shut Down Bangkok by End of Next Week," Thai PBS, 29 December 2013, http://english news.thaipbs.or.th/pdrc-shut-bangkok-end-next-week/. Accessed 1 February 2019.

Yu, Sonia. "Thai Soldiers Censor Art Exhibition in Bangkok." *ArtAsiaPacific*, 20 June 2017, artasiapacific.com/News/ThaiSoldiersCensorArtExhibitionInBangkok. Accessed 1 February 2019.

MAGICALLY, NEW HIGHWAYS, STADIUMS, AND POLICE STATIONS EMERGE

What, How and for Whom/WHW

The global developments of the last decade have substantially changed the character of what we call the "art world." It appears that the internationalization of art in the globalized capitalist system had been completed and that there is no new region to be (re)discovered and integrated into the ever proliferating global circuit of biennials and international art shows. And yet the visibility in the field of culture is not a guarantee of power. The element of fashion—in which long-standing practices and bodies of work are reframed and presented as "new discoveries" to satiate the constant thirst of the market for novelty—should not be discounted. Various regions fall into and out of "art world" interest in line with their economic growth and recession or sometimes in parallel with their political (mis)fortunes. In the 1990s, the fall of the Berlin Wall and the opening of Eastern European markets were followed by a string of exhibitions presenting the art from the region. In the early 2000s, a number of exhibitions dealing with the Balkans followed the end of the war in former Yugoslavia and the normalization of the political situation. The optimism that followed the increased presence of artists from countries of former Eastern Europe in the global arts arena did not take into account the fact that the real power relations and different hierarchies that facilitate and enable these inclusions are far from resolved or abolished. As it usually goes, only a few artists from the region have established international careers in the long run, and heightened interest in the region was followed by a rather long period of indifference. It seems that in the last couple years, the rise of the extreme right throughout the region has sparked curiosity about the ways in which arts and culture are coping with new developments, but in this case, one has to wonder whether being in fashion is a good thing after all. David Hodge and Hamed Yousefi argue that, far from resolving it, the "globalization" of art has in fact increased and neoliberalized provincialism and the influence of Western centers. The illusion of the constant possibility of having an international "break-through" in their careers encourages artists to take part in a grueling competition process for grants, residencies, and exhibition invitations, which effectively blocks the possibility of regional or transnational solidarities and perpetuates unevenness (Hodge and Yousefi).

It should not be forgotten that the "globalization" of the art world has happened in parallel to the growth of economic disparity across different geographical regions. In a stark contrast to liberal arguments about art's autonomy, its status as a financial good—one particularly suited for speculation—is growing.[1] Art places a critical role in what Luc Boltanski and Arnaud Esquerre call the "enrichment economy," a new formation that describes the changes in the

shifting dynamics of the capitalist system over the last decades (Boltanski and Esquerre). The economy of enrichment is based on the creation of exceptional objects and experiences, while the value of an object itself is based on a story, usually rooted in the past, and the story carries the promise of the rising price of the object, discursively enriched. In the face of this, preserving the transformative, critical potential of art becomes increasingly challenging. It calls for a long-term engagement with specific social, cultural, and political concerns, as well as building a practice interrelated with actions of the social movements within a particular community and region. And yet beyond engagement and embeddedness, art's greatest potential is still in its ability to push us beyond what we take for granted, to challenge the "naturalized" conceptions of the ways in which societies are structured. In a recent article called "Beware of Artists, They Are Acquainted with All Classes!" art historian Branko Dimitrijević discusses the need to move away from a dichotomy of two seemingly opposed modes of instrumentalizing art: the one in which art's primary function is to be a commodity and the one in which its primary function is to have a clear political message. Dimitrijević argues that the politicality of art comes from its autonomous position, which enables it to be:

> [a] place of production, of thinking, where political can be created, and not a place where the political frame, as progressive as it is, can find its artistic format. If art stops producing misunderstanding, if it becomes predetermined by its importance, good intentions, progressive positions, then it, in fact, it loses its political potential. Art's political potential is in the production of the uncomfortable.
>
> *(201)*

Why an artist cannot represent a nation-state

Philosopher and writer Boris Buden characterizes the current sociopolitical constellation as "the end of post-communism," stating its global importance and that it is by no means limited to the former communist countries. According to Buden, in the aftermath of the fall of the state socialism in the late 1980s and early 1990s:

> post-communism was a condition of an unconditional belief in democracy and capitalism, free from crises and basic conflicts. It was also a belief in their universal translatability; the whole world was expected to embrace and implement Western-style democracy and identify with the promise of capitalist prosperity, as the societies of Eastern Europe after the collapse of the communist regimes so enthusiastically did.
>
> *(Fiala)*

The end of naïve postcommunist belief in the virtues and translatability of Western-style capitalist democracy came as a consequence of the awareness of its hegemonic character. Yet what is often forgotten is that democracy as we know it is neither an ornamental accompaniment nor a precursor and enabler of neoliberal markets but a result of a series of difficult political struggles that included battles both lost and won. Already before the bankruptcy of the Lehman Brothers, which still serves as both the symbolic and real marker for the beginning of the ensuing global recession, there was a strong feeling that the late 1930s were repeating. The decade that followed, defined by crisis, only made that feeling stronger, as different varieties of reactionary populism, conservative consolidation, and extreme right historical revisionism took hold in many places around the world. Although growth indexes of many countries, especially in the global north, bounced back fairly quickly, the ripples of the economic

meltdown that started in 2008 can still be felt in an increasing rift between the haves and have-nots, as well as in the constant dread of the next big bubble burst, announced daily and anxiously expected in media from all sides of the political spectrum. In the meantime, the fear of imminent economic collapse has been joined by fear of the consequences of climate changes on the planetary scale, as well as by the fear of the dissolution of political systems as we know them due to the development of complex systems of data control, analysis, and manipulation. What most can agree on is that different crises coalesce into something that is here to stay, a new normal we have to live with and endure.

Contrary to arguments that the string of crises (financial, environmental, migrant) merging into one has brought about an erosion of solidarity on all levels, Buden points out that solidarity networks are still existing—but that, in the condition of rapid erosion of the society as such, they are mediated through identity, resulting in exclusivist, xenophobic, fundamentalist, racist, or fascist forms of solidarity (Fiala). Since the 1970s, artist Sanja Iveković has been exploring the relations between gender and power from a feminist position, looking into possibilities of transforming the political uses of mediated images. In the aftermath of the violent breakup of

Sanja Iveković, *Lady Rosa of Luxembourg*, 2001.

Photo by Christian Mosar. Courtesy Sanja Iveković.

Yugoslavia and the formation of a new nation-state on its ruins in the early 1990s, Iveković's has often been critically examining the problematic procedures of the naturalization of national identities. One of her most iconic works dealing with this subject is *Lady Rosa of Luxembourg* (2001), a replica of Luxembourg's monument *Gëlle Fra (Golden Lady)*, a symbol of the country's independence erected in the 1920s commemorating the victims of World War I. The artist made a heavily pregnant replica of the female figure standing on top of the obelisk and, for the work's original installation, placed it in a public space in Luxembourg, within eyesight from the original monument. The caption honoring male heroism at the original monument's base was replaced by text in French (*la résistance, la justice, la liberté, l'indépendance*), German (*Kitch, Kultur, Kapital, Kunst*), and English (*whore, bitch, Madonna, virgin*) and was renamed the Golden Lady as Rosa Luxemburg, thus transferring an abstract, allegorical context into concrete historical circumstances.

By giving the statue the name of a real and revolutionary woman and by equipping her with a new, rather impudent inscription, Iveković questioned the benign, serene character of the female figure that is devoid of agency and used as an aesthetic ornament. This deconstruction of the iconic monument provoked fierce reactions in Luxembourg, resulting in a heated public debate that touched upon a number of neuralgic questions related to problematics of national representation. In 2018, the pregnant figure of *Lady Rosa of Luxembourg* has been installed in public space again, as part of EVA International biennial in Limerick, in the midst of the Irish campaign to repeal the Eighth Amendment and legalize abortion in Ireland. The monument's affront to the patriarchal appropriation of the female body made its transposition to different political context easy, as golden Nike is clearly pregnant by her own choice, carrying all of the attributes on her base with pride.

Iveković broached the topic of national representation again after being invited to exhibit in the context of the festival titled *Croatie, la voici*, organized by the Croatian Ministry of Culture and Institut Français for the Year of Croatia in France 2012. Iveković developed the performance *Why an Artist Cannot Represent a Nation State*, in collaboration with writer and philosopher Rada Iveković. The work was first performed in the Musée d'art contemporain du Val-de-Marne, by Rada Iveković, who read her text written for the performance, discussing the ways in which the construction of "national" at the same time excludes and naturalizes through "mechanisms *from subtraction to immunization* in order to keep others away," and by actor Isabelle Voizeux, who translated the text into sign language (Iveković). For some viewers, both the theoretical discourse and the sign language might have, at moments, seemed hermetic; yet the transposition of the text into a bodily gesture resulted in questioning the ways in which we internalize or confront dominant models of culture. Inserted as a Trojan Horse within the framework of a national festival, the performance negated the notion of our artist and stated boldly:

> An artist has no obligation to obey the logic of the nation or of the national state. In a transnational world, now, for better or for worse, she or he can only agree to a cosmopolitan vision. She or he, the artist, in the best cases, can only hope to transcend the boundaries through art, to go to the other, to others: to those who are not included in the nationality, in citizenship, in humanity.
>
> *(Ibid.)*

The work was performed once more in Zagreb as part of the *Ten Thousand Wiles and a Hundred Thousand Tricks* exhibition, organized within the framework of the itinerant festival Meeting Points in 2013.[2] This time the text was read by eight women: journalist Paulina

Photo by Christian Mosar. Courtesy Sanja Iveković.

Sanja Iveković, *Lady Rosa of Luxembourg*, 2001.

Arbutina, LGBT activist and poet Aida Bagić, workers' rights activist Đurđa Grozaj, philosopher and writer Vesna Kesić, Roma rights activist Ramiza Memedi, advocate against violence against women Nela Pamuković, LGBT activist and writer Mima Simić, and workers' rights activist Kata Šečić, while translation into sign language was performed by choreographer and dancer Sandra Banić Naumovski. The performance was held at a critical time in Croatia when several of the very few textile factories that survived globalization were being closed under bankruptcy and in the midst of a campaign leading to the referendum that would create a constitutional prohibition against same-sex marriage. Unfortunately, the referendum, orchestrated by the conservative organization On Behalf of the Family with substantial support from the Catholic Church, took place a few months after the performance and the conservative option won.[3] The referendum, which was initiated by gathering more than 700,000 signatures in the spring of 2013, marked the onset of a massive right-wing mobilization that continues to this day and that, in many ways, appropriated the know-how and working methods of the liberal nonprofit organizations that had formed the backbone of Croatian civil society in the

Sanja Iveković, *Lady Rosa of Luxembourg*, 2001.

so-called "transitional" years of the 1990s and early 2000s. *Why an Artist Cannot Represent a Nation State* did not directly tackle the issues with which the women who were reading at the stage were directly concerned, such as the massive loss of jobs for women of "unemployable" age over 50 or the referendum itself. And yet it negated the logic through which "for men of power, be they intellectuals, it is common to confuse their own biography with that of their country" and worked toward building an image of women who participate on equal terms in public affairs and politics, refuting the still dominant attitudes advanced further by the rising far right, according to which family and motherhood are still the only proper areas for women's engagement and fulfillment (Iveković).

"All that is globalized requires its local color" (Debray 42)

While discussing the devastating effects of today's "civilization," Regis Debray notes:

> This archipelago is united by business and commerce, but since an economy by itself has never made up a civilization, it must satisfy a certain number of other requirements: a film festival, a museum of contemporary art, an annual art fair, an economic forum, architectural feats (the highest tower, the longest bridge), shopping malls and six-starred hotels.
>
> *(Ibid.)*

Large numbers of people feel excluded from the PhotoShopped contemporary panorama of business, commerce, culture, and leisure. As political options that have previously been considered on the left spectrum (such as various social-democratic parties throughout Europe)

turned to neoliberal solutions for "fixing" the economy, the constant fear of being on the losing side of these processes breeds resentment that feeds the far right. What has become clear, at least since the outcome of the latest U.S. presidential election, the success of extreme identitarian politicians throughout Europe, and the result of the Brexit referendum in the U.K., is that to call people names ("xenophobes," "chauvinists," "racists," and the like) and to feel superior on the grounds of our more enlightened, cosmopolitan position does not get us very far. In this situation, the critical question of artistic internationalism becomes looking into complicated entanglements of the notion of "us" and questioning the criteria and demarcation lines for inclusion and exclusion beyond the art world, in society at large. Who are the people remaining off the radar, excluded from the economy and any real political power?

During the last decade, Victoria Lomasko has been producing series of drawings that record the hidden circumstances surrounding the political and class conflicts in contemporary Russia, such as *Slaves of Moscow* (2012), based on interviews with women from Kazakhstan who were robbed of their passports and held in slavery by grocery store owners in Moscow. Her drawings include reportages from the well-known trials of the political performance group Pussy Riot—which took place in Moscow in the spring and summer of 2012—as well as drawings of lesser known circumstances, details, and conflicts surrounding the repeated and savage state persecution of activists and grassroots anti-Putin protesters, such as the so-called Bolotnaya Square case.[4] One of her long-term projects, *Drawing Lesson*, consisted of working as a volunteer for the Center for Prison Reform, giving drawing lessons to inmates of juvenile prisons outside of Moscow.

Due to the infrequency of lessons and the high rotation of inmates, the project is more about putting the kids in contact with the world beyond prison than teaching them how to draw. Lomasko has developed a study program that works with the kids to develop analytical thinking and empathy and has put an emphasis on building their self-confidence. As in most of her projects, in *Drawing Lesson* Lomasko collaborates with social activists to gain access to the people she portrays, and the drawings are usually done on the spot with an isograph drawing pen and a sketchpad, in a quick manner and without corrections. The series of drawings are then published in books, fanzine format, or exhibited in narrative sequences. In cases when drawings cannot be shipped, they are produced through a decidedly low-tech approach: printed on simple A4 or A3 sheets. This enables Lomasko to circumvent problems of expensive distribution and insurance, as well as to avoid problems that might occur in sending the drawings through customs when exhibiting them abroad. In defiance of the culture created and exhibited in the gentrified Moscow city center, she often travels through Russian provinces and former Soviet republics, following the traces of social conflict and economic hardship. Her drawings give voice to unwanted people, invisible in the public sphere: migrant workers, grassroots political activists, sex workers, old people, members of the LGBT community, working poor, juvenile prisoners. As much as the testimonies they deliver are often shocking, brutal, and uncomfortable, Lomasko's drawings are never exploitative of the misfortunes of others. Through the drawing process, she engages with nonnormative knowledge production of the people she portrays in a way that counters the contempt or disbelief with which they are customarily met. The drawings question processes through which members of society are disowned and stripped of both their basic rights and their voices: through depicting the defiance, strength, and humor of the protagonists, they oppose victimization. Their directness and cheekiness serve as a trigger for activating empathy among equals, thus countering the patronizing, pitying gaze of the mainstream "better-to-do" public.

The boys said the concert was cool, but that it was odd the musicians were wearing slippers and torn socks.

Singer: "We're fighting a plague, we're fighting the entire Russian narcomafia."

Activists sometimes visit the penitentiary, for example, a band made up of former alcoholics and drug addicts, from the organization Transfiguring Russia. The musicians performed for the boys songs they had written about the benefits of a healthy lifestyle.

Viktoria Lomasko, from graphic reportage "Drawing Lessons at a Juvenile Prison," 2010. Ink.

Viktoria Lomasko, from graphic reportage "The Prisoners of May 6th," 2014. Isograph.

A similar project of engaging with alternative, outcast sensibilities is at the center of Želimir Žilnik's lifelong engagement with invisible, suppressed, under- and misrepresented members of society. From his beginnings in the amateur film scene of Yugoslavia in the 1960s, Žilnik has gone on to make more than 60 films, including a number of feature films and TV productions, often in the genre of docudrama. Although Žilnik's docudramas are scripted, the protagonists—who are, in most cases, nonprofessional actors—contribute to the creation of the storyline with their own experiences and are selected to take part in the film based on their ability to represent a certain "type" around which social conflict revolves. Žilnik does not shy away from melodrama, and his protagonists' "playing of themselves" calls for empathy, but at the same time it creates a distancing effect as the viewers constantly question the relationship between "the real" and "the fictional." One of the best examples of this approach is the trilogy featuring Kenedi Hasani as main protagonist [*Kenedi Goes Back Home* (2003); *Kenedi, Lost and Found* (2005); and *Kenedi Is Getting Married* (2007)], which started as an inquiry into the stories of Roma families forcibly repatriated to Serbia from Germany in the early 2000s. In the films, Kenedi attempts to visit his family house only to find out that he no longer can even access it, emigrates and gets deported yet again, attempts to raise money for paying off the debts and finishing the new family house by working as a gigolo, and finally tries to obtain entrance to Germany again through a relationship with a man. Through following the struggles of Kenedi and his family to make ends meet after European bureaucrats decided that their lives were not in danger anymore, although, in fact, they had no place to return to, Žilnik tackles the European antimigrant policies long before they became the "migrant crisis" and a feature in the mainstream media.

His latest film, *The Most Beautiful Country in the World* (2018), takes place in Vienna and follows Bagher, a young immigrant from Afghanistan, and several of his friends as they

БАКИЯ
с СЫНОМ
БАУРЖАНОМ

Courtesy Viktoria Lomasko.

Viktoria Lomasko, from the graphic reportage "Slaves of Moscow," 2012. Isograph.

struggle to find jobs and obtain legal status in Austria, while waiting for news from home and meeting the expectations of often conservative families. The film follows both happy moments and the disillusionment of the processes of "integration," as well as the way in which traditional gender roles play out differently in this process. In parallel, it provides an optimistic, encouraging look into forging different solidarity nets from new international friendships to feminist support groups and a migrant choir covering a repertoire of songs from the Balkans to Iran. In Žilnik's own words, a film—first and foremost—has to make sense for its protagonists and be a transformative experience for them; otherwise, there is no reason for making it. This interest in giving voice to the people at the margins of society—a

Courtesy Želimir Žilnik.

Želimir Žilnik, still from *Kenedi, Lost and Found*, 26 min., DV camera, 2005.

margin that is increasingly becoming majority everywhere—is taken up as a possibility to imagine a new concept of citizenship that pushes current limits and borders.

Many of Žilnik's films have prophetically announced later events that mirror topics tackled in his work, such as the dissolution of Yugoslavia, economic transition from socialism to neo-liberal order, the annihilation of workers' rights, and the wider social erosion related to labor and migration. The title of this text—"Magically, New Highways, Stadiums, and Police Stations Emerge"—is in fact taken from Žilnik's film shot in Germany in 1976: *Paradise. An Imperialist Tragicomedy*.[5] The quote is still accurate 40 years on, as building construction continues to be one of the strongest smoke screens for all kinds of political and business corruption, both in the developed countries and in the new economies of the former Eastern Europe. Culture follows the general trend, and new museums and cultural institutions in most cases provide an occasion for politicians to inaugurate it, while the programs continue to be dictated by populist political demands and by sponsorship deals.

Although from different generations—and each with his or her own distinctive approach to artistic media—the practices of Sanja Iveković, Želimir Žilnik, and Victoria Lomasko have many things in common, including a strong reliance on self-organization, a weariness toward art market mechanisms, a distancing from exclusivist approaches toward cultural produc-tion and consumption, and an awareness of one's own entanglements in social processes. The politicality of their work is in the method rather than in the subject, and at its center is the project to change the concept of citizenship and to look into new models of solidarity that would counter the growth of both cynical individualism and identitarian identifications of recent years. The forging of new solidarities and a new internationalism, built from below and standing in the opposition to the shiny world of newly built "highways, stadiums, and police

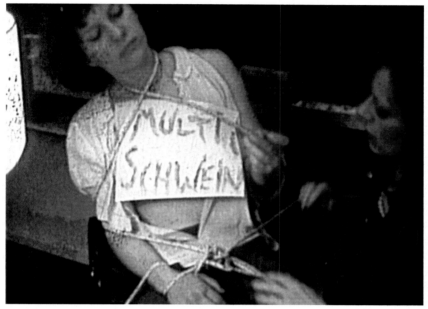

<div style="text-align:right">Courtesy Želimir Žilnik.</div>

Želimir Žilnik, still from Paradise. *An Imperialist Tragicomedy (Paradies)*, 90 min., 16 mm, color, 1976.

stations" (and, for that matter, contemporary art museums too), is a necessary undercurrent of both new left politics and critical artistic production, if they are to regain their relevance and the topicality of their address.

Notes

1 See Fraser (2012). In this text, Fraser points out that the contemporary art world actually benefited from the recent financial crisis—the biggest growth of the art market took place in countries that also had the biggest growth of inequality.
2 *Ten Thousand Wiles and a Hundred Thousand Tricks* was curated by What, How & for Whom and from September 2013 to July 2014 it took place in Gallery Nova, Zagreb; MHKA—The Museum of Contemporary Art, Antwerp; Contemporary Image Collective, Cairo; Para Site, Hong Kong; Beirut Art Center, Beirut; 21er Haus, Vienna and Institute for African Studies, Moscow.
3 The percentage of eligible people voting was 37.9%, with 65.87% voting *yes* and 33.51% *no* for the constitutional ban on same-sex marriage.
4 During an authorized opposition march in central Moscow on May 6, 2012, the day before President Putin's reinauguration, nine people (Andrei Barabanov, Yaroslav Belousov, Alexandra Dukhanina-Naumova, Mikhail Kosenko, Sergei Krivov, Denis Lutskevich, Alexei Polikhovich, Artyom Savyolov, and Stepan Zimin) were selected, seemingly at random from the tens of thousands of their fellow citizens who were also at Bolotnaya Square that day to play the role of "rioters," in the show trial that followed. In February 2014, seven of them were convicted by a Moscow court of "rioting" and "assaulting police officers" and handed heavy sentences of up to four years in prison, while Mikhail Kosenko was committed to internment in a psychiatric hospital.
5 In the aftermath of the controversy surrounding his first feature film *Early Works* from 1968, which won Golden Bear at the International Berlin Film Festival but was met with hostility by political and cultural elites, Žilnik left Yugoslavia for West Germany in 1973. There he made several well received short films

and his feature film *Paradise. An Imperialistic Tragicomedy*. The film revolves around the story of a rich capitalist faking her own kidnapping. However, being inspired by the events of the turbulent West German 1970s, the parallels got him in trouble with the authorities there too, and yet again Žilnik was forced to leave the country.

Works cited

Boltanski, Luc and Arnaud Esquerre. "The Economic Life of Things." *New Left Review 98*, March–April 2016, https://newleftreview.org/II/98/luc-boltanski-arnaud-esquerre-the-economic-life-of-things. Accessed 30 July 2019.

Branko Dimitrijević: Čuvajte se umetnika, oni se poznaju sa svim klasama! *Reč—Časopis za književnost i kulturu, i društvena pitanja*, no. 87/33, 2017, pp. 193–205.

Buden, Boris. *Zone des Übergangs: Vom Ende des Postkommunismus (Zone of Transition: On the End of Post-communism)*. Suhrkamp, 2009.

Fiala, Jaroslav. "The Ideals of 1989 Turned Upside Down [Interview]." *Political Critique*, 8 December 2016, politicalcritique.org/cee/2016/the-ideals-of-1989-turned-upside-down-interview/. Accessed 30 July 2019.

Fraser, Andrea. "There's No Place like Home." *Whitney Biennial 2012*, 2012, https://whitney.org/uploads/generic_file/file/804/_There_s_No_Place_Like_Home_.pdf, pp. 28–33. Accessed 16 December 2018.

Hodge, David, and Hamed Yousefi. "Provincialism Perfected: Global Contemporary Art and Uneven Development." *e-flux journal* 65 SUPERCOMMUNITY, May–August, 2015, supercommunity.e-flux.com/texts/provincialism-perfected-global-contemporary-art-and-uneven-development/. Accessed 30 July 2019.

Iveković, Rada. Excerpt from the performance text "Why an Artist Cannot Represent a Nation State," 2012.

Jaroslav Fiala, Interview with Boris Buden in Krytyka Polityczna, The Ideals of 1989 Turned Upside Down, 8 December 2016, http://politicalcritique.org/cee/2016/the-ideals-of-1989-turned-upside-down-interview/. Accessed 30 July 2019.

Debray, Regis, "Civilization, a Grammar," *New Left Review* 107, September–October 2017.

Ten Thousand Wiles and a Hundred Thousand Tricks was curated by What, How & for Whom and from September 2013 to July 2014 it took place in Gallery Nova, Zagreb; MHKA—The Museum of Contemporary Art, Antwerp; Contemporary Image Collective, Cairo; Para Site, Hong Kong; Beirut Art Center, Beirut; 21er Haus, Vienna and Institute for African Studies, Moscow.

PART IV

Dialogue

10 global issues,
100 art projects

PART IV: SECTION 1

State of Siege

*Project descriptions by Corina L. Apostol,
Corinne Butta, and Shimrit Lee*

STATE OF SIEGE

Justine Ludwig

It is July 16, 2006 in the city of Beirut. Musician and illustrator Mazen Kerbaj stands on his balcony and engages in a duet with an unlikely partner, the Israeli military. Kerbaj plays trumpet; the Israeli military drops bombs. In the midst of what is known to some as the July War and to others as the Second Lebanon War, a single individual is playing amid the chaos. In the recording, the sound of the trumpet provides an entry point inviting the listener to access Kerbaj's reality. The musician collaborates with trauma. The war continues for 34 days.

We live in a time of constant global warfare—terror, political violence, and revolution. We live in a time of global siege. In the wake of seismic shifts, we experience aesthetic resonances. The question is posed: how may art intercede, challenge, and upturn narratives? How may it impart urgency?

Artistic interventions offer an alternative to the media spectacle surrounding violence. They place the human and the personal at the center of the narrative—privileging the individual over statistics. This is opposed to the journalistic approach intended to create objective presentation of violence. In his essay *The Intolerable Image*, Jacques Rancière discusses the journalistic photographic documentation of atrocities and intolerability of the photographer observing and capturing a devastating event by choice. Rancière writes, "[T]his is precisely why the philosopher criticizes the photographer: for having *wanted* to witness. The true witness is one who does not want to witness" (Rancière). For artists, the representation of violence is determined by their own subjectivity. Often driven by trauma and personal experience, these projects provide local context and nuance for understanding.

The militarization of society, violence, and the siege mentality they engender is prime for news media distribution. War, terrorism, and mass shootings are recorded in images—smoking, smoldering, blood-drenched images. This is ideal content that drives media viewership and interest. It keeps people glued to their televisions, social media feeds, and newspapers. On the other hand, it denies the experience of the individual, the human cost, and the understanding of long-term ramifications. Language and documentary images fail in the face of unthinkable violence. They are flat, both conceptually and in physical manifestation. Violence is an affront to all senses.

Kerbaj's trumpet cuts through the sound of the bomb blasts and offers a digestible manifestation of the rupture that violence creates. The sound serves in opposition to the trivializing power of semantics that makes drones, mass shootings, genocides, and revolutions, as well as invasions,

feel far away and without direct affect. The musician's cyclical breathing techniques evokes a siren. One man declares he is alive in the midst of the violence through his sustained breath.

Two and a half years after Kerbaj's balcony performance, I was awoken from a deep sleep in my Mumbai apartment by a sound not totally unfamiliar. Fireworks were until that moment my frame of reference for loud cracking reverberations followed by the smell of gun powder. Experiencing terror through the television screen provides no familiarity or frame of reference. Violence is not two-dimensional. It does not belong to slick broadcast images, restrained voice-overs, or black ink on news print. Violence fills your lungs, mouth, and ears—reverberating through your entire body. It makes a home inside of you and demands you witness.

Work cited

Rancière, Jacques. *The Emancipated Spectator,* Translated by Gregory Elliott. Verso Books, 2011. p. 91.

Projects

TanzLaboratorium

The Ukrainian revolution of 2014 was a fundamental moment not only for Ukrainian recent history but also for the contemporary art community in Kiev. Local artists were key figures in the protests that led to the removal of the corrupt president Viktor Yanukovych and the toppling of his government. Artists have remained engaged in the ongoing sociopolitical processes that followed, including opposition to the forceful annexation of Crimea by the Russian Federation through military intervention.

Ukraine continues to go through upheavals wherein its territory and public spaces remain contested by local and foreign powers. One of the most engaged artist groups in Kiev that have reacted and led important discussions on recent political struggles is TanzLaboratorium. The TanzLaboratorium theater was founded in 1999 in Kiev as a space for communication between local and international dancers, performers, and sound artists. The group's artistic practice has developed by working with the body as medium and as an agent for critical thinking.

In the introduction to a recent performance celebrating the 200-year anniversary of poet Taras Shevchenko, the group wrote: "When reality is silent, art speaks for it. When reality speaks, art can only invoke its own feebleness and learn from this feebleness" (Babij). In a context in which violent struggles for power have been at the center of political life, these artists have used discreet gestures to express poignant views of their local context and relationship to the world.

In fall 2012, the curatorial group HudRada organized the project *Disputed Territory* at the Kroshitsky Art Museum in Sevastopol. The gesture of marking a "disputed territory" made conditions in the art museum and the surrounding community visible, leading to heated public discussions between local Sevastopol artists and the visitors from Kiev.

TanzLaboratorium's action *Headless* featured small headless beings accompanied by well dressed security personnel who emerged from a limousine to lay flowers beside monuments to war heroes and imperial rulers. The Sevastopol artists revealed their desire for isolation, perpetuating the rituals and memories of the Soviet cult of the Great Patriotic War (World War II), while members of the museum staff expressed their curiosity for expanding their idea of possible art forms

The exhibition text claimed:

To declare a territory as being disputed is a form of terrorism, revealing somebody's expansionist intentions. The illusion of stability turns to dust, our familiar world collapses, and off in the distance the flames of some warlike operation can be seen busily burning away.

(Babij)

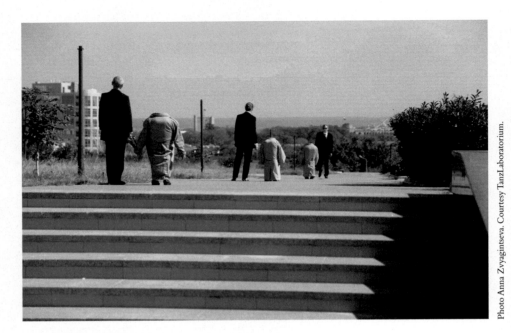

Photo Anna Zvyagintseva. Courtesy TanzLaboratorium.

TanzLaboratorium, *Headless*, 2012.

Work cited

Babij, Larissa. "Reports and Interviews From: Kiev," The Brooklyn Rail: Critical Perspectives on Art, Politics, and Culture, May 2014, https://brooklynrail.org/special/ART_CRIT_EUROPE/reports-and-interviews-from/kiev-april-29-2014

Regina José Galindo

Regina José Galindo has developed a socially and politically motivated practice in which she strives to acknowledge the 36 years of civil war endured by her country, Guatemala, while looking forward to a more peaceful and productive future. Galindo typically challenges both herself and her viewers through extreme actions, which draw attention to the violence and injustice built into power relationships. Her recent work, *The Shadow* (2017), is a nine-minute film taken from nine hours of footage that the artist spent fleeing a tank. The effort and distress involved are extremely evident. The film was made for Documenta and features a German Leopard tank from World War II, so critiquing the extensive supply of arms from German manufacturers to Galindo's high-murder-rate home nation. Previously, in her 2012 film *Tierra (Land)*, she brought into focus the criminal actions of José Efraín Ríos Montt, the former president of Guatemala, who was accused of genocide and crimes against humanity. Galindo's video is a haunting reinterpretation of the atrocities recounted during his trial. *Tierra* begins with the artist standing naked in a verdant field, the tranquility of which is shattered by an earth-moving machine. Here, Galindo alludes to the incident in which innocent citizens were murdered and coldheartedly buried in a bulldozer-dug mass grave. The stark contrast between the machine's huge, armored bulk and the artist's vulnerable body captures the injustice of Montt's regime, while the abyss that grows around her serves as a poignant symbol of the despair and alienation born out of political violence in general and of Montt's postconviction acquittal in particular. Galindo poignantly uses her body to demonstrate how state violence impacts the bodies of women and racial minorities.

With the support of the University of the Arts London and La Maréchalerie Centre d'Art Versailles. Thanks to Clare Carolin, Associate Curator. Produced by Lucy + Jorge Orta. Photo Bertrand Huet. Courtesy Regina José Galindo.

Regina José Galindo, *Tierra*, 2013. Originally commissioned and produced by Studio Orta. Realized during the Les Moulins Residency Program, 2013.

Khaled Hourani

Known for his conceptual, politically engaged art projects, Khaled Hourani also served as the artistic director for the International Academy of Art in Ramallah, Palestine. Driven by the notion that "there are possibilities in impossibilities," he sought to bring a famed Picasso painting, *Buste de Femme* (*Bust of a Woman*, 1943), for viewing at the space in occupied Palestine in 2012. The project, ultimately successful after a two-year odyssey, was done in collaboration with the Van Abbemuseum and marked the first time a European "masterpiece" was seen publicly in the West Bank. Hourani's project is not only about art but also about the protocols, agreements, ports, and checkpoints along the way, and more broadly, it speaks to the role art plays in the vision of a people struggling for a sense of normality while forging the nascent institutions of a state.

Picasso was the academy's choice not only for his iconic status but his political consciousness. "Picasso was engaged in politics, war, peace, and conflict. Yet *Buste de Femme* is not like Guernica; it's a portrait of a woman," Hourani observed. Hourani and his students, who voted between three Picassos at the Van Abbemuseum, liked the idea of bringing something "normal."

Due to the occupation and limitations on Palestinian sovereignty, what ordinarily would have been a straightforward loan from one museum to another took on a political, diplomatic, and military character. Every step in the journey highlighted the statelessness of Palestinians and the determination of the artist to overcome obstacles. However, the project also involved some form of collaboration with Israeli authorities: for example, Israel waived its deposit of 15 per cent of the value of the work to transport the Picasso to Ramallah, which underscored the reality of occupier and occupied.

Hourani argued that Picasso in Palestine showed "how bad the situation is around here, how ugly is the occupation." Palestinians have "no access to import and export things, they

Unpacking Picasso's *Buste de Femme*. Hourani, Khaled. *Picasso in Palestine*. International Academy of Art–Palestine, Ramallah, West Bank, 2012.

Courtesy Khaled Hourani.

have to work with an Israeli company." The arduous journey to bring the painting into Palestine was "part of what this Picasso is showing. It's not about the painting. It's about the circumstances. It's about the state. It's about freedom." Finally, in 2014, Pablo Picasso's *Buste de Femme*, cradled in a 200- kilogram wooden crate with the word "Palestine" stamped on its side, was lowered by crane onto the landing of the International Academy of Art–Palestine in Ramallah. At the opening, international artists, diplomats, television crews, and locals lined up to see the heavily guarded painting. While some problematized the relevance of a Picasso while Palestine is not a state, Hourani pointed out that: "What should be normal is bringing a Picasso. The thing that should stop is the occupation." These experiences were distilled in the documentary film, *Picasso in Palestine* (2012), telling the story of an almost impossible journey of a prized work of art and the resoluteness of a generation that continues to imagine a postoccupation future in Palestine.

Further reading

Tolan, Sandy. "Picasso Comes to Palestine." *Al Jazeera*, 16 July 2011, www.aljazeera.com/indepth/features/2011/07/2011715131351407810.html. Accessed 28 June 2018.

Amar Kanwar

Amar Kanwar approaches zones of conflict from many angles. Often working with film, he turns a poetic lens on the politics of power and issues of justice. His works take a situation of conflict and examines it from all sides, resulting in works featuring a cacophony of voices, each quietly interrupting the other to provide a different perspective and lend a different narrative.

The Sovereign Forest is a traveling exhibition that takes land conflicts in the Indian state of Odisha as its subject. It was produced in collaboration between Kanwar, activist and educator Sudhir Pattanaik, and graphic designer Sherna Dastur. Over the past 15 years, wilderness and farmland have been sold and rented for commercial use, taking the land away from the indigenous people and farmers who had been previously living off of it. A local resistance formed to draw attention to issues of development, industrialization, and ecological restoration. Kanwar's works focus on the land in question, providing a record—what he calls "proof"—of the profound effects of this loss on the people of Odisha.

The Scene of the Crime (2011) is a video documenting different patches of land just prior to their acquisition by mining and aluminum companies. It memorializes them in their current state, on the precipice of destruction. The work is complemented by three others—*The Counting Sisters and Other Stories* (2011), *The Prediction* (1991–2012), and *The Constitution* (2012)—a series of videos projected onto handmade books. They contain stories written by Kanwar and documentation of the lives people lived on the lands in question: images of tools, personal belongings, news items reporting on the development. Kanwar adopts the strategies of documentary and journalism to begin to ask questions through his work that problematize the way we understand crime and criminality. He asks: "Is legally permissible evidence adequate to understand the extent and nature of a crime? Can 'poetry' be presented as 'evidence' in a criminal or political trial? What is the validity of this evidence?"

Amar Kanwar, *The Sovereign Forest*, 2012. Partial view, Mixed-media installation including five films, three handmade books, two photographs, five small books, and rice seeds. Dimensions variable.

Kanwar envisions the work as not only an artwork and exhibition but a public trial. Viewers are invited not only to review his works and news clippings but also to contribute photos to the ongoing visual archive and to weigh the questions he proposes in discussion and action.

Works cited

"Amar Kanwar/*The Sovereign Forest*." Bildmuseet Umea Universitet. 2011, www.bildmuseet.umu.se/sv/utstaellning/amar-kanwar-the-sovereign-forest/tsf-sv/31466. Accessed 17 September 2018.

Kanwar, Amar. "*The Sovereign Forest*." 2011, http://amarkanwar.com/the-sovereign-forest-2012/. Accessed 17 September 2018.

Conflict Kitchen

Conflict Kitchen is a restaurant that serves cuisine from countries with which the United States is in conflict. The menu rotates every few months in relation to current geopolitical events and has featured food from Iran, Afghanistan, Cuba, North Korea, Palestine, Venezuela, and most recently, the Haudenosaunee Confederacy, a league of six indigenous nations located in upstate New York with historic ties to Western Pennsylvania. Founded in 2010 in East Liberty, Pittsburgh, by Carnegie Mellon University Art Professor Jon Rubin and artist Dawn Weleski, Conflict Kitchen uses the communal act of eating to "engage the general public in discussions about countries, cultures, and people that they might know little about outside of the polarizing rhetoric of governmental politics and the narrow lens of media headlines" ("About"). In April 2013, the restaurant relocated to the Oakland campus of the University of Pittsburgh. The first menu was Iranian, in honor of the June 2013 Iranian presidential election and the subsequent Green Movement.

Alongside the takeout restaurant, Conflict Kitchen connects with local diaspora communities and offers educational programs, including lectures, film series, trivia nights, and cooking lessons.

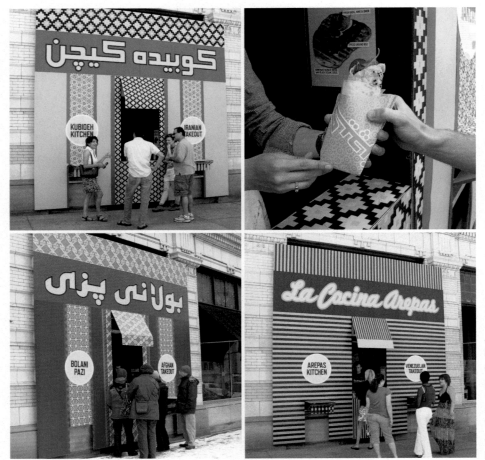

Photos and courtesy Conflict Kitchen.

Conflict Kitchen, *Iran* (top), *Afghanistan* (lower left), and *Venezuela* (lower right), 2010-2015.

For example, during the restaurant's Cuban iteration, Conflict Kitchen cohosted a Cuban dance class and lunch hour with the Malpaso Dance Company; a restaging of Tania Bruguera's participatory artwork *Tatlin's Whisper #6* in collaboration with Creative Time and other arts organizations; and a performative reinterpretation of famous speeches by Hugo Chavez and Fidel Castro. Weleski and Rubin explain that Conflict Kitchen aims to "seduce the public, on a daily basis, into cultural and political conversations that are often uncomfortable for many Americans to have because they involve recognizing the common humanity of people living in countries our government is at odds with." Part of the educational objective of each menu involves custom-designed wrappers printed with geopolitical information as well as interviews with people from the featured country. When Conflict Kitchen began serving Palestinian cuisine in 2014, the food wrappers, which featured interviews with Palestinians on topics including food, protests, and settlements, prompted B'nai B'rith International to condemn the restaurant as "anti-Israel" (Pengelly). The controversy escalated to the point where Rubin and Weleski faced death threats and were forced to close the restaurant doors permanently.

Works cited

"About." Conflict Kitchen. 2018, www.conflictkitchen.org/about/. Accessed 27 August 2018.

Pengelly, Martin. "Pittsburgh Restaurant Receives Death Threats in 'Anti-Israel Messages' Furore." *The Guardian*, 9 November, 2014, www.theguardian.com/world/2014/nov/09/pittsburgh-restaurant-conflict-kitchen-death-threats-israel. Accessed 27 August 2018.

Agung Kurniawan

Agung Kurniawan is an artist and sociocultural activist living and working in Yogyakarta. He cofounded the Yayasan Seni Cemeti [now the Indonesian Visual Art Archive (IVAA)] and Kedai Kebun Forum (KKF), a small community and art space supporting social change through art. Kurniawan started his artistic career with book illustrations, drawings, and comics, offering harsh satirical critiques of Indonesian society.

Agung Kurniawan's work *The Shoes Diary: Adidas Tragedy Series* (2009–2012) is part of his commentary on political protest from Jakarta to Ramallah and Cairo. It was recently shown as

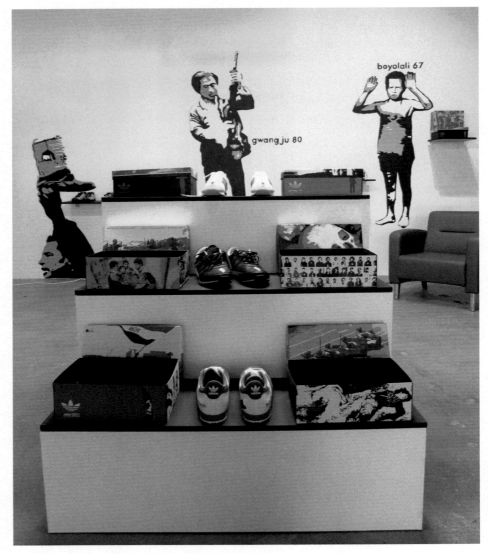

Courtesy Agung Kurniawan.

Installation view of *The Shoes Diary: Adidas Tragedy Series* in the 2012 Gwangju Biennale.

Source: Courtesy Agung Kurniawan.

part of the 2012 Gwangju Biennale, founded in 1995 to commemorate Korea's 50th year of independence and also to remember the spirit of the Gwangju Democratization Movement of 1980. The citizens of Gwangju then came together to protest against dictatorship, with an uprising resulting in many fatalities. The artist used sports shoes, which he modified to be uncomfortable when worn, as a metaphor and medium to invoke memory and to share pain so that people can remember the bitter history. For the Gwangju Biennale, with its own dark history, the project was extended to cover incidents in cities in many other parts of the world. Through this project, Kurniawan attempts to see how ideology and the spirit of revolt can move from one place to another and from one generation to the next.

In today's more connected world, what happens in another hemisphere is extensively aired on television and disseminated through social media, deeply inspiring social groups elsewhere to carry out similar acts. For instance, Cairo's Arab Spring movement demonstrated an inspiring mobility of revolutionary spirit and dynamics. In previous decades, movement was not as fast as it is now, yet the 1955 Asian-African Conference in Bandung, Indonesia, showed how the ideas and perspectives of the era could sow the seeds of nationalism and the concept of the nation-state. Phnom Penh, Beijing, and even small towns like Boyolali in Central Java have their own revolutionary histories similar to Gwangju or Jakarta.

Shoes also symbolizes a basic tool for movement, and by wearing Kurniawan's shoes, one can transform his or her pain. Kurniawan shows how pain can move in different contexts of time and space.

Further reading

"Agung Kurniawan." *ARNDT*, www.arndtfineart.com/website/artist_25876?idx=k. Accessed 30 July 2019.

Mujeres Públicas

Established in 2003, Mujeres Públicas defines itself as a group of visual activists, working between the visual arts and political activism as an effective crossroad in the communication of its feminist ideas. The group includes five women: Verónica Fulco and Cecilia Marín (who only participated in the first two years of work), Fernanda Carrizo, Lorena Bossi, and Magdalena Pagano. The group's name comes from the popular definition "public women," used for both prostitutes and women's rights activists in Latin America. The collective's actions, graphic works, and performances are often situated in the streets, which historically have been a domain for Argentina's women's movements. Their long-term work *No Title* (2003–2016) features urban posters that address, from a political perspective, women-specific problems, based on creativity and visual impact, and are understood as alternatives to the more traditional forms of militancy. The posters consist of sinister images of knitting needles (the symbol of unsafe amateur abortionists operating in a nation where abortions are illegal). Like a graphically visualized feminist shout against an oppressive religious patriarchy, *No Title* addresses the need to protect the endangered female

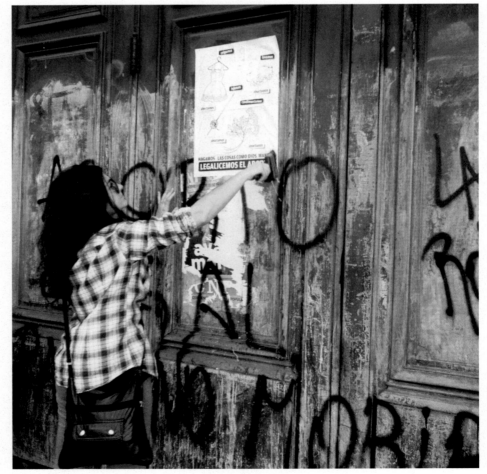

Mujeres Públicas, Dios Manda, Buenos Aires, 2011. Graphic Campaign.

body. The posters are paired with a matchbox, which features a quote from Spanish Civil War hero and anarchist Buenaventura Durutti written on it. The quote reads: "The only church that illuminates is a burning church." The group effectively uses this denunciation as a vehicle to make visible the situations of oppression suffered by women. Furthermore, they use inexpensive and reproducible materials as a method to move away from the traditional production of art. Identifying as feminists, queers, and precarious cultural workers, the group struggles for defining the rules of inclusion in political life. Mujeres Públicas uses a website that works as a platform through which audiences, in addition to knowing their work, can appropriate their visual productions and proposals, and use them in further actions, protests, or workshops. The multiple objects, posters, and flyers are constantly reissued by the members of the group and have been translated and appropriated by different feminist groups around the world.

Pussy Riot

The Moscow-based feminist punk rock group Pussy Riot was founded in 2011, right before Vladimir Putin's consolidation of power in Russia. The group had a variable number of young women members who staged unsanctioned political performances in public spaces. These were distributed as tactical media on the Internet and reached sizable national and international audiences. Pussy Riot addressed feminism(s), capitalism, human rights violations under the Putin regime, and its collusion with the Russian Orthodox Church.

In 2012, Pussy Riot staged their most infamous performance, *Mother of God Chase Putin Away: A Punk Prayer inside Moscow's Cathedral of Christ the Savior.* The women declared that their actions were directed at the Orthodox Church leaders' support for Putin during his reelection campaign. The women ascended onto the dais of the altar and sang their unflinching lyrics: "Black robes and golden epaulettes," "an Easter procession of black limousines," "gay-pride is sent off to Siberia in shackles." Pussy Riot's iconic image and radical messages were in stark contrast with the mild tone of the protest movement in Russia and its embrace of national-democratic values. Their lyrics went beyond the restrained slogans of the opposition and revealed the immense repressive apparatus in the country.

The group's actions were deemed sacrilegious by the Orthodox clergy, and, as a result, three of the group members, Nadezhda Tolokonnikova, Yekaterina Samutsevich, and Maria Alyokhina, were arrested and charged with hooliganism. They were denied bail and held in custody until their trial. Eventually, the three members were convicted of "hooliganism motivated by religious hatred" and sentenced to two years' imprisonment. Following an appeal, Samutsevich was freed on probation and her sentence suspended. The sentences of the other two women were upheld.

The trial and sentence attracted considerable attention and criticism worldwide. Human rights groups designated the women as prisoners of conscience, while the public in Russia was

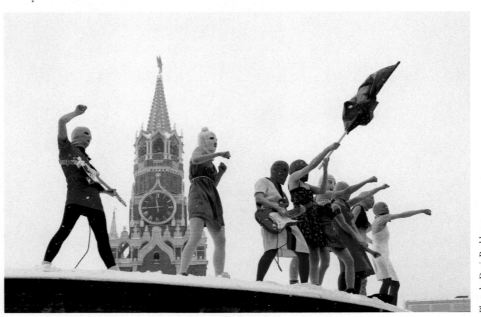

Photo by Denis Bochkarev.

Pussy Riot at Lobnoye Mesto on the Red Square, Moscow.

less sympathetic. Yet even some leading clerics in the Russian Orthodox Church came in their defense, asking for mild punishment and even pointing to the hypocrisy of their own institution. After serving one year and nine months, the State Duma granted amnesty to Tolokonnikova and Alyokhina. After the trial, the band was affected by internal disagreements, leading to its disintegration. Nonetheless, Pussy Riot represents a key moment in the history of social protest movements. Currently Tolokonnikova and Alyokhina continue to produce music, videos, and act in support of the opposition movement in Russia.

Jonas Staal

Staal explores the entanglements among art, democracy, and propaganda that generate lively public debates. Staal conceived of the New World Summit in 2012 as an alternative parliament for political representatives of organizations that have been placed on international terrorist lists. The artist considers the opaque resolutions by which these lists are routinely created as a threat to democratic politics. He cites numerous political parties, human rights organizations, theorists, and philosophers who have demonstrated that labeling an organization as a "terrorist group" is not an objective process but rather the result of certain prejudices, diplomatic, economic, or military interests by key political players.

The Summit presents a challenge to the political status quo and offers an alternative to it. The event questions the politics that are based on exclusion and deny participation to those groups that have been listed as terrorist. Through his project, Staal articulates a new kind of public space where representatives of the organizations debate the limits of the current military-industrial complex. The artist considers the event as based on a notion of fundamental democracy pursuing the ideal of an open, egalitarian society.

So far, six summits have taken place worldwide, for which Staal collaborated with producer and researcher Younes Bouadi, architect Paul Kuipers, curator Robert Kluijver, editor and advisor Gerven Oei, and designer Remco van Bladel, among others. The summits took place in Berlin, Germany (7th Berlin Biennale, 2012); Leiden, The Netherlands (Museum de Lakenhal and De Veenfabriek, 2012); Kochi, India (1st Kochi-Muziris Biennale, 2013); Brussels, Belgium (Royal Flemish Theater KVS, 2014); Derik, Rojava (2015); and Utrecht, The Netherlands (Aula

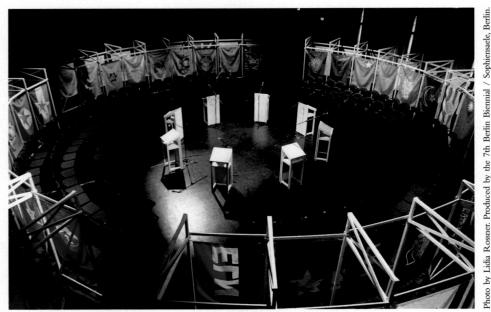

Photo by Lidia Rossner. Produced by the 7th Berlin Biennial / Sophiensaele, Berlin. Courtesy Jonas Staal.

The interior of the Sophiensaele Theater where the New World Summit–Berlin was held in 2012. Staal, Jonas.

Source: Photograph Lidia Rossner. *New World Summit—Berlin*. 7th Berlin Biennial, May 4–5, 2012, Sophiensaele Theater, Berlin, DE.

Utrecht University, 2016). During these iterations, the New World Summit hosts representatives of the Kurdish Women's Movement, the Basque Independence Movement, the National Liberation Movement of Azawad, and the National Democratic Movement of the Philippines, as well as lawyers, judges, and governmental advisors involved in high-profile cases after the passing of the Patriot Act (an antiterrorism law passed in the United States Congress in 2001 in response to the September 11 terrorist attacks in New York City and Washington, D.C.).

The New World Summit constitutes an alternative to the contemporary art spectacle as the cultural expression of neoliberal capitalism. Staal devised a political theater in which global collective resistance is acted out and alternatives are freely debated. The New World Summit thus claims art as a radical political space where an emancipatory, fundamental democracy takes form.

Further reading

Documentation on the various iterations of New World Summit on the project page available online, *New World Summit,* http://newworldsummit.org. Accessed 30 July 2019.

Lawrence Abu Hamdan

Lawrence Abu Hamdan's work centers on the political implications of sound. In 2016, Abu Hamdan, in conjunction with the organizations Amnesty International and Forensic Architecture, reconstructed the Syrian prison of Saydnaya from earwitness testimonies of former detainees. Known as the Assad regime's most notorious jail, a "black spot on the human rights map," Saydnaya has been off-limits to journalists and monitoring groups. The prison also remains largely invisible to detainees, as inmates are consistently blindfolded or forced to cover their eyes when guards entered their cell. Prisoners thus become attuned to the smallest noises and develop an acute experience of sound. Drawing from his background in music production, Abu Hamdan developed a technique of "echo profiling," whereby he could ask former detainees to identify sounds they remembered hearing in the prison, and through their auditory memories, he could construct a physical layout of Saydnaya, including the size of each cell, and the locations of doorways, stairwells, windows, and corridors.

Saydnaya (The Missing 19dc) (2017) is Abu Hamdan's installation that came out of the larger investigation. At its center is a light box that documents how the volume of the whispers of Saydnaya inmates became four times quieter after the Syrian uprising began in 2011. The drop in decibel points to the increase in violence and fear within the walls of the prison, which effectively turned into a death camp. Over 13,000 people have been executed since the protests in 2011 began. Abu Hamdan's interest in the politics of listening has previously brought him to investigate the use of audio in asylum hearings in the

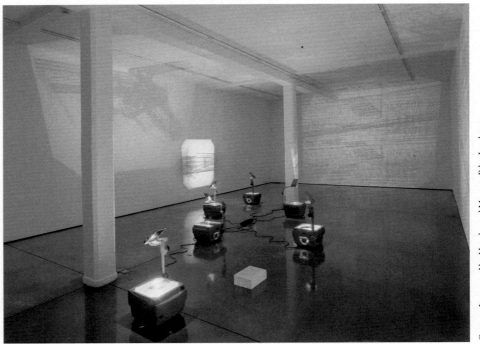

Saydnaya (ray traces), 2017. Inkjet prints on acetate sheets on overhead projectors, exhibition view, Maureen Paley, London, 2017.

Courtesy Lawrence Abu Hamdan and Maureen Paley, London.

United Kingdom, the visual soundwaves of Qur'anic recitation, the buzzing sounds of CCTV surveillance cameras, and, most recently, the sound effects of fortified border walls deep below the Earth's surface.

Further reading

"Saydnaya: Inside a Syrian Torture Prison." *Forensic Architecture*, www.forensic-architecture.org/case/saydnaya/. Accessed 6 September 2018.

Wainwright, Oliver. "'The Worst Place on Earth': Inside Assad's Brutal Saydnaya Prison." *The Guardian*, 17 August 2016, www.theguardian.com/artanddesign/2016/aug/18/saydnaya-prison-syria-assad-amnesty-reconstruction. Accessed 6 September 2018.

PART IV: SECTION 2

Surveillance

Project descriptions by Corina L. Apostol,
Corinne Butta, and Shimrit Lee

DEMILITARIZING THE ALGORITHM

Mari Bastashevski

In Andrew Niccol's dystopian drama *Anon* (2018), set in a future where every civilian wears an internal video recorder not dissimilar to those in *Deathwatch* (1980), a woman that is identified to us as The Girl makes a career of replacing memories, directly collected from the human cortex, in the state surveillance database. With an extensive arsenal of hacking skills at her disposal, she patches up personal identities just enough to get her clients off the hook. She works and lives in a luxurious solitude.

The film features one of the latest examples of a paranoid hero, a political artist and a lone wolf in an asymmetrical struggle against algorithmic surveillance. From artworks based on the Snowden archive to frameworks for methodical paranoia, theories of creative camouflage, and widespread advocacy for permanent, on-principle encryption, the conversation about surveillance seems to be stalled in the militant subjectivity it aims to oppose.

The familiar argument that, in gaining access to the military machines of countersurveillance, a civilian can undermine the power of the corpo-state, neglects to take into account that an access to technology is equally capable of subverting the individual, further eroding the already illusory border between an individual, a corporation, and a state. The good guy with a gun? After dedicating her life to an obsession with struggle against the surveillance, it would seem that The Girl can only desire her archnemesis, the policeman. This affection is, of course, mutual, but what does that achieve for anyone who refuses to mimic the state methodology? More importantly, how does this union influence the viewers' perception of the supposedly highly sophisticated surveillance machine?

What little temporary respite the militant protectionism provides from the very paralysis it induces is far surpassed by the dangerous idea it perpetuates by replicating the image of a sovereign-with-a-human-face, the detective character played by Sal Friedland.[1] This only exacerbates the built-in paranoid logic of the surveillance machines by reiterating to the algorithms that anything with a face is a potential target for somebody.

Unlike in the grid-futurism scenario of an all-seeing state in *Anon*, neither the state nor the thousands of companies and users engaged in perpetual surveillance and in, simultaneously, being surveilled, control any fraction of the global transactional surveillance network connected across political spectrums and political power.[2] The network sprawls through previously disconnected hubs of states, markets, individual communities, and private search histories. In exceeding the access and political influence of any one Despotic State or singular company, the network

designates its own sovereignty and, in that, reverses the role of a human as a proprietor of the surveillance machine. However, it is not the complete capture of subjects but their obfuscation— the unreadable that insists on difference—that both prevents those who employ this data from recognizing themselves as equally viable targets and allows for its continued justification.

Behind the fear of totalitarian control over surveillance nests the fear of an impossibility of control over a network that does not adhere to the vertical hierarchies of power governed by the rules that rely on distinctions among individual, curated identities. As an exercise in alleviating the imagination from paranoid paralysis, let's imagine this has already occurred. The discussion of surveillance today is no longer who regulates and controls the data but what sort of ecosystem and militant logic is necessary to imagine a liberal algorithm, one intelligent enough to negotiate the relationship between itself, a human, and the unstoppable surveilling apparatus of algorithmic power at work today.

Notes

1 Sal Friedland, the detective played by Clive Owen in *Anon*.
2 Parisi, particularly her book *Contagious Architecture*, served as the inspiration for thinking about affinity and taking algorithms seriously. The urgency to speak against the production of paranoia arose during a protracted correspondence with a curator Lesia Prokopenko (Parisi).

Works cited

Anon. Directed by Andrew Niccol, performances by Clive Owen and Amanda Seyfried, K5 International, Altitude Film Distribution, 2018.

Deathwatch. Directed by Bertrand Tavernier, performances by Romy Schneider, Harvey Keitel, Harry Dean Stanton, Max von Sydow, *Quartet Films*, 1982.

Parisi, Luciana. *Contagious Architecture: Computation, Aesthetics, and Space*. MIT Press, 2013.

Projects

Zach Blas

Blas's artistic practice engages security technologies as well as queer politics. His recent long-term project *Facial Weaponization Suite* (2011–2014) consists of collective masks that cannot be detected as human faces by biometric facial recognition software. The masks are made in workshops by aggregating the biometric facial data of participants, allowing them to resist governmental biometric control. The workshops are coordinated in art or community spaces and divided into two parts. During the first session, the artist facilitates a discussion around global and local politics of biometrics and face detection. Next, to develop a mask, Blas scans all the participants' faces in order to obtain a 3D model of each one. Afterward, a 3D model of a mask is generated from the participants' facial data. The artist brings this data together in 3D modeling software and gathers it into a composite, resultin in a face resembling an abstract surface that is biometrically unrecognizable. Blas produces a mask mold from the 3D mold, which he then uses to vacuum-form masks. In the second stage of the workshop, each participant receives a mask and tests wearing it. Finally, the group engages in masked public intervention that highlights the inequalities of biometric facial recognition.

Blas created the first *Facial Weaponization Suite* mask, *Fag Face Mask* (2012), in response to scientific studies that link the successful determination of sexual orientation through rapid facial recognition techniques. The artist generated the mask from the biometric facial data of several queer men's faces, which he collected during a workshop in Los Angeles. The resulting *Fag Face Mask* was colored fuchsia and resembled an amorphous blob. Countering the scientific

Facial Weaponization Suite: Procession of Biometric Sorrows (2014). MUAC, Mexico City, Mexico.

determinism of sexual orientation, this mask engenders an opacity that eschews such readability. Blas conceived of the mask not as a denial of sexuality but rather as a collective and autonomous means of self-determination that evades conventional identification rules. In March 2013, the artist organized a second *Facial Weaponization Suite* workshop at Reed College in Portland. There, he facilitated a mask-making workshop together with students and produced a paper mask as a DIY alternative to the previous plastic version.

Similar to present-day and historical collective protest tactics that evade individual recognition, like the Zapatistas, Anonymous, the Black bloc, and Pussy Riot, wearing the faces of a collective makes participants unrecognizable. The masks have both practical and utopian characteristics: while they can function to prevent biometric facial detection in everyday life, they are also aesthetic tools for collective transformations of the face. Blas considers the masks as weapons of defacement that escape governmental recognition control and engender a queer illegibility that disallows facile categorizations of identity. Straddling the paradox of recognition, the masks make us question who is co-opted, who is rejected, and why. *Facial Weaponization Suite* posits illegibility as a radical strategy against governmental forms of inclusion and exclusion, liberating participants to grasp a queer horizon beyond official recognition and identification.

James Bridle

James Bridle is a British artist and writer whose work explores themes of surveillance, artificial intelligence, and the hidden side of technology. He has lectured and written extensively on what he terms the "New Aesthetic," the visual and social systems produced by the blending of virtual and physical realities. His *Drone Shadows* series (2012–2017), in collaboration with designer Einer Sneve Martinussen, is a collection of full-scale drawings of unmanned aerial vehicles in public spaces meant to expose the invisibility of the U.S.-led covert drone program. Bridle's installation acts as a public memorial to unseen drone victims and forces a reckoning of what is justified under the guide of "security." In a similar vein, his *Dronestagram*, in collaboration with the Bureau for Investigative Journalism, was a three-year project in which Bridle posted images of the landscapes of drone strikes to Instagram, Twitter, and Tumblr. It has also been exhibited as an interactive installation.

In *Every CCTV Camera* (2017), Bridle attempted to photograph every CCTV camera in London's congestion charge zone, an area in the center of the city where motorists must pay to drive. The series interrogates how the notion of a "smart city" opens up new venues for surveillance and policing. In *Citizen Ex* (2015), Bridle developed a downloadable Chrome plug-in which identifies the physical locations of the websites one visits virtually, compiling what he terms "algorithmic citizenship," a form of belonging linked to our data, which is constantly being revised and multiplied based on our Internet activity. The *Citizen Ex* extension works out the location of a website based on its IP address, the same process used to work out a user's location. While the Internet may bring us together by bridging nations and continents, algorithmic citizenship demonstrates how the same technological processes are used by government surveillance agencies like the National Security Agency (NSA) and Government Communications Headquarters (GCHQ) in what amounts to a nearly limitless invasion of our privacy.

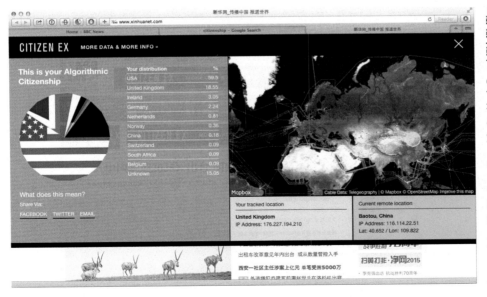

Co-commissioned by The Space. Created for Southbank Centre's Web We Want festival. Courtesy James Bridle.

James Bridle, *Citizen Ex,* 2015. Digital capture, project site: http://citizen-ex.com/.

Metahaven

Founded by Daniel van der Velden and Vinca Kruk, Metahaven's practice spans art, filmmaking, writing, and design to provoke new imaginaries that are equally bound to aesthetics, poetics, and politics. Recent work has focused on a critique of the notion of the "brand state," promoting or creating reputations for countries, and explored the possibility of dismantling branding itself.

Music videos by Metahaven include *Home* (2014) and *Interference* (2015), both for musician, composer, and artist Holly Herndon, as part of an ongoing collaboration. Metahaven's full-length documentary and multimedia exploration, *The Sprawl (Propaganda about Propaganda)*, was made between 2015 and 2016. Composed of a documentary film, multichannel video installation, YouTube channel, and website, the project's point of departure was the shooting down of Malaysia Airlines Flight 17, which crashed in conflict-fraught eastern Ukraine in 2014. The incident prompted competing media narratives, with Russia and Ukraine offering divergent interpretations of the event. *The Sprawl* explores such mutation and multiplication of information in the age of social media and constant surveillance, where events such as the Malaysian Airlines crash not only generate instantaneous and competing messages but exist alongside other global news events such as the migrant crisis and the ongoing wars in the Middle East. *The Sprawl* adopts a dispersed format in order to occupy the same space as its subjects, becoming, as Metahaven describes it, "propaganda about propaganda."

As its name suggests, *The Sprawl*'s form does not submit to easy categorization. It includes an audio recording made by the Ukrainian Security Service supplied to the Dutch police investigating the crash; talking-head scenes with journalist Peter Pomerantsev, artist and theorist Maryam Monalisa Gharavi, and academic Benjamin H. Bratton; grainy "citizen journalism" videos from the Bahraini uprising of 2011, which Gharavi uses to demonstrate how the uprising's narrative was effectively "erased" in mainstream media; studio shot clips of actors gazing at

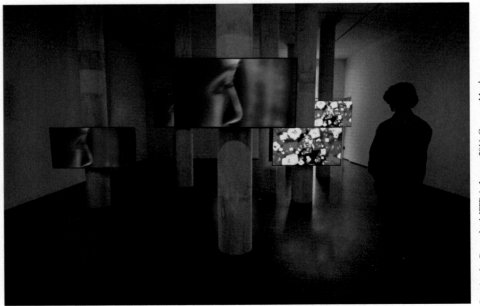

Metahaven, *The Sprawl*, 2016. 70 min. immersive video, installation view.

Premiered at Rotterdam's IFFR in January, 2016. Courtesy Metahaven.

screens amidst plumes of smoke; and passages from Russian literature, including a poem by Anna Akhmatova and an extract from Leo Tolstoy's 1897 book *What Is Art?* read by a Russian narrator. These elements are presented in a nonlinear combination of cinematic and documentary devices, empowering audiences to construct their own narrative arc. *The Sprawl* is less focused on getting to the truth behind the tragedy of the Malaysian airline crash than it is on the impact that the Internet's array of conflicting narratives has on reality.

Works cited

Metahaven. *The Sprawl*, 2016, http://sprawl.space/. Accessed 16 July 2018.
Metahaven and Marina Vishmidt, editors. *Uncorporate Identity*. Lars Muller, 2010.

Trevor Paglen

Visualizing the architecture and symbolism of the surveillance state is one of the core themes of artist and writer Trevor Paglen's work. The artist photographs "that which cannot be seen." He has been exploring the secret activities of the U.S. military and intelligence agencies for the past decade, publishing, speaking, and creating arresting visual works. The artist is interested in questioning the widely accepted notion of documentary as a form of truth telling. In the

ICE ROCKET

ICE ROOT

ICE SCRAPER

ICE STORM

ICEBERG

ICEBLOCK

ICEBOX

ICECREAM HORNET

ICEFLOW

ICEMEN

ICEPACK

ICEPICK

ICY WORLD

IDLE DONKEY

INCANDESCENT MOON

INCENSER

INDRA

INFINITE MONKEYS

INNER THREAD

INSENSER

INSULT SPASM

INTERQUAKE

INTERSTELLAR DUST

INTREPID SPEAR

INTRUDER

IRASCIBLE HARE

IRASCIBLE MOOSE

Courtesy Trevor Paglen.

Still from Paglen's *Code Names of the Surveillance State* (2015). Paglen, Trevor.

Source: Code Names of the Surveillance State. 2015, Three-channel video HD video installation on three TV monitors, looped, 121½ × 23 × 1¼ in.

series *Limit Telephotography* (2007), for example, he employed astrophotography optical systems to capture top-secret governmental sites around the world, such as the National Reconnaissance Office Ground Station in New Mexico; The Salt Pit, a previously secret CIA prison, northeast of Kabul, Afghanistan; or a U.S. Surveillance Base near Harrogate, Yorkshire. In *The Other Night Sky* (2007), he used the data of amateur satellite watchers to track and photograph one 189 classified spacecraft in Earth's orbit. Paglen's large-scale, exquisite images work within and subvert the classical language of art history to bring to the forefront the deep structures of the surveillance state.

Indeed, the artist is invested in developing a cultural vocabulary around surveillance. In his view, audiences routinely consider government agencies as separate from civic institutions, thinking and speaking about them in abstract terms. In the video installation *Code Names of the Surveillance State* (2014), the artist included more than 4,000 National Security Agency (NSA) and Government Communications Headquarters (GCHQ) surveillance program code names, culled from the Edward Snowden files. The artist projected the information onto public buildings in London (including the British Parliament) as a looped scrolling column. The code names he selected were deliberately nonsensical and humorous, without discernible connection to the programs they designate. For example, Fox Acid referred to an NSA-controlled server that inserted malware into web browsers, while Mystic was a program to collect every phone call originating in the Bahamas. The installations ridiculed and exposed the NSA's attempts at being opaque to audiences, presenting a decontextualized, seemingly endless stream of found text that allowed audiences to laugh back at the surveillance state.

Further reading

Paglen, Trevor. "The Other Night Sky." 2007, project documentation available online, www.paglen.com/?l=work&s=othernightsky&i=2. Accessed 30 July 2019.

Paglen, Trevor. "Code Names of the Surveillance State." 2014, project documentation available online, www.paglen.com/?l=work&s=code_names_of_the_. Accessed 30 July 2019.

Laura Poitras

Around the world, Poitras is best known for her groundbreaking films focused on the U.S. government's post-9/11 War on Terror. The first film *My Country, My Country* (2006) focused on life in Iraq under U.S. occupation; the second, *The Oath* (2010), on the detainment of prisoners at Guantánamo Bay; and the third, *Citizenfour* (2014), on Edward J. Snowden's leak of classified National Security Agency documents, which revealed mass surveillance and extensive drone wars.

These investigations were continued in Poitras's exhibition at the Whitney Museum, *Astro Noise* (2016), an immersive installation of new works on the nexus of mass surveillance, drone programs, torture, and occupation. The title is inspired by the name Snowden gave to an encrypted file of evidence, which he shared with the filmmaker in 2013. It also refers to the faint sound of thermal radiation disturbance echoing from the Big Bang. The installation began with *ANARCHIST* (2016), comprised of seemingly banal inkjet prints that beget another meaning as they are revealed to be descrambled surveillance ephemera from the U.K. Government Communications Headquarters, which operated from a mountaintop listening post in Cyprus. Among the files provided by Snowden were a series of "snapshots" from Israeli drone feeds, which offer a rare glimpse at the closely guarded secret of Israel's drone fleet.

In a recent interview, Poitras emphasized the importance of transparency in the era of total surveillance and of audiences beginning to understand the information collected by the government: "If it's a secret system where people can't give their version of events, you're creating a very dangerous situation in terms of civil liberties. That's the context in which you should look at this . . . exhibit."

Laura Poitras, *ANARCHIST*, 2016.

Further reading

Abedian, Anita. "The Sleepless Nights of Laura Poitras: The Snowden Collaborator and Award Winner on Her Return to New York." *The Village Voice*, March 2016, www.villagevoice.com/2016/03/01/the-sleepless-nights-of-laura-poitras-the-snowden-collaborator-and-award-winner-on-her-return-to-new-york. Accessed 13 November 2018.

Hito Steyerl

Steyerl's work investigates the connections among media, technology, and the global circulation of images. She pushes the boundary of traditional video through layers of metaphors and poignant humor, thinking through the consequences of contemporary technology and its role in everyday life. In her seminal essay, "In Defense of the Poor Image" (2009), Steyerl traced the "economy of poor images," how their usage has developed and is perpetuated, and how their status within a certain hierarchy of pictures is designated. Steyerl defined the poor image as "a ghost of an image, a preview, a thumbnail, an errant idea, an itinerant image distributed for free, squeezed through slow digital connections, compressed, reproduced, ripped, remixed, as well as copied and pasted into other channels of distribution." The artist argues that images no longer function as a representation or index of an established truth and instead actively construct our reality.

HOW NOT TO BE SEEN: A Fucking Didactic Educational. MOV File (2013) is a witty parody of an instructional video, in which Steyerl outlines strategies to avoid being seen: hiding in plain sight, shrinking down to a unit smaller than a pixel, living in a gated community, being female and over 50 years old, being undocumented. A robotic male voice reads out the instructions, and the artist herself, along with several anonymous figures, demonstrate the proposed methods. Many of them like to swipe, to shrink, and to take a picture, which represents gestures familiar to using an iPhone. The choreography of the characters in the video refer to both virtual and material worlds.

Nowadays, images are a form of currency, and sharing images online is a proof of existence. Online, information can be erased, sociopolitical realities can be revised, and people can disappear. These dimensions are highlighted in the video, which was filmed in a California desert covered in photo calibration targets (whose primary use is to test the focus of airplane cameras). In part, this photographic precision led to the development of unmanned aerial vehicles (or drones), allowing them to hit their targets. Soldiers sitting behind a computer screen control the actions of the plane and its weaponry. How not to be seen, then, is to be physically elsewhere.

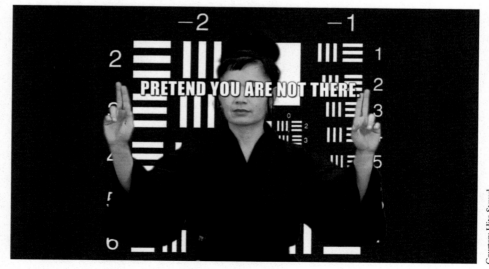

Hito Steyerl, *How Not to be Seen*, 2013. Video still.

Steyerl emphasizes how surreal this situation is by superimposing a computer desktop onto the desert landscape, with anonymous figures in green bodysuits dancing ecstatically in front. Meanwhile, the robotic voice-over explains that while "resolution measures the world as an image," the "most important things want to remain invisible. Love is invisible. War is invisible. Capital is invisible." Steyerl's work makes visible these "most important things," connecting economies of images, violence, entertainment, affect, and capital.

Further reading

Steyerl, Hito. "In Defense of the Poor Image." *e-flux Journal*, no. 10, November 2009, www.e-flux.com/journal/10/61362/in-defense-of-the-poor-image/. Accessed 30 July 2019.

Steyerl, Hito. *How Not to be Seen: A Fucking Didactic Educational. MOV File*, (2013), 15:52, www.artforum.com/video/mode=large&id=51651. Accessed 30 July 2019. All further quotes from the film.

Hasan Elahi

Elahi's work turns the surveillance state on its head, at once pointing to its structural flaws and our own complicit participation it in. Since 2002, the artist has meticulously documented his life: every airport he's been in, bed he's slept in, meal he's eaten, and bathroom he's used. In 2002, Elahi was held by the I.N.S. upon return to the United States from a business trip abroad. He was interrogated on his whereabouts on September 12, 2001 and on his comings and goings over a period of six months. Confused and scared by the amount of data that had been collected on him, unbeknownst to him, Elahi cooperated fully.

After several hours of conversation—in which Elahi shared his personal calendar and reviewed each of his daily whereabouts—the agents began to realize there was a mistake. Elahi was allowed to leave freely on the condition that he "check in" regularly with the F.B.I. These check-ins would turn into the artist's ongoing project *Tracking Transience* (2002–present). At first, he simply sent the requisite e-mails to agents, updating them on his movements and activities. Slowly, these messages became longer and longer, including links and images. Eventually—even after Elahi was given official clearance—he decided not only to maintain this personal archive but to make the running log public through his website.

Began just as social media started to become mainstream, *Tracking Transience* illustrates the self-surveillance that we willingly partake in every time we share our location on social media. By making this information public, we provide easily accessible data on our activities, where once the F.B.I. might have had to go to greater lengths to track our every movement. But Elahi has a theory: this overwhelming amount of information can work as a mask. He writes, "Making my private information public devalues the currency of the information the intelligence gatherers have collected" (Elahi). If the market of information is "flooded" by what is provided freely and willingly, truly secret intelligence is not only harder to obtain but of less value.

Hasan Elahi, *Tracking Transience*, 2002-present. Image capturing showing artist's location October 17, 2009.

Elahi's database highlights the flaws in the surveillance system at not only accurately identifying those it supposedly tracks but also at keeping up with the changing structure of information flow. The artist provides us, as networked and self-surveilling users, an opportunity to use that "transparency" to our advantage.

Work cited

Elahi, Hasan. "You Want to Track Me? Here You Go, F.B.I." *The New York Times*, 29 October 2011, www. nytimes.com/2011/10/30/opinion/sunday/giving-the-fbi-what-it-wants.html. Accessed 16 August 2018.

Jill Magid

Artist and writer Jill Magid has developed a body of work that directly engages with the intimacies and secrecy embedded within systems of power. Notably, the artist's projects have grown from her own experiences inside authority systems: the military, the police, and the intelligence agency. The experience of being mentored as a spy between 2005 and 2008 (after being commissioned to create a new work by the Dutch General Intelligence and Security Service) was the focus of her exhibition *Authority to Remove* (2011) at London's Tate Modern. The same security organization would eventually confiscate her novel, *Becoming Tarden*, from the exhibition after threatening the artist they would recover the manuscript.

Indeed the exhibition was centered around the artist's aforementioned novel, which tells the story of the artistic commission for the Dutch Secret Service's new headquarters. Fascinated by the prospect of transforming herself and become an agent, Magid went on to obtain security clearance, which allowed her unprecedented access into the organization. Her experience from artist to agent was similar to that of Tarden, the protagonist of the novel *Cockpit* (1975) by the Polish-American author Jerzy Kosinski. Like Tarden, Magid is a gifted mimic, an expert role player, who delves into the complex matrix of mystery, fact, and fiction that is the world of intelligence agencies.

During her training, the artist was forbidden to record and instead documented her meetings with secret agents by keeping handwritten notebooks, from which she created artworks such as the neon sculptures from the series *I Can Burn Your Face* (2008), an expression referring to the threat of exposing an agent's identity. On display in the exhibition were both Magid's manuscript, redacted by the Secret Service, and her unredacted novel, *Becoming Tarden*, made inaccessible under a glass case. After its removal, it became the property of the Dutch Government. The texts on display, paradoxically, are not so much about revealing secrets but about revealing

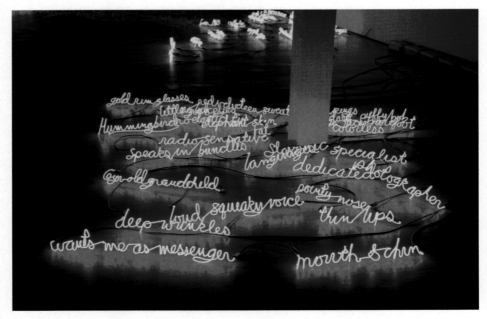

Courtesy Jill Magid and Russell Perkins.

Jill Magid, *Authority to Remove*, 2009-2010. Installation view, Tate Modern, London.

a world in which survival and doom, reward, and punishment are interdependent. As Magid herself has stated in her report for the Secret Service on the Subject of Its Face: "The secret itself is much more beautiful than its revelation."

Further information

"Level 2 Gallery: Jill Magid." *Tate*, www.tate.org.uk/whats-on/tate-modern/exhibition/level-2-gallery-jill-magid. Accessed 13 November, 2018.

Paolo Cirio

In 2007, Google launched its now ubiquitous StreetView platform in several cities in the United States, which has since expanded to include cities and rural areas worldwide. Streets with Street View imagery available are shown as blue lines crossing Google Maps. Google Street View has displayed panoramas of stitched images documenting apartment blocks, sidewalks, storefronts, subway stops, and also, occasionally, the people who inhabit these cities. According to conceptual artist, hacktivist, and cultural critic Paolo Cirio, all these images have been misappropriated. He observed: "It's really interesting for me that Google didn't ask permission to do what they did, just going around every single city in the world and taking pictures without even alerting the police, or the public administration."

As a response to this privacy violation, Cirio combed Google Street View for pictures of people, then printed life-sized versions of them and posted them without authorization at the same locations where they were taken by Google. Appearing in several cities across the United States, Europe, and Asia, the clipped Internet pictures have been further repurposed and blurred to bring the conflicts over legal privacy aspects, economic considerations, and visual perception to the attention of the public. The artist refers to his practice as "de-virtualizing" people, reenacting the very real consequences of the infowar in today's city, where governments, corporations, and citizens are fighting over the boundaries between public and private information. The "digital

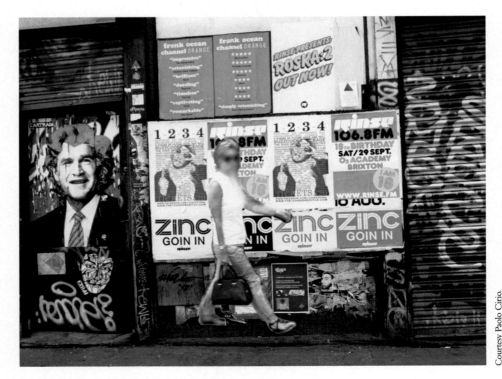

Paolo Cirio, Street Ghosts, 2008-present. Photo documentation.

shadow haunting the real world," as the artists refers to these images, have become manifest in the public realm raising the questions over how we negotiate our presence in this space and if our portraits truly belong to us.

Further reading

Badger, Emily. "Bringing the 'Ghosts' of Google Street View to Life." *CityLab*, September 2012, www.citylab.com/design/2012/09/bringing-ghosts-google-street-view-life/3424/. Accessed 13 November 2018.

Xu Bing

While primarily known for his large-scale installation work and printmaking, which make the audience question conventional understandings of the visual, Xu Bing's practice took an unexpected turn with his ambitious film debut, *Dragonfly Eyes* (2017). The feature film appears to be a romantic story as old as time; however, it defies categorization as it is dramatized through the slicing and stitching of over 10,000 hours of surveillance footage culled from the Internet. In China, a country where film censorship continues to be stringent, there are over 200 million surveillance cameras capturing everything from everyday activities to dramatic, even violent events.

Who is the camera operator? Who are the main actors? Is the film a documentary or a fiction? These straightforward questions are not easily answered as the real-world situations and images are mediated by security cameras operating in a terrifying and unknown landscape.

The artist takes the story of finding one's object of desire into a sharp analysis of identity, privacy, and digital communication.

The protagonist, Qing Ting (voiced by Liu Yongfang) is a young woman who leaves her Buddhist monastery training behind for a job in a dairy factory. There she meets Ke Fan (voiced by Su Shangqing), an agricultural technician who follows her when she quits and moves to another city. Qing Ting gets fired from her next job at a dry cleaners after being impolite to an entitled client and becomes a waitress. Ke Fan gets revenge on the woman who was rude to his beloved, and he is put in prison for his actions. While he is in jail, Qing Ting gets plastic surgery and becomes an online chatroom celebrity, going by the pseudonym Xiao Xiao. When he is released, Ke Fan realizes she has changed identities and is desperate to find her. Using a melodramatic plot line, Xu Bing weaves together critiques of reality television, our obsession with celebrities (and plastic surgery), and the appeal of video chat rooms, in a world where our lack of privacy increases as does the violence around us.

Xu Bing, director. Dragonfly Eyes, 2017. 81 minutes, Video still.

Further reading

Frazier, David. "Man, Machine or Dragonfly?" *Asia Art Pacific Magazine*, March–April 2018, http://artasia pacific.com/Magazine/107/ManMachineOrDragonfly. Accessed 13 November 2018.

PART IV: SECTION 3

Confronting inequity

Project descriptions by Corina L. Apostol,
Corinne Butta, and Shimrit Lee

APHRODITE

Núria Güell

The law does not always embody what is just, singular, or urgent. In Spain, visual artists don't have a specific legal designation and, until not long ago, could acquire working rights only if they contributed to Social Security under the category of "Professional Bullfighters and Other Spectacle Providers." This gesture is symptomatic of the indifference of legislators—and the disdain of the administration—toward the specificity of our labor. Despite the fact that we often work for public institutions, we are not public servants, we are not providers, and we are not businesses. We occupy agendas and cultural centers imbued in variegated kinds of precariousness: they demand flexibility, self-exploitation, extreme mobility, job insecurity, low wages, and deregulation of working rights—a list that runs even longer if you are a woman who wants to be a mother.

My 2017 project *Aphrodite* consisted of asking the Museum to commit the production budget for my work to instead pay for my Social Security contributions for seven months, the minimum length required in order to receive maternity leave pay in Spain.[1] With a lawyer's help, I wrote a template for a contract clause—a template that any artist could incorporate into their contracts—stating that the institution would cover the Social Security contributions due from the artist. After many conversations and disagreements with the Museum's lawyers, they finally refused to accept that clause, but agreed to comply using the money intended for the production of the work to cover my Social Security.

My piece is titled *Aphrodite*. If I talk about maternity, love, and beauty—all attributes assigned to the myth of Aphrodite—we will all agree that these are qualities worthy of respect. I am not going to talk about the role of beauty and love in our society, but about motherhood, about what happens to a woman when she wants to be a mother, to a real woman, not to a goddess or a virgin, or to a symbol of nature or the Earth, or anything like that. The trouble is that the body and life of that real woman are not as respected as that of the childbearing goddess.

Motherhood and fertility are well suited to become symbols of worship. They fit perfectly in museums and temples but not in a body. In other words, the reproductive capacity of women is seized by power, severed from her body. Those are the grounds on which Power stands to manage her. What happens when we talk about motherhood not in the realm of artistic representation but that of the cultural industry?

Power finds it irrelevant that individuals classified as artists, in the exercise of their profession, have a decent, mediocre, or even impoverished life. Artists—those who have a body, not those

APHRODITE*

TEMPLATE CLAUSE FOR THE ASSUMPTION OF THE SOCIAL EXPENSES OF THE VISUAL ARTISTS BY THE INSTITUTION THAT COMMISSIONS THE WORK

This clause can be utilized in contracts with cultural institutions so that they cover the social costs that the artist is obliged to take on due to social security needs. The clause has a limited scope: what it does allow is the justification of the aforementioned social expenses (for the so-called self-employed) as necessary expenses for the production of the work in the hopes that the institution, and not the artist, economically covers these costs.

"Both parties agree that the monthly fees of the RETA, or the Special Regimen for the Unemployed, that the Author must pay for their Social Security during the period of execution of the artwork for the fulfillment of the present contract will be imputed as production expenses of the current work. The institution commits to paying for the aforementioned costs per invoice issued by the Author whose intention will be specified as follows: "production expenses: fees for the RETA." The maximum amount of fees for the RETA that the Author is authorized to impute as production expenses in virtue of the current clause is [x]€ (including taxes).

For purely explanatory purposes, the Author demonstrates knowledge of the fact that the payment of contributions to Social Security in the RETA is a personal obligation of the Author when it comes to Social Security and, as a consequence, the Institution will not obey in the case that the Author does not comply with her obligation of payment of the aforementioned contributions."

Núria Güell Serra, September 2017, Spain

*Aphrodite consisted in me asking the museum to allocate all the production costs to the payment of the fees of my social security over the course of six months, the minimum required to cover the lowest provision of maternity. To this end, with the counsel of a lawyer, I compiled this template clause.

Núria Güell, *Aphrodite*, 2017. Translation of the clause requiring the museum to pay for the commissioned artist's social expenses.

when she wants to be a mother,
to a real woman, not to a goddess ...

Courtesy Núria Güell.

Núria Güell, *Aphrodite*, 2017. Still from press conference video documentation.

who have become a myth——-are, surprisingly, an annoyance to the Art *dispositif*.[2] If we have not yet been removed from it, it is because, somehow, they believe we remain crucial to its survival. Art, as an institution, keeps on functioning because, in the sphere of power and public opinion, art still enjoys a degree of cultural prestige and material value, even if what it signifies on a larger scale is doubtful. The possible response of Power, usually substantiated through bureaucratic tricks or moral excuses, is to fight these public outbursts by destroying, condemning, and ignoring artworks or by absorbing and making them its own. It exerts control over them so that everything remains the same.

From my perspective, the "services" rendered by artists do not involve a production of one or several objects, fitting the category "artworks," but to project, through the methodology the artist finds most appropriate, a "vision," or range of sensations on the surface of media. It is concerned, therefore, to show publicly something that was not in sight before. In my case, instead of working with the various traditional art languages, I use the confrontation of realities. If art involves the projection of some kind of mental impression, let us say a vision, or whatever we want to call it, art has therefore a psychic origin, and objects are thus irrelevant. That painting, sculpture, photography, video, or installation are considered the most appropriate artistic "media" for achieving this goal is just the result of the market, of the market economy, and not of the inherent characteristics of the practice. The art market is a fetish market. We know that. To demand the market to protect labor rights is naïve. I do consider, however, that public institutions must take the lead to solve this matter.

I want to point out that the conflicts derived from my decision to be a mother are not limited to only a clash with bureaucracy. No, there are many more, but on this occasion, I dedicated myself to rethink the role of bureaucracy. I have stuck to the most common issues concerning the public procurement of my services. I know, of course, that many workers would switch their labor status for mine. I made this piece not to denounce an injustice of which I would be a victim but to uncover an underlying reality.

For all these reasons, in this case, the what is the how.

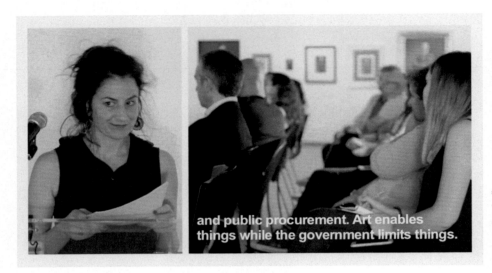

Núria Güell, *Aphrodite*, 2017. Still from press conference video documentation.

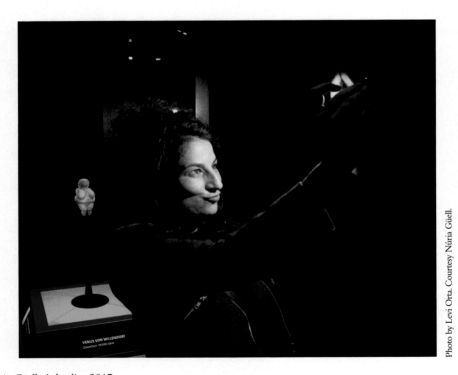

Núria Güell, Aphrodite, 2017.

Notes

1 In Spain, it is mandatory for self-employed visual artists to pay taxes even if they don't have economic benefits. The minimum tax fee in 2017 is of €275 euros per month.
2 *Dispositif* is a term used by Michel Foucault to describe the composite systems of power—physical, intellectual, administrative—that hold power over the social body. See "Confessions of the Flesh" for further explanation.

Work cited

Foucault, Michel. "Confessions of the Flesh." *Power/Knowledge: Selected Interviews & Other Writing 1972–1977 by Michel Foucault*, edited by Colin Gordon, translated by Colin Gordon, et al. Harvester Press, 1980, pp. 194–229.

Projects

Atis Rezistans

In the late 1990s, the Haitian artist collective Atis Rezistans opened their studios and yards in a so-called slum neighborhood in Port-au-Prince as art museum for an international audience. The collective developed autonomous and subaltern mechanisms of self-representation in a local neighborhood, slyly parodying institutional forms of the musealizations of art objects in European and North American art exhibitions.

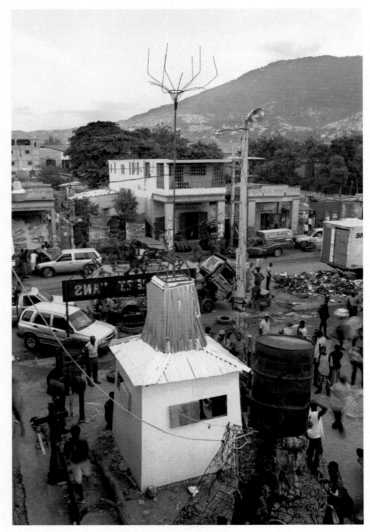

The site of the Ghetto Biennale in Port-au-Prince, Haiti.

The art museums by Atis Rezistans create a space where foreign visitors and local artists find themselves embodying structural positions of center and periphery, as they become involved in reconfiguring difference, sameness, and inequality in their interactions. Gétho Jean Baptiste's exhibition space Royaumes des Ordures Vivantes and André Eugène's Musée d'Art: E Pluribus Unum are some prime examples of this strategy. The artists curate their own exhibition spaces and retain their right to self-determination. While the exhibition spaces may seem overcrowded and lacking the curatorial control to which a Western fine arts consumer is accustomed, this strategy unsettles the white cube model, embracing a polyphonic openness and curatorial opaqueness. The subaltern creolization of bourgeois Western art institutions in this particular neighborhood can be thought of as a means to escape marginalizing frameworks and to acquire agency.

Since 2009, the Haitian collective has organized the Ghetto Biennale in two adjacent informal neighborhoods in Port-au-Prince, Lakou Cheri and Ghetto Leanne. The Biennale attempts "to momentarily transform spaces, dialogues and relationships considered un-navigable and unworkable into transcultural, creative platforms" and "to offer a vibrant creative platform to artists from wide socioeconomic classes." The main issues addressed by the Ghetto Biennale revolve around the discursive fields of class, gender, race, and sexuality. Atis Rezistans use established discourses of marginalization and Othering for their own ends as a strategic cultural and socioeconomic alterity.

Ghetto Biennale succeeds in diminishing clichéd images of the urban poor and has provided an opportunity for more nuanced and self-determined representations for artists in Port-au-Prince. It is a case of "globalization from below" that creates a space for debate and conflict. By traveling to these neighborhoods and experiencing an uncomfortable and exhilarating nearness, the invited artists engage with the community and deconstruct and transcend clichéd images of a "ghetto."

Further reading

"Ghetto Biennale." Ghetto Biennale, 2009, http://ghettobiennale.org/. Accessed 10 July 2018.

Urban Reactor

Urban Reactor was created by a collective of architects and planners in Tbilisi, Republic of Georgia, with the goal of utilizing debate, research, and education to expand the practice of architecture and planning by infusing them with meaningful social and cultural meanings. Understanding the conditions and processes behind unequal and unjust development in urban environments has been the collective's principal focus. In recent years, Urban Reactor has created a timeline of urban development in Georgia, including so-called "beautification initiatives" led by the government. As the architects revealed, these have worked on only a very superficial level to restore and redevelop the country's main historic towns and have done little to improve communities' social and spatial conditions.

Another key project conceived by Urban Reactor is *The Library for the Built Environment Studies*, an active platform for research, debate, and education. As part of their activities for the library, the group began to select and collect relevant literature, offered translations of key texts important to Georgian audiences, and activated these materials by organizing roundtable discussions and reading groups with architects, planners, and activists. The library became a lively platform for research, debate, and education, bringing together different disciplines from urban studies to contemporary art and geography. In striking contrast to the conventional libraries in Georgia, Urban Reactor's project functioned as more than a repository for information, striving toward the active exchange of ideas that they believe can bring positive and meaningful changes to Georgian society.

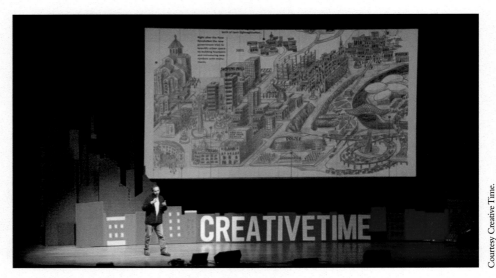

Courtesy Creative Time.

Levan Asabashvili of Urban Reactor presents at the 2013 Creative Time Summit.

Further reading

Urban Reactor. Urban Reactor Collective, http://urbanreactor.blogspot.com/. Accessed 27 November 2018.

Alexandra Pirici

The practice of the Romanian, Bucharest-based choreographer and artist Alexandra Pirici critically engages public space and sculpture. Her 2011 project *If You Don't Want Us, We Want You* was produced in response to budget cuts by the Romanian Ministry of Culture to the performing arts, which nevertheless directed funds to the so-called beautification of the city. Instead of supporting projects by contemporary artists and spaces to show their art, the Ministry invested its budget in commissioning monumental historical sculptures across major squares in the capital.

Photo by Tudor Borduz. Courtesy Alexandra Pirici.

Pirici and performers in the shadow of the *Monument of Rebirth (To the Heroes and the 1989 Revolution)*. Pirici, Alexandra. *If You Don't Want Us, We Want You*, 2011, Bucharest.

Source: Photograph by Tudor Borduz.

Deprived of the spaces in which to perform, Pirici and a troupe of Romanian performers took to the streets and imitated the forms of the public statues and monuments.

Pirici's performative piece initiated a dynamic relationship among artists, the work, and the audience, breaking down the hierarchical relationship between a monument and its audience. By disarming the controversial equestrian statue of *Carol I* and shadowing the contested *Monument of Rebirth (To the Heroes and the 1989 Revolution)*, she humbled these monuments in the eyes of people accustomed to maintaining a decorous and even respectful distance. Audiences become the artists' witnesses to the deconsecration of these constructions, putting them in an uncomfortable tension with the human body. The project breaks down the distance between the public, the artist, and the glorified sculpture or building, underscoring the economic injustice of prioritizing stone and metal over socially engaged artistic practice. The artists' approach undermines the authority of monuments by incorporating the bodies of the artists in their immediate vicinity. The monuments' disruption gives way to a present-day inscription.

Further reading

Apostol, Corina L. "Anti-monuments: Afterlives of Monumentality and Specters of Memory," *Close-Up: Post Transition Writings*, edited by Vjara Borozan. Academy of Fine Arts Prague, 2014.

Mika Rottenberg

Mika Rottenberg's seductive videos expose the surreal inner workings of capitalism. Her main subject is labor: physical, often exhausting and dehumanizing, and pointless. In her works, people—often women—churn, pump, crank, and stomp in order to keep the world spinning. In an original way, Rottenberg maps economies. Women are the central focus of many of her works, represented as physically bound up in the grinding wheels of capitalism.

Rottenberg explains, "Part of it is trying to find my own position, trying to place myself within these big systems" (Rottenberg). That doesn't come without its share of challenges. Unlike gritty exposés of labor abuse, her film *Squeeze* (2010) mixes reality and fantasy to such a degree that distinctions between the two become imperceptible. The artist notes: "Squeeze is about capturing energy and the way things are made. So much basic activity is just expansion and contraction, the logic of the body and planetary movement."

The video features a telekinetic machine the artist built in her Harlem studio and uses special effects to create visual slippage among three locations. In *Squeeze*, there are portals to the rubber plant and the lettuce farm, which allow workers to collaborate on the production of an object. The telekinetic machine produces a compressed cube from globally sourced rubber, lettuce, and makeup.

Her work focuses on elucidating the mechanics of late-stage, global capitalism by way of absurd and poetic comparisons. Through physical sculpture combined with sensory video experiences, Rottenberg creates immersive scenarios that probe connections between alternate universes and visible reality, calling attention to the tenuous closeness

Courtesy Mika Rottenberg and Andrea Rosen Gallery.

Mika Rottenberg, *Squeeze*, 2010. Single channel video installation, c-print, 20 minutes.

between the real and the absurd. Her works highlight the female body's proximity to capitalist production, often exploring the actual commodification of bodily possessions—and persons—themselves.

Work cited

Rottenberg, Mika. "Squeeze." *ArtForum*, 20 July 2010, www.artforum.com/interviews/mika-rottenberg-discusses-squeeze-26008. Accessed 6 September 2018.

Ibrahim Mahama

Living and working in Ghana, Mahama creates collaborative, large-scale installations, engaging with everyday consumer materials gathered from urban environments. The artist focuses on jute sacks specifically, as they are emblematic of the trade markets in his home country. The sacks are produced in Southeast Asia and imported by the Ghana Cocoa Boards for the transportation of cocoa beans, yet locals utilize them for multiple purposes: from daily domestic tasks to the transportation of food and commodities. Mahama notes that "you find different points of aesthetics within the surface of the sacks' fabric." His interest lies in "how crisis and failure are absorbed into this material [imbued] with a strong reference to global transaction and how capitalist structures work."

Mahama's first utilization of the jute sacks was in 2012 with an installation at the Mallam Atta Market in Accra, in which he covered piles of coal with large patchworks of the sacks. As a compelling intervention in this commercial environment, the sacks transformed into a makeshift sculpture, serving as a continuation and disruption of the literal fabric of the market itself. This intervention reached beyond typical art audiences, toward the traders and passers-by that inhabited this collective space. In subsequent Ghanaian site-specific interventions, such as at the Malam Dodoo National Theatre in Accra in 2016, the artists sew and collaged the sacks together with the aid of dozens of collaborators, including work-seeking migrants from rural areas.

The sacks' visible variations in hues and textures are pronounced when stitched together on a large scale, revealing the remnants of each bag's personal history and journey. Some feature official writing such as "Product of Ghana," while others bear locations and family names of collaborators. In this, the artist's installations "expose how the condition of the body becomes inherent

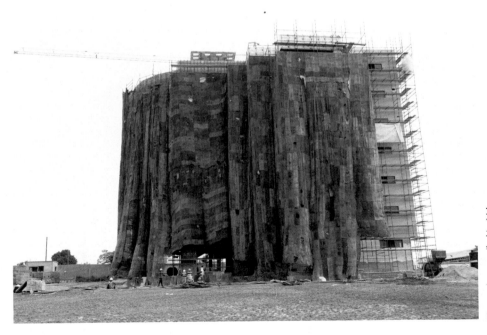

Photo and courtesy Ibrahim Mahama.

Ibrahim Mahama, Untitled, 2012. Accra, Ghana.

in the work and how precarious methods of their production—whereby each collaborator can influence the aesthetic of the work in different, unexpected ways—bring the jute sacks to life."

Further reading

Mahama, Ibrahim. "*Fragments* Exhibition Statement." White Cube Gallery, 2017, http://whitecube.com/exhibitions/exhibition/ibrahim_mahama_bermondsey_2017. Accessed 10 July 2018.

Illuminator

The activist-art collective The Illuminator emerged out of the Occupy Wall Street movement in 2012, after a group of artists, educators, filmmakers, and technologists came together to design and build a customized cargo van in New York City. The group hacked a white 2002 Ford Econoline 350 van, equipping it with a periscope that can raise and lower a projector through its roof. They also designed what they coined "The People's Pad," which allows anyone to write in light on buildings and in real-time.

Since then, the collective has staged hundreds of projection interventions in public spaces. Their aim is to transform these spaces from sites of contemplation, transit, and passive

The Illuminator, Student Debt Rebellion, 2016.

consumption into active places of engagement and dialogue. Their numerous interventions have drawn attention to pressing social issues in the United States and internationally and have been in support of ongoing calls for a more just and sustainable society.

As part of the 2016 Hemispheric Institute's Encuentro, eXcéntrico,[1] the Illuminator came together with student activists in Santiago, Chile, to highlight the urgency of student debt and to call for educational reforms. Students in the Confederation of Chilean Students (Confech),[2] Deuda Educativa, as well as technical institute students and anarchists—all representing various social and ideological positions on the matter—projected messages from the student movement. They then invited audiences to complete the following sentences: "Student debt is. . . ," "There won't be free education while. . . ," and "Education should be . . ."

The Illuminator's interventions were also bolstered by a video that highlighted the inherent issues with the educational reform led by the government. Audiences were then engaged in a discussion that touched on key questions, such as the right of education for all, the connection between debt incurred during one's studies and the larger system of capitalist oppression, and ways of collective resistance.

Notes

1 The Hemispheric Institute's 10th Encuentro, eX-céntrico: Dissidence, Sovereignties, Performance took place in Santiago, Chile, July 17–23, 2016. It consisted of performances, keynote lectures, street art actions, work groups, exhibitions, teach-ins, and roundtable discussions.
2 Established in 1984, the CONFECH brings together students from the universities in Chile, organized in democratically elected federations. It is the only national student organization in the country.

Further reading

The Illuminator. The Illuminator Collective, http://theilluminator.org/. Accessed 15 November 2018.

Oda Projesi

Oda Projesi, a collective formed by artists Özge Açıkkol, Güneş Savaş, and Seçil Yersel, began when the three women transformed their Istanbul apartment from a private space into a public one. This apartment was located in a residential building within the Galata neighborhood in the Beyoğlu district, a part of the city with a long history of immigrant and newcomer communities; in the 1970s and 1980s, it became home for many of those moving to the city from Turkey's rural north and east regions. The neighborhood had, over the years, accommodated many people from different places, of different ages, and with varied backgrounds.

Beginning with the most basic unit of a city—the room (*oda*)—the artists aimed to create a space whose use and value were determined by the people who used it. They provided paper and markers for the children living in their building and cooked meals with their parents; when the artists were out of town, they left the key with a neighbor so that the apartment could remain active. They ran theater workshops, held readings, and exhibited artworks. The audience for these events was not the art public but instead their immediate neighbors and Galata community.

Seçil Yersel views the project as being inspired directly by Istanbul itself, saying, "You can easily see that there are always interventions in urban space in Istanbul, small or big touches. . . . Everybody touches the city and in a way makes it his/her own" (Özkan). This improvisational spirit motivated Oda Projesi's first collaborations and is carried by the artists into new spaces and contexts following the loss of the original apartment in 2005 due to gentrification. Taking inspiration from Istanbul's *gecekondus*, houses built without permits to accommodate newcomers

Nadin Reschke, So Far So Good - So Weit So Gut, 2004. Oda Projesi space, Galata, Istanbul, Turkey.

Coutesy Oda Projesi.

to the city, Oda Projesi worked with experienced builders of this type of housing to think collaboratively about architectural forms that meet the needs of their inhabitants. At the exhibit at the Istanbul Biennial, viewers were invited to contribute to the project. Throughout their works, Oda Projesi explores how the city, its public spaces and private, might become flexible to fit the needs of the communities that use and occupy them.

Work cited

Özkan, Derya. "Spatial Practices of Oda Projesi and the Production of Space in Istanbul." OnCurating.org, no. 11: Public Issues, https://urbanheritages.files.wordpress.com/2011/11/ozkan_oncurating_space.pdf. Accessed 16 August 2018.

Halil Altındere

As an artist, curator, and writer, Halil Altındere has been a central figure in the Turkish contemporary art scene since the mid-1990s. His work explores the political realities in Turkey by highlighting tensions that persist between Ottomanism and Kemalism, nation and identity, authoritarianism and the collective. Altındere is known to challenge concepts of nation-state by manipulating institutional objects, such as identity cards, banknotes, stamps, and flags. In 1998, he was accused of offending the decency of an official state document—in the form of an oversized identity card with a picture of a naked female torso—and was summoned for a parliamentary hearing.

His 2013 piece *Wonderland* is a music video created in collaboration with hip-hop group Tahribad-ı isyan, who rap about the gentrification and police violence in the Istanbul neighborhood of Sulukule, in which an urban renewal project is displacing the majority Roma community. The rap directly addresses TOKİ, the Turkish Ministry of Housing, for their role in confiscating land from vulnerable communities in the name of "historic preservation" to make way for luxury housing. The film was a run-up to protests in Istanbul's Taksim Square, which began in opposition to plans to replace Gezi Park with a shopping mall, and evolved into a wider demonstration for freedom of press and assembly. In focusing on marginalized communities most affected by such urban developments, Altındere poses a challenge to the authority and power of Turkey's increasingly oppressive political system. In his most recent video *Homeland* (2016), Altindere blends realism and fiction to spotlight the experience of forced migration. Once again, the story is told through the voice of rapper Syrian Mohammad Abu Hajar, whose lyrics accompany the viewer through precarious border crossings in Turkey and Germany.

all your talk is nothing until you come and live here

<div style="writing-mode: vertical"></div>

Courtesy Halil Altındere and Pilot Galeri, Istanbul.

Halil Altindere, Wonderland, 2013. HD video, color/sound, single channel, 8:25 min.

Yao Jui-chung

The works of Taipei-based artist Yao Jui-chung examine the absurdity of the human condition across media, including photography, painting, and installation. One of his ongoing projects is *Mirage: Disused Public Property in Taiwan*, in which he has assembled photos of ruins and failed public construction projects to reveal the political and economic situation in Taiwan hidden behind the trends of globalization. In 2010, Jui-chung was invited to teach courses on contemporary photography and performance art at two Taiwanese universities. Before each class began, he offered his students the option of following a conventional curriculum using textbooks or of turning their class into a field survey of the so-called Mosquito Halls. These abandoned public construction projects were functioning, as their colloquial nickname suggests, as incubators for mosquitoes. Students, if they chose the latter option, would explore Taiwan's history of public construction, a sensitive subject often unexamined within art history textbooks. Following the end of 38 years of martial law in 1987, Taiwan underwent massive and misguided building sprees to spur economic development and to promote local Taiwanese identity and culture. Hundreds of facilities did not operate as planned. Budgets were mismanaged, buildings were poorly maintained, visitor numbers were too low to support businesses, and locals found no practical use for the facilities. Jui-chung's students formed a temporary organization to catalogue and raise questions about the abandoned projects called the "Lost Society Document." Over the next six months, the students and the artist traveled across Taiwan, documenting 147 such buildings in photographs and writing. These findings became the focus of a 600-page book, *Mirage: Disused Public Property in Taiwan*. The photographs from *Mirage* also reached journalists and politicians, triggering an onslaught of coverage that caught the government's attention. Taiwan's prime minister vowed that government agencies would conduct extensive investigations and revitalize the Mosquito Houses within a year. In October 2011, one year after the premier's widely

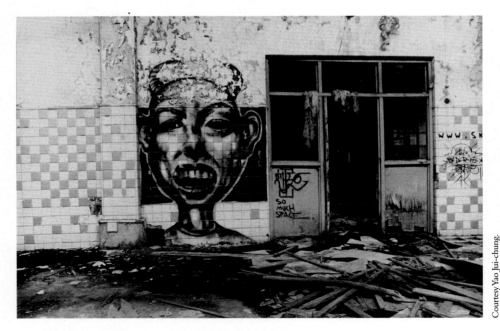

Yao Jui-Chung, *Mirage: Disused Public Property in Taiwan*, 2010-present. Photo selection from the series.

publicized pledge to revitalize the Mosquito Halls, the Lost Society Document team performed a new round of surveys. They found an additional 100 cases—published as a second volume—raising doubts about the government's promise of revitalization. Two years later, the team was amazed to discover yet another 100 cases and created a third volume. All three volumes created a wave of public pressure and prompted senior government leaders to once again publicly promise that they would finish reinvestigating Mosquito Halls across Taiwan. The Lost Society Document is still awaiting any substantial action.

Brigada Puerta de Tierra (BPDT)

In Puerto Rico's capital, San Juan, the neighborhood Puerta de Tierra has a special historical and strategic value. For centuries, the community there has struggled against adversities and injustices. The disenfranchised young working class has struggled against urban decay, forcing them to choose between living in an isolated, poor, unsafe, and deteriorated area and leaving altogether.

The grassroots artist collective Brigada Puerta de Tierra (BPDT) was formed in 2015 by children and young community members, centering its activities on the preservation and well-being of this very neighborhood. According to cofounder Jesús Bubu Negrón, "La Brigada started as an immediate response to the systematic destruction, abandonment, and dispossession of the Puerta de Tierra (PDT) neighborhood. It developed quite organically, through observation and listening, and the shared recognition that we are all affected as neighbors by these processes."

Using art as a tool, BPDT has continued to resist nefarious urban development processes. One of their most successful outreach community campaigns has been under the slogan "*Aquí Vive Gente* (People Live Here)." It raised awareness about the seminal role of youth empowerment in nourishing and sustaining the neighborhood and in developing problem-solving approaches to inequality and neglect. BPDT has accomplished getting the San Juan Municipality to collaborate with the Puerta de Tierra communities with the goal of redeveloping buildings fallen in disrepair and transforming them into community-driven social centers. They have also driven campaigns to halt the spread of perilous diseases such as the Zika virus, rehabilitate bus stops, and reactivate community gardens as places of education and empowerment.

Brigada Puerta de Tierra, *Puerta de Tierra Libre de Zika*, 2016–present.

Most importantly, BPDT conceive of their work as long term, bringing together a new generation of young activists to "reactivate the communication and solidarity bonds in the community by organising initiatives aimed at the rescue of the neighbourhood, its history and its people."

Further reading

Negrón, Jesús Bubu, Luis Agosto-Leduc, and Julia Morandeira Arrizabalaga. "'Aquí Vive Gente,' a Conversation between Jesús Bubu Negrón, Luis Agosto-Leduc, and Julia Morandeira Arrizabalaga.on La Brigada Puerta de Tierra." Visible Project, 2017, www.visibleproject.org/blog/aqui-vive-gente-a-conversation-between-jesus-bubu-negron-luis-agosto-leduc-and-julia-morandeira-arrizabalaga-on-la-brigada-puerta-de-tierra-2017/. Accessed 27 November 2018.

PART IV: SECTION 4

The uprising

Project descriptions by Corina L. Apostol,
Corinne Butta, and Shimrit Lee

THE *LOW END THEORY*: WHEN THEY GO HIGH, WE GO LOW[1]

Rashida Bumbray

In many of the rapidly closing societies around the world, where we live and work, active citizenship—democracy—is under attack. Authoritarianism's handmaidens—white supremacy, patriarchy, and occupation—are continually manifest through violence and censorship.

And while the current global rise of fascism is unprecedented, and we must speak about the many dangers of autocrats *rising*—I am focused on who is *falling*. I am sending myself underground with the many artists and activists who survive the height of the deafening silences that are white supremacy, patriarchy, and occupation by descending and "going low."

Set in the Caribbean, Shakespeare's *The Tempest* is a tale of the first new world conquest. The character Sycorax, mother of Caliban, is the unseen "witch" whose magic Prospero has stolen, along with the island. In the story, we never see Sycorax. She is banished and she descends. Poet and theorist, Kamau Brathwaite, makes an illuminating distinction here: by "descending," she does not die, but rather she goes "underground" and is submerged where she becomes one with the land and sea. Brathwaite names this "Sycoraxian" aesthetic[2] to help us understand the dissident works of Harriet Tubman, Toussaint L'ouverture, and Queen Nanny of the Maroons, all of whom who believed in the power of the plant, the Earth, the roots of the tree, the direction of the stars, and the alternative to death, depression, and insanity. All of whom designed their massive uprisings underground.

Underground spaces have long offered safety and security, a cloak under which to imagine a reinvention of the future. Senegalese economist and poet Felwine Sarr speaks about the imagination as a revelatory space—a space of necessity.[3] An uprising is first an act of the imagination. For many of us, working in the global south or from perspectives of marginalization within or in relation to the West, imagination is a highly developed, core strategy for survival.

This perspective of the underground as a space of strength and revolutionary imagining is helpful to our thinking about recent histories of radical engagement—and the work of socially engaged artists. The artists in this section are working in a diversity of authoritarian or closing contexts around the world: Egypt, Lebanon, Palestine, Turkey, Russia, Slovenia, Austria, Spain, Argentina, and the United States. These artists have developed tactics that maintain spaces for debate, even when silenced or forced underground or into exile. Working in theater, photography, journalism, street performance, cinema, satire, exhibition making, and community organizing, they construct a subversive, maroon space for the collective imagination wherein we can dialogue with the idea of uprising.

What is most profound about these artists is not only their commitment to a reinvention of the future. For many, freedom is not aesthetic or conceptual abstraction. Their fight for a new reality is based in their own participation in the many divergent stages and forms of revolution:[4] prerevolution leading to uprising; return of the old regime; long periods of time when political change is not possible, a postrevolution status quo; assessments of the number of disappeared, prisoners, political exiles, and murdered. The young actors in the Palestinian Free Theatre played roles that allowed them to imagine an alternative to their own very harsh reality of occupation. Soon after, these company members joined the struggle as the front lines of the armed liberation front. Freedom could no longer exist only in the imaginary.

The ten-year celebration of the Creative Time Summit is still the beginning of the kind of network that becomes more urgent every day. As we build solidarity with oppressed peoples around the world, we must strategize underground and then share our works in communities— out loud, from exile, from the front lines of the liberation struggle—wherever we can all be heard. At the Summit, we put a metaphoric ear to the ground, to the soil—where we can become the maroon network that we need for the future, a collection of underground societies, a Sycoraxian lifeline.

Notes

1 *Low End Theory* is the second studio album by A Tribe Called Quest, released in 1991.
2 Kamau Brathwaite's *Barabajan Poems*, 1994, gives voice to Sycorax, the silenced African woman. A postcolonial interpretation of the *Tempest*, Brathwaite's poems in this volume outline the history of the Caribbean through Sycorax's eyes.
3 Felwine Sarr, delivered the lecture, "Re-opening the Future" in December 2018 for the Intra-Disciplinary Seminar series at the Cooper Union.
4 In an interview and text by Caroline Christie in *Document Journal*, Jan 3, 2019, Egyptian-Lebanese artist, Lara Baladi, speaks about how the events of the revolution in Egypt resonate across culture, time, and geography, with other, past and present, global social movements. She is working on visualizing how revolutions go through stages and are an intrinsic part of the history of civilizations.

Projects

Nabil Al-Raee

The Freedom Theatre, based in the Palestinian West Bank refugee camp of Jenin, is dedicated to using culture and art as catalysts for social change. Through workshops, classes, and professional theater productions, the company helps Palestinians develop tools to deal with the hardships of daily life under occupation. The Freedom Theatre's Performing Arts Training Program trains students through a three-year program in acting, dance, playwriting, design, and management. Nabil Al-Raee joined the Freedom Theatre in 2007 as an educator and went on to become the Theatre's Artistic Director, continuing the legacy of cofounder Juliano Mer-Khamis, following his assassination, which was linked to his work at the theater. Nabil has directed many notable productions, including *The Siege*, a critical retelling of the story of the 2002 siege of Bethlehem's Church of the Nativity during the height of the second intifada, a Palestinian uprising against the Israeli occupation of the West Bank and Gaza. The siege paralyzed the center of Bethlehem and kept tens of thousands under curfew. Drawn from interviews with survivors, the play takes the point of view of several of the armed Palestinian fighters who found refuge in the church. Along with 200 civilians, they were given sanctuary by the church's resident priests and nuns and spent 39 days there with dwindling food, water, and medical supplies. While the world watched, the fighters grappled with survival, ideology, and the decision to continue the struggle to the end or surrender. Whatever they chose, they will have left their families and their homeland behind forever. Most of the play focused on the conversations among six soldiers who debate

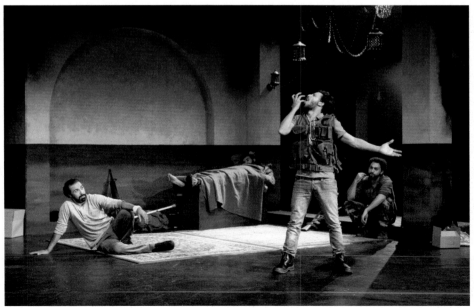

Courtesy and photo Ian Douglas.

Freedom Theatre at NYU Skirball Center.

223

the existential toll of resistance and the historical value of martyrdom. The dialogue is based on interviews conducted by Al-Raee with the exiled fighters, who had to leave for Europe in the deal brokered by the EU to end the siege. Through the fighters' stories, the audience is made to understand the struggle and the spirit of the Palestinian people under occupation. The play was shown in Jenin as well as in Europe and across the United States in 2017.

Lara Baladi

During the 2011 revolution that resulted in the toppling of Egyptian president Hosni Mubarak, Tahrir Square in Cairo was transformed into a vibrant space for protests, social solidarity, and political struggle. Activists used the hashtag #Jan25 to disseminate powerful photographs and videos of the uprising through social media channels. During the demonstrations, Egyptian-Lebanese artist, Lara Baladi began collecting a digital archive of videos, photographs, articles, and more data related to the events in Egypt. This archive is titled *Vox Populi* (2011–present) from the Latin for "Voice of the People." Live events, publications, and artworks that "perform the archive" have stemmed from this digital platform.

Following a Fellowship at the Massachusetts Institute of Technology's (MIT) Open Doc Lab in 2014, during which the artist researched innovative forms of documentary, Baladi has been working on presenting the *Vox Populi* archive as a web-based interactive platform that maps the emotional, psychological, cognitive, chronological, and historical aspects of the Egyptian Revolution.

Baladi is currently finalizing the open-source, web-based interactive timeline, which she refers to as a "transmedia painting," bringing together audio, video, visuals, and text and demonstrating the correlations between key events in the Egyptian uprising and other global social movements, past and present. The project raises questions about the uses of creative technologies, the challenges of archiving and interpreting history at the height of the digital age.

The timeline invites audiences to search and explore the archives through different filters and envisions future, multiple uses and implications for the material Baladi has amassed. Baladi

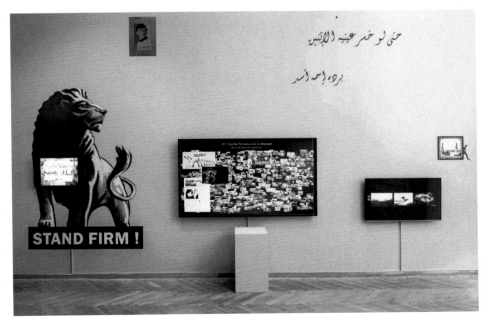

Courtesy Lara Baladi.

Lara Baladi, *Vox Populi*, 2011. Installation of the archive.

considers *Vox Populi*, above all, as a powerful tribute to the 2011 Egyptian revolution and as a resonant chord with sociopolitical movements all over the world.

Work cited

Baladi, Lara, *Vox Populi*. 2011, www.tahrirarchives.com. Accessed 16 July 2018.

Molly Crabapple

Molly Crabapple is an award-winning illustrator and journalist whose work engages war and resistance movements. In 2011, when Occupy Wall Street began just a few blocks from her lower Manhattan apartment, she began a nearly 24/7 documentation of the events, sketching the protests, clashes, and arrests. Through her iconic ink drawings, she went on to cover the antiausterity demonstrations in Greece, the hearings of Guantanamo inmates, and the War on Drugs. Her most recent project is the book *Brothers of the Gun: A Memoir of the Syrian War*, cowritten with Syrian journalist Marwan Hishan. A coming-of-age story that takes place during the Syrian War, the memoir probes questions of identity and nationality, while shining a light on how the ecstasy of the Syrian Revolution evolved into a catastrophe on a global scale. Crabapple met Hisham in 2013, when she started covering the war in Syria.

In subsequent years, she would interview him and create sketches based on his experiences. She describes how she wanted to draw moments in time for which no accompanying photos were available. As she puts it: "There are so many photos from Syria of every possible atrocity—this is the most documented war in history—and people are kind of numb. You need to try to get people in the West to give a shit. Drawing is very slow, it's very invested" (Rosenbaum). By selling original pages of her animations online to raise money

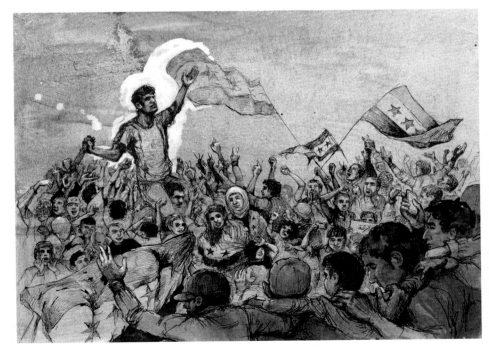

Molly Crabapple, *Brothers of the Gun*, 2018.

Courtesy Molly Crabapple.

to aid Syrian refugees, Crabapple merges her art and activism. Moving beyond stereotypical portrayals of the Middle East as a place of routinized violence, *Brothers of the Gun* opens up a world of humanity, dignity, and nuance.

Work cited

Rosenbaum, Ron. "Meet Molly Crabapple, an Artist, Activist, Reporter, and Fire-Eater All in One." *Smithsonian Magazine*, April 2016, www.smithsonianmag.com/arts-culture/molly-crabapple-artist-arctivist-reporter-fire-eater-180958502/. Accessed 27 August 2018.

Etcétera

Composed of visual artists, poets, and actors, the radical collective Etcétera was founded in 1997 in Buenos Aires. Their art engages with social conflicts in public space and also inserts these conflicts into the media and art institutions. Drawing on the legacy of Surrealism and Dada, their irreverent practice is characterized by humor, sarcasm, poetic research, and deconstruction. In 2005, Etcétera cofounded the International Errorist Movement, an international organization that claims the concept of "error" as a life philosophy. The movement started when former U.S. President George W. Bush visited Argentina in 2005. "People in Argentina hated Bush, so they were demonstrating against him. Also the anti-terrorist law had just been passed," explained Etcétera member Federico Zukerfeld.[1]

The group researches terrorism and in particular reflects on the idea of terrorism through theater. When the group's members began performing with lifelike drawings of machine guns on cartoons, they were almost arrested. Etcétera believes that making errors is necessary in order to break stereotypes and prejudices. Zukerfeld wittily observed, "We always reject error. But for an Errorist, an error is something good."

The Errorist movement has spread to other countries, including Turkey, where Etcétera participated in the 11th Istanbul Biennale, What Keeps Mankind Alive?, curated by the What, How and for Whom/WHW curatorial collective in 2009. Their installation, which was organized as a cabaret, featured the Argentine Marxist revolutionary, Che Guevara, as well as Turkish figures such as Hrant Dink, a Turkish-Armenian journalist who was murdered in January 2007 by an ultranationalist, and Deniz Gezmiş, a Marxist-Leninist activist who was one of the founding members of the People's Liberation Army of Turkey (THKO).[2] In the Errorist Cabaret, the audience became one of the protagonists, as they wandered through the space, completing the piece with their presence.

Courtesy Etcétera.

Etcétera's *Errorist Kabaret* at the 2009 Istanbul Biennial. Etcétera.

Source: *Errorist Kabaret*. 2009, multimedia installation, *What Keeps Mankind Alive?*, 11th International Istanbul Biennial, Istanbul.

The artists conceived of the installation's cabaret-like format as an invitation "To reflect about dreams, social change, etc. . . . For us, our only weapon is the metaphor." They remarked, "The only way to open space for new ideas and to be able to change something is to accept error. Because if you believe only in perfection, you cannot change anything. So error is the key to [opening] new possibilities."

Notes

1 All quotes by Zukerfeld and Guzman from press interviews on the project's page, https://erroristkabaret. wordpress.com. Accessed 30 July 2019.
2 The THKO was an armed underground left-wing movement in Turkey, and Gezmiş was sentenced to death and executed in 1972.

Victoria Lomasko

Victoria Lomasko has witnessed numerous political trials and protests in Moscow since the mid-2000s, producing poignant drawings of the tumultuous processes that shape today's Russia. Creating what she refers to as "graphic reportage," Lomasko first came to prominence for covering the protests over the arrest of feminist punk performance group Pussy Riot and the ensuing trial that resulted in the conviction of three of the band's members in 2012. Lomasko's drawings revealed gender conflicts deeply rooted in the social fabric of contemporary Russia. Her related series, *Chronicles of Resistance* (2011–2012), engages in civic activism by covering rallies and protest actions in Moscow surrounding the election fraud that resulted in Vladimir Putin's consolidation of power. Lomasko documented everyday participants in protest, focusing not only on prominent participants giving speeches but on all the different layers of society involved. The artist also made specific portraits of the protests, revealing their character and atmosphere. The series represented an effective tool for society to exert influence on the authorities. She also turned her attention to grassroots protest actions in Russia, including the long-haul truck drivers' strike and protest camp in Khimki in 2015 and the resistance to the Russian Orthodox Church's controversial construction projects in Torfyanka Park and Dubki Park in Moscow.

Lomasco's graphic reportage builds on the legacy of Soviet nonconformist artists such as Viktor Pivovarov, Erik Bulatov, and Ilya Kabakov, who used illustration to discuss taboo or repressed aspects of Soviet life during the Cold War. Lomasko's use of drawing also stems from the fact that in many situations in Russia, it is dangerous to use a camera because people do not feel safe when they are photographed or filmed.

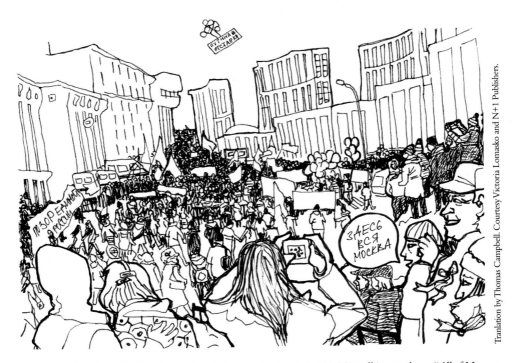

Victoria Lomasko, Chronicles of Resistance, from Other Russias, 2017. P. 145. Man talking on phone: "All of Moscow is here." Sign at Left: UNITED RUSSIA SHOULD BE ASHAMED. Sign on Balloons: RETIRE PUTIN.

Tranlation by Thomas Campbell. Courtesy Victoria Lomasko and N+1 Publishers.

She has also traveled around Russia and through the former Soviet republics of Armenia, Georgia, and Kyrgyzstan, paying attention to the psychological, spiritual, and economic condition of marginalized groups. Lomasko's ongoing project, the graphic reportage *Bishkek–Yerevan–Dagestan–Tbilisi: Investigations with a Sketchbook* (2016–present), combines her own visual observations with recorded interviews she made with LGBT people, feminist collectives, sex workers, and farmworkers living in these varied communities. Through her feminist perspective and choice of characters, Lomasko reveals the disintegration of traditional forms of life, social unities, languages, and intercultural exchanges under the rampant capitalism and nationalism in Russia.

Further reading

Lomasko, Victoria. "Other Russias." *n+1 Magazine*, 2017.

Leónidas Martín/Enmedio

As an artist, professor, and activist, Leónidas Martín has invigorated the wave of Spanish antiausterity protests beginning in 2011, known as M15. Martín organizes social actions with the Barcelona-based artist collective Enmedio (which translates to "among" in English). Referring to his involvement with the social movement, Martín writes:

> This experience . . . made me realize that there was no turning back, that the politics we had known until then was obsolete, that nothing we had done before was useful anymore and that, from this moment on, all social protests were going to be anonymous, direct and impossible to represent. Like the 'world record' we set for the most people shouting, 'You'll never own a house in your whole fucking life.' . . . An event that gathered thousands and thousands of people in cities all over Spain to shout, collectively and publicly, what had been experienced until that moment as a personal problem.
>
> <div align="right">(Martín)</div>

One of Enmedio's largest and riskiest actions was *Surround the Congreso de los Diputados* (Spain's Congress). Their aim was to provoke the downfall of the government in order to initiate a new, citizen-run constitutional process. First, they designed a poster full of colorful dots around the phrase "On September 25 we will surround the *Congreso* until they resign. *Punto*" (Spanish for "period" and "That's it!"). They printed thousands of them and put them up around the city of Madrid, and then they collected photographs of people holding colored dots, on which were

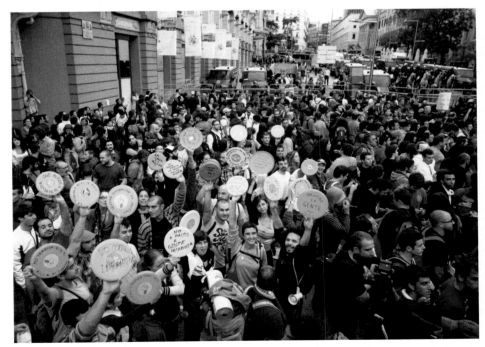

Participants raising their frisbees during the action *Surround the Congreso de los Diputados*, 2011.

233

printed their reasons for surrounding the Congress. The photographs spread across the Internet, capturing the attention of the press for weeks.

A few days before the September 25 action, the government announced that a sizable police force would barricade the Congress during the planned protest. As a result, the activists organized the *Discongreso*, turning the colorful dots into *discos* (Spanish for "frisbees"). Through social networking, they asked people to get frisbees and write their own ideas for their democracy—or rather for a political system worthy of the name "democracy." Hundreds of people with their marked-up frisbees launched them toward the building, with slogans like "People first," "Ban the debt," and "No bankers will ever govern a country again." For Martín, the discs flying over the police was a metaphor for the current situation in Spain, "Where democracy is truly in the air."

Work cited

Martín, Leónidas. "Spain: The Nameless Force behind the Protests." *Creative Time Reports*, 30 November 2013, http://creativetimereports.org/2012/11/30/spain-the-nameless-force-behind-the-protests/. Accessed 4 September 2018.

Tomáš Rafa

In 2009, a group of Slovakian nationalists constructed a wall in the town of Michalovce. It was meant to bar the town's Romani population from leaving the neighborhoods they live in. This act of fencing out a minority community is not an isolated incident in Slovakia or in Eastern Europe at large. In fact, it has become increasingly frequent in recent years, with fringe nationalist groups becoming mainstream and gaining political power and momentum throughout Europe. After seeing similar situations of segregation occur in other cities, filmmaker Tomáš Rafa began to travel to and film the sites where far-right nationalism shows its face.

His film *New Nationalism in the Heart of Europe* (2015–2016) is the record of the resulting confrontations between those most vulnerable and the militant and xenophobic forces who aim to restrict their movement and take away not only their hopes for the future but their human rights. Moving from the borders of Hungary and Croatia to the refugee camp in Idomeni, Greece, before its closure, the videos document these clashes and trace their fault lines. With open protests by nationalist extremists in city centers throughout Europe and the United States, it is evident that this xenophobic turn is neither fringe nor occurring only at the borders and frontiers.

Rafa preserves the distinctions between one place and another, turning his lens on the specifics rather than on the general: specific people, gestures, and slogans. By preserving the singularity of each of the protests and confrontations, he is able to make clear how urgent the stakes are to individuals. However, he also employs repetition—one clash, one country after the next for 52-minute loops— not only to indicate the expansivity of the issue but to illustrate how easily history repeats itself.

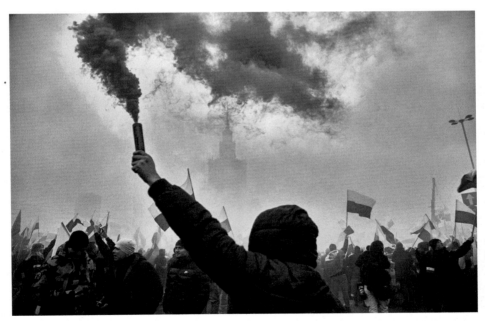

Courtesy Tomáš Rafa.

Tomáš Rafa, *New Nationalism in the Heart of Europe*, 2015-2016. Video still.

Work referenced

Heidenry, Rachel. "Tomáš Rafa: *New Nationalisms* at PS1." *Art21 Magazine*, 10 August 2017, http://maga zine.art21.org/2017/08/10/tomas-rafa-new-nationalisms-at-moma-ps1/#.W3Xj2mRKj1w. Accessed 16 August, 2018.

Oliver Ressler

Oliver Ressler produces installations, projects in the public space, and films concentrating on issues such as economics, democracy, global warming, forms of resistance, and social alternatives. Ressler questions whether an activist practice can gain a new relevance in what he sees as the current situation, where not a single state but the global capitalist system is in crisis.

His recent works have addressed the emergence of the movements of the squares and the Occupy movement as a response from people who fought against the massive increase in social inequality and dismantling of democracy in times of financial and economic crisis globally. Ressler's three-channel video installation *Take the Square* (2012) is based on discussions conducted with activists from the Indignados movement in Madrid, the Syntagma Square movement in Athens, and Occupy Wall Street in New York. Reenacting the format of the working groups behind the protest movements, activists discuss with one another in front of the camera; they touch upon issues of organization, horizontal decision-making processes, the importance and function of occupying public spaces and how social change may occur. Ressler shot the footage in places central to the movements of the squares: the Plaza de Pontejos, a square in the immediate vicinity of the central Puerta del Sol in Madrid; at Plaza de la Corrala, a meeting place for the neighborhood assemblies of Lavapiès in Madrid; in Syntagma Square, the central assembly and demonstration point in front of the Parliament in Athens; and in Central Park in New York, where Occupy Wall Street held the Spring Awakening 2012.

The installation brings together activists from three cities central to the movement (Ressler). A participant in the Collective Thinking Work group in Madrid observes, "I consider inclusiveness and respect used as a means to build horizontality and recover our power without the

Image from Oliver Ressler's piece *Take the Square* (2012).

Source: Ressler, Oliver. *Take The Square*. 2012, three-channel video installation.

need to have somebody representing us very powerful." This rejection of representation is based on the conviction that people should be politicized and encouraged to have agency over their destinies.

Another activist of the square movement in Athens says, "It's the political process, the one that creates the man who is concerned with the commons, who participates. . . . If it wasn't horizontal, it would have had no meaning." For an activist in the Occupy Wall Street movement, this has created, "the first people's movement in this country [United States of America] that has called out the ruling class as the enemy." *Take the Square* contributes to spreading the organizational knowledge of these movements and translates the oppositional processes between these places of resistance.

Work cited

Oliver Ressler. *Take the Square*. 2012, project documentation and video, www.ressler.at/take_the_square/. Accessed 16 July 2018.

Daniel Tucker

Working as an artist, writer, and organizer, Daniel Tucker has been developing documentaries, publications, exhibitions, and events related to social movements and the people and places behind them. Among his collaborative projects at the intersections of art and politics, *Organize Your Own: The Politics and Poetics of Self-Determination Movements* (2016) stands out. Taking place in both Philadelphia and Chicago, the project unfolded as a multiformat curatorial platform that brought together art, historical research, and community organizing. Building on a central inquiry, in Tucker's words, "What does it mean to organize your own?" the project explored themes of belonging and accountability within homogeneous, rather than diverse, communities, during a time of deep racial segregation in the United States.

Photo by Paul Gargagliano. Courtesy Daniel Tucker.

Daniel Tucker, *Organize Your Own*, 2016-2019. Participants performing.

The artist drew inspiration from the historic call by members of the Student Nonviolent Coordinating Committee (SNCC). It's then leader, Stokely Carmichael, wrote that he believed that: "One of the most disturbing things about almost all white supporters of the movement has been that they are afraid to go into their own communities—which is where the racism exists—and work to get rid of it."

From this premise—and in keeping with the call to organize one's own community against racism—the project featured work by contemporary artists and poets that responded to archival materials related to the history of white people organizing their own working-class white neighborhoods in Philadelphia (the October 4th Organization) and Chicago (the Young Patriots Organization). Questions of racism, community, and identity remain ever relevant in the current era of Black Lives Matter and immigration struggles. *Organize Your Own* engaged with these current debates and connected them to similar hard-fought battles of the 1960s and 1970s. The project revealed not only the continued urgency of political art but also created a space for reflection within which participants could organize and challenge their own value systems.

Further reading on the project's webpage

Tucker, Daniel. *Organize Your Own*, https://organizeyourown.wordpress.com/. Accessed 15 November 2018.

Joshua Wong—The Umbrella Movement

In the latter half of 2014, the world watched the peaceful two-and-a-half month-long prodemocratic occupation of Hong Kong by hundreds of thousands of young people, who came to call themselves The Umbrella Movement. Named for the use of umbrellas for protection against pepper spray, the umbrella came to symbolize not only peaceful demonstrations but also prodemocracy. A few thousand secondary school and university students went on strike, demanding a real democratization of Hong Kong's elections for the city's chief executive. Joshua Wong, then 17 years of age, led the student protest organization, Scholarism, which rose to prominence within the movement by calling on the crowds to retake the symbolic Civic Square, which is located in front of the city's parliament, the Legislative Council. Once built as a space open to all citizens, Civic Square was closed in July 2014 following protests against infrastructural projects in Hong Kong's north, also known as the New Territories. Wong's call to reclaim Civic Square became a cry for democracy, civil liberties, and self-determination for the people of Hong Kong.

The Umbrella Movement's demands went beyond electoral reform of Hong Kong's chief executive election, expressing the protesters' desire for the city's self-determination. The Movement was not only prodemocratic but also aimed at gaining autonomy for Hong Kong from mainland China. The movement turned into the largest and most significant demonstration for democracy on Chinese soil since the forcible suppression of student-led demonstrations at Beijing's Tiananmen Square in 1989.

After the end of the occupation, The Umbrella Movement disintegrated, and the diversity of the prodemocratic camp became visible. The future of the prodemocratic movement largely depends on the question of whether it will succeed to unite again by bridging the divide not only between radicals and moderates but also between generations and social classes. In

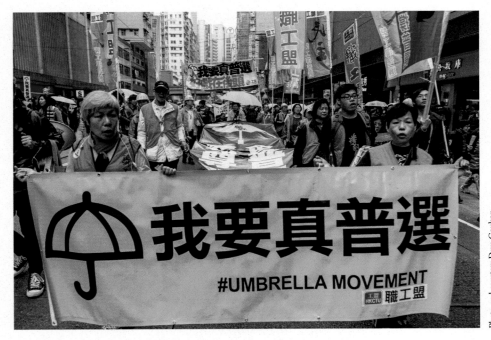

Umbrella Movement protest, 2014–2016.

Photo and courtesy Dave Coulson.

August 2017, Wong and two other prodemocracy activists were jailed for attempting to "retake" the closed Civic Square in 2014. However, the fight for the city's future continues, and the hope of making the impossible become reality lives on. The next round of demonstrations for Hong Kong's autonomy from mainland China is imminent.

Further reading

Aldama, Zior, and Miguel Candela. "Joshua Wong: The Teenager Who Defied China." *Al Jazeera*, 16 July 2017, www.aljazeera.com/news/2015/09/teenager-defied-china-150925085531871.html. Accessed 28 June 2018.

Henley, Jon. "How the Umbrella Became a Symbol of the Hong Kong Democracy Protests." *The Guardian*, 29 September 2014, www.theguardian.com/world/2014/sep/29/umbrella-symbol-hong-kong-democracy-protests. Accessed 28 June 2018.

"Hong Kong Protesters Converge on Government Headquarters." *DW*, 30 November 2014, www.dw.com/en/hong-kong-protesters-converge-on-government-headquarters/a-18102827. Accessed 28 June 2018.

PART IV: SECTION 5

Exodus

Project descriptions by Corina L. Apostol,
Corinne Butta, and Shimrit Lee

EXODUS

Kinana Issa

When I think of the Syrian exodus, I don't think of human masses stuffed together on narrow paths, walking on foot, fleeing with nothing but the clothes they're wearing or small bags of what is left of their belongings. Nor do I think of desperate refugees drowning at sea dreaming to reach the other side. When I think of exodus, one image comes to mind: a man from Douma[1] with gray hair, sitting on the sidewalk near his house after one of the raids on his city. He seemed to be waiting for something or someone, refusing to believe what was happening. A moment that condenses the personal moment preceding the exile journey—where "homeland" quits being the space of belonging and becomes a space of shock and fear. Each individual who went through such moment will carry it out every step along the way.

Even though we may conceive the concept of exodus-en-mass, the reality of such a condition is far lonelier than it looks in pictures. Every foot that has trodden the migration path felt the Earth beneath it separately, felt different fears, and carried a different cross that has affected each uniquely throughout the mass migration experience. Collective identity is also capable of concealing smaller identities and narratives; some may even be more threatened, disoriented, and further culturally displaced by the bigger group identity or even the identity of the fraction of the group they came with. This becomes specifically true when it comes to idealists, artists, and other socially "different" and nonbinary personalities. If we add to this their being women and self-identified women, this makes identity questions even more complex. For them, belonging was and will always be one of their biggest challenges everywhere they go.

On the brighter side, such people also get the privilege of meeting one another, attracting each other, and transcending boundaries of ethnicity, culture, religion, nationalism to work together towards a common human intangible ideal. Most importantly, they are capable of reproducing and maintaining authentic cultures of resilience and inclusivity that is much needed in almost every human context. I learned this through having the privilege to meet other invisible idealists from different backgrounds and to learn their personalized displacement experiences.

This has led me to discuss with a collective, with which I was involved in its early stages of establishment, the possibility of gathering these self-identifying women artists who are engaged in social practices and facilitating conversations on identity within a symbolic artistic platform. I felt the need to, first, be part of a collective experience we design for ourselves in order to tackle our own questions of identity, before we can pass along these experiences and share them with other groups.

Kinana Issa, *Exile*, 2013. Shot in Beirut at the beginning of the artist's exile journey.

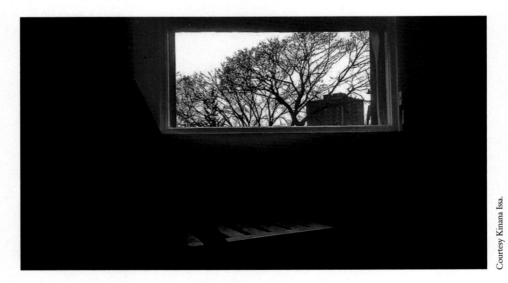

Kinana Issa, *Exile*, 2013. Shot in Beirut at the beginning of the artist's exile journey.

Soundtography,[2] the name of our project, is an auditory exploration for migration/displacement journeys, aiming to transcend our current understanding of maps and what they stand for. We are using sound imprints to map out the migration and displacement journeys of a group of Toronto-based artists[3] who self-identify as women through a series of collaborative, reflective,

and meditative workshops. Maps as we know them to exist as divisive lines imposing certain, singular definitions of who we are and who we could become. Such lines come in juxtaposition with the intuitive/organic migration paths our species was able to develop throughout its evolution history. *Soundtography* is meant to be a force of resistance against the violent imposition that our cartographic history and trajectory impose upon us.

It is also a serious attempt to find what is it that makes up a "home" and how we can feel at home in our own bodies. How such space could be created collectively with others that we may (or may not) share cultural histories with and how we can extend such experiences to those communities with which we do share those histories. We explore how the personal/collective can come into play in understanding our mutual human wounds and transforming our chains—in this context I refer to trauma and uprootedness as the mental/emotional chains we carry individually throughout the displacement journey—into a guiding map to freedom that may, according to organic migration patterns, extend for two or three generations from the beginning of its quest.[4]

Soundtography is an experience that is still under construction, a very fragile mission and challenging task to design an experience that we, as organizers will be also its participant, calling in experienced artists to facilitate all sessions. It is an attempt I'm making, personally, to jump off the Syrian exodus for a while and see myself as an individual part of the larger human context—one face among those who have witnessed displacement in many shapes and forms, trying to build a mutual brave space of symbolic discovery and nonbinary artistic expression, at one of the farthest stops of the human migration journey here in Toronto, Canada.

Notes

1 A Syrian city near Damascus that was bombed, besieged, and destroyed by the Syrian regime.
2 *Soundtography* is a collaborative artistic project using sound imprints to map out the migration and displacement journey of a group of Toronto-based artists who self-identify as women. We will be mapping out these journeys through a series collaborative, reflective, and meditative workshops. Followed by a production phase where those sound imprints will be turned into an artistic installation exhibit.
3 This project targets independent artists from different disciplines and backgrounds who work around themes related to identity, displacement, gender, and social justice.
4 Monarch butterflies, for example, may take five generations to migrate to United States. Monarch butterflies may take as many as five generations to make it from Mexico to southern Canada and back again.

Projects

Richard Bell

The Aboriginal Tent Embassy was first set up in 1972, when four Aboriginal activists—Bertie Williams, Billy Craigie, Tony Coorey, and Michael Anderson—staged a protest for Aboriginal land rights by planting a sun umbrella and placards on the lawns of Australia's Parliament House. The Embassy, which later expanded into a gathering of tents, remains in place today as an icon of Aboriginal protest, a meeting place and a sign of an ongoing Aboriginal sovereignty.

Richard Bell's work for the 2016 Sydney Biennale is a recreation of the Embassy. The work consisted of a heavy canvas tent equipped with camp lights, plastic chairs, placards, and a screen. The Tent hosted a rich program of events: a screening of films about twentieth-century Aboriginal activism and culture, as well as conversations with Bell himself, art historians, and other activists and artistic collaborators.

The film program placed the Embassy within the longer history of Aboriginal activism and Australia colonialism, at the same time carving the outlines of a significant genealogy of Aboriginal activism and film, which stretches from documentary works from the 1960s and 1970s, up to more recent artistic works such as Vernon Ah Kee's *Tall Man* (2013). The work's cunning lay in its replication not only of the Embassy's material components but also its symbolic attack: its demarcation of an unceded Aboriginal sovereignty in the very language (that of the original Embassy's) of the colonial power that it challenges and radically undermines. Bell's *Embassy* is a work of activism as subversive translation, spoken in the increasingly complex language of the

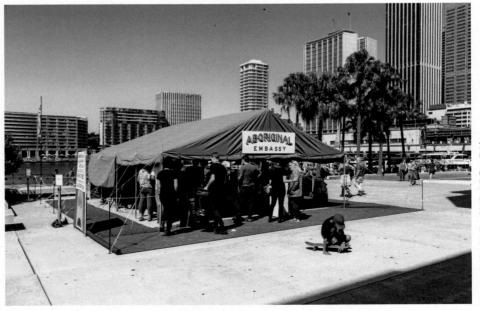

Richard Bell, *Embassy*, 2013-ongoing. Canvas tent with annex, aluminium frame, rope and screens; synthetic polymerpaint on board. Installation view for the 20th Sydney Biennale, 2016.

contemporary art world—or what Bell calls "this art caper." Bell intervened at the moment in which the very language of the traditionally white, Western-centric art world appears at a point of collapse—the publicity material stumbles under the weight of the work's heterogeneity (it is a, "hub," a "confluence," a "platform," an "exhibition space").

Bell is an activist-artist well used to speaking in multiple languages, and his work since the early 1990s has insistently confronted the Australian art world with an uncomfortable recognition of its white, patriarchal conditions of possibility. In the past few years, Bell has moved to a larger global stage. And as the global contemporary art world struggles to reconfigure its critical apparatus to encounter work such as the Embassy, the artist has already assembled his forces, making it clear that the work does not end here—this "art caper" is just a means to an end.

Further reading

Psaltis, Alice-Anne. "Systems of Black Power: Richard Bell's Aboriginal Tent Embassy." *Runway: Australian Experimental* Arts, http://runway.org.au/systems-of-black-power-richard-bells-aboriginal-tent-embassy-2/. Accessed 17 July 2018.

Chen Chieh-Jen

Chen Chieh-Jen has been an influential figure of Taiwanese conceptual art since the early 1980s. He has relentlessly challenged the limits of expression through political performances, unsanctioned exhibitions, and interventions in public spaces.

The artist examines the history of Taiwan within the larger context of globalization. In particular, his work addresses the effects of consumerism and migration, as well as the power of images to upend the status quo. In the film *Empire's Borders II—Western Enterprises, Inc.* (2010), Chen investigates borders and boundaries within a transforming geopolitical landscape while simultaneously reflecting on the history of Taiwan–U.S. relations. The film reveals the little-known

Courtesy Chen Chieh-Jen.

Chen Chieh-Jen, *Empire's Borders II - Western Enterprises, Inc.*, 2010. Video still. Upper image: Representatives of the America Military Assistance Asvisory Group inspect the Green Island prison for political prisoners in the 1950s. Lower Image: A young man carries the body of an Anti-Communist National Salvation Army soldier who was killed in action.

establishment of an American CIA stronghold in Taiwan between 1951 and 1955—operating under the facade of the trading company Western Enterprises Inc.—in support of the Taiwanese Anti-Communist National Salvation Army's (NSA) takeover of Communist China.

The work is at the same time deeply personal: Chen's family history is interwoven with that of Taiwan's from Japanese colonial domination into the Cold War period following 1949 when the political party Kuomintang fled to Taiwan after battles with the Chinese Communists during the Chinese Civil War. Due to these conflicts, Taiwan has had a problematic position across the eras of the Cold War, the Martial Law period, and the present day as it has become a locus for neoliberal global infrastructure.

Chen challenges collective amnesia by unveiling the hidden layers of social and historical contexts. The characters in Chen's film enact the imaginary scenarios of the past, in which they encounter the ghosts of history as they move through the vacuous spaces of struggle, absence, and erasure. Chen's deceased father, himself an NSA member, left behind an autobiography and a list of NSA soldiers killed during the China offensive. Chen's fictive visit to the company's ruined premises is a proposition for imagining and creating a transformative space where these suppressed histories might come to the fore and thus open a possibility for both a reconciliation with the past and new prospects for the future.

Electronic Disturbance Theater (EDT)

The Electronic Disturbance Theater (EDT) is a group of cyber activists and artists engaged in developing the theory and practice of electronic civil disobedience (ECD), a form of nonviolent, direct action utilized in order to bring pressure on institutions engaged in unethical or criminal actions. The group has focused its electronic actions against the Mexican and U.S. governments to draw attention to the war being waged against the Zapatistas and others in Mexico.

In 2008, the Electronic Disturbance Theater (EDT) 2.0/b.a.n.g. lab released the first version of the Transborder Immigrant Tool (TBT), a mobile-phone technology that provides immigrants with poetry aimed at providing not only inspiration for survival but also information on food and water caches, security activities, and directions to potentially safer routes. Its software aspires to guide "the tired, the poor," the dehydrated citizens of the world to water safety sites. Its simple, user-friendly interface is designed as an alternative to low-cost cell phones (Dominguez).

Although the tool can in theory be applied to any border, the principal border it has been tied to and tested on is the U.S.–Mexico border, where recent years has seen a spike in migrant deaths. The EDT present the project as an artistic disruption of the national political theater staged at that border. The project refocuses attention on the basic human needs of those caught in the middle of the stale and stalemated divide. For the EDT, every part of the project participates in this disruption, not merely the finished application or the poetry but the code as well.

In 2010, the project proved quite controversial on the U.S. political scene, and the artists involved were investigated by Republican Congressmen, the FBI Office of Cyber Crimes, and the University of California, San Diego (UCSD). Ricardo Dominguez, cofounder of EDT (with Brett Stalbaum) and principal researcher of the b.a.n.g. lab, is an associate professor in the Visual Arts department at the university. TBT was targeted by right-wing media, specifically Fox News, which prompted a bombardment of violent e-mails toward the members of EDT/ b.a.n.g. lab. The investigations sought to find a way to stop TBT and to detenure Dominguez.

Electronic Disturbance Theater, *Transborder Immigrant Tool*, 2008–present. Mobile phone tool in use.

After a lengthy battle in the courts and the media, all the charges were dropped, and UCSD did not find any misuse of funds for the project.

While it cannot alone resolve the lengthy histories of fear, prejudice, and misunderstanding on both sides of the Mexico–U.S. border, TBT draws on the overlapping traditions of transcendental and nature writing, earthworks, conceptual art, performance, border art, locative media, and visual and concrete poetries to sustain the struggle for immigrant rights.

Work cited

Dominguez, Ricardo and Electronic Disturbance Theater 2.0/b.a.n.g. lab. "Border Research and the Transborder Immigrant Tool." *Media Fields Journal*, no.12, 2017, pp. 1–5.

The Fire Theory

Immigration has been a cornerstone of the United States' identity since the country's inception and the "American Dream" has remained an inspiring—yet often unattainable—one for millions of immigrants all over the world. In the current system, racism and xenophobia endanger immigrants, limit their movements and actions, and make the path to citizenship inaccessible. I.C.E., the United States agency responsible for border control, trade, immigration, and deportation programs generates "a situation of freezing, a stand-by between families, friends, on both sides of the border," according to the Salvadoran artists of The Fire Theory.

The Fire Theory art collective was formed in 2009 by Crack Rodríguez, Melissa Guevara, Ernesto Bautista, and Mauricio Kabistan. In their 2017 project titled *ICE*, Rodríguez opened the Open Source gallery in Brooklyn, New York, as a workspace and exhibition space for the group. Guevara, Bautista, and Kabistan, whose travel visas for this exhibition were denied, remained in El Salvador, sending their work digitally to Open Source for the exhibition. Over the course of *ICE*, the group worked together remotely, exchanging ideas, stories, and artwork, to explore immigration, both in New York and in El Salvador.

Rodríguez, on-site in Brooklyn, worked with the community surrounding Open Source to gather stories of those who left their home countries to seek a better life. During gallery hours, the performer was in residence at the gallery, welcoming visitors for discussion and collaboration. In El Salvador, Guevara, Bautista, and Kabistan carried out similar projects, speaking with their own respective community members on issues of immigration. While The Fire Theory has been separated by the borders they seek to question, during *ICE* they maintained a dialogue across them, exploring I.C.E., the United States, and the so-called American Dream.

Hammocks installed at Open Source gallery in Brooklyn, NY during The Fire Theory's exhibition *ICE*.

Photo by Anja Matthes and Open Source Gallery. Courtesy The Fire Theory.

Postcommodity

Postcommodity is an artistic collective composed of Cristóbal Martínez and Kade L. Twist. The duo—and contributors to their projects—share a mission of challenging destructive cultural and social discourse and educating the public on Indigenous narratives of self-determination. Working among video, sound, and site-specific installations, they address the intersection of technology and power, as well as the relationship between the natural and the human-made.

Beginning in 2008, the duo has used the image of the "scare-eye balloon," a bird repellent product used to alter aviary flight paths, as a vehicle for inquiry into the architecture of the border. Their first work to explore these concepts was the *Repellent Eye over Phoenix* (2008). The red, yellow, and black balloon hung suspended over the city as a "sign of defiance" against colonialism and globalism through its use of medicine colors shared by many Indigenous peoples of the Americas. This emblematic scare-eye balloon appears throughout several more of the collective's projects, most notably *Repellent Fence* (2015). For this work, Postcommodity partnered with the city administrations of Douglas, Arizona, and Agua Prieta, Sonora, in order to install a two-mile-long stretch of scare-eye balloon replicas from one side of the border to the other. Floating 100 feet above the ground, they represented a suture: a healing link from one side to the other.

The aim of *Repellent Fence* was to encourage dialogue around and recognition of the border-lands as a site of diaspora. By drawing attention to the site as a historic place of communication and human movement, the collective addresses the binary discourses that perpetuate polarizing nationalism and disrupt dialogues on shared heritage and "transborder knowledge." Through involving the local government in the process of installing the balloons—as well as partnering

Photo by Michael Lundgren. Courtesy Postcommodity and Bockley Gallery.

Postcommodity, *Repellent Fence*, 2015. Installation view along the Douglas, Arizona, U.S./Agua Prieta, Sonora, Mexico border.

with organizations including the Mexican Consulate in Douglas, La Casa de la Cultura in Agua Prieta, and Fronteras de Cristo—Postcommodity was able to bring this crucial discussion to the attention of city administrators and cultural workers, as well as the public.

Work cited

"Works." *Postcommodity*, http://postcommodity.com/Work.html. Accessed 11 December 2018.

Khaled Jarrar

Over the last decade, Khaled Jarrar has used the subject of the Israeli occupation of the West Bank to investigate militarized societies, including gendered violence and the connection between economic and state powers that fuel and profit from wars. Jarrar's 2014 series *Upcycle the Wall*, which has been shown internationally, draws attention to the occupation of Palestine with sculptures made of reappropriated concrete from the Apartheid wall that annexes and cuts through parts of the West Bank.

More recently, for the project *Khaled's Ladder* (2016), the artist intervened at the U.S.–Mexico border, where he removed and reappropriated a piece of the wall in order to create a ladder that now stands as a symbolic means of crossing for Mexicans who are separated from their families in the United States. He traveled in a 34-foot RV from San Diego, California, to Juarez, Mexico, crisscrossing and following the U.S.–Mexico border along the way. Jarrar was traveling as part of Culturunners, a project initiated by Edge of Arabia in partnership with Art Jameel, in which artists travel from place to place in order to explore contested boundaries. On the journey, the group encountered border patrol agents on both sides of the border, met and worked with locals living near the border, and organized talks at galleries and public spaces. During his time on the road, Jarrar created and installed *Khaled's Ladder*, using material pulled from the border fence. Coming from his home in the West Bank, where the Israeli separation wall shapes daily life and restricts freedom of movement, Khaled was alert to the ways in which the U.S.–Mexico border informs the experiences of those who live on either side of it.

He observed that:

> the purpose of the wall is to separate people and to stop people and to limit people from moving. And that's why I made the ladder out of the rebar that I removed from

Khaled Jarrar, *Khaled's Ladder*, 2016. Locals in Juarez, Mexico interact with the installation.

Courtesy Khaled Jarrar.

the border wall—the ladder is a bridge to the other side. When you climb the ladder, it's like Jacob's Ladder. You have this ladder to go to heaven, to survive, to escape from misery. And people have the right to decide where to live or where to go, in spite of all these nations, territories and divisions.

The artist productively uses the power of art to open up free spaces to practice creativity on the ground. Jarrar continues to raise questions and tell stories that lead to solutions that allow people to go beyond borders.

Work cited

Jarrar, Khaled. Interview with Rachel Riederer/Creative Time. "Crossing Borders, Looking Over Walls." *Creative Time Reports*, 14 March 2016, http://creativetimereports.org/2016/03/14/khaled-jarrar-look ing-walls/. Accessed 17 July 2018.

Tings Chak

Tings Chak's work responds to conditions of migration across a number of disciplines, from an architecture-based visual arts practice to her work as a migrant justice activist. From borders to detention centers, Chak recognizes that architectures—whether they are physical structures or territorial divisions—structure the experiences of global movement. She takes that as a starting point for her investigations into improving conditions for migrants and educating a wider public. In 2014, Chak published *Undocumented: The Architecture of Migrant Detention*; the book focuses on the migrant detention centers of Canada, where Chak spent her childhood. Canada does not follow recognized international human rights policies for detainees. There is no maximum

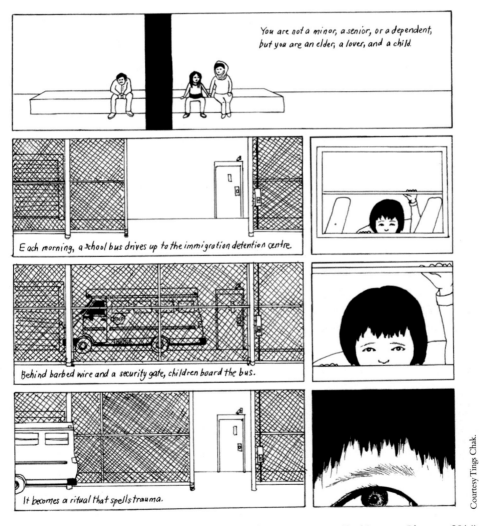

Tings Chak, excerpt from *Undocumented: The Architecture of Migrant Detention* (Architecture Observer, 2014).

amount of holding time, and, because the country has only three designated migrant detention sites, many migrants find themselves incarcerated in prisons. Without independent agencies to monitor the conditions that migrants live under, migrant voices are often lost within the system. Chak's book suggests that a starting place for an active confrontation with this issue is through an examination of the architectures that hold—and consequently control—migrants' bodies. The project *Toronto Immigration Holding Centre* (2016) furthers this work with a spatial installation of pages from the book alongside architectural models by artist Sheena Hoszko. Chak's illustrations adopt the visual language of architectural diagrams, provoking the viewer with the contrast between the clinical visuals and the human experiences they describe. "Understanding architecture as a machine provokes the observation that built space is always actively doing something" (Basit) and consequently can't be neutral. Chak demonstrates the stark violence that becomes part of the mundane, industrial spaces that regulate migrant movement and, in response, activates space in the gallery and on the page in service of educating a wider public on spatial justice.

Work cited

Basit, Ayesha. "DETENTION: Essay on the Works of Tings Chak and Sheena Hoszko." *Tings Chak*, March 2015, https://tingschak.com/art-architecture/DETENTION. Accessed 23 July 2018.

Tanja Ostojić

Artist Tanja Ostojić creates long-term perform-ative projects that address the radical negotiation of borders, be they ideological, physical, or social. Between 2000 and 2005, the artist searched for a husband as a means to acquire an EU passport, bluntly naming her interdisciplinary project *Looking for a Husband with EU Passport*. Having a Serbian passport, the artist was restricted to traveling abroad only with a visa. Initially, Ostojić posted an ad as a political statement, but after a while, her correspondence went in another direction. What started as an online exchange between the artist and a global community of strangers evolved into performance art and then, after getting married in Düsseldorf in 2002, into research on immigration laws. Before chat rooms, social media, and apps, Ostojić e-mailed with applicants and also researched the construction of online identity and marriage markets. A recurring theme in her project is the biopolitics of what she refers to as "Fortress Europe," including the violence of the borders, restrictions of citizens' rights, and the fragility of gender in the context of immigration.

Ostojić's current project *Misplaced Women?* (2009–present), invites women to carry packed suitcases in public spaces and repeatedly pause to pack and unpack as they move through the space. Locations for performances include migration-specific places: train stations, airports, borders, underground, police stations, refugee camps, specific parks, prisons, and the like. The project involves contributions by international artists, students, and people from otherwise transitory and diverse backgrounds. The participants embody and enact an everyday life activity that, according to the artist "signifies a displacement as common to transients, migrants, war and disaster refugees, and itinerant artists traveling the world to earn their living." The performances reveal relations of power and vulnerability in regard to the transient and the female body, a recurring theme in Ostojić's projects.

Furthermore, participants are invited to perform *Misplaced Women?* and to share their experiences on the web blog and during public discussions. Contributions are posted in the form of

Tanja Ostojić, *Misplaced Women?*, 2009–present. Artist performing at the Bergen airport in 2011.

images, notes, stories, or videos to the projects blog. While contributing to one of the group performances or a performance of their own, participants are empowered to develop sensibilities and attitudes toward issues and processes pertaining to global movement. The results of the performances are not as important as these intellectual and emotional processes that are being documented, archived, and written about by the participants.

Work cited

Ostojić, Tanja. *Misplaced Women?* https://misplacedwomen.wordpress.com/. Accessed 23 July 2018.

Slavs and Tatars

Founded in 2006, Slavs and Tatars is an international collective whose work focuses on the vast, multiethnic region of Eurasia. The group defines themselves as "a faction of polemics and intimacies devoted to an area east of the former Berlin Wall and west of the Great Wall of China known as Eurasia." Their work spans media, disciplines, and a broad spectrum of both high- and low-cultural registers.

The group's seminal exhibition at the Presentation House Gallery in Vancouver, Canada, titled *Friendship of Nations: Polish Shi'ite Showbiz* (2011), investigates immigration and cross-cultural influence. Slavs and Tatars' works in this series made surprising connections between Polish and Iranian cultures. Polish and Farsi slogans adorn handmade banners, highlighting an unlikely shared heritage between Poland and Iran's movements toward self-determination. In particular, the series revealed the revolutionary potential of crafts and folklore behind the ideological impulses of two key modern moments, the Islamic Revolution of 1979 and the Solidarność (Solidarity) movement in the 1980s in Poland. For example, one banner read "Long Live Long Live! Death to Death to!," highlighting the celebratory gesture and rhetorical justice that often undermine revolutions and uprisings. Slavs and Tatars' performative slogans aim to evoke strong sentiments in the viewers, causing them to visualize an alternate reality to their own.

Dear 1979, Meet 1989 (2011)—an installation of traditional vernacular *takhts* (Persian riverbeds) while stands, originally used for holy books, displayed printed ephemera from Slavs and Tatars' archive on the Iranian Revolution and Poland's Solidarność movement—was another central piece in the exhibition. Historically used across Central Asia and Iran as collective seating, the riverbeds allowed for public seating, providing a place where diverse audiences could

Slavs and Tatars, *Friendship of Nations: Polish Shi'ite Showbiz*, 2011. Installation view at 10th Sharjah Biennial.

share a meal, tea, and hookah and engage in open discussions. The exhibition doubled as a platform for reading, viewing, reflection, and discussion. Slavs and Tatars' works employ lightness and humor while also retaining a certain opacity, unless one spoke Persian or Polish. Their eponymous accompanying publication was at the same time well researched and comical.

With their research, the collective opens a wider window into the complexities of Eurasian history. The use of language in their performances and installations makes their work accessible to many different audiences, from those with prior art historical, sociological, or anthropological training to those who do not have previous knowledge. By activating the performative potential of language, Slavs and Tatars' works cultivate and validate histories, offering diverse audiences the opportunity to encounter linguistics as experience.

Work cited

Slavs and Tatars. "Friendship of Nations," www.slavsandtatars.com/cycles/friendship-of-nations, 2011. Accessed 17 July 2018.

Trampoline House

Tone Olaf Nielsen's practice as an independent curator, activist, and educator is informed by her belief in the ability of art to contribute to social and political transformation. It is with this ethos that in 2011 she cofounded Trampoline House with artists Morten Goll and Joachim Hamou. Trampoline House is a community center in Copenhagen that offers counseling, education, and community to refugees, asylum seekers, and migrants, combating Denmark's exclusive immigration policy.

Denmark is one of ten European countries to accept the most refugees in proportion to their population. However, the mobility and rights of many of these migrants are severely restricted. As many asylum seekers wait for a response to their claims, they wait in the camps where they were placed immediately after arrival. These camps are located outside the major cities, making mobility out of them nearly impossible. Combined with a measure passed by Danish lawmakers to restrict benefits given to asylum seekers and a new policy increasing the amount of time a family would have to wait before qualifying for a reunification program, migrant conditions in Denmark are not as positive as they appear in the statistics ("Copenhagen's 'Trampoline House' . . .").

In response to this unjust and imperfect system, Trampoline House functions as a self-organized platform for social interaction, knowledge exchange, and solidarity building across lines of privilege, exclusion, and inequality. Among many other activities, the house offers refugees and asylum seekers free legal advice, medical and psychological counseling with the help of volunteer translators, as well as language lessons and child care. In order to combat the social isolation and sense of powerlessness that many refugees and asylum seekers face, Trampoline House seeks to cultivate a sense of involvement and responsibility. One of the core values of the house is that there is no charity—asylum seekers get only their transport to and from the center

Community members enjoying a meal in *Trampoline House's (2010-preset)* cafe.

Photo by Mikkel and Horlyck. Courtesy Trampoline House.

265

paid by Trampoline House if they are present to work or engage in activities. The house tries to send the message "we need you and your skills" and empowers its community through creating a participatory system of mutual aid ("About Us").

Works cited

"About Us." *Trampoline House*, www.trampolinehouse.dk/news/. Accessed 23 July 2018.
"Copenhagen's 'Trampoline House' Helps Refugees Integrate." *The Observers*, 4 April 2017, http://observers.france24.com/en/20170404-copenhagen-trampoline-house-refugee-integrate. Accessed 23 July 2018.

PART IV: SECTION 6

Cosmopolitics

Project descriptions by Corina L. Apostol,
Corinne Butta, and Shimrit Lee

COSMOPOLITICAL STRUGGLES FOR A PLURIVERSAL PLANET

Maja Fowkes and Reuben Fowkes

As the ecological crisis intensifies, the extractivist logic of late liberal capitalism is entering a new phase of adaptation and profit-seeking, unleashing a high-stakes rivalry for control over dwindling natural resources and an opportunistic exploitation of the geophysical effects of climate change. The drive to reduce all living and nonliving matter on Earth to its financial value is accompanied by the rise of deviant democracies in which kleptocratic elites use state apparatuses to maximize their private wealth, fueling a tendency to disregard civil rights, abrogate international agreements, and resort to populist techniques to distort public debate. Although all indicators are in the red, and the alarm bells are ringing, the present danger that the noxious pairing of xenophobic nationalism with disaster capitalism will triumph over the alternative course toward a pluriversal, inclusive, and ecologically attuned politics is still not a foregone conclusion. As these trajectories hang in the balance, contemporary art has the potential to unmask the covert infrastructures of extractivist power and give voice to the cosmopolitical demand for planetary justice.

The vortex of waste covering vast ocean surfaces, with undulating fields of discarded plastic and its microparticles contaminating the biological makeup of fish, birds, and people alike, are dramatic markers of the damage done to the biosphere by corrosive consumer capitalism. They also are harbingers of the encroaching hybridity of naturally occurring organisms and fabricated materials. Equally, the toxic dust emitted by distant manufacturing plants is turning pristine polar landscapes into synthetic wildernesses, a further sign that the detritus of industrial modernity can no longer be contained. In *Debrisphere* (2017), artists Anca Benera and Arnold Estefan have designated the layer of "made ground" on the Earth's crust resulting from the forceful alteration of the environment, most strikingly visible in the military constructions of the Cold War era and similar undertakings today. Reconstructing the entangled natural and human histories of human-made mountains and islands—such as the Diego Garcia atoll in the Indian Ocean—they use scale models and imaginary botanical atlases to reveal the interconnections between colonial violence against indigenous inhabitants, lethal military uses, and the devastation of marine habitats. By exposing the industrial-military complex's proclivity for geoengineering and its cumulative effects on localities, species, and the geological matter of the Earth, such practices join the collective unraveling of nefarious lines of power and domination.

The pace of polar ice sheet melting and the worldwide retreat of permafrost—as well as record-breaking heatwaves, wildfires, droughts, and floods rippling unpredictably across

Anca Benera and Arnold Estefan, *Debrishphere,* 2017- ongoing.

continents—are manifestations of climate change that can no longer be downplayed as slow and imperceptible processes primarily afflicting impoverished and marginalized communities. As it advances from a remote threat to concrete reality, anthropogenic climate change turns from a scientific to a sensuous phenomenon experienced in chilling proximity by the living generation across the globe. Oto Hudec's *Concert for Adishi Glacier* (2017), a recital performed one-on-one to the ice, in which the intensifying sounds of the artist's guitar attune with the disconcerting gush of meltwater, transmits an empathic gesture of cosmopolitical care for the untimely demise

Courtesy Anca Benera and Arnold Estefan.

Anca Benera and *Arnold Estefan, Debrishphere,* 2017- ongoing.

Courtesy Oto Hudec and Gandy Gallery.

Oto Hudec, *Concert for Adishi Glacier,* 2017.

of a mountain glacier. As they explore expanding solidarities with natural entities, artists are also challenging monolithic globalization and its neocolonial logic to open a space for a pluriverse in which multiple entangled worlds coexist. Correspondingly, the people's tribunal thematized in Uriel Orlow's film *Imbizo Ka Mafavuke (Mafavuke's Tribunal,* 2017) brings together traditional healers, activists, lawyers, and the ghosts of colonial explorers at a nature reserve on the outskirts

Uriel Orlow, *Imbizo Ka Mafavuke (Mafavuke's Tribunal)*, 2017

of Johannesburg to illuminate the ontological clash between indigenous practices of plant medicine and the capitalist mentality of the pharmaceutical industry.

It is salutary to recall that popular discontent aggravated by the severity of environmental degradation, from acid rain, poisoned rivers, and air pollution to the final blow of the Chernobyl nuclear disaster, was instrumental in the downfall of the communist system in Eastern Europe. The upsurge of environmental concern around 1989 resonated across the world, giving rise to a precious opportunity to address ecological crisis from a global perspective at the Rio Earth Summit of 1992, which crucially failed to confront the environmental implications of globalization. Today, despite the craven attempts of global capitalist elites to take advantage of climate change, the portents of ecological crisis for the neoliberal economic order are as momentous as they were for the socialist version of industrial modernity. This time around, however, the systemic crisis is planetary, and the prospects for an optimal denouement depend on a process of democratic renewal, one that by expanding to encompass more-than-human constituencies overcomes the exclusion of the natural world from the public sphere during the fossil fuel era. By projecting their visions for the precarious future of a shared planet beyond the darkened horizons of dominant political and economic paradigms, artists nurture the prospects of radical ecological change.

Projects

Zuleikha Chaudhari

Theater director Zuleikha Chaudhari has developed an extensive body of work, engaging with the relationship between the body and space, the texture of the performative space itself, and the nature of the viewing experience. Chaudhari's works look to expose the courtroom as a site of performativity guided by spectacle.

In 2017, Chaudhari directed the piece *Landscape as Evidence: Artist as Witness*, which was presented by the Khoj International Artists' Association, an intellectually driven arts organization based in New Delhi. The performance focused on the case of petitioners who had opposed the construction of an imaginary "river-linking project" with striking similarities to the recent Ken-Batwa river-linking project in the Indian state of Madhya Pradesh. The current Hindu nationalist leadership has pulled together enough financial and political support for a fresh set of proposals, which suggest the linking of 37 major rivers and the construction of over 3,000 dams.

Chaudhari's performance took shape as a mock trial held at the Constitution Club of India in New Delhi, with real, practicing lawyers on either side. The lawyers argued both for and against, with three artists introduced into the courtroom as expert witnesses, presenting their artworks as evidence. The participating artists were Ravi Agarwal, Navjot Altaj, and Shebha Chachi, all of whom are artists working on the edge of environmental activism. Elaborating on this experimental concept, Pooja Sood, director of Khoj explained that the project was a long-term collaboration between Khoj and Chaudhari. Reacting to the judgment, the theater director observed: "The hearing has been made in the context of a performance, so it is interesting to see what validity the judgment has in the real world. Even though the judgment has been given by a real judge, how one views this conclusion still remains a big question."

Zuleikha Chaudhari, *Landscape as Evidence: Artist as Witness,* 2017.

Chaudhari's performance piece reinterprets the language of the law through art, by positing that contemporary art is capable of inventing creative and critical approaches that analyze, defy, and provide alternatives to reigning political, social, and economic forms of neoliberal globalization.

Work cited

Chaudhari, Zuleikha, and Khoj Association. *Landscape as Evidence: Artist as Witness*. Khoj Association, 2017, http://khojworkshop.org/programme/landscape-as-evidence-artist-as-witness/. Accessed 24 July 2018.

Cannupa Hanska Luger

Multidisciplinary artist Cannupa Hanska Luger's work communicates experiences of complex Indigenous identities coming up against twenty-first-century challenges, including alienation from and destruction of ancestral lands. He compels diverse audiences to engage with Indigenous peoples and values outside of colonialist or capitalist structures. One of his most recent and notable works is *The Mirror Shield Project* (2016), for which he invited the public to create mirrored shields for water protectors at Oceti Sakowin camp, near Standing Rock. He also created a tutorial video that was shared on social media. People from across the United States created and sent these shields to the water protectors on-site at camps in Standing Rock. *The Mirror Shield Project* has since been adapted and used in various resistance movements. In a project statement, Luger writes:

> This project was inspired by images of women holding mirrors up to riot police in the Ukraine, so that the police could see themselves. The materials I chose to use were affordable and accessible, and I chose to use a reflective mylar on a ply-board instead of glass mirror for safety and durability. This project speaks about when a line has been drawn and a frontline is created; that it can be difficult to see the humanity that exists behind the uniform holding that line. But those police are human beings, and they need water just as we all do, the mirror shield is a point of human engagement and a remembering that we are all in this together. The project represents how just one person can acquire one sheet of plywood and cut it into 6 shields, those shields could stand on the frontline protecting hundreds behind them in prayer for the water, and right behind that line stands a camp where there are thousands of people standing for the water protection for the 8 million

Courtesy Cannupa Hanska Luger

Cannupa Hanska Luger, *The Mirror Shield Project*, 2016. Participants form a serpent.

275

people down river, who all use the Missouri River as their water source. And so the Mirror Shield project demonstrates how one person can help protect 8 million.

(Luger)

Work cited

Luger, Cannupa Hanska. "Mirror Shield Project." *Cannupa Hanska Luger*, 2016, www.cannupahanska.com/mniwiconi/. Accessed 23 July 2018.

Hope Ginsburg

Ginsburg's long-term projects are collaborative, cooperative, and participatory, seeking to build community around learning. For each new project, the artist spends time mastering skills such as beekeeping, vermiculture, scuba diving, wool felt-making, and natural dyeing through informal apprenticeships and skill sharing. Driven by curiosity, Ginsburg aims to challenge institutionalized pedagogy, traditional disciplinary boundaries, and hierarchies of expertise. Her 2014 project *Breathing on Land*, began when the artist was in residency in Captiva, Florida, working through the memory of a car accident and the healing process that followed, "in an environment where all is quiet, calm and neutrally buoyant (but where peril is potentially lurking a split-second away)" (Ginsburg). During this time, Ginsburg was inspired by a group of people meditating on the beach with scuba gear and, working backward from that image, turned her studio into a diving shop that accommodated herself and seven fellow resident artists.

Breathing on Land uses group meditation with scuba equipment as a site for exploring healing both in the body and of its ecological surroundings. Ginsburg observed about the project that:

> The image presents the absurdity of hyper-mediation and suggests a sinister, survivalist impulse in the face of environmental catastrophe. However the practice (of breathing on land with scuba) makes for a kind of assisted meditation. The mild, if not moderate, discomfort of the equipment (its weight, warmth, constraints) keeps the wearer in mind of his or her body. The amplification of each breath becomes a kind of involuntary meditation; it is hard not to 'show up' for each exhalation when an entire apparatus is calling attention to it.
>
> *(Ginsburg 1)*

Courtesy Hope Ginsburg with acknowledgement of The Rauschenberg Residency/ Robert Rauschenberg Foundation

Hope Ginsberg, *Breathing on Land: Beach II,* 2014.

According to the participants, the experience of a room full of people breathing in an amplified chorus created a highly unusual and immersive soundscape. Events of the Land Dive Team have since taken place in Zekreet, Qatar, in Richmond, Virginia, and in Beach Lake, Pennsylvania. During her 2015 solo land dive in a Dukan desert in Qatar, the project summoned the specter of a future ocean, as rising sea levels are clearly a threat in the Arabian Gulf region. In a period of divisiveness regarding the state of Earth's environment, *Breathing on Land* focuses attention on the body, its context, and, implicitly, the health of our atmosphere.

Work cited

Ginsburg, Hope. "*Breathing on Land*: Project Description." *Hope Ginsburg*, 2014, www.hopeginsburg.com/work/breathing-on-land-2014. Accessed 23 July 2018.

Huhana Smith

Artist and researcher Huhana Smith has been leading the groundbreaking project *Manaaki Taha Moana: Enhancing Coastal Ecosystems for Iwi* since 2010. The project engages with the use of land in horticulture and agriculture, as well as the relationship between land and waterways in New Zealand. For decades, Smith, who is of Ngāti Tukorehe (affiliated to Ngāti Raukawa) descent, has embraced both contemporary art and museum practice and indigenous knowledge and scientific research in order to address major environmental and climate change issues, particularly as they affect indigenous peoples. In New Zealand—as well as in Australia, Canada, Brazil and the United States—indigeneity as a discourse and as a movement has emerged prominently in the past decade, putting forth possibilities of genuine alternatives to the global policies and concepts that circumscribe these people's lives.

Grounded in indigenous ways of seeing a fertile landscape for resistance and a way of surmounting radical cultural difference, Smith's 2015 exhibition *Tiaki* (Bartley + Company Art, Wellington) was dedicated to *kaitiakitanga*, or guardianship of our environment. Through visual culture, she explored how *kaitiakitanga* has been used in the cultural and agricultural landscapes of her community (or *iwi*) in coastal Horowhenua. Her works bring together the multifaceted cultural, physical, and spiritual connections between lands and waters with her own research into sustainable water resource management. Relating her visual work with her research, the artist has observed that her painting practice represents "a complementary research method, or a personal creative catalyst for practical action research, where the canvas is the base upon which to layer information, research and context. My painting practice helps visualise evidence based, hands-on environmental action for better environmental outcomes."

Courtesy Huhana Smith and Bartley and Company Art.

Huhana Smith, *Tiaki,* 2015. Oil on linen, 50 x 1530 mm.

Further reading

Smith, Huhana. "Huhana Smith: *Tiaki.*" *Bartley + Company Art*, www.bartleyandcompanyart.co.nz/exhibi tions.php?exhibitionID=277. Accessed 13 November 2018.

Futurefarmers

Futurefarmers was founded in 1995 in California by a group of diverse practitioners (artists, researchers, designers, architects, scientists, and farmers) interested in making work that is relevant to their surrounding community in the Bay Area of California. Their studio serves as a platform to support art projects, an artist in residence program, and the group's research interests.

Futurefarmers collaborates with scientists and are interested in generative practices of inquiry. They create participatory projects, spaces, and experiences meant to broaden rather than narrow perspectives. Food policies, public transportation, and rural farming networks are recurring topics that the group visualizes in order to understand the way they operate and work within society. Futurefamers' work provides a playful entry point to gain insight into deeper fields of inquiry—not only to imagine but to participate in and initiate change in society.

The organization's 2011 temporary art project *Soil Kitchen* came to be both an architectural intervention as well as an environmentally conscious study. At the same time as the Environmental Protection Agency's National Brownfield conference and Philadelphia's 2015 Green Initiative launched, *Soil Kitchen* rehabilitated an abandoned building through windmill power into a multipurpose space. For one week, residents and audiences exchanged soil samples from their property and enjoyed free soup while the samples were tested for contaminants. Located parallel to Philadelphia's Don Quixote monument, the windmill paid homage to Miguel de Cervantes's crucial scene of Don Quixote tilting the windmills, while also functioning as a symbol of self-reliance. The windmills literally and symbolically breathed new life into the formerly discarded building. Through a combination of workshops and healthy debates, Philadelphia residents were able to join together and imagine a possible green future.

Courtesy Amy Franceschini, on behalf of Futurefarmers.

Futurefarmers, *Soil Kitchen,* 2011.

In addition, Futurefarmers distributed a Philadelphia Brownfields Map and Soil Archive; offered free workshops on wind turbine construction, urban agriculture, soil remediation, composting; and facilitated lectures on soil science and lessons on cooking.

Work cited

Futurefarmers. "Soil Kitchen." 2011, www.futurefarmers.com/. Accessed 20 August 2018.

Lucy + Jorge Orta

Lucy and Jorge Orta cofounded Studio Orta in 1992. Since then, the partners have worked together, bringing their respective backgrounds in architecture and performance to form a body of work investigating networks of ecological and social interaction. Their practice explores the interwoven reliance of humans and their environments and questions how political, legal, and social constructs change this relationship.

In 2007, the duo traveled to Antarctica. The territory has been considered politically neutral and as a base for international scientific inquiry and study since the signing of the Antarctic Treaty[1] in 1959. With this in mind, the artists approached Antarctica as a symbol of hope and borderless cooperation. Their piece *Antarctic Village—No Borders* (2007–2008) was a site-specific installation of 50 tents constructed from the flags of over 100 countries. Though the installation in this setting was unpopulated, instead becoming a symbolic image, the exhibition traveled around the world several years later where it was visited by many. Audiences then had the opportunity to sign up for an Antarctica World Passport, confirming their commitment to defend natural environments, support humanitarian actions for displaced people, and share values of peace and equality.

The piece references the current climate of migration, drawing attention to the plight of stateless people. This is a concern carried across many of their works; from the early 1990s, Lucy and Jorge have developed a series of architectural wearables for refugees. From ponchos that transform into tents and anoraks that can be reconfigured into rucksacks, the garments are both a practical solution and an illustration of the myriad problems facing those who are homeless, stateless, or otherwise without access to reliable and consistent shelter.

Using both the gallery and the environments central to their pieces—whether the frigid Antarctic tundra or the railway stations of major urban cities—the duo reaches multiple audiences with their message. Lucy Orta frames their bright, graphic works as "Utopian interventions," bisecting this world with a dream of another, better one.

Lucy + Jorge Orta, *Antarctica World Passport,* 2015. Tundra installation view.

Note

1 The Antarctic Treaty regulates international relations in regard to Antarctica, the only continent without a native human population. The original signatories included the 12 countries pursuing scientific research on the continent in 1959, including the Soviet Union, United States, Argentina, and Australia, among others.

Work cited

Nunes, Andrew. "That Time Art and Activism Met in Antarctica." *Creators*, 25 January 2016, https://creators.vice.com/en_us/article/jpvaa8/lucy-jorge-orta-antarctica. Accessed 20 August 2018.

Nut Brother

Beijing's unprecedented levels of pollution have been a major concern for many years, inspiring the creation of words such as "smogocalypse" and "airmageddon" to describe the poor air quality. While recent attempts to alleviate the crisis by reducing the use of coal have been somewhat positive, there is still a lot of work to be done.

Since 2013, the Chinese activist-artist Nut Brother (whose real name is Wang Renzheng) has fought against the toxic smog covering the capital city literally and symbolically by using an industrial appliance to suck up the pollutants from the city's atmosphere. Nut Brother purchased the vacuum cleaner from Shanghai and proceeded to extract the smog across Beijing, walking past some of the city's most famous landmarks. After walking the streets for hours with his black plastic nozzle, he extracted the smog from the machine and turned it into a dark smog-brick. In a recent interview, he claimed that his aim was "to show this absurdity to more people. I want people to see that we cannot avoid or ignore this problem and that we must take real action. . . . You have nowhere to hide. It is in the air all around us."

The media and social networks were quick to respond, and images of the artist-activist quickly caught the imagination of the public. In one photograph, Nut Brother clears up dust beside the larger-than-life-sized portrait of Mao Zedong at the entrance into the Forbidden City, while in another he is just outside of the China Central Television headquarters designed by Rem Koolhaas. His attempts to clean up the smog in the heavily policed Tiananmen Square was met with some resistance; however, even those authorities did not prevent him from continuing his operation. While the artist himself recognized that one would need an army of vacuum cleaners to purify China's air, his symbolic action nonetheless drew unprecedented attention to the country's pressing ecological concerns, using "imaginative ways to change society."

Courtesy Nut Brother.

Nut Brother, *Project Dust,* 2015.

Further reading

Phillips, Tom. "China's Vacuum-Cleaner Artist Turning Beijing's Smog into Bricks." *The Guardian,* 1 December 2015, www.theguardian.com/world/2015/dec/01/chinese-vacuum-cleaner-artist-turning-beijings-smog-into-bricks. Accessed 13 November 2018.

Benvenuto Chavajay

Benvenuto Chavajay's work critiques colonialism as he sees it in contemporary Guatemala and challenges the accompanying colonialist notion of Indigenous people as historic sources of inspiration. San Pedro La Laguna, a remote area of Guatemala, is one of several Indigenous towns located at the edge of Lake Atitlán in the department of Sololá, Guatemala. It is home to the Tz'utujil community, one of 21 ethnic groups in the country that make up the ancient Mayan civilization. Today, an influx of foreign travelers have turned the town into a tourist site with an overflow of backpackers, hostels, and restaurants run by foreign retirees. Chavajay, who resides in both Guatemala City and San Pedro La Laguna, links the environmental deterioration

Courtesy Benvenuto Chavajay.

Suave Chapina sandals used in Benvenuto Chavajay, *Suave Chapina,* 2007-2009.

285

of the lake to the arrival of a foreign modernity. In his *Suave Chapina* (2007–2009) series, the artist transforms rocks, stones, and other objects from Lake Atitlán by attaching them to the plastic straps of the popular sandal brand, Suave Chapina. The brand's name merges *suave*, "soft," and *chapina*, the informal name used to refer to a Guatemalan woman. As Chavajay has noted about plastic: "This material marked Guatemalan society, above all the Indigenous world. With its arrival everything changed. Modernity implasticated our culture" (Chavajay). This brand of sandal became both an inexpensive commodity of desire and an alternative to going barefoot. While the lightweight material of the sandal should project comfort, Chavajay has replaced the sole of the sandal with rocks from San Pedro La Laguna, bringing forth the weight, heaviness, and plight of the Tz'utujil community. This juxtaposition and interrelation between materials goes beyond a critique of environmental destruction of land brought about by the tourist invasion of San Pedro. The series is not a rejection of modernity but rather a reassertion of resistance and survival. Chavajay recognizes in much of his work the process of transculturation so germane to the Americas but maintains a Tz'utujil connection through the base and sole of the artworks, pieces of earth that have existed for centuries. Chavajay's work challenges the dominant ill treatment and violent disregard of nature prominent in the coloniality of power, capitalism, and Western ways of living—especially as they entail the destruction of Indigenous lands, sacred plants, and bodies.

Work cited

Chavajay, Benvenuto. A los chunches no los transformo. Los trans guro. No hay nada que hacerles, interview by Beatriz Colmenares, El Periódico, 12 May 2013, www.elperiodico.com. Accessed 31 July 2019.

Otobong Nkanga

In Otobong Nkanga's work, objects and landscapes are inhabited by memory and emotion. Natural elements like plants and minerals reoccur in her complex installations. They provide evidence of what actually makes up our environments, reconfigured within the artist's installations. In her performances, she narrates their impact on the past, the present, and a possible future.

In the performance *Contained Measures of a Kolanut* (2012), Nkanga used the kola nut, a key emblem of ritual, hospitality, commerce, spirituality, and community among many West African peoples and their neighbors or trading partners. The artist devised an installation of two photo-collaged weavings: one depicting the kola tree and another portraying two girls with feet planted in the ground, like trees. Surrounded by wooden furnishings, including a small table and two chairs, Nkanga invited her audience to join her across the table.

There were two varieties of the kola nut and a suspended decanter dripping its amber-colored extract onto handmade cotton paper. Once sitting, the guest could choose between the darker brown *Cola acuminata* or the lighter yellow, or cream, *Cola nitida*. Once the nut was chosen, it was cut in half with a knife as a sign of respect, according to the custom of Nkanga's Ibibio people, and then was to be chewed slowly. All this was prepared as a stage for conversation. If a visitor did not partake in the kola nut, a truthful conversation between this person and the artist could not unfold. In the course of a performance that could last up to ten hours (requiring great endurance on the artist's part and interestingly also demonstrating the stimulating powers of the kola nut), Nkanga engaged in a series of tête-à-têtes. Her interlocutors could choose from the image plates the artist supplied to stimulate a conversation about aspects of what they just consumed—and therefore something about themselves. Through such ritualized processes, the dialogues and stories exchanged gained weight and value.

Courtesy Otobong Nkanga.

Otobong Nkanga, *Contained Measures of a Colanut,* 2012. Performance documentation, Tropical House in the University of California Bontanical Garden, Berkeley, 2016.

The colonial plundering of minerals like mica, copper, and malachite have irrevocably scarred resource-full environments. This violent removal is memorialized in Nkanga's work, where she has created platforms for remembrance and discussion to bring attention to the environmental conditions around us (Mutumba).

Work cited

Mutumba, Yvette. "Otobong Nkanga." *documenta 14*, 2017, www.documenta14.de/en/artists/13502/oto bong-nkanga/. Accessed 23 July 2018.

Pablo DeSoto

Pablo DeSoto is an architect and cartographer. His work often takes place at boundaries both social and physical, tracing geographies that structure the experience of those who cross them. This work traces back to the early 2000s, when DeSoto organized the experimental architectural project *Fadaiat* (2004). Taking the Strait of Gibraltar as a microcosm of sociocultural exchange and international migration, DeSoto gathered a group of multidisciplinary practitioners to link both sides of the strait—the northern shore in Tarifa, Spain, and the southern in Tangier, Morocco—through a wi-fi connection shared between two computers. On the other side of each monitor was a group of journalists, scholars, and artists who engaged in a discussion on borders and access. The immaterial wireless connection stood in for a "bridge," or invisible pathway across the border.

With this project as an impetus, DeSoto's work has continued to investigate radical cartography as a means of questioning the invisible histories and relationships that form the world around us. In 2011, he traveled to Fukushima, Japan, where he began a three-month-long investigation into the site of the former nuclear crisis and created an archive of materials related to the disaster, from news clips to interviews, videos, and images. With these, he constructed a map called *The Zone* (2011–present), an ongoing project that visualizes the ecological and social impact of the nuclear disaster on the surrounding area. The central feature of the piece consists of an interactive map projected onto the floor, where the viewers have the opportunity to activate multimedia features corresponding to specific coordinates. With these techniques of viewer

Pablo DeSoto, *The Zone,* 2018. Installation view, LABoral Centro de Arte y Creación Industrial, 2018.

Photo Gabriel Diez. Courtesy LABoral.

engagement, DeSoto again works to bridge the gap between nations, while drawing attention to the consequences of human actions on the shared environment.

Work cited

DeSoto, Pablo. Interview with Alice Buoli. "From the Strait of Gibraltar to Fukushima: Situated Practices and Future Imaginaries at Contemporary Borderscapes: A Conversation with Pablo DeSoto. *Traces*, 4 December 2017, www.traces.polimi.it/2017/12/14/from-the-strait-of-gibraltar-to-fukushima-situated-practices-and-future-imaginaries-at-contemporary-borderscapes-a-conversation-with-pablo-desoto/. Accessed 28 August 2018.

PART IV: SECTION 7

Race matters

Project descriptions by Corina L. Apostol,
Corinne Butta, and Shimrit Lee

AFTER THE FIRES, IN THE CLAY DUST

Syrus Marcus Ware

There were fires, in the end. Forest fires that spread across vast patches of land, lighting up the terrain in bold yellows and golds. When I imagined the future, the revolutionary moment that would spur us on to great change, I always pictured Molotov cocktails and fires that we had started, fires of change. But, in the end, it was the Earth that was on fire, its crust burning from the inside out, as it sunk deep into the depths of the Anthropocene.

I had never had to think about the time after the fires. I had been raised to believe that only a few of us would make it out of the revolution alive. It was selfish and narcissistic to imagine that I would necessarily be one of them. But, somehow, survive I did.

Now, I am holding what we have left: writings and scraps of paper that describe a time before now, before the free. This time of the free is so different from life before—we have a greater sense of connectedness now that we have witnessed the fall of capitalism and a revolution in the social world. What follows are examples of the critical thinking about race in the twenty-first century, thinking that helped us get here now, free.

I thumb through some of the pages, before holding them up to my nose to breathe in the deep smell of "book," a smell so far and so foreign a concept in this time after writing, after paper, after the Internet, after the fires stopped burning. I could read the letters on the page: something that wasn't true for many of the survivors. I read aloud to myself, my voice dry and scratchy from the ash and dust in the air. I read aloud:

> This text features the works of artists who are responding to the social uprisings that are taking shape across the planet. Their works highlight the social power of activist artists and encourage all to get involved in the fight. Their works embody the Toni Cade Bambara quote about marginalized artists being charged with making the revolution irresistible.[1]

I put down the pages. To make the revolution irresistible. I remembered drawing, creating larger–than–life portraits of activists as a way of ensuring their survival, their thriving. I remember being part of a community of artists who were writing, dancing, and drawing our revolution into reality.

Now, in the time after the fires, artists are perhaps everywhere, or perhaps we are all artists. We have time to find the necessities for survival and time for little else. But with what free

time we have, most use it to attend one of many communal art-making circles, dancers moving around the cipher with moves of ecstatic rebellion, painters covering every surface with victorious graffiti.

I returned to the pages in my hands, curled and dusty from the clay around my feet. I flipped through the pages, the work of Kara Walker, Melanie Cervantes, Maksaens Denis, and Nástio Mosquito coming to life in my imagination. I leaned back and rest my hand on the ground behind me, propping myself up. I look through the pages and continue reading.

Note

1 The original quote reads: "As a cultural worker who belongs to an oppressed people my job is to make revolution irresistible."

Work cited

Bambara, Toni Cade, and Thabiti Lewis. "An Interview with Toni Cade Bambara: Kay Bonetti." *Conversations with Toni Cade Bambara*, edited by Thabiti Lewis. University Press of Mississippi, 2012, p. 35.

Projects

Melanie Cervantes

Melanie Cervantes' visual art is inspired by her native San Francisco communities' desire for radical change and social transformation. In 2007, she cofounded Dignidad Rebelde, a graphic arts collective that creates political posters, screen prints, and multimedia projects. These projects are inspired by indigenous movements that build people of color's power to transform the displacement and loss of culture resulting from colonialism and exploitation. Dignidad Rebelde

Melanie Cervantes, *Dignidad Rebelde,* graphic arts workshop, 2007–present.

has been visually translating cycles of resistance and struggle into art that is used in turn by the communities who inspire it, thus also helping to build community.

The collective follows principles of Xicanisma and Zapatismo, creating art representative of social movements, connecting struggles through their work and inspiring solidarity among communities worldwide. Intervention in the relationship between text and images in today's interconnected world of symbols and signs is a powerful tool for Dignidad Rebelde to challenge the status quo, continuing a long tradition of protest art in the twenty-first century in which people of color have played a seminal, albeit unsung role.

Dignidad Rebelde emphasizes the critical role that images play in building awareness around injustice, as well as the complicated way in which resistance has taken place not only in the street but also as online activism. They offer not only physical artworks but downloadable posters and drawings, freely available to communities. Their art has been spread widely through hashtags, viral images, and creative digital interventions. Rather than a sterilized presentation of radical politics, their art represents a vital call to action, intended to spark the coming together of bodies in public places in the midst of mourning, struggle, and challenges.

Further reading

Cervantes, Melanie, and Jesus Barraza. *Dignidad Rebelde*, https://dignidadrebelde.com. Accessed 5 December 2018.

Pope.L

Interdisciplinary artist Pope.L began creating performances on the streets of New York in the late 1970s. One such key work is *Tompkins Square Crawl* (1991), which preceded his earlier *Times Square Crawl* (1978), during which the artist crawled around Tompkins Square Park on a hot summer day, wearing a business suit, probing issues surrounding race, gender, language, and community. Pope.L conceived of the crawls as group performances, even though this aspect of the performance was not realized until another decade. In 2011, as part of Prospect New Orleans, he conceived of *Blink* in the wake of the tragedy of Hurricane Katrina, during which volunteers hauled a black ice-cream truck from the Lower Ninth Ward to Mid City for over 12 hours.

Pope.L's recent practice continues to be engaged with the United States' painful and complex history of race relations. In 2015, he reimagined an earlier piece, *Trinket* (2015)—a 5-meter-high by 14-meter-long altered American flag (the artist introduced one extra star in the design), twisting and turning in the wind produced by four industrial fans—at the Museum of Contemporary art in Los Angeles. The work had been first shown in 2008, as an irreverent monument to empty displays of patriotism in the aftermath of the sensationalized lapel pins (or lack thereof) of then presidential candidate Barack Obama. While in that year *Trinket* pointed to the devastations of U.S. imperialist policies, its reimagining in 2015 brought closer to home the injustices of racially motivated violence in the country.

As the flag began to fray at its ends due to the constant whipping of the forced air, it transformed into an unmistakable metaphor for the complexities of engagement and participation, as thousands took to the streets to protest the Staten Island grand jury's failure to convict the New York Police Department officer charged with Eric Garner's death. Protesters' use of Garner's last words—"I can't breathe"—as a slogan and chant against police brutality underscores the sharp protest implicit in *Trinket*, as unchecked police brutality toward Black people

Photo By Brian Forrest. © Pope.L Courtesy the artist, The Museum of Contemporary Art, Los Angeles and Mitchell-Innes & Nash, New York.

Pope.L, *Trinket,* 2015. Installation view, The Geffen Contemporary at MOCA, Los Angeles, 2015.

continues to grow. At the same time, Pope.L's flag speaks to a certain endurance, the continuous existence in a space of disagreement, transforming an abstract symbol into a deeply felt presence.

For more information please see

"William Pope.L: Trinket." *MOCA*, www.moca.org/exhibition/william-popel-trinket. Accessed 13 November, 2018.

Otabenga Jones & Associates

Otabenga Jones & Associates is a Houston-based artist collective, founded in 2002 by artist and educator Otabenga Jones in collaboration with members Dawolu Jabari Anderson, Jamal Cyrus, Kenya Evans, and Robert A. Pruitt. Foregrounding a primarily pedagogical mission, the collective creates interdisciplinary projects that have taken the form of actions, texts, installations, and even DJ sets. The collective's projects have brought to the fore the challenges of Black representation, staying true to the Black radical tradition and mentoring the next generation of young Black youth.

In 2014, Otabenga Jones & Associates took part in Creative Time's Funk, God, Jazz, and Medicine: Black Radical Brooklyn, a larger public project that asks contemporary artists to make artworks based on the ideas of the historic Weeksville settlement, which was one of the first free Black communities in the United States in the nineteenth century. The residents established schools, churches, and associations and were active in the Abolitionist movement. Settled on the corner of Malcolm X Boulevard and Fulton Street, Otabenga Jones & Associates established the FM hub, raising awareness about the history of the neighborhood. The FM hub consisted of a refurbished Pepto-Bismol–pink 1959 Cadillac Coupe de Ville, which functioned as a temporary outdoor community radio station broadcasting live. The Cadillac paid tribute to the 1990 album cover *To the East, Blackwards* by the legendary Brooklyn Hip Hop band X Clan.

Daily programming featured live musical mixes of rediscovered vinyl, stories on Black political histories, community dialogues, improvisational jazz performances, artist interviews,

Courtesy Creative Time.

Otabenga Jones and Associates collaborated with the Central Brooklyn Jazz Consortium to produce a temporary outdoor radio station, broadcast live from the back of a pink 1959 Cadillac Coupe de Ville. The project took place within the context of the Creative Time project *Funk, Jazz, God & Medicine: Black Radical Brooklyn* (2014).

and experimental sound. The project became a recognizable aesthetic fixture, augmented by an important activist statement, as a fresh, engaging way of engaging with Bed-Stuy's Black radical past.

Further reading

"Jazz: Otabenga Jones & Associates in collaboration with Central Brooklyn Jazz Consortium." *Creative Time*, http://creativetime.org/projects/black-radical-brooklyn/artists/otabenga-jones-and-associates/. Accessed 5 December 2018.

Maksaens Denis

Coming from a classical music background, Maksaens Denis is a multimedia artist and DJ from Haiti working between Port-au-Prince and Paris. Based on vernacular visual cultures of the Caribbean, Denis's art skillfully weaves together a political awareness with spiritual content and visual poetics. In his video installations and performances, Denis juxtaposes a range of images:

Maksaens Denis, *Trageéie Tropicale*, 2015. Video still.

scenes from everyday life and religious ceremonies of the Black communities in the Caribbean, video clips of the Caribbean landscape, Vodou symbols, together with digital animation, improvised soundtracks. His installations create a total environment with which experiences communicate associatively.

The video installation *Tragédie tropicale* (*Tropical Tragedy*, 2015) was exhibited as part of the exhibition *Noctambules*, Forum AfricAmericA 2015 at Villa Kalewès, Pétion-Ville, Haiti. In the Haitian context, exposing the Black male nude figure is considered provocative, as it is particularly taboo. By superimposing two levels of images, the artist evoked different levels of reflection: between reality and spirituality, North–South relations, racial and social inequalities and belief systems, politics, and everyday life. Denis choreographed the space in order to make the polarities of the world feel, sound, and vibrate differently.

As always, Denis placed the focus on a subject that touches and preoccupies him: the presence and historical resonances of the Black body. To achieve this, sound and image are intimately nested. In this installation of *Tragédie tropicale*, while the soundtrack plays "The Revolution will be not televised!" the image of the Black body is covered with signs and other images, some of which are very striking, like blood, stigmata, and ropes. All of this is augmented by the presence of barbed wire installed on the ground. The whole of these elements builds a work of great complexity that places race at the intersection of contemporary cultural, social, and economic interactions between African and Afro-descendent people and imagines the Black body as a space of encounter. Parts become elements representing a Black selfhood encompassing local, national, ethnic, and diasporic qualities.

Further reading

Denis, Maksaens. *Maksaens Denis*, 2018, www.maksaens-denis.com/. Accessed 4 December 2018.

Simone Leigh

Simone Leigh is known for her explorations of female African American identity through sculptures, videos, and installations informed by African American and historical African object-making. In 2014, Leigh presented the project *Free People's Medical Clinic* (FPMC) in the framework of Creative Time's *Funk, God, Jazz, and Medicine: Black Radical Brooklyn* in collaboration with the Weeksville Heritage Center, a Brooklyn community established by free and formerly enslaved Black citizens 11 years after abolition in New York State. The artist's project critically examined the intersections of women's labor, racial identity, and public health. It asked audiences to ponder the often invisible or unknown Black women nurses, gynecologists, osteopaths, and midwives who have supported the African American community for centuries.

The project was reminiscent of the Black Panthers' community-based health care efforts in the 1960s and 1970s across the United States, which brought direct care services to communities with the help of volunteers. The Black Panthers also focused on screenings and treatment for sickle cell anemia, a genetic disease that disproportionately affects African Americans. Leigh's own project also paid tribute to nineteenth-century medical pioneers such as Dr. Susan Smith McKinney Steward, the first Black woman doctor in the state of New York, Dr. Josephine English, the first African American woman to have an OB/GYN practice in the state of New York, and The United Order of Tents, a secret fraternal order of Black Women nurses founded during the Civil War. Leigh was also inspired by her participation in the Àsìkò school, which travels to a different country each year and convenes a panel of African artists, curators, and scholars.

Leigh hosted the clinic in Dr. English's home, converting the residence into a space that explored the dignity and power of Black women whose medical work is often hidden from view. Leigh's FPMC pointed to a larger need for better health care experiences by offering an array of homeopathic and allopathic services, including yoga and pilates instruction, community

Photo and courtesy Michelle Gustafson for the *New York Times*.

Simone Leigh in the studio with *Brick House* (2018).

acupuncture, dance lessons, blood pressure, and HIV screenings offered by Brooklyn-based practitioners. Her seminal initiative brought together historical legacies of Black community politics with a socially engaged practice that reimagines the idea of community. On the background of the emergence of the Black Lives Matter movement, participants in Leigh's clinic contemplated the meaning of belonging in a community and acting collectively, questions that continue to hold a particular urgency for our times.

Rena Rädle and Vladan Jeremić

Artists, activists, and cultural workers Rädle and Jeremić have been working together since 2002, when they founded Biro Beograd, an association for critical practice that goes beyond conventional forms of contemporary art, cultural, and political activism. One major recent focus of their research is the emerging Roma emancipation movements in Europe today.

Their recent film *The Housing Question* (2014) brings together present-day views of the city of Rome, animated drawings of its inhabitants, and the discourses of three main characters: an elderly woman who survived a concentration camp in Germany and two young men who live in contemporary ghetto-like settlements in the capital. The film brings into focus the continuity of European racist policies toward the Roma people, whose settlements have been demolished and who have themselves been relocated to containers.

The artists argue that European societies' relation with the Roma, who represent the continent's largest minority population, is symptomatic of a deep-seated colonial mentality and inextricably linked to the prevalent class-based racism on the continent. The film reveals

> [T]he political and economical exploitation of Roma people that has been made possible through cultural stigmatisation, social isolation and spatial segregation in the city of Rome. . . . We learned about Rome's history of immigration and the practice of self-organized and mostly "illegal" building of houses during the 20th century. Roma, who came as guest-workers from Yugoslavia during the 70s, integrated easily into this housing model. With the implementation of the "Nomad plan" in the 80s, the situation changed. This new policy referred directly to the Roma population and was based on the idea of "cultural protection" of a traveling group of Sinti from Italy, securing

Courtesy Rena Rädle & Vladan Jeremić.

Videos: *Belleville, The Housing Agenda, The Housing Question* with wall drawing. Installation view, *The Housing Question,* ngbk, Berlin, 2013.

them camping sites during their travel. From the marking of a group's 'cultural identity,' a new racist housing policy was derived.

The Housing Question is part of a larger series of works that resulted from the artists' years-long engagement with Roma communities in Europe. Through publications, drawings, installations, and related films, the artist continue to draw attention to the perpetration of racist policies and ways audiences can get involved sociopolitically.

Further reading

Rädle, Rena, and Vladan Jeremić. *The Housing Question* (2009–present), self-published, 2014, http://raedle-jeremic.net/pdfs/about_the_housing_question_full.pdf. Accessed 13 November 2018.

Nástio Mosquito

Nástio Mosquito produces music, performances, objects, and videos under a range of monikers, including Nastiá, Saco, Cucumber Slice, and Zura Zuara. He also develops works under the collectives Nastivicious and Bofa da Cara. Within his diverse multimedia projects, the artist adopts the role of postcolonial respondent, while mocking the idea of any such imposed position. The artist is particularly invested in African politics, especially those pertaining to Angola, exploring the legacy of the violent civil war, alongside sexual politics and rampant consumerism ushered in by globalization.

In 2010, Bofa da Cara produced *My African Mind*, a video exploring Western constructions of Africa, with a dramatized voice-over layered over a 1940s Hollywood–style soundtrack. The artists render in three dimensions cutouts of pictures drawn from comic books, movie posters, advertisements, and nineteenth-century missionaries. Revealing landscapes of dramatically shifting foregrounds and backgrounds, the images are immediately gripping and compelling. Moving back and forth between image and text, *My African Mind* brings into focus the ideological construction of race and historical violence through the colonial gaze and its contemporary manifestations: Western aid, the nongovernmental organization industry, and the continued exploitation of resources. The work forces audiences to face the past horror of one continent's encounter with the other and the scars this has left on the face of the present.

Through both landscape and direct speech, Mosquito addresses the complex legacy and continuous contemporary reinforcement of Western colonialism and racism, and its consequences in terms of thought, speech, and the biopolitical sphere. Mosquito's politically charged dark humor draws light to society's passive acceptance of hegemonic rationales and their insidious propaganda, revealing a dysfunctional system on the edge of a collapse.

Courtesy Bofa Da Cara.

Nástio Mosquito/ Bofa da Cara, My African Mind, 2010. Video still.

Marika Schmiedt

Marika Schmiedt, a politically engaged Roma activist-artist from Austria, is renowned for her politically controversial posters, collages, and films. They work to expose and critique various forms of racism, nationalism, and fascism in Europe. As Amnesty International continually reports, the Roma are located between borders—in bureaucratic, social, and political no-man's lands—where they are persecuted, often homeless, and without education or political protection. By linking the history of the persecution and killing of Roma and Sinti to the current forms of systematic and violent discrimination and murder of these peoples in Europe and worldwide, Schmiedt's work hits a nerve in the neofascist atmosphere of European politics. Her work enrages nationalists from various countries, as well as politicians and public figures, who find her work too confrontational.

The artist has been censored, threatened, and attacked. For example, during her solo exhibition *Thoughts Are Free—Anxiety Is Reality for Roma in EUrope* (2012), a Hungarian nationalist and her Austrian husband attacked the artist and began to tear down her posters on the construction site fence. One of the organizers of the exhibition and Schmiedt stopped the attack. The Hungarian woman called Schmiedt a racist and threatened to sue the artist for her purported defamation of the Hungarian nation. Schmiedt stated that her posters represent "artistic

Courtesy Marika Schmiedt.

Marika Schmiedt, Thoughts Are Free--Anxiety Is Real for Roma in EUrope, "Roma Integration," 2012.

interventions or confrontages" meant to disrupt the comfortable silence by exposing "the visual culture of racism and its many languages" (Schmiedt). Schmiedt's artistic production functions as a constant criticism of the language of hate speech and a lucid investigation into the mechanisms of silence and indifference.

Given Hungary's constant violations of human rights, censorship of the media, and the cultural sector, Schmiedt's posters function as a poignant critique of these political developments. Furthermore, the European Union continually fails to address the rampant hatred of Roma, anti-Semitism, and homophobia existing in Hungary. Schmiedt's work bears witness to these developments and offers resistance against complicity and capitulation of civil courage.

Work cited

Schmiedt, Marika. "Catalog: The Thoughts Are Free." *ARTBRUT,* https://marikaschmiedt.com/die-gedanken-sind-frei/. Accessed 6 September 2018.

Sethembile Msezane

Sethembile Msezane was born in the KwaZulu-Natal province of South Africa. Now based in Cape Town, her performance pieces focus on the absence of Black women in the South African historical and political landscape. She explores the different ways in which women are restricted in movement, attire, and body form in society. She performs in order to assert her existence, identity, role in society, and importance in time and space.

Untitled (Heritage Day) was the first in Msezane's *Public Holiday* series (2013–2014), initiating a body of performative work that spanned two years. In these works, Msezane recontextualizes and remembers the physical geography of Cape Town and its monuments. Not only does Msezane's work operate at the level of race—contesting the concrete representation and ionization of whiteness and the legacy of Black subjugation in the form of monuments in the Cape Town architectural scape—but the work also counterposes this layer of critique by gendering the lens.

In the series, Msezane performs her gendered body as inextricably linked to her racialized body. *Heritage Day* sees her in the traditional, celebratory garb, and adornments of Memulo (the coming-of-age ceremony for women in Zulu tradition). The performance of these signifiers operates as a critique not only of the white and rainbow-washing of September 24, Heritage Day, but also as a critique of the valorization of historic, masculine figures and the implicit invisibility of female figures. This counterposition then becomes an intersection, the crossing of which is the body of Msezane. The lens is not only racial but cultural; not only cultural but gendered; not only contemporary but a recapitulation of a history of erased Black femininities.

The layered didacticism of Msezane's work is one of its pivotal axes. Black Africans and Black women have had their history effectively erased under the rhetoric of nonracialism, and therefore there is a necessary and urgent kind of activism to unearthing these erased histories and, not only to unearth them, but to critically engage with them. Msezane re-remembers Black African women and their bodies into the canon of history.

Courtesy Sethembile Msezane.

Sethembile Msezane, Untitled (Freedom Day), (2014).

Kara Walker

For over two decades, artist Kara Walker has been renowned for her sharp investigations of race, gender, violence, and sexuality through silhouette figures that have been exhibited internationally. Like ghosts of the past, these figures evoke the United States' fraught relationship with race and the history of violence and discrimination that still informs the present. In the artist's conception, they are signifiers of power inequality that separates those who have shaped history and owned land and those who have worked the land and claimed their rights, despite seemingly insurmountable odds. In the silhouettes, Walker's Black characters are created from Black paper, the color of mourning, while her white characters occupy white spaces of reflection.

In recent years, Walker has produced large-scale public projects, such as her celebrated monumental installation titled *A Subtlety: Or . . . the Marvelous Sugar Baby an Homage to the unpaid and overworked Artisans who have refined our Sweet tastes from the cane fields to the Kitchens of the New World on the Occasion of the demolition of the Domino Sugar Refining Plant* (2014). Commissioned and presented by Creative Time, the project revolved around a mammy-as-sphinx sculpture covered in sugar. It was on view at the Domino Sugar Factory in Brooklyn and responded to the difficult history of sugar as it intertwined with the history of slavery in the United States. The factory was built in 1882 and by 1890, it produced half the sugar being consumed in the United States. In 2000, there was a long labor strike, during which 250 workers protested labor conditions. After the closure of Walker's project, the factory was torn down and its site developed. Its history has now been buried behind apartments.

Measuring approximately 75.5 feet long and 35.5 feet high, the white sculpture was made out of bleached sugar, which is a metaphor and reality. Several sculptural attendants, in the form

Courtesy Creative Time.

Kara Walker, A Subtlety, 2014. Installation view, Domino Sugar Factory, Brooklyn, NY.

311

of life-size childlike figures, stand around the main figure, cast from boiled sugar with a dark amber coloring. The choice of using sugar in different states is both metaphorical and real. Sugar is brown in its so-called raw state. Even the title, *A Subtlety*, refers to sugar sculptures called subtleties that were once created in thirteenth-century North Africa to be gifted to the poor on feast days. Walker found inspiration in this history and also in the history of the slave trade in America, prompting audiences to ask questions about the people who cut the sugar cane, transformed it into syrup, bleached and gathered it in sacks.

These overlapping narratives are embedded in the hybrid figure of the sphinx-mammy, which speaks of a past of slavery and subjugation at the same time that it stands triumphant.

Further reading

Smith, Roberta. "Sugar? Sure, But Salted with Meaning." *New York Times*, 12 May 2014, www.nytimes. com/2014/05/12/arts/design/a-subtlety-or-the-marvelous-sugar-baby-at-the-domino-plant.html. Accessed 11 December 2018.

PART IV: SECTION 8

Classroom in crisis

*Project descriptions by Corina L. Apostol,
Corinne Butta, and Shimrit Lee*

CLASSROOM IN CRISIS

Jasmina Tumbas

Universities have become acute sites of compound and multiplying crises, satellite and stratified communities oozing the harsh realities of neoliberal capitalism. Much of the difficult task of shaping future generations rests on the shoulders of a growing precarious labor force that includes graduate student teaching assistants, adjunct professors, and university staff, who are more and more strained by administrative changes and demands without financial security. Along with this changing labor force in higher education, an increasing level of censorship of professors worldwide calls for new pedagogies that transcend the university walls and rethink the possibilities of creative engagement beyond the limitations of institutions. One great lesson of the twentieth century is that the sphere of art, while flawed and deeply implicated in the destructive force of capitalism, colonialism, and patriarchy, can offer up moments for experimentation with pedagogy that transcend and address the "poverty of student life" ("On the Poverty of Student Life . . .").

At best, these moments or situations compel profound political transformation. The classroom—when dislodged from the space of the room, relocated from campus to the streets, community centers, alternative architectural sites, and communal actions—can become a place for permanent creativity, as Robert Filliou called it (*Teaching and Learning*). Or, as shown by Decolonize This Place,[1] actions at various art institutions—museums themselves—can be converted into active classrooms that thrive on community interventions against the whitewashing of culture and stagnation of cultural memory. We know that today, many of our students never heard of Auschwitz, do not know of the Roma people, and are not aware of the colonial histories of their countries. Many more will never even have a chance to be students or teachers in university classrooms, are stateless, or unable to pursue education because of their class, their race, or their gender.

While elite academics increasingly fear the recent rise of right-wing ideologies, those on and in the social and institutional periphery, such as refugees, immigrants, poor folks, women, children, trans folks, and people of color, know the limitations of liberal democracies too well.

Descriptors for art—terms like "subversive," "transgressive," and "radical"—have gained global cultural capital and may be frequently found in accounts of a plethora of "activist" artworks that critique capitalist oppression. They are also commonly displayed in international biennials supported by capitalist globalization. Similarly, pedagogical models in museums habitually co-opt such strategies to increase memberships and gain cultural capital.

The artists and collectives in this chapter try to resist this co-optation by liberal democracies and offer alternative models of teaching and engagement within numerous cultural contexts. Reaching in scope from refugee camps in Palestine, Nigerian architectural mediations, Senegalese hip-hop and rap music, Romanian communism, dissidents in Cuba, experimental educational models in Indonesia, reinterpretations of a student-driven universities, to a horizontal approach to teaching in Latin America, Italy, Puerto Rico, Cambodia, and the United States, these artists challenge us to consider education as a living system that demands ethics, action, and commitment. More than anything, it commands courage.

Note

1 "Decolonize This Place" is a space focusing on action-oriented works on the indigenous struggle, Black liberation, Free Palestine, global wage workers, and degentrification. It is facilitated by MTL+ located at 55 Walker Street, New York, www.decolonizethisplace.org/. Accessed 31 July 2019.

Works cited

Filliou, Robert. *Teaching and Learning as Performing Arts.* Verlag König, 1970.
Situationist International. *On the Poverty of Student Life: Considered in Its Economic, Political, Psychological, Sexual, and Particularly Intellectual Aspects, and a Modest Proposal for Its Remedy.* University of Strasbourg, 1966.

Projects

Kunlé Adeyemi

In June 2012, the Nigerian federal government gave Makoko's 86,000 residents less than three days to evacuate their homes. Locals inhabiting the former fishing village on the Lagos Lagoon were not offered compensation or temporary housing. As a response to this dire state of affairs, Nigerian-born architect, designer, and urban researcher Kunlé Adeyemi created the *Makoko Floating School* (2013), a pioneering prototype floating structure located on the lagoon. The prototype offered an innovative solution to overcrowded living conditions, infrastructural damage from tidal flooding, and the state-sanctioned demolitions experienced by the community's residents under the guise of progressive development. The school was built from by a team of local residents, using wooden offcuts from a nearby sawmill and locally grown bamboo, making it an inexpensive, sustainable, and easy-to-build structure. During its construction, the school became controversial, drawing criticism from the Lagos state government, who considered that it was illegal to be built in the first place. The vision behind Adeyemi's architectural activism is to develop an ecologically friendly urban blueprint that would bridge the infrastructural gaps of shoreline settlements in the global south.

In 2016, the school collapsed, with no casualties, due to poor maintenance and a lack of proper collective management. The materials of the school, such as the solar power system and barrels, were salvaged and stored for reuse. The destruction only added to the criticisms surrounding the school, leaving the community at risk. Despite the controversy of the floating structure, the government did cease demolition plans by approving a regeneration plan instead.

Courtesy NLÉ.

Kunlé Adeyemi/NLÉ, MFS III—*Minne Floating School* in Bruges, Belgium—NLÉ's third prototype and iteration of the Makoko Floating School in Lagos, Nigeria, 2018.

317

Adeyemi's designs were also selected by the state ministry of urban development for new housing plans.

The scope of Adeyemi's practice is not limited to architecture. He has also designed furniture, among many other things, and continues to explore critical social and cultural possibilities that contribute to urbanism. He writes:

> Whether a chair for charity in South Africa, a revolutionary rotating art space for Prada in Seoul or the visionary plan to eliminate traffic paralysis in Lagos with the 4th Mainland Bridge, in each project the essential needs of performance, value and identity—critical for success—are fundamentally the same for me. Although quantitatively different from place to place, the responsibility of achieving these needs at maximum, with minimum means, remains the same globally. I am constantly inspired by solutions we discover in everyday life in the world's developing cities.
>
> *(Kunlé Ademi)*

Works cited

"Kunlé Ademi: Founder/Principal." *NLÉ*, 2018, www.nleworks.com/team-member/kunle-adeyemi/. Accessed 31 July 2019.

Okoroafor, Cynthia. "Does Makoko Floating School's Collapse Threaten the Whole Slum's Future?" *The Guardian*, 10 June 2016, www.theguardian.com/cities/2016/jun/10/makoko-floating-school-collapse-lagos-nigeria-slum-water. Accessed 31 July 2019.

Campus in Camps

Campus in Camps is an experimental educational program for third-generation Palestinian refugees located in the West Bank. The program was founded in 2012 by Italian-Palestinian architects Alessandro Petti and Sandi Hilal, both of whom also founded the Decolonizing Architecture Art Residency (DAAR). Every year, Campus in Camps, which is accredited as an MA at Al-Quds University, brings together 15 participants to produce "new forms of representation of camps and refugees beyond the static and traditional symbols of victimization, passivity and poverty" that persist among Palestinians and the international community ("Commons & Commoning"). The program invites critical scholars, designers, architects, and artists to support young Palestinian refugees in their efforts to imagine futures that go beyond their realities of the camp and the 65 years of displacement that has defined the Palestinian condition since the founding of the state of Israel.

Based on a collective pedagogical method called *mujaawarah*—meaning "communication" or "gathering" in Arabic—all participants and community members work to transform the refugee camp into a site of knowledge production. Campus in Camps is therefore consistently revising itself to accommodate the needs and interests that emerge from the group's discussions. Each pedagogical cycle of the project brings together theoretical inquiry and practical exercises. The first cycle, called the Collective Dictionary, allowed participants to redefine terms such as "ownership," "vision," "sustainability," and "participation" as a means of reclaiming these terms from the humanitarian discourse that defines much of refugee existence. Other cycles included

Photo by Brave New Alps and courtesy Bianca Elzenbaumer and Alessandro Petti.

Campus in Camps, 2012. Ayat Al Turshan, Fabio Franz, Nedaa Hamouz, and Sara Pelligrini walking behind a farmer on the fields around the Al Fawwar camp south of Hebron, discussing the role of agriculture in creating common spaces for the camps.

Agriculture and Resistance, in which participants explored the relationship between agricultural practices, food production, and political power through readings, fieldwork, and interviews with local farmers. In another cycle called The Opaque Document: The Poetic and Political Dimension of the Everyday, the group documented the politics of everyday life through their mobile phones. Through these collective investigations, Campus in Camps aims to decolonize methodologies of knowledge and reimagine alternative futures within the camps without normalizing the status of Palestinian refugees as a permanent condition.

Sources

"Commons & Commoning." *Brave New Alps*, 2012, www.brave-new-alps.com/commons- commoning/. Accessed 28 August, 2018.

Elzenbaumer, Bianca. "Speculating with Care: Learning from an Experimental Educational Program in the West Bank." *Architectural Theory Review*, 22:1, 2018, pp. 100–119.

Francheschini, Silvia, and Luca Guerrini. "Campus in Camps: Decolonizing Knowledge and the Question of Un-Learning." *Re-Visiones*, 2017, www.re-visiones.net/index.php/RE- VISIONES/article/view/202/368#_ednref10. Accessed 28 August 2018.

KUNCI

Since its founding in 1999 in Yogyakarta, Indonesia, KUNCI has been deeply involved with critical knowledge production and sharing through means of media publications, cross-disciplinary encounters, action-research, artistic interventions, and education within and across community spaces ("About Us").

Exploring scenarios of dealing with differences, workshops collect and experiment with tools from the realms of art, critical education, everyday life, and intersectional experiences and theories. The exchange is based on methods from the KUNCI School of Improper Education, a project of vernacular education within and across community spaces in Yogyakarta, Indonesia, that focuses on the potentials of education as a site of contestation. Their work is based in the question of how to engage with conflicts and contradictions as methodologies for mobilizing togetherness that are open to difference in terms of race, class, gender, and sexuality, instead of retreating to reconciliation as a goal; especially if the latter is considered an everyday mechanism of reproducing power asymmetries and sustaining normative practices.

Courtesy KUNCI Cultural Studies Center.

The School of Improper Education, 1999-present. A child uses the library at the KUNCI Cultural Studies Center.

The School of Improper Education is an experiment in the sustainability, both material and immaterial. It engages with alternative modes of education and knowledge transmission, while also interrogating the meaning of togetherness. The school's main activities include an examination of the meanings of studying and ways to study such meanings. One of the School's practices is learning sign language. While none of the students have hearing impairments, their learning process is twofold: to master the language while also understanding how the language operates.

Participants come from all different professional backgrounds, which are based in their own modes of knowledge circulation. Each student is encouraged to reflectively engage with one another's varying forms of knowledge circulation.

Through such practices, the School works to disrupt the hierarchical relation between student and teacher while also better understanding the homogenizing tendencies of pedagogical principles upon the body and the mind.

Work cited

"About Us." KUNCI Cultural Studies Center, http://kunci.or.id/about-us/. Accessed 26 July 2018.

Ahmet Öğüt

While universities around the world are increasingly offering online courses and degrees, recent socially engaged art practices have invested in pedagogical assemblies during which diverse peoples share a certain space and time. Ahmet Öğüt's *The Silent University* (2012–present) defines itself as "an autonomous knowledge exchange platform by and for refugees, asylum seekers, and migrants" (Öğüt), who hold professional backgrounds but cannot gainfully practice their trade due to the limitations of their political and social status. This mobile university challenges the idea of silence as a passive state and explores its powerful potential through performance, writing, and collective thought. By inventing alternative currencies in place of money, *The Silent University* creates a process of exchanging knowledge and experience that is mutually beneficial to everyone involved in order to allow for democratic access to education beyond social hierarchies and class distinctions. Originating in London, *The Silent University* has reached beyond the U.K. and collaborated with cultural institutions in Stockholm, Hamburg, Amman, and Athens, while pursuing an alternative institutional practice.

The Silent University relies on the generosity of local art institutions, communities, and education centers, as it uses the existing facilities and networks of these various institutions. With these community contacts, the university activates the knowledge of refugees, asylum seekers, and migrants who have been silenced in their new countries of residence. Öğüt emphasizes taking direct measures and immediate action, defying the bureaucratic aspects of the modern educational system in an act of social liberation.

This work emphasizes the systemic failure and the loss of skills and knowledge experienced through the erasure of asylum-seeking people. Lecturers teach across the humanities, law, psychology, business, visual arts, and health; while students cannot receive a formal degree, they have access to specialized courses. In this way, *The Silent University* is also a radical exercise in advocacy. People who are excluded from formal social systems and power gain access to courses taught by people who have also been silenced by their lack of access and participation in education.

Courtesy Ahmet Öğüt.

A class at *The Silent University,* 2012-present.

Thus, the university supports a transversal pedagogy around participation and creative commons where everyone has the right to be educated. Such pedagogic practices require long-term engagement, commitment, and determination. Participants at *The Silent University* have adopted the project as their own and continue to keep it open as an autonomous platform.

Work cited

Öğüt, Ahmet. "Towards a Transversal Pedagogy." *The Silent University*, 2012, http://thesilentuniversity.org/. Accessed 26 July 2018.

Pepón Osorio

Renowned for large-scale installations influenced by his experience as a social worker in the Bronx, New York, Pepón Osorio has created projects in collaboration with the neighborhoods and people with whom he is working. His commitment to returning art to the community is evident in his project *reForm* (2014–2017), which deals with the controversial 2013 school closures in Philadelphia.

The project was housed at the Tyler School of Art (located in Northern Philadelphia) and focused on nearby Fairhill Elementary, which Osorio chose because it was located along his commute to work. Osorio remarked that: "The ghost of the building, and the presence of that ghost around the neighborhood, and what that meant for the community was overpowering to me." *reForm* presents the complex story of Fairhill Elementary's tragic closure and of the students who were evicted as a result. The school remains closed today. Similarly, two dozen other schools were closed by the Philadelphia city council, citing budgetary constraints.

In collaboration with teachers, students, parents, and neighbors, Osorio collected abandoned items from the school and placed them in a multilayered installation that exposed the injustice of the closing of Fairhill. Osorio also worked with a team of students called the Bobcats (the school's mascot), whose stories were recorded in video art and mixed-media installations that emphasized their resilience in the face of challenging financial struggles. In the installation along a corridor, a row of cubbies displayed backpacks, jackets and coat hooks, and a glass case showed the mascot standing on a pile of opened books. Inside a classroom, a text of a letter sent by Dr. William R. Hite (the school district's superintendent) was put on view on a blackboard. The text, addressed to Fairhill's principal, Darlene Lomax, informed her of the school's imminent closure. The classroom also showed a teacher's lectern, affixed with part of a "Property Available" sign. In fact, when the school closed, a similar placard was placed on the building to attract potential buyers.

Courtesy Pepón Osorio.

A Fairhill School student participates in Pepón Osorio's *reForm* project, 2016.

Some of the most impactful elements of the exhibitions were essays by Fairhill students written in pencil directly on lined paper on the walls of the space. Osorio noted that the directness of the pencil on paper is exemplary of the authenticity of the students' feelings of outrage about the closure. Similarly, students' voices were heard in videos placed next to the essays, which expressed a sense of disappointment in the face of bureaucratic decisions, as well as the fear that the closure would damage their education prospects in the future. In an effort to comprehend why and how their school was closed, the students also made models of the decisions of the senior officials who were responsible. Osorio observed, "It's really about understanding not only the implications but also the system itself."

Further reading

Hurdle, Jon. "Art Show Captures the Wrenching Effects of Closing a School." *New York Times*, 28 August 2015, www.nytimes.com/2015/08/29/arts/design/art-show-captures-the-wrenching-effects-of-closing-a-school.html. Accessed 4 December 2018.

Luis Manuel Otero Alcántara and Yanelys Nuñez Leyva

In 2016, artist Luis Manuel Otero Alcántara and art historian Yanelys Nuñez Leyva decided to redefine what it means to be a dissident in Cuba. They created the *Museum of Dissidence*, a website that chronicles the importance of people and groups who have stood in opposition to the government throughout history. Among the dissidents featured are President Raúl Castro and his brother Fidel, who took power through an armed rebellion, as well as key opposition groups who have been suppressed by the Cuban government. Icons such as the indigenous leader Hatuey and independence martyr José Martí are profiled, as well as Oswaldo Payá, one of the current government's fiercest critics, who died in a 2012 car crash that remains unexplained. Through myriad such examples, the project illuminates the figures that seek to overturn Cuba's entrenched ruling class.

"We set out to dismantle the pejorative meaning the word 'dissident' has had in Cuba. It was designed to be a space to generate dialogue," Nuñez said in an interview (Londono). Nuñez worked as a staff writer at a magazine published by Cuba's Ministry of Culture when the site was created. Due to her involvement in the project, she was fired several months after it was launched. Previously, Alcántara, too, pushed the boundaries of free speech in Havana through performance art and sculpture. Probing the boundaries between reality and fiction, in his work he alters elements of everyday life in order to provoke closer examination.

As Cuba's one-party state continues to impose strict restrictions on speech, assembly, and press freedom, the founders of the *Museum of Dissidence* have continued to organize radical public art projects and installations, concentrated in the poorer neighborhoods of Havana. In 2017, the *Museum* worked with graffiti artists to create illicit murals representing aliens and balaclava-clad characters with no mouths, a reference to Cuba's tight control on speech. In a striking

Courtesy Luis Manuel Otero Alcántara and Yanelis Nuñez Leyva.

Luis Manuel Otero Alcántara and Yanelys Nuñez Leyva, *Another Poet Commits Suicide,* 2017. Cuba. The artists stage the death of Cuban poet and visual artist Amaury Pacheco in a celebration of Cuban writers lost to suicide.

project titled *Another Poet Commits Suicide*, they drew attention to the many seminal artists and writers to have taken their own lives. The *Museum* continues to offer an incredibly important space for ideas and projects dangerous to the one-party state and offers a platform for the artists in Cuba to connect to the global community.

Work cited

Londono, Ernesto. "A Bold Attempt to Redefine 'Dissidence' in Cuba." *New York Times*, 2017, www. nytimes.com/2016/09/04/opinion/sunday/a-bold-attempt-to-redefine-dissidence-in-cuba.html?_ r=0. Accessed 3 August 2018.

Dan Perjovschi and Lia Perjovschi

Over the course of two decades, Lia and Dan Perjovschi have created radical institutional and artistic platforms operating at the nexus of art theory, history, politics, science, and philosophy. Before the social and political transformations of the 1989 Revolution, Romanian citizens had little access to outside information. In the wake of the transformations that gripped the country throughout the 1990s, Lia and Dan Perjovschi have generated projects that respond to social problems and needs. Their work stems from a drive to understand, discuss, and share knowledge with their audiences

In 2009, Lia Perjovschi exhibited *Plans for a Knowledge Museum* (2009), a museum-like installation dedicated to moving away from the exhibition as spectacle or a form of entertainment and toward an open-structured, archival model. Perjovschi envisioned a museum with seven departments—The Body, Art, Culture, The Earth, Knowledge and Education, The Universe, and Science—reflecting her own interdisciplinary approach to the organization of information. The installation comprises the artist's own drawings, as well as objects, charts, photos, and color prints. Most of the objects were bought in museum gift shops from around the world, and she uses this material culture to draw attention to the ways in which art and museums themselves are commodified and marketed. The items are loosely grouped, as the project's "departments" are not mutually exclusive. The artist's project shows the conflicts, contradictions, and inequalities present in our world. At the same time, her position is not neutral, for she is on the side of the have-nots, the oppressed, and the marginalized, and from that position, she launches her critique.

Photo and courtesy Lia Perjovschi.

Lia Perjovschi, *Knowledge Museum - Kit,* 2007. Installation view Liechtenstein Museum.

The "Art Department" of Lia Perjovschi's installation of the Knowledge Museum includes Dan Perjovschi's drawings. His series of marker drawings, titled *Time Specific*, comments on national symbols and the fragile state of the Spanish national economy in 2010. *Revoluti ON/ OFF* is a play on words, reminding viewers of the social movements in the Middle East, Europe, and the United States that seriously challenged or even deposed dictatorial regimes or oppressive governments. Another related work, *Local/Global*, juxtaposes two faces, one depicting a pair of fangs, and the other, multiple sharp teeth. Underneath the first figure, the artist wrote "local," while the latter has "global" written parallel to it. Politically charged, this drawing prompts the audience to reflect on "glocal" political and cultural situations affecting freedoms, autonomy, and the construction of knowledge (Bryzgel and Apostol).

Work cited

Bryzgel, Amy, and Corina L. Apostol. "Reflections on Artistic Practice in Romania, Then and Now." *IDEA Arts + Society*, No. 45, 2014, pp. 92–105. Print.

Journal Rappé

Journal Rappé is a weekly Senegalese television segment presented and created by rappers and activists Cheikh "Keyti" Sene and Makhtar "Xuman" Fall. Each Friday on the Senegalese television station 2S, the rappers take on the personas of broadcast journalists, delivering the week's most pressing headlines in rhyme—they rap the news in both English and Wolof. From its inception in 2013 as a YouTube venture, *Journal Rappé* has received both national and international praise. The program serves as an alternative source of information, one that deviates from the mainstream through cultivating entertainment value and appealing to youth culture. The duo observed that many young Senegalese watched hip-hop videos, but they had absolutely no interest in watching the newscast: "They were uninformed on local, global and current events, so we decided to give them news in an entertaining hip-hop format, called *Journal Rappé*" (*Journal Rappé*). Their initiative combats the biased and even corrupt state of Senegalese news distribution.

Journal Rappé serves as a vehicle for bringing to light Senegalese societal values, remedying current sociopolitical problems and corruption and catalyzing sociopolitical progressive agendas in Senegal. Indeed, Keyti and Xuman engage young Africans with serious topics such as politics, climate change, and corruption. They explain:

> We want to provide different kinds of information on a new web platform. The only way to do that in an unbiased way was to incorporate music. Music that educates, not just party music. The *Journal Rappé* format has now been copied in Uganda, Jamaica, Vietnam and other countries as well.
>
> (*Journal Rappé*)

Over the years, their objective in bringing news to young Senegalese people has stayed consistent. *Journal Rappé*'s credibility as a news source was built through the duo's continuous fight for

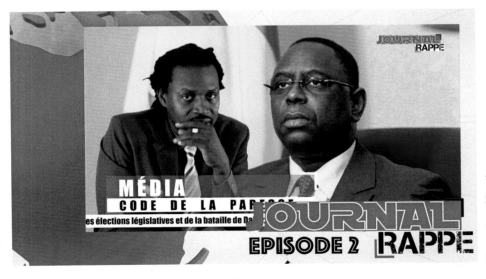

"Episode 2," *Journal Rappé,* 2013–present. Video still.

freedom of expression in order to criticize both their government and the opposition. They observe: "The debates that come out of the *Journal Rappé* are now part of the national conversation, precisely because we have remained unbiased."

Work cited

Journal Rappé. Interview with Team True, "Xuman: The Senegalese Rapper behind *Journal Rappé*," *True Africa*, 5 November 2015, https://trueafrica.co/article/xuman-the-senegalese-rapper-behind-journal-rappe/. Accessed 26 July 2018.

Marinella Senatore

In 2013, Marinella Senatore founded The School of Narrative Dance, which uses strategies of storytelling, nonhierarchical learning, and self-training toward the creation of an active community of dance and choreography. Nomadic and free of charge, the School takes different forms depending on the spaces it temporarily occupies. The School offers a wide range of classes from literature to math to choreography, encouraging individuals to share their skills or acquire new ones. According to the artist, she uses dance as a common language through which "to celebrate the vernacular, amateur, and professionally trained gestures of the participants." Each performance includes a final parade that is located in a different place in the city, and is structured according with the landscape participants want to work on (Senatore).

The School of Narrative Dance organized its first public action in Berlin, involving hundreds of people engaged in a performance in the neighborhood of Auguststraße, Mitte. When the school traveled to Cuenca, Ecuador, the local conservatory provided a hall for rehearsals, local musicians composed scores for the several performances, and public and private buildings alike offered their spaces. Traditional folk dance groups, boarding school bands, teachers, and a large number of amateur and professional dancers took different approaches to storytelling and theater dance. In Sweden, Senatore worked in three major cities of the country—Malmö, Göteborg, and Stockholm—and involved refugees from Syria, young political activists, feminist choirs, and antimilitary groups such as Ofög and Megafonen. Finally, the School organized a Public Procession within the framework of *Visible on the High Line: Making Collaborations*, part of the 2015 Creative Time Summit: The Curriculum NYC.

By organizing the school's activities within cultural institutions and involving diverse audiences in the workshops, Senatore's projects temporarily transform these spaces into laboratories

Marinella Senatore, *The School of Narrative Dance (Venice)*, 2015. Fine art print on Hahnemühle paper, framed. 80 x 105 cm.

of self-empowering education. Reflecting on the notion that art is "a participatory expressive form," Senatore conceives of the creative process in such a way that all participants share their skills, memories, and experiences in an open forum. The School of Narrative Dance is thus a powerful example in connecting art and society, the intimate and the public, in a practice geared toward giving collective agency to a community.

Work cited

Senatore, Marinella. The School of Narrative Dance. 2013, project documentation, www.marinella-senatore.com/index.php?/the-school-of-narrative-dance-2013-2014/the-school-of-narrative-dance/. Accessed 3 August 2018.

Stiev Selapak

Stiev Selapak, an arts collective formed in Cambodia in 2007, was founded by six artists and photographers: Heng Ravuth, Khvay Samnang, Kong Vollak, Lim Sokchanlina, Vandy Rattana, and Vuth Lyno. The collective's purpose was to produce socially engaged art projects by sharing knowledge and resources. In 2009, the group opened Sa Sa Art Gallery, which has since then hosted a number of exhibitions by young Cambodian artists.

Their recent project White Building Art Archive (2014–present) examines Phnom Penh's White Building. Designed by Cambodian architect Lu Ban Hap and built in 1963 as part of an ambitious precinct for the Arts, Culture and Civil Service, the White Building is an icon of Cambodian modernist architecture and Cambodian contemporary culture. Presently home to over 2,000 people, the building is notorious for its dilapidated exterior and for its reputation as a site of illegal activities and home of the urban poor. However, the building demonstrates a neighborhood that is thriving despite its economic deprivations: enriched by a large and long-term community of tight-knit and self-sufficient artists and cultural producers.

The White Building Art Archive gathers audiovisual materials produced by students in collaboration with residents of the White Building. The Archive reflects the diversity of experiences in the community it records, from artists to activists to the city's citizens. In addition to this online archive, a physical Archive and Library Room is also accessible inside a studio at the White Building, where the public can also access and discuss rare materials regarding this neighborhood.

During a related symposium, *Time, Space, Voice: Phnom Penh's White Building*, local and international researchers and practitioners addressed the deep time of the White Building's layered histories, the dense space of the White Building's architectural forms as these have mutated over

Courtesy Khvay Samnang and Sa Sa Art Projects.

Khvay Samnang, *Human Nature*, 2010–2011. A photography series of the residents of Bassac Municipal Riverfront Apartments in their living spaces. Also known as "The White Building" in Phnom Penh.

time, and the multiple voices that shape and speak of the building, both from within and from the outside. The symposium was convened at a critical, even urgent moment for the building, as local and transnational governments and corporate interests announced their intention to demolish it. The concerned community brought together by Stiev Selapak's project resists this threat on both heritage and humanitarian grounds: it would needlessly destroy an acclaimed architectural masterpiece and symbol of cultural achievement, and it would be yet another in a series of often violent forced evictions that unjustly target low-income city dwellers.

Further reading

Selapak, Stiev. "Collections." *The White Building*, http://whitebuilding.org/en. Accessed 15 November 2018.

PART IV: SECTION 9

Queer and now

Project descriptions by Corina L. Apostol,
Corinne Butta, and Shimrit Lee

FOR THE *WE*/DISPOSSESSION IS THE *I*

A.L. Steiner

Queer is not theory. Peculiar, particular notions of what constitutes *I* and *we* shape paradoxical understandings of what constitutes *civic* and *political*. *Tangible* and *palpable* enter into understandings of *community* and *solidarity*. A diagnosis of human-centric freedoms and catastrophes and the extreme strangeness of our species' conditions and behaviors beget an understanding of how we have arrived in the here and now. Perhaps, though not likely, they indicate where we are to go.

We are in a time of great human reckoning when we see and feel change, as change becomes consecutive disappointing blows, sad hits (Yang and Krukowski). *Queer* cannot absorb and transform this great, strange sadness, no matter its potentialities or futurities. This sadness of babies-cum-adults born into the construction of happiness interrupted, happiness as competitive sport. The precarity of carbon-based life forms in new ages makes us feel. Again, and again. It is inevitable, however unenviable, that we humanoids will go out with feeling, with newfound beliefs. There is nothing human *other* than, nothing *outside of*, queer. Queer is now fully queered, vectorless, transient, available, a postmodernism post-op that no theory can describe, no patriarch can control, no seer can predict, no politic can equalize, no philosopher can shape. The shapes of movements cannot resist a priori.

Queer will become what it will become, consciousness and intelligence left hanging on the line, their beautiful wondrousness out of reach, out of frame, in the nick of time.

To wonder aloud, *can no future come close, closer, more close* (Edelman). Closer to the reckoning of utterness and deepness, to confusion becoming possibility, to a globe-shaped planet of questionable problems becoming tangible, palpable, touchable. To touch *humyn*.

Within touch and sense, deep time in a hole, the hole becoming filled, vacuated, liquid air, breathing space. Silica-slickness without answers, hyperobjects (Morton) remaining obstinately invisible. Sensate memory cards floating untethered from the time–space continuum in a muddy slime replacing the firmamental figment of *I* and *We*. *We* reticulate an oppressive counterintelligence so deeply unseated by fact, wrapped in reality so deeply compromised, an elusive illusion of consciousness unfounded, found to be inexistent. *I* will bury our guns in continental villages gone mad.

A relief like a relief we've never felt, never quite known. Imaginary friends named *gods* are relieved of their litany of duties. We look the other way, over there, relieved. Dismantle the set, dismiss the crew, brush off the dust, skin the creatures, bury the bones. Relieved as we slay the

A.L. Steiner, *Appendage (triptych),* 2018.

A.L. Steiner, *Untitled (Jairo + Dolores), 2018.*

stems of one imagined world, in exchange for another wild. The salty brined chalice smashes and we call it a day, relieved.

When we run out of language, we find a place to start over. The pages, characters, words that follow relinquish *future*, refuse everything, say yes to no, and no to no. Letting go of faith rendered invisible, thoughts lucky to be gone. An insatiate hunger forever relinquished, vanished, hanging forever without answer, banished. Answers are the most dangerous, the most disappointing. A time without answers is both the best and worst. Solar flashes, rains, fires winds, Earth creating contours unknowable, cosmically programmable, hexagonal, holographic, porphyrinal (Timofeeva), rainbow-like.

Works cited

Edelman, Lee. *No Future: Queer Theory and the Death Drive*. Duke University Press, 2004.

Morton, Timothy. *Hyperobjects: Philosophy and Ecology after the End of the World*. University of Minnesota Press, 2013.

Timofeeva, Oxana, "Ultra-Black: Towards a Materialist Theory of Oil." *e-flux journal* #84, September 2017, www.e-flux.com/journal/84/149335/ultra-black-towards-a-materialist-theory-of-oil/. Accessed 29 October 2018.

Yang, Naomi, and Damon Krukowski. "International Sad Hit." *20–20–20*, www.20-20-20.com/internationalsadhits/. Accessed 29 October 2018.

Projects

Fredman Barahona

Creating radical performances under the pseudonym Elyla Sinvergüenza, Barahona reflects, through his work, on the processes of transgender identity construction and this process's relationship with politics itself. Self-taught, he theorizes through these performative interventions. In his work, he moves between disciplines, from social anthropology to theater to contemporary art, mainly addressing identity, sexuality, politics, and cultural boundaries. Barahona explores the construction of LGBTQI identities to reflect on human diversity.

Fredman Barahona, *Sólo fantasia…*, 2014. Studio Image, Ninth Biennial of Nicaragua, 2014.

Situational performance is fundamental to Barahona's practice: *More Than Fantasy* . . . (2014) is a piece for which the artist created and wore a gold-studded, rainbow-painted costume using symbols of the political aesthetics of the Nicaraguan governments, from the Somocista period until the current administration (2011–2015). During the performance, which took place in Managua, he walked along the Avenida Bolívar from the Hugo Chavez roundabout to the now former Concha Acústica plaza where presidential acts routinely occur.

The artist remarked that he was interested in making an analogy that:

> erases some difference between state power—the capacity of the latter to build the idea of identity in a people through the transformation of symbologies . . . and the political power that is experienced in the body when we challenge gender norms established in heteronormative societies in the West.

In this way, the artist connects the cultural with the political and the political with the personal: "I began to be interested in trans-practices and Nicaraguan folkloric rituals, and at the same time question what it means to embody transgender-ness as a performative act—that is, how to live from difference and use that as a flag born in battle."

Barahona continues to engage in cultural practices of ephemeral drag and gender-bending expressions within indigenous/mestizo rituals. He is also a member and founder of the Operación Queer collective that works on blurring fictional limits between academia, art, and activism.

Further reading

Barahona, Fredman. "Perfil Container: Fredman Barahona—Performance." YouTube, uploaded by Container Reality Show, 18 April 2016, www.youtube.com/watch?v=jgbRlwAucVs. Accessed 28 November 2018.

Giuseppe Campuzano

The Peruvian philosopher, artist, and drag queen Giuseppe Campuzano articulated his creative practice as stemming from drag as a series of acts and effects that bring into focus important tensions between spaces. Campuzano seeks to resist certain official histories of colonizers and colonized, of race, gender, and territories as fixed borders and insurmountable chasms.

Campuzano created the itinerant project *Museo Travesti del Perú* (*Transvestite Museum of Peru*) (2003–2013) in order to present a queer counternarrative—a promiscuous, intersectional thinking of history that collects objects, images, texts, and documents, press clippings, and appropriated

Photo Claudia Alva. Courtesy Archivo Giuseppe Campuzano.

Giuseppe Campuzano, *Carnet. Fotografías para documento de identidad,* 2011. Digital print on paper, 46.5 x 35.5 cm.

artworks—and proposes actions, stagings, and publications that fracture the dominant models of production of images and bodies. The project, situated halfway between performance and historical research, proposes a critical reviewing of the history of Peru from the queer perspective of a fictional figure Campuzano calls the "androgynous indigenous/mixed-race transvestite" (La fountain-Stokes). Here, transgender, transvestite, transsexual, intersexual, and androgynous figures are posited as the central actors and main political subjects for any construction of history.

For a decade, Campuzano's *Museum* has toured cities such as Lima, Brighton, Montreal, La Havana, São Paulo, Bogotá, Monterrey, Santiago de Compostela, Santiago de Chile, and Rio de Janeiro. Unlike large institutional projects and their discourses of authority, this nomadic museum does not attempt to represent or integrate minorities into the dominant discourses of progress and prosperity. It is, rather, a deliberately artificial device that dramatizes official histories and fractures the privileged site of heterosexual subjectivity. This subjectivity turns all difference into an object of study and renders invisible the social processes that led to its constructions. The *Transvestite Museum of Peru* challenges classical theory and history through an irreverent rewriting of transversal imaginaries, referents, and bodies of knowledge, for a subject unable and unwilling to fit into existing taxonomy.

Work cited

La fountain-Stokes, Lawrence. "Giuseppe Campuzano and the Museo Travesti del Perú." *e-misférica Journal*, no. 6.2, 2010. Print.

Cassils

Throughout their work, Cassils has cultivated an intentionally fluid yet politically sharp persona. Utilizing strategies from intense physical training, including martial arts and weightlifting, and remixing queer embodiment, Cassils has firmly set aside binary gender norms, challenging audiences to think through powerful physicality. As the artists observed, "I resist the idea that you have to live as a man or as a woman. . . . The crux of my work is to create something that isn't so black-and-white."

Cassils's 2012 project, *Becoming an Image*, exemplifies this ethos. Conceived as a site-specific project for the oldest active LGBTQI archive in the United States, the ONE Archives in Los Angeles, it consisted of an endurance performance during in which the artist was seen to attack a 2,000-pound clay sculpture in the dark. Cassils had built the piece themselves. Flashes of camera illuminated the half hour performance, creating a series of embodied photographs etched into audiences' memories. The artist observed that the violent punches represented in turn "senseless acts of violence against trans and queer bodies beyond the historical lens. . . . The audience becomes both camera and witness to the beating, and the clay remains are then put on display."

Cassils's medium, their body, continues to undergo evolution as they strive to challenge the violence and injustices against these communities by confronting oppression with resilience. Indeed the artist appears at the same time powerful and vulnerable, pushing their own biologically female body into a visual alchemy that compels our engagement, moving audiences on a

Courtesy Cassils.

Cassils with Zachary Hartzell, *Becoming an Image Performance Still No. 3*, 2016. Pennsylvania Academy of Fine Arts, Historic Casting Hall, 2016.

profound, visceral level. For Cassils, it is a political act, as well as an artistic performance: "Our bodies are sculptures formed by society's expectations. I am a visual artist, and my body is my medium."

Further reading

Frizzell, Nell. "Heather Cassils: The Transgender Bodybuilder Who Attacks Heaps of Clay." *The Guardian*, 3 October 2013, www.theguardian.com/artanddesign/2013/oct/03/heather-cassils-transgender-bodybuilder-artist. Accessed 30 November 2018.

Evan Ifekoya

Multidisciplinary artist Evan Ifekoya explores the politicization of contemporary society and culture, using appropriated historical material from archives as well as popular contemporary visual culture. The artist queers everyday imagery to investigate the politics and potentialities of intimate knowledge production, combining film, performative writing, and music.

His recent work, *A Score, A Groove, A Phantom* (2015) is a performance as a multisensory song, weaving the public nature of death together with the performance of the queer body. During the piece, the artist created a rich, layered environment consisting of a disco ball and photographs from his personal family album, together with chewing gum and pink fur. The work draws on Ifekoya's research into the nightclub as archive, as well as Black and queer culture: iterations of disco and house music, as well the assembled footage of feminist filmmaker Sandi Hughes, whose videos from the 1970–1990s traced Liverpool's nightclub scenes, local community events, and national political protests.

By highlighting contemporary Black and gay life, Ifekoya has created a powerful archive and precious material for others to refashion into revelatory insights of their own. Reflecting upon ideas of belonging and legacy—including experiences of racism, homophobia, and sexism—Ifekoya's performance unfolds in a liminal space between recorded histories and the present moment.

The artist explained the piece as:

> expanded song, exploring the role of language in cultivating and nourishing spaces
> of belonging. By drawing on queer black archives of social space and nightlife, the

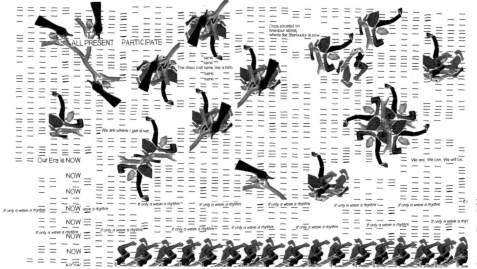

Courtesy Evan Ifekoya

Evan Ifekoya, *A Score, A Groove, A Phantom,* 2016.

performance explores darkness in abundance as spectrality and the mouth as site of experience. 16 bars is a refrain, an overwriting undermining. A gift. A glitch. A glow.

Further reading

"Evan Ifekoya." *Sound Acts*, www.soundacts.com/evan-ifekoya.html. Accessed 30 November 2018.

Yevgeniy Fiks

Inspired by the collapse of the Soviet bloc, Fiks has created a body of work that reexamines the Soviet experience in the context of the history of the left, including that of the international gay movements. Fiks has been interested in reflecting on repressed narratives that highlight the complex relationships between the social histories of the West and Russia in the twentieth century.

In 2016, Fiks originated a project called *Pleshka-Birobidzhan*. Established in 1934 in the Soviet Union as the Autonomous Jewish Region of the USSR, Birobidzhan (located in a remote area

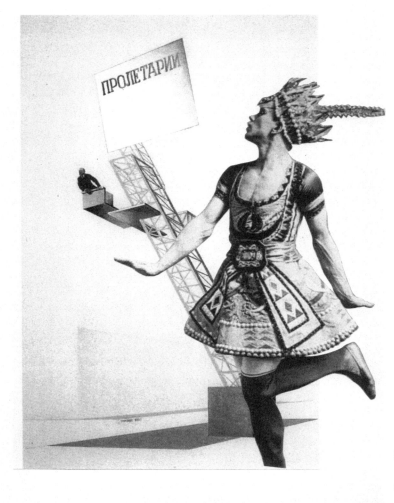

Yevgeny Fiks, *Pleshka-Birobidzhan #2,* 2016.

Courtesy Yevgeny Fiks.

at the border with China) was at the time even considered a rival to Israel, capturing the world's imagination. Fiks's project comprises collages, drawings, and a video installation that "engages the relationship between identity, fiction, and history by recreating an oral story about a group of Soviet gay men who traveled from Moscow to Birobidzhan in 1934." According to the fictionalized narrative of the exhibition, Birobidzhan was not only a Soviet Jewish Autonomous Region but also the Gay and Lesbian Autonomous Region, which "appeared to exist alongside, and at times overlapped with the Soviet Jewish Utopia there." Collages in Fiks's exhibition depict gay men discussing the recriminalization of homosexuality under Stalin at *pleshkas*, or gay cruising sites. Fearing persecution and feeling disillusionment, they set out for Birobidzhan.

In the related video installation, *Cruising Birobidzhan*, Fiks juxtaposes propaganda photographs of Soviet-era Birobidzhan with a present-day discussion in New York City between post-Soviet LGBTQI people about the (im)possibility of a "queer" utopia. In *A Map of Birobidzhan*, Fiks mapped the Jewish Autonomous Region, replacing city names with names of historical queer left-wing icons such as Angela Davis, Harry Hay, and Bayard Rustin. The installation also includes street signs for streets, avenues, and squares of the imagined utopian region, named after figures of Soviet and post-Soviet gay and lesbian history such as Yevgeny Kharitonov, Igor Kon, and Roman Kalinin.

In contemporary times, all aspects of LGBTQI life and culture are under assault in the Russian Federation, while Jewish organizations in the country seem to be in support of the government policies, focusing on bolstering so-called traditional values. In this context, Fiks's project asks whether a Jewish Autonomous Region could also function as a safe territory for Soviet gays and, more importantly, whether it is "possible to imagine these two communities sharing a common space, either geographical or discursive—an actual territory open for Jews and gays, or some kind of parallel gay reality coexisting with Jewish Region? Is there a hope for mutual understanding or solidarity between these communities?"

Further reading

Fiks, Yevgeny, editor. Tatiana Istomina. "In and Out of Tradition: Yevgeniy Fiks." *Metaleptic Stories*, December 2016, http://metaleptic.blogspot.com/2017/01/in-and-out-of-tradition-yevgeniy-fiks.html. Accessed 28 November 2018.

Fiks, Yevgeny. "Pleshka-Birobidzhan, 2016." *Yevgeny Fiks*, https://yevgeniyfiks.com/section/441807-Pleshka-Birobidzhan-2016.html. Accessed 28 November 2018.

Krudas Cubensi

Founded in 1999, Krudas Cubensi is an influential, all-female hip-hop group composed by members Odaymara Cuesta and Olivia Prendes. They have enjoyed critical acclaim both in their native Havana, Cuba, and present home within the United States. Their powerful lyrics speak to a global community of women, while also addressing pressing issues such as the politics of race and gender. One recent song is *Mi Cuerpo Es Mio* (*My body is my own*), from the album Poderosxs (Powerful) (2014):

Whose bodies?

Our bodies!

Whose rights?

Our rights!

Whose decisions?

Our decisions!

Krudas Cubensi one more time representing womyn and queer

people's choices

Their music is committed to an unwaveringly feminist agenda, calling attention to the situation of women in a sociopolitical context in which hard battles continue to be waged at the intersection of racism, sexism, status, and privilege. Despite their cult following, they are just beginning to enjoy wider exposure in the media, as the history of rap music continues to exclude the contributions of women as fans, advocates, and artists. Moreover, the powerful resistance to hegemonic notions of femininity and Black female sexuality in lyrics expressed by female rappers has been opposed as extraneous to political rap. Krudas Cubensi therefore occupies a gendered space within an unjust landscape for Black Cuban people, despite the official proclamations of egalitarian principles of government.

Krudas Cubensi performance (1996–2006 Cuba, 2006–present US).

As openly queer musicians, Krudas Cubensi has added a significant dimension to the public discourse surrounding gendered violence and homophobia, as well as racist hegemonic ideas of beauty—topics that have entered into a wider societal discourse both in Cuba and globally. Krudas do not speak to a simplified, revolutionary image of Cuba but to the current and complex levels of discourse and exclusion. Their songs call women to work toward overcoming heteronormative thinking, drawing on personal experiences of discrimination and exclusion from the canon. Their voices address a burning need for change.

Further reading

Krudas Cubensi, www.krudascubensi.com/. Accessed 27 November 2018.

Carlos Motta

Promoting self-representation, Motta creates works bordering normative discourses on gender and sexuality, questioning the writing of mainstream history and the construction of political memory. The artist argues for and demands systemic transformation of the current state of democracy, transformations that go beyond tolerance and inclusion. Drawing from his Colombian cultural heritage, Motta investigates the history of the subaltern body in pre-Hispanic and colonial cultures in Latin America, as well as in contemporary queer politics.

In his installation *We Who Feel Differently* (2011), presented at the New Museum in New York and venues around the world, he addresses critical issues of international contemporary queer culture in the light of 40 years of LGBTQI politics. Motta focused on the concept of difference as opposed to equality, which continues to be central in queer politics internationally. The project presented an extensive archive of initiatives and ideas put forth by artists, activists, academics, and medical doctors. Visually resembling a queer learning-center, the installation included rainbow carpeting, computers, posters, and reference books. The installation also featured several monitors displaying thematically arranged videos of Motta's interviews with LGBTQI activists in Colombia, Korea, Norway, and the United States, as well as historical footage devoted to ACT UP (AIDS Coalition to Unleash Power), an international direct action advocacy group working to positively impact the lives of people with AIDS. Motta envisioned it as a welcoming space, where audiences would feel invited to spend time and reflect on the questions raised.

As an oral history of forms of collective struggle, dissent, and political antagonism, *We Who Feel Differently* offers a much needed perspective into contemporary debates around alterity, efficacy, and reform. Motta also launched an online journal that features analyses and critiques of international LGBTQI communities and questions current politics from queer perspectives.

Photo by Naho Kubota. Courtesy P.P.O.W. Gallery, New York; Mor Charpentier Galerie, Paris; Galeria Vermelho, São Paulo.

We Who Feel Differently (2012), multi-media installation, installation view of "Museum as Hub: Carlos Motta: We Who Feel Differently," New Museum, New York, 2012.

Creating discursive platforms to enable conversations around matters of sex and gender as issues in social justice, Motta's work challenges the conservative grounds of society: the violent regulation of gender as a legal and a moral category, the hegemonic authority of the Church, and the governmental regulation of bodies and identities. The artist creates counterhistories that inscribe what has been overwritten, forgotten, or violently suppressed. His complex work asks both what is at stake and what is made possible by embracing queer strategies within contemporary art, politics, and society.

Bhenji Ra

Interdisciplinary artist Bheji Ra has carefully constructed a practice based on her own gender-queer journey, combining dance and choreography with video and installation, and even organizing club events and voguing balls. Her projects have been based on the transformation of her identity, at the same time reframing conventional performance art practice and wading through conventional cultural theories from the perspective of indigeneity.

Bhenji Ra and House of Slé(2018).

Photo Jonno Revanche. Courtesy Bhenji Ra.

Collaboration with her community in Sydney, Australia, has also been central to her work. In her major project *Sissy Ball* (2018), she has worked together with her house named Slé, whose work consists of hosting events and balls at the intersection of community and performance. Building on the vogueing traditions of the 1920s in Harlem, where this dance style and culture had a major impact, Ra has contributed to the evolution of voguing by helping to nurture the genre and expand it to include queer people of color from around the world. Thinking of the legacy that she is creating, Ra observed, "It's totally magical and intuitive that connection we share, a lot of familiarities are met in that space" (Revanche).

The Sissy Ball has brought Australia and, more broadly, Southeast Asia's burgeoning vogue scene to international acclaim and reintroduced legends of the vogue scene. Emphasizing collective action, Ra continues to engage with the multiplicities of spectacle and performances, disrupting gender normativity in Australia and shattering the status quo of conventional Western dance. Confident, Ra is slowly making space for queer people of color to express themselves, declaring, "We are making moves and you will probably see us taking over your space in the near future" (Michael).

Further reading

Revanche, Jonno. "Slé and the Odyssey of Australia's Vogueing Scene." *i-d*, 22 February 2018, https://i-d.vice.com/en_au/article/qveebq/sle-and-the-odyssey-of-australias-vogueing-scene. Accessed 30 November 2018.

Michael, Michael Love. "Bhenji Ra Is Taking Her Time." *Paper Magazine*, 19 September 2018, www.papermag.com/bhenji-ra-2605984112.html?rebelltitem=1#rebelltitem1. Accessed 30 November 2018.

Sharon Hayes

Over the past decades, Sharon Hayes's practice has strikingly blended performance and social engagement, working in public space to investigate how private and public speech intersect with the construction of sexualities and gender, desire, politics, and history. Drawing on a range of artistic and academic practices, her artistic method draws heavily on the New York City theater scene of the early 1990s, defined as staunchly political, feminist, queer, and deeply affected by the AIDS epidemic. The diversity of topical issues that her installations and performances have addressed include gay and transgender rights, as well as the U.S. imperialist wars in Afghanistan and Iraq, Patty Hearst and the Symbionese Liberation Army (an American, left-wing militant organization active between 1973 and 1975), and the 1968 Democratic Convention (held during a year of violence, political turbulence, and civil unrest.)

Her 2010 installation, *Parole*, features several scenes where public speeches happen in different contexts: for example, the artist stages the "re-speaking" of gay activist Anna Rüling's 1904 speech "What Interest Does the Women's Movement Have in the Homosexual Question" for new audiences. The original speech, given in Berlin at the annual meeting of the Scientific Humanitarian Committee (the first gay organization in world history), brought gay rights and women's rights under one umbrella.

The title of the installation, *Parole*, refers to the term used by Swiss linguist Ferdinand de Saussure to differentiate between individual acts of speech (*parole*) and a larger system of language (*langue*). These historical speeches and the artist's work as a whole reveal unexpected continuances across time periods, focusing on articulations of the construction of gender and sexuality and those of political protest at key historical junctures. *Parole* inspires audiences to connect past forms of protest that can inform the present. In the films, the artist pays particular attention to how the effects of public speech are altered as they are being documented. This is

Courtesy Sharon Hayes Studio.

Still from Sharon Hayes's installation *Parole* (2010).

achieved by focusing on a central character who records sound but never speaks. *Parole* untangles the relationship between politics and aspiration, togetherness and alienation, hearing and communication.

Further reading

Hayes, Sharon. *Sharon Hayes*, www.shaze.info/. Accessed 4 December 2018.
Yablonsky, Linda. "Women's Work." *New York Times*, 22 February 2010, www.nytimes.com/2010/02/28/ t-magazine/28talk-women.html. Accessed 4 December 2018.

CUDS

The University Collective of Sexual Dissidence (*Colectivo Universitario de Disidencia Sexual*, or simply CUDS) is a queer activist group whose theoretical production and street activism have dominated public spaces in their home country of Chile and throughout Latin America. The collective emerged in 2002, continuing the work done by their predecessors, the Left Committee for Sexual Diversity (Comité de Izquierda por la Diversidad Sexual, CIDS) which gathered several radical communities of local LGBT activists. The goal of the group was to engender solidarity between leftist social movements and queer activism. When the CIDS dissolved, some of its members decided to continue their work in the university context. Member Felipe Rivas observed, "Never before had a queer collective been politically articulated within the university realm, so there was a lot of uncertainty, no straight direction, and it had us wavering between different practices."

In 2010, CUDS organized one of their most daring public projects, *Twice Holy: A Pilgrimage for Karol Romanoff*, which involved a large-scale procession for "Chile's first transsexual saint." Appearing as apostles, CUDS activists carried a larger than life-size statue of Romanoff that was in stark contrast to the traditional Virgin Mary. Born Miguel Ángel Poblete, he was a clairvoyant who drew hundreds of people to Membrillar Hill, in Villa Alemana, Chile, between 1983 and 1988 in order to witness the conversations between him and the Virgin Mary. During trances, they wept blood and spoke in a made-up language, which many considered divine. These public spectacles occurred at the height of the Pinochet dictatorship in the country, which left the people of Chile traumatized, tired, and weary. The visions of Poblete appropriately described an impending apocalypse and carried a collective sense of urgency. In 1988, according to their

Courtesy CUDS.

Dos veces santa: peregrinación por Karol Romanoff [Twice holy: the pilgrimage for Karol Romanoff], Public Intervention and video-performance. Santiago de Chile, December 8, 2010. Procession for Chile's first transsexual saint organized during the Catholic pilgrimage to San Cristóbal Hill.

last vision, Poblete changed their name to Karol Romanoff (claiming to be the last heir to the Russian dynasty) and gender (becoming a woman.)

Two decades later, CUDS brought back into collective consciousness the seminal yet forgotten history of this historical figure, rejecting and problematizing the normative ideas of sex, gender, and desire in a still conservative and deeply religious country. Performances like this one and others that CUDS has carried out in a public space have a political objective as well. "We do not work from the perspective of the dominant politics, but through the political, those small spaces, fissures, that may occur," observed member Jorge Diaz.

Further reading

"CUDS—Karol Romanoff—E-misférica 10.2 Dissidence" *Vimeo*, posted by Hemispheric Institute, https://vimeo.com/146689528. Accessed 27 November, 2018.

López, Miguel A. "'Social Transformation Will Not Be Written along a Straight Line.' A Conversation with Felipe Rivas and Jorge Díaz (CUDS)." *Manifesta Journal*, www.manifestajournal.org/online-residencies/miguel-lopez/social-transformation-will-not-be-written-along-straight-line. Accessed 27 November 2018.

PART IV: SECTION 10

The device

Project descriptions by Corina L. Apostol,
Corinne Butta, and Shimrit Lee

IS IT WORKING?

Tega Brain

Steve Jobs was known for saying, "It just works!" when describing new Apple products. What he meant was, "it" works automatically, seamlessly, and for people like him. But if you are a worker at an Amazon fulfillment center, a tin miner on the Indonesian island of Bangka, or a taxi driver no longer able to make a living wage, you would probably say that "it" is not working for you. Dominant technological narratives, which assert that engineering offers an endless capacity to solve problems in lieu of nontechnical regulatory or economic responses, are aggressively maintained by the likes of Jobs and his followers. These stories intentionally ignore all those who are left out. They are embellished and refined through marketing, concretized by design, and subsumed into the interfaces we use every day. Celebrated ideals like "seamlessness" and "user-centeredness" obscure the material costs of computation and its social effects, encouraging what artist Joana Moll calls a "culture of irresponsibility." As Moll's work reveals, the factory behind the interface is vast and requires substantial energy, water, and mineral resources to keep it running. Every snap, chat, ping, and poke is contingent on heavy planetary infrastructures that are recomposing our atmosphere and further obscuring the ongoing destruction of the Earth's ecosystems. In the span of five years, energy use by IT and digital networks has doubled (Cubitt 16), and the resultant carbon footprint exceeds that of the aviation industry ("Cisco Visual Networking Index"). Yet our devices and interfaces typically disconnect digital action from these worldly effects and thereby diminish our capacities to understand, question, and contest the dominance of technological systems.

An ethical reckoning within engineering remains elusive because, historically, success in the field has been understood primarily through the lens of functionality, with little regard for any deeper engagement with ideology. In other words, if your technology "just works" and doesn't produce short-term harm to the user, you have fulfilled your ethical responsibilities. Yet computational technologies are reshaping public life and political reality. As surveillance, automation, artificial intelligence, and algorithmic media dramatically transform mechanisms of control and of resistance, what becomes clear is that we must update the intellectual and ethical framework through which technologies are developed. We must recognize how technology is intertwined with fundamental issues of human rights and human dignity, and we must put methods of questioning and critique—techniques that are so central to the arts—into meaningful engagement with the overly optimistic propositions coming from those in the business of manufacturing technologies.

One arena where technological experimentation has long occurred in a context of cultural and social engagement has been within media arts, where technologies themselves are treated as an artistic medium. Technology is understood, in terms of its materiality, as computers, sensors, and circuits and, conceptually, as logic, modes of perception, practices, and aesthetics (Franklin). What artists in particular understand is how technologies act on attention, affect, mediation, and representation. Although science and engineering tend to monopolize claims to technological development, artists have also long been deeply engaged with these processes (Levin). When Karolina Sobecka sends cloud seeding technology into the atmosphere (*Cloud Machine*, 2014), Morehshin Allahyari, using emerging 3D rendering and printing technologies, reproduces artifacts destroyed by ISIS in the Middle East (*Material Speculation ISIS*, 2015–2016), or when Sam Lavigne, Brian Clifton, and Francis Tseng create a white collar crime policing tool (*White Collar Crime Risk Zones*, 2017), we see emerging technologies repurposed and adapted for critical, creative, and political agendas, stretched with what Mitchell Whitelaw calls "a non-industrial latitude." Artists point to what industry overlooks or negates, like Ramsey Nasser when he develops a programming language in Arabic (قلب, 2013) or Mary Maggic when she attempts to synthesize estrogen in her kitchen (*Open Source Estrogen*, 2016). Blending and recombining strategies from conceptual art, tactical media, and civil disobedience, this type of work highlights assumptions, contradictions, and blind spots in technological development and profoundly reveals how questions of technology, like those of utility, efficiency, and access, ultimately emerge through culture.

These strategies are also at play in my own work. *Unfit Bits* (2015) encourages the misuse of fitness trackers by providing techniques for faking and obfuscating activity data and, in doing so, points to the problematic use of this data in the context of the U.S. insurance industry.

Courtesy Tega Brain.

Unfit Bits, 2015.

In *Being Radiotropic* (2016), I adapt and reengineer the stuff of the Internet itself in a series of wi-fi routers with networks contingent on environmental conditions. One network fluctuates with the phase of the moon, another is controlled by a living plant, and a third requires a candle to be lit in order to bring up the network. These devices subvert technological ideals that have emerged with the Internet—that of fast, always-on, uninterrupted connectivity—and prompt a diversion of attention from virtual environments to local conditions.

These works, like the many others showcased within this chapter, deoptimize, refigure, subvert, and estrange technologies. In doing so, they produce a grammar for articulating the politics

Being Radiotropic, 2016.

Being Radiotropic, 2016.

of our technological systems. How do these systems redistribute resources and power? How do they restructure capacities for agency and passivity? And how do they reshape the ways we perceive the world?

Works cited

"Cisco Visual Networking Index: Forecast and Methodology, 2011–2016." CISCO, White paper 518, 2012. Web. Accessed 15 October 2018.

Cubitt, Sean. *Finite Media: Environmental Implications of Digital Technologies*. Duke University Press, 2017, p. 16.

Franklin, Ursula. *The Real World of Technology*. House of Anansi, 1999.

"It Just Works. Seamlessly." *YouTube*, uploaded by all about Steve Jobs.com, 19 September 2009, www.youtube.com/watch?v=qmPq00jelpc. Accessed 31 July 2019.

Levin, Golan. "New Media Artworks: Prequels to Everyday Life." *Flong Blog*, 19 July 2009, www.flong.com/blog/2009/new-media-artworks-prequels-to-everyday-life/. Accessed 3 October 2018.

Moll, Joana. "Deep Carbon." *Research Values 2018*, 3 January 2018, https://researchvalues2018.wordpress.com/2018/01/03/joana-moll-deep-carbon/. Accessed 1 September 2018.

Whitelaw, Mitchell. *Metacreation: Art and Artificial Life*. MIT Press, 2004.

Projects

Karolina Sobecka

Artist and designer Karolina Sobecka creates projects at the intersection of art, science, and technology. Recent works have investigated the forces that drive technological progress and at the same time shape the cultural and ideological dimensions of the relationship between humans and the environment.

The Matter of Air (2016–present) takes up the poetic and unlikely subject of "air" as a key concept to investigate the ways in which nature is imbricated with sociotechnological systems and the extent to which science has been able to understand, predict, and control the climate. The artist carried out her investigations through various projects, ranging from setting out tactical devices to change the atmosphere, to using synthetic biology to analyze the equivalence of the infosphere and the biosphere, to designing practices for training audiences for acute climate transformation, and to building a sociotechnological device as a tool for new ways of seeing. To achieve these investigations, Sobecka has organized audiences to observe and then create "a crowdsourced image of the sky that is equal and opposite to the image taken by a satellite at the same time." She has also founded a biotech association that advances "the use of biosphere for data transfer and storage."

Through her ongoing interdisciplinary project, Sobecka suggests the need for an atmospheric turn, which compels us to think about air as well as think with air. The imperceptibility of the air is in part due to the fact that it is everywhere: however, if it disappeared, we would notice its lack instantly. The artist offers strategies to bring the atmosphere into focus, through artistic experiments on the materiality of air that help us shape its imaginary.

Courtesy Karolina Sobecka.

The Matter of Air (2016–present).

Further reading

Karolina Sobecka, www.karolinasobecka.com/. Accessed 11 December 2018.

Molleindustria

Molleindustria was founded in 2003 by a group of artists, designers, and programmers in order to create conversation surrounding the social and political implications of videogames. Since then, the group has explored the intersection of ideology and electronic entertainment through experimental video games dealing with topical themes such as sex, religion, labor, and ecology. The group redirects the revenues generated by the games to organizations fighting corporate abuse. One such game is *Phone Story* (2011), an educational game featuring the situations and sites that play into the creation of a smartphone, from coltan extraction in Congo, to outsourced labor in China, to environmental waste in Pakistan, and to the incredible demand for gadgets in the West. In one of the mini games, workers are seen leaping from their factory building: a clear

Courtesy Molleindustria.

Still from the *Phone Story* (2011) game.

reference to suicides by workers driven to despair by Foxconn, Apple's manufacturing partner. In another instance, users are tasked to oversee underage miners and distribute smartphones outside a store with a white pear logo on the front. Although the game did not target Apple's labor practices directly, the company reacted by banning the app from it store merely a few hours after it was released. This reaction came as no surprise to Molleindustria's Paolo Pedercini, who said that the censorship is a comment on the iOS system:

> Here's the problem: the unanimous reaction from [the] developers community has been, 'Wow, it's incredible *Phone Story* made it through Apple's review process.' To me, this signals a full acceptance of a regime of censorship, the equivalent, for developers, of what journalists call the 'chilling effect.' I'm sure that Apple doesn't spend that much time in policing its marketplace, because the developers are already censoring themselves.
>
> *(Dredge)*

Molleindustria has since released a version of the application for Android-powered devices, which is now available for download. In addition to provoking a critical reflection on the egregious effects of the growing lust for technological platforms, the group has donated earnings from the game to victims of Foxconn's factory complex.

Work cited

Dredge, Stuart. "Apple Bans Satirical iPhone Game Phone Story from Its App Store." *The Guardian*, September 2011, www.theguardian.com/technology/appsblog/2011/sep/14/apple-phone-story-rejection. Accessed 3 August 2018.

Lauren McCarthy

Artist Lauren Lee McCarthy produces interdisciplinary projects as examinations into timely social issues, such as increased levels of surveillance, automation, and network culture, and how they impact our society.

McCarthy's recent project *LAUREN* takes up our fascination with intelligent home assistants designed by technology companies. Namely, the artist explores the paradox of the popularity of these devices in an age when our lives are already overwhelmed by digital surveillance. As the artist observed, unlike earlier devices that parents would often gift their children, this new generation of smart devices is ubiquitous from the start. The artist unveils the serious implications of this development.

For *LAUREN*, she became a human version of Amazon's Alexa, a smart home intelligence for use in people's own homes. The performance lasted several days and included the installation of a series of custom-designed, networked smart devices (cameras, microphones, switches, door locks, faucets) in the homes of a selected group of people. The artist watched over each person 24/7, having the ability to control all aspects of their home. McCarthy observed that her aim was to be more efficient than an AI device, attempting to anticipate the group's needs as a person. The relationship that was forged among the artist and the participants threads the line between human and machine. Through mediated interactions, the artist pushes the group to reflect on the limits of allowing AI to tap into their private spaces and, by extension, their information and decision making.

LAUREN delves into the tensions of the smart home, between intimacy and privacy, convenience and agency, and the question of what the role of human labor in future automation may be. As the artists observes: "We are meant to think smart home devices are about utility, but the space they invade is personal. The home is the place where we are watched over, socialized, cared for. How does it feel to have this role assumed by artificial intelligence?" The

LAUREN (2017), a human intelligent smart home system.

Courtesy Lauren McCarthy.

project demonstrates that, as we attach ourselves to these devices, we also allow them to alter our identity and become plugged into a system of values determined by a homogeneous group of technology developers.

Further reading

"Lauren." *Lauren McCarthy*, http://lauren-mccarthy.com/LAUREN. Accessed 11 December 2018.

Josh Begley

Josh Begley is a data artist and app developer whose work centers on data visualization of contemporary issues. Begley's projects are wide-ranging, from *Officer Involved* (2017), a five-minute video featuring the satellite imagery of each of the over 1,100 sites of fatal police brutality that year in the United States, to *Concussion Protocol* (2018), which joins each of 280 concussions suffered in the National Football League into one nearly six-minute video. Begley introduces this project with the question, "When we watch American football, what are we seeing?" This question, which questions forms of violence both instantaneous and systematic in what some categorize as "just sport," is symbolic of Begley's practice. He uses the practice of data visualization not only to present information but to problematize the way that this information is digested and question its impact on the corresponding social and political commentary.

Perhaps his best-known work, *Metadata* (2017), is an app that sends a notification each time a U.S. drone strike is reported in the news. The app organizes the information on a map, each strike marked with a location point that opens a text box with the information reported. The data points are concentrated in Pakistan, Somalia, and Yemen; Begley thinks about this type of information mapping as an alternate cartography. "I also believe maps are instruments of power. Trying to understand the process that goes into making a map can be a useful entry point to try to think about power. And what the nation state means."

However, in an era where our maps are digital and drawn from satellites, these birds-eye positions of power and privilege are sometimes obscured by the veneer of so-called "unbiased" imaging and scientific technologies. The user is always plotted at the center of their map. Begley

Screen display of *Metadata+/Drones+* (2014).

is concerned with revisualizing the relationship between users and their data, humans and their surroundings. In designing *Metadata*, he reconciled the distancing effect of the map and of violence happening elsewhere. The push notification that users of *Metadata* receive offers a physical jolt to the user. Begley expands, "What does that mean for the rest of your day? How do you live with that data—data about people?" Projects like Begley's serve as a reminder that data corresponds to realities and lives, often disrupted by the very systems of power that draw the map.

Further reading

Begley, Josh. *Josh Begley*, 2018, https://joshbegley.com/. Accessed 4 December 2018.

Begley, Josh. Interview by Eric Hynes. "Interview with Josh Begley, Director of Best Luck with the Wall." *Field of Vision*, 26 October 2016, https://fieldofvision.org/interview-with-josh-begley. Accessed 4 December 2018.

"Josh Begley." *The Intercept*, 2018, https://theintercept.com/staff/josh/. Accessed 4 December 2018.

Li Liao

Liao aims to expose social complexities in seemingly mundane environments through asking pressing questions about expectations and reality in his multimedia installations and performances. One of his most prominently featured works, *Consumption* (2012), is an installation piece that scrutinizes the disparity in assembly line labor and mass consumption by displaying a lab coat, ID card, and iPad that the artist used during a month-long period of employment at the notorious electronics manufacturer Foxconn in Shenzhen.

The artist remembers from his experience at the factory:

> I initially thought that it would be very hard to get a job, but, in fact, it was easy. I simply applied and passed the physical exam and the face-to-face interview. They had almost no requirements at all. As long as you're literate with no significant physical problems, you get hired.

Li Liao's Foxconn identification card in his work *Consumption* (2014).

Liao's job was to inspect iPad circuit boards for ten hours a day. After 45 days, he earned enough money to buy an iPad and quit the job. The artist was surprised to find that the actual work was harder than he anticipated:

> You stay in the factory twelve hours a day—ten hours in the workshop, two hours for lunch and dinner. The work was repetitive and boring. Your relationship with your bosses is just about work. If we see each other outside the factory, without our uniforms, we probably wouldn't recognize each other.

When he exhibited the project at the Ullens Center for Contemporary Art in Beijing in 2013, Liao placed the iPad he purchased on a pedestal, next to his uniform and badges hung on the wall, and his framed contract under glass. The combination of these vestiges of a transformative experience speaks to the nexus of capital, technology, and dreams. Through a seemingly innocuous participation in daily working life at the factory, the artist revealed the alienation of the consumer products and their producers. "I will never go back to the factory to work," he concluded.

Work cited

Liao, Li. Interview with Evan Osnos. "What Is an iPad Doing on a Pedestal at a Chinese Art Museum?" *New Yorker Magazine*, 13 January 2013, www.newyorker.com/news/evan-osnos/what-is-an-ipad-doing-on-a-pedestal-at-a-chinese-art-museum. Accessed 3 August 2018.

Rabih Mroué

Lebanese multidisciplinary artist Rabih Mroué uses lecture performances to blur the line between art and activism. He addresses the effects of the Lebanese Civil War (1975–1990) on today's political strife. In his recent multimedia work, *The Pixelated Revolution* (2012) (Mroué), he shared and analyzed videos of the Syrian revolution recorded by civilians during the massive 2011 protests against the Assad regime and theorized the implications of using cameras as arms

Still from *The Pixelated Revolution* (2012); Video, color, sound; 21:58 min.

against state oppression. Mroué explained that when the revolutions began, it became clear to him that he could not continue to create art as if nothing was happening.

Presented as a "non-academic lecture," Mroué's work explores the manipulation of images for political purposes, the construction of truth through editing, and the way in which recording devices relate to the construction of time and memory. *The Pixelated Revolution* is divided into an introduction and seven sections, each of which develops an idea about the act of recording the shooting of civilians by official forces during the protests. Mroué positions the camera as the new eye of the protester, suggesting that the camera is used as a weapon and thus highlights its necessity to the revolution.

Protesters are viewing reality through a mobile phone that has virtually become an extension of their bodies. Making this key connection, Mroué further explores the function of those implanted eyes through the lens of optography, a nineteenth-century field studying the possibility of extracting the image last seen by the eye of a dead person from their retina. In the Syrian videos, the phone serves as the retina of the dead activists, encapsulating the memory of their last vision—namely the face of their killers. The activists do not flee the life-threatening danger, even though they have time to run. Instead, they continue to record the scene, under the illusion of protection afforded by standing behind a camera lens. As the artist explains, "This is why the Syrian cameraman believes that he will not be killed: his death is happening outside the image."

The Pixelated Revolution reveals subjective views of the revolution, of the significance and liminal spaces of the chosen videos, and offers insights into the politics of representation. Mroué reveals the importance of the fragmentary, pixelated, and shaky quality of videos captured on protester's devices. In both the nature and the content of their communication, these are the weapons of the revolution.

Work cited

Mroué, Rabih. *The Pixelated Revolution*, lecture performance, 15th Media Art Biennale WRO 2013 Pioneering Values, 2015. *Vimeo*, https://vimeo.com/119433287. Accessed 3 August 2018.

Mary Maggic

Mary Maggic works at the intersection of art, science, and technology, exploring the role of the creator across each discipline. The question of how innovation in science and technology might generate a more just world outside the bounds of neoliberal technologic expansion is central to their practice. Maggic uses their background in biological science to explore the boundaries of each field their work resides in, developing a hybrid practice that they describe as "bio-art, bio-hacking, art-science, [and] citizen-science, though it would rather abandon all."

In their project *Estrofem Lab* (2016), Maggic developed a set of tools and protocols for low-cost estrogen-hacking workshops. Responding to their earlier work *Open Source Estrogen* (2015), the project considers the estrogen molecule as a highly politically-charged molecule at the center of the hormonal control of female and trans bodies moderated by governments and industry. Maggic asks, "Can biological intervention free our societally-bound bodies through mutation at the molecular level?" *Estrofem Lab* is their exploration into the potentials of this question. The ongoing project has led to the development of yeast estrogen sensors called YES-HER, a column chromatography urine extraction action, and a DIY vacuum pump solid phase extraction. All of these technologies, or "recipes" as Maggic calls them, are designed to detect, extract, and synthesize estrogen molecules using tools as simple as cigarette filters as a form of social resistance. They arm individuals with accessible tools for gender hacking, for recognizing the fiction of biological determinacy, and for creating a noninstitutional, DIY source for hormone access. Maggic suggests a future for resistance that queers prescribed, binary forms in favor of what they describe as "permeable, mutable . . . increasing[ly] alien."

Courtesy Rabih Mroué and Sfeir-Semler Gallery.

Mary Maggic, *Estrofem Lab* (2016) materials.

Further reading

Maggic, Mary. "Estrofem! Lab (2016)." *Maggic*, http://maggic.ooo/Estrofem-Lab-2016. Accessed 4 December 2018.

Morehshin Allahyari

Morehshin Allahyari is an artist, activist, and educator whose practice centers on the role of the digital in archival practices, particularly those that reform the archive as a more just record. One of her most acclaimed works is *Material Speculation: ISIS* (2015–1016), which responds to artifacts destroyed in ISIS's 2015 attack on the Mosul Museum in Iraq. Allahyari 3D-modeled and printed 12 of these artifacts, storing within their plastic bodies a flash drive and memory card containing images and documents related to their respective histories. She additionally made the file for the reproduction of King Uthal available for public download, offering to all the tools and corresponding responsibility to become stewards of historical and cultural memory. In this sense, her work contributes to an ongoing dialogue about how to use evolving technologies like 3D printing in ways that are both boundary pushing and reflective of the medium's material history.

Plastic filament, a commonly used material in manufacturing and 3D printing, is a derivative of crude oil. Allahyari addresses this through an inspection into what she calls the "Petropolitical and Poetic Relationships between 3D Printing, Plastic, Oil, Technocapitalism, and Jihad." In *Material Speculation* and in her practice at large, Allahyari argues for an emotional approach to technology's place and potential uses in the world, as well as its role in repairing and creating historical memory. She explains, "This is where I exactly find thinking and working around a technology like 3D printing really important and exciting. When it's both about functionality

Courtesy Morehshin Allahyari and Upfor Gallery.

Lamassu from *Material Speculations: ISIS* (2015-2016)

(how) but also criticality (why). . . . When it's about both resistance but also inclusion." While Allahyari's project is very clearly an archival initiative for those artifacts destroyed by ISIS, it also serves to archive our particular moment with 3D printing technology, capturing a still radical technology as it is applied to new uses and crafted into new forms.

Further reading

Allahyari, Moreshin. Interview by Fillippo Lorenzin. "Spread What Has Been Destroyed: An Interview with Moreshin Allahyari." *Digicult*, http://digicult.it/news/spread-what-has-been-destroyed-interview-with-morehshin-allahyari/. Accessed 3 December 2018.

Allahyari, Morehshin. "Material Speculation: ISIS." *Morehshin Allahyari*, 2016, www.morehshin.com/material-speculation-isis/. Accessed 3 December 2018.

Jenny Odell

Multidisciplinary artist and writer Jenny Odell's work traces the impact of the Internet's capability to obfuscate and blur realities, often through features that are intended to make the user experience streamlined or user-friendly. From a mural project on a Google data center using the satellite imagery generated by the technology inside to an article uncovering hidden business empires, across all media, Odell focuses an investigative eye on digital practices that impact the infrastructural composure of life offline. In writing about the way that early computers were marketed, Odell uses the example of Microsoft Bob: "a short-lived Microsoft software product that imagined the computer desktop as a house with rooms containing calendars, checkbooks, a Rolodex, and a desk with pen and paper." This early conceptualization of the computer as a tool at the hand of the user—an easily navigated space equipped for your convenience—has been replaced by an image of the Internet-as-matrix with unknown spatial qualities and ever growing uses.

Odell adopts an object-focused approach to her practice in order to illustrate the impact of the network on the stuff of everyday life. In one such project, *There's No Such Thing as a Free Watch* (2017), Odell uncovers the material history of a watch donated to the Museum of Capitalism in Oakland, California, where she was in residence at the time. The watch, originally marketed as "free" (besides the cost of shipping), was cheaply made by a company called Folsom & Co. Odell uncovered a number of companies worldwide that sell the same product, using standard website templates with falsified company logos and recycled copy; she followed a trail of product reviews, Instagram tags, and even took a dive into the Internet Archive's Wayback Machine. In the end, Odell could only track the web of fiction behind the watch; its original provenance remained unknown. She concluded: "In that sense, it may be the best artifact of capitalism one could ask for." The project highlights the ways in which technocapitalism produces the physical world around us and serves as an important reminder of the impact this has on our connection with it. Odell calls for new strategies in navigating an Internet that is no longer a replica of the world but a producer of it.

Courtesy Jenny Odell.

Jenny Odell making her zine *There's No Such Thing as a Free Watch* (2017).

Further reading

Odell, Jenny. "There's No Such Thing as a Free Watch." *Topic*, 2017, www.topic.com/there-s-no-such-thing-as-a-free-watch. Accessed 3 December 2018.

Joanna Moll

Joanna Moll is a researcher and artist working at the indistinct border between material, embodied experience and digital technologies. Much of Moll's work focuses on visualizing this relationship, whether by using images already created by surveillance technologies or by generating this visibility herself. In her piece *There Was a Wildness and Randomness in the Air That Was Beginning to Feel Almost Abstract* (2010), Moll connected 12 black metal wires to 12 corresponding engines; a pickup coil detects the electromagnetic fields within the installation space, causing the wires to rotate. In this sense, Moll created a visual translation of what previously could not be seen.

Writing on the dissonance between the logic of networks and that of networked society, Moll states, "While humans are becoming increasingly machine-like and dependent on data, the connection between humans and their life-giving natural habitats, is hastily fading away." From this observation came her web project *DEFOOOOOOOOOOOOOOOOOOOOOOOOREST* (2016), which illustrates the number of trees needed to absorb the CO_2 generated by the worldwide number of visits to Google.com each second. The webpage features a scrolling list of trees lining the page like lines of text: fir, elm, baobab, on and on. Moll has calculated that the number of trees necessary for humans to plant in order to counteract the CO_2 emissions would equal roughly 23 trees per second.

With this piece, she returns again to the questions of visibility, using the tools of the network to craft a visual able to be understood as a material consequence by a networked society. When confronted with the image of trees multiplying across the page, audiences are compelled to consider the impact of technology on the natural environment. As society learns increasingly more about the destructive impact technological development has had on the natural world, we are forced to consider that, while we think of that natural world as divorced from our own, we are reliant on it for the very air we breathe. Works like Moll's *DEFOOOOOOOOOOOOOOOOOOOOOOOOREST* are capable of making visible what is sometimes difficult to conceptualize: the volume of human impact on the environment and the necessity of critically addressing our role in a technologically engaged society.

Joanna Moll, DEFOOOOOOOOOOOOOOOOOOOOOOOOOREST (2016).

Courtesy Joana Moll.

Further reading

Moll, Joanna. "DEFOOOOOOOOOOOOOOOOOOOOOOOOOREST." *Janavirgin.com*, 2016, www.jana virgin.com/CO2/DEFOOOOOOOOOOOOOOOOOOOOOOOOOREST_about.html. Accessed 3 December 2018.

PART V

Epilogue

Responsibilities and affirmations for the future

Justine Ludwig

For the past decade, the Summit has been a cornerstone of Creative Time's annual program—an opportunity for a meeting of the minds where we pause and reflect upon our current socio-political reality, take a hard look at the past, and envision a path forward. At Creative Time, we are guided by the belief that art matters, that artists' voices are important in shaping society, and that public spaces are places for creative and free expression. We seek to actively create platforms for artists to contribute to the dialogues, debates, and dreams of our times. The Summit works to break down the silos separating activism, the arts, and innovative thought. In this spirit, the program embraces the interstices where boarders are crossed and exclusion zones breached.

Socially engaged art seduces the public's understanding into action through employing the strategies of active viewing and, at times, beauty, to impart urgency. It embraces contradiction and makes space for a multitude of expressions. Socially engaged art is a strategy for articulation where words fail. The role of art here is to offer personal perspectives, to ask questions, and to complicate accepted narratives. The field serves to identify the catalysts to crises, while demanding that we think differently and privileging nuance. Within this field, *Making Another World Possible* serves as both guidebook and proposition, with the intention that it is used. Similarly, to the Summit itself, it is an opportunity to pose questions.

It is the voices of individuals and collectives that come together to shape our understanding of the field and the world we live in. We bring this approach to the Summit, which over the past decade has featured over 350 speakers and 10,000 live attendees. This book features the work of hundreds of artists, writers, activists, and dreamers.

This book offers the mantra that we can do better, that we will do better. We are culpable, we are responsible. The future is ours, and we have a responsibility to it. We must learn from past errors and successes, our own and those of others, in order to forge a path forward. Together, we may collectively imagine creative solutions for a common future.

PART VI

Glossary of terms

Corina L. Apostol

Access One of the important elements of socially engaged art is connecting with communities, guaranteeing their access to art. Through gatherings and dialogues, cultural projects need to meaningfully integrate themselves into the local context and the immediate community.

Age of Experience The contemporary age, preceded by the Information Age, is regarded as a time in which the fundamental tenet of communication is visual information communicated through the presentation of identity, both on- and offline. Social and political movements, such as the Black Lives Matter and the #metoo movements, have benefited from immersive products (Instagram, Snapchat, Twitter) that have allowed their reach to extend exponentially faster and farther than social movements of previous decades. A criticism of these "social media movements" is that they both start and end digitally. The next decade will bring to the fore questions of experiential technology's ability to effect lasting change.

Anthropocene and Its Discontents The Anthropocene, or the Human Epoch, is a concept that appeared in 1938 and was later popularized by ecologist Eugene F. Stoermer in the1980s and again by atmospheric chemist Paul J. Crutzen in the 2000s. Although the term "Anthropocene" is not officially approved internationally, it is widely used by scholars. It acknowledges humans' significant impact on Earth's geology and ecosystems. A criticism of the popularization of the term is the overt focus on human species, while disregarding other significant factors humans may—or may not—be aware of.

Antifascism Fascism is a revolutionary form of populism that arises in zones of protracted crisis. Inspired by a totalitarian vision of collective rebirth, it challenges liberal political and cultural power, while also promoting economic and social hierarchy. Fascism is based on the cult of racial and ethnic purity, so we must unmask its repressive nature by promoting egalitarian ideas as well as preserving cultural and economic difference. This task garners increasing urgency in the United States and across the globe, as new hybrid forms of neo-liberal, conservative, and imperialist governing are gaining momentum.

Art into life This expression is often attributed to Vladimir Tatlin, a member of the Russian Constructivists and Productivists, who aspired to bring art into a liberated, revolutionary everyday life. The contrary argument states that art should absorb the entirety of life experiences and express them through new forms. Russian avant-gardists, proponents of the latter strategy, claimed that the principal task of these new forms is transformative, dissolving

into and provoking life's transformation. The recognition of art as an important sphere of autonomous activity, which is distinct from social activity and the everyday, does not mean that we simply discard the interconnections of art and life. Art is not life but can communicate something important about life that cannot be done otherwise.

Art School Traditionally, artists of one generation share with the next their faith in art and its power, their doubts, hopes, fears, and passions. The twentieth century produced many such projects: Unovis in Vitebsk, Russia, in the 1920s, the Bauhaus in Germany in the 1920s–1930s, Black Mountain College in the United States in the 1930s-50s, and even the unofficial circles that formed around a number of dissident artists in the late Soviet period. Some of these projects left an indelible mark on history, a force for change. In today's global context, where basic democratic freedoms are under threat and societal violence are reaching a critical level, where there is no support for an independent, critical culture, and where academic contemporary art programs are prohibitively expensive or nonexistent, the importance of socially engaged art becomes evident.

Art Workers The historical term "art worker" or "creative worker" emerged in the context of the 1871 Paris Commune, referring to the relationship between art, creativity, and work. It was one of the first instances when artists' aspiration for social change led them to align themselves with a wider workers' movement and break with the bourgeois institutions of art and the monarchy. Alongside the struggle against injustice at the workplace, the collective defense of rights within militant trade unions and street politics, art workers today are making important steps toward a reexamination of their position and change within the broken art system.

Art Worlds Works of art are produced through cooperation. The creating artist, group, or collective works with a network of suppliers of materials, distributors of artworks, fellow artists, and with critics, theorists, and audiences. Together, these contributing individuals and organizations constitute an art world. And the very existence of this art world gives artists the opportunity and means to make art.

Assembly and the New Activism Michael Hardt and Antonio Negri's book *Assembly* (Oxford University Press, 2017) investigates the emergence of new activism. The new activism proposes a less centralized and hierarchical organization for activism: nonsovereign institutions. While acknowledging the significance of organizations and leaders in activist movements, Hardt and Negri observed the emergence of an alternative organizational model in the 2010s that better appealed to the democratic imperatives of contemporary activists. The model of new activism will better acknowledge movements that are generated collectively rather than being created by a leader.

Avant-gardes The French socialist philosopher Henri de Saint-Simon introduced the concept of the avant-garde in his book, *Opinions Littéraires, philosophiques et industrielles:* "We, the artists, will be the vanguard of the intellectual revolution. The power of art is, in fact, the most effective and the fastest. We have all sorts of weapons: when we want to propose new ideas, we engrave them in marble or we draw them on a canvas" (de Saint-Simon, 341). As Chto Delat? proposed that the radicality of art, therefore, cannot be reduced to its connection to social or political imperatives or to formal stylistic innovation but must also be understood through its poetic force, its ability to question and destabilize the very notion of the political, social, cultural, and artistic.

Biopolitics The concept of biopolitics has been developed since it was first coined by Rudolf Kjellén and frequently used in a wide variety of contexts. One of the most influential meanings of the concept was derived from Michel Foucault's biopower: various forms of strategies overseeing human life on a massive scale. Foucault observed biopower strategies

in education in training a better disciplined population of citizens. Scientific and technological strategies used to control birth rate, death rate, and other data sets are another form of biopower in overseeing human life on a statistical level. That these strategies and practices regulate and normalize conditions of life means that human life is under the charge of politics. That individuals, in their complexity, fail to be recognized in the application of biopolitics is inherent to the ways that discourses surrounding power develop and are rationalized.

Black Consciousness Movement The Black Consciousness Movement (BCM) was a grassroots, anti-Apartheid activist movement that emerged in South Africa in the mid-1960s. The movement created an inclusive Black identity in opposition to the oppressive white minority government of South Africa. The movement resulted in the Soweto uprising of 1976, a riot where many protesting students were killed by the security force. Steve Biko, the leader of the BCM, was imprisoned, and movement-related organizations were banned by the government. Biko died at the hands of security police in 1977.

Capitalist Realism According to writer Mark Fisher, it's easier to imagine the end of the world than the end of capitalism. He argues that after 1989, capitalism presented itself as the only realistic political-economic system, a situation that the 2008 global banking crisis compounded. Fisher's book, *Capitalist Realism*, analyzes the development and principal features of this "capitalist realism" as a lived ideological framework. Using examples from politics, film (*Children of Men, Jason Bourne, Supernanny*), fiction (Le Guin and Kafka), work, and education, he argues that capitalist realism, coloring all areas of contemporary experience, is anything but realistic. If so, how can capitalism and its inconsistencies be challenged? Are the economics and politics of free market neoliberalism givens or constructions?

Capture Capture refers to biometric recognition technologies that identify human subjects through biological features. Retinol, voice, and fingerprint recognition are a few of the most commonly used biometric recognition technologies. The type of "capture" frequently discussed in this book refers to facial capture through surveillance imagery. The employment of biometric surveillance technology under the banners of defense and national security have accelerated rapidly in the past decade.

On Care and Affective Labor Affective labor forms communities and collective subjectivities. The production of affect in our labor and social practices has catalyzed the ground for anticapitalist projects, particularly within the context of discourses on use-value or desire. Numerous feminist analyses have understood affective labor as "kin work" and care labor. Care, interpersonal and corporeal, induces affect and emotion that, while thought of as "immaterial," produces social networks, collective subjectivities, and forms of community as a result.

Climate Resistance Climate resilience is defined as the capacity for both ecological and human systems to absorb external stress from climate change and to prepare for future climate impacts. Climate resilience can happen on each of the following levels: country, state, and community. It encompasses strategies from adaptation to changing conditions to the prevention of exacerbating them, and it includes advance preparation and education for expected impact.

Collaboration In the contemporary context, collaboration in art refers to artists and art workers collaborating across disciplines, from science and technology to education. Collaborative art practices could also include collective contributions from communities, audiences, and the public. The rise of collaboration enabled opportunities for creative expression within many other traditionally "nonartistic" fields and the simultaneous discussion of vital issues from multiple perspectives at once.

Community In its everyday usage, the concept of community carries a note of nostalgia, which helps build optimism or inspiration or creativity. There is the "international community," the "scientific community," the "expert community," and the "artistic community." Is it possible to regenerate a different meaning for this word that would not simply point to the attributes of some groups or their coming together in societies and collectives but instead describe a more complex configuration that encompasses and incorporates difference of experience and knowledge, both in content and methodology?

Commoning and the Commons The commons describes resources that are shared and managed among a group of people. Commoning refers to a social practice of self-governing a resource—whether economic, territorial, or even knowledge-based—not by a state or market but by a community. Commoning is popularized by historian Peter Linebaugh to describe the action of how citizens can shape their communities without solely depending on state agencies or profit-driven mechanism. Such actions could be so mundane that they are recognized as common sense. In the wake of the 2008 worldwide financial crisis, commoning practices have been recognized as a modality of resistance to and recovery from global market forces.

Communism and Anticommunism Nowadays, one-dimensional liberal propaganda upholds the present domination of the neoliberal economy in concert with human rights rhetoric and legal democracy. Communism is painted as a forlorn, utopian project that ended in totalitarianism and violence—in other words, a disaster that should not be repeated. Neoliberalism instead encourages us to aspire to a better future by focusing on our individual lives and using our abilities to work our way up the career ladder. At the same time, the general anticommunist sentiment has ended in a new disappointment. The reality of a global economic, ecological, and political crisis has shattered the liberal utopia of the free market. All debates about communism, going back to Karl Marx's mid-nineteenth-century conceptualizations, have become once again actual and important.

Cryptocolonialism Anthropologist Michael Herzfeld coined the term "cryptocolonialism" in his paper on anthropology titled "Absence Presence" (2002). Herzfeld defined cryptocolonialism as a situation where an independent nation has aspects of its culture and customs refashioned to suit the ideals of foreign powers. At the moment, there is a new wave of cryptocolonialism, one entirely different from what Herzfeld first envisioned. This wave involves the mass migration of cryptocurrency and blockchain resources to parts of the world affected by disasters or bearing the hardships of the current capitalist crisis. The goal of these activities is the creation of a so-called cryptoutopia.

Dark Matter Dark matter, or dark energy, makes up about 96% of the universe. It is perceived indirectly by observing the motions of visible astronomical objects such as stars and galaxies. Gregory Sholette argues that this phenomenon, the "missing mass problem" (Sholette, 1), relates to creative dark matter, or what makes up the bulk of the postindustrial artistic activity. Creative dark matter is invisible primarily to those who lay claim to the management and interpretation of culture (i.e., critics, art historians, collectors, curators, and arts administrators). Sholette states that the art world is just as dependent on its shadow creativity as the universe is on dark matter and as countries are secretly dependent on shadow activity for their dark, informal economies.

Dialogic Art Dialogic art is brought into being through exchanges between people as they interact with information, objects, and/or one another. Addressing the question, "What is dialogic art?" involves asking, "What is dialogue?" What are the possibilities of using the dialogue embodied in participatory and collaborative art making to create more coauthored

works of art? How might an expanded notion of "the artwork" as well as a distributed sense of "the artist's subjectivity" support this form of cultural production?

Dreamers The term "Dreamers" describes people who are protected under the DACA (Deferred Action for Childhood Arrivals) program created in 2012 by former U.S. President Barack Obama. The DACA program granted these undocumented young people the temporary right to live, study, and work in the United States. Under the Donald Trump administration, the DACA program no longer accepts any new applications, and current dreamers will face the possibility of losing their status, being deported, and sent back to their parents' countries. As a response to this, the DREAMers movement, comprised of primary undocumented youth and students, has risen to prominence, tackling issues related to immigration, citizenship, and education.

Enrichment Economy In their book *Enrichissement. Une critique de la marchandise* (Gallimard, 2017), Luc Boltanski and Arnaud Esquerre introduced a new perspective to categorize merchandise goods into four ideal types of value: the "standard form," the "asset form," the "trend form," and the "collection form." The collection form of value describes those that are based not on the analytics of the object but on its narrative. This means that heritage, celebrity, or storytelling could increase the value of the objects that fall into this category. The term "enrichment economy" refers to the increasing amount of goods that fall into the "collection" value category. The authors are pessimistic about the observation that Western society has been shifting toward an enrichment economy that still inherits the inequalities of the previous industrial economy.

Gentrification Gentrification describes the process of renovating deteriorated urban neighborhoods by means of the influx of more affluent residents. Gentrification is a controversial topic in urban planning. It improves communities' infrastructures and causes business to prosper, but it raises property value, resulting in complicated social impacts. One of the central problems is the displacement of the community's original residents—more often lower-income than the new residents—who can no longer afford the rising living expenses. Nowadays, gentrification is criticized as an outcome not only limited to top-down urban planning. Art galleries, public art, and other social practice art practices are criticized for their role as gentrifying agents.

Gugur "Gugur," meaning "the fall [of]," is word in the Indonesian language that is used only when describing heroes. An Indonesian patriotic song *Gugur Bunga* honors soldiers killed in the Indonesian National Revolution. The song's line "*gugur satu, tumbuh seribu*" (one falls, a thousand arise) has entered into common Indonesian vernacular.

Friendship In the history of art, there are a variety of groups, collectives, and works of art based on the idea of friendship. This usually implies a broader political dimension rather than the mere understanding of friendship as a consensus of opinions, closeness, or affinities. Friendships can become a form of emancipation, not in the sense of political correctness or unanimity, but as a constant discovering of what one becomes in the process of encounter between different subjectivities. Ultimately, in times of reaction, social catastrophe, and war—together with growing capitalist alienation and individualization—friendship, positively released in collective forms of creative work and political struggles, is the only way to remain sane and committed to shared ideals and goals.

Hierarchy Hierarchy usually describes the arrangements of objects or people in organizations and most commonly is used in sociology. Social hierarchy refers to stratification categorized by wealth, social status, and power. Nowadays, social hierarchy refers not only o the categorization of classes (upper, middle, and lower) but also to race, ethnicity, and gender.

More broadly, hierarchy implicates the inequality of power, rights, and awareness in both local and global social situations.

Identity Politics Identity politics has been used since the 1960s and1970s to describe political positions based on interests and perspectives stemming from self-identification. Such identities include but are not limited to religion, sex, gender identity, race, and political party. Criticisms of identity politics have focused on the premise that diverse identity groups divert attention from fundamental issues such as capitalism.

Indigeneity Nowadays, indigeneity not only means being native to a geographic location but also a political and legal identity with international valency. One criticism of the term "indigeneity" claims it as a polythetic concept that applied in many fields including anthropology, law, and politics.

Infrastructure of Resonance The infrastructure of resonance refers to the organizational capacity of activists to develop sustainable alternative spaces. These infrastructures, unlike temporary tactical actions, could provide long-term structures that amplify the impact activists make.

Labor Labor has a wide range of meanings but nowadays commonly refers to physical and intelligence work that produce goods and services. According to Marx, under capitalism, labor becomes a commodity and is also recognized as a basic unit of human capital. As an essential element in a capitalist society, labor is related to complicated human rights issues.

Liberation and Liberation Movements Liberation movement often refers to a political movement seeking to rebel against colonial power or national government. It also describes liberation from unequal racial and gender issues. Art has often been employed as a tool of liberation movements, from literatures of liberation to graphic campaigns. Many artists help to raise awareness for liberation movements and speak with minority and impacted groups. Many artists are a vital force in contributing to liberation movements. Visual expressions, thoughts, and gathering are a handful of art forms used in liberation movements. The documentation of liberation movements also becomes important as a historical record. Liberation politics has gained prominence as organizations and political movements have led rebellions and nonviolent actions against the old colonial powers, seeking independents based on an anti-imperialist outlook.

Mediation Mediation is an ancient form of resolving conflict. Art mediation could be seen as a new way for people to interact with artworks. Rather than a passive exposure to an artwork or a guided tour, art mediation encourages audiences to actively talk and discuss issues in artworks with the mediator. Art mediation is sometimes integrated into art curation or art education.

Methodological Nationalism The term has been developed by Andreas Wimmer and Nina Glick Schiller in their essay "Methodological Nationalism and Beyond: Nation-state Building, Migration, and the Social Sciences" (*Wimmer 2*, 2002) to discuss whether a distinct, logical division of nations in social science exists. Their claim opposed the traditional social science practice of conceptualizing social phenomena within the boundaries of the nation-state. Wimmer and Schiller proposed that such categorization would limit the capture of important social interactions, trends, and structures.

Négritude and Beyond Négritude was a 1930s Parisian cultural movement launched by Black, French-speaking graduate students from French colonies in Africa and the Caribbean. These intellectuals converged around issues of race, identity, and Black internationalist initiatives to combat French imperialism and to reclaim African self-determination, reliance, and respect. The movement signaled an awakening of race consciousness for Black people

in Africa and within the African Diaspora, while also sparking a collective condemnation of Western domination, enslavement, and colonization of Black people. The concept is a milestone in the rehabilitation of African and diasporic identity and dignity. It further contributed to writing African achievements back into history and fostering solidarity among Africans and people of African descent.

Neoliberalism Pierre Bourdieu defines neoliberalism as an ideology in which elites exert their supremacy through the distorted co-optation of progressive language, reason, and science, accompanied with total privatization. It contends that the market must be free and that any effort to contain it is regressive. Neoliberalism also champions a radical, unrestrained capitalism through modern forms of domination and manipulation, such as business administration, market research, and advertising. While undermining workers' rights won after decades of social struggle, Bourdieu also notes, neoliberal misinformation must be challenged by intellectual and cultural weapons. This must motivate us to harness art and culture-inspired critical thinking to reject the growing privatization of resources and insist on the proliferation of commons.

On Compromises Politically engaged artists inevitably face the question of compromise in their practice. It primarily arises when they must decide whether to accept funding from one or another source or participate in a biennale, exhibition, or other public display. Artists resort to several strategies: some emphasize the impossibility of adhering to all of their values in a corrupted world, while other artists regard themselves as purists in the kingdom of darkness. The conversation about the balance between purity and impurity is banal, although finding this balance is, in fact, the principal element of existing and making a living within the professionalized art world.

On Dialectics Dialectics are central to the philosophy of Karl Marx and his mentor, Georg Hegel. Dialectics generally refers to a method of understanding reality and to the nature of that reality. There is nothing static in the world for the dialectical thinker, as everything is in a process of change. In the midst of this dynamic process, the social whole breaks into parts that are opposed to one another. The conflict between them drives toward a resolution that contains a leap into something new. The succession of conflicts and resolutions forms a progressive series of cumulative and advancing development. This theory is emblematic of Western, post-Enlightenment thinking.

On Horizons *On Horizons: A Critical Reader in Contemporary Art* (BAK, 2011) is a landmark publication that uses the horizon as a metaphor to discuss the unapproachable demarcation between contemporary art and the political imagination in the present. The contributors of the book pose the question: Is the notion of the "horizon," in the philosophical and artistic sense, an instrument that can be used to reformulate the relation between art and politics? Can we create possibilities for artistic practices and political projects by breathing new life into the concept of the "horizon," repositioning it in today's world ruled by neoliberalism?

On Horizontality The Occupy movement has brought back into focus issues of horizontal organization and direct democracy, embracing diversity and conflict within these political structures. With no universal narrative or national identity, the movement was critiqued for having no demands, no structure, and not standing *for* anything. However, upon a closer look, Occupy embodied an important political message and inherited a complex, albeit not perfect structure that has been developed for half a century. This structure began to acquire a common name, that is, "horizontality," a term used to signify a decentralized, networked form of democratic decision making as a replacement of representative democracy.

393

Parachuting In In the contemporary art world, the phrase describes artists and cultural workers who do projects on the fly, without fully understanding the geographic context where and the community for whom the projects are produced.

Participatory Practice Few things are more participatory than reading a good book, watching a great film, or visiting an exceptional exhibition. Often, people come about their politics through the books they read, the films they watch, or paintings they encounter. Participatory art, by its experiential nature, leads people to understand the concerns of art as those within everyday life.

Patriarchy and Its Discontents Patriarchy is a social system where males hold the primary power and predominant roles in political and social leadership. Patriarchy is also associated with a set of ideologies that justify the phenomenon as an inherent difference between genders. However, sociologists don't think of patriarchy as a result of the biological difference between genders but rather as a social product. Most contemporary societies are patriarchies. In order to fight against heteronormativity and gender oppression, activists and artists provoke and blur the rules and lines pressed by solely male and male-dominant leadership. In the fight against patriarchal repression, the recognition of the system's disproportionate impact on communities of color and queer communities is crucial.

Pedagogy of the Oppressed *Pedagogy of the Oppressed* (Seabury Press, 1968) by educator Paulo Freire proposes a pedagogical relationship between student, teacher, and society. In his book, Freire explored oppression and how it is maintained by both oppressor and the oppressed. Freire criticized the education system that dehumanized both students and teachers and encouraged a new way to cocreate knowledge.

Privilege Social privilege indicates a special advantage granted for one person or a certain group of people in the society. Privilege is usually a result of inequality due to social hierarchy, as well as a perpetuation of it. Social privilege impacts people's psychological well-being, including their level of comfort and self-confidence.

Queer and Now Bodily transformation, the process of becoming, and the blurring of boundaries between "static" modalities of being—the human and the environment, the man and the woman, the living and the dead—are strategies of political existence at the border between this or that form of being. This border is radicalized through this experience, which becomes an experience of bordering itself. The contemporary use of the word "queer" can describe ways of relation and being that celebrate indeterminacy and ways of living "otherwise." As José Esteban Muñoz observed, "Queerness is essentially about the rejection of a here and now and an insistence on potentiality for another world" (Muñoz, 1).

Revolution Revolution, the foundation of modern democracy, is an eventful overturn of old conservative hierarchies. Starting with the French, Haitian, and American revolutions of the 1780–1790s, we have since lived in a regime of global permanent revolutions. Revolutions create both liberal democratic and totalitarian regimes and threaten to subvert them by being repeated against these very same regimes.

Self-education Today, education values are in crisis globally, and one of the symptoms derives from the decline of both theories and practices based on the disciplinary, humanist ideal of education, which traditionally empowered its subjects with both a sense of civic rights and responsibilities, as well as the means for changing and overturning the present state of affairs. The growing servility of education to market demands represents a serious threat to any creativity or vibrancy in a society's development. In response, several artists and collectives have resisted this state of affairs by spreading and producing alternative forms of

uncovering knowledge that further develop the emancipatory traditions to be found in a variety of educational practices.

Socially Engaged Art Engagement in art means, first and foremost, that art is created as a reaction to the conditions and often the difficulties of the world and makes them appear differently from people's expectations. Engaged art differs from activism, as the latter has always dealt with the efficiency of real politics and media. Engaged art knows how to wait and find its own way of addressing people outside the narrow professional art community. Engaged art is neither the reflection of reality nor the intervention into it, but rather the reality *of* this reflection that adds a new dimension into the struggle of changing it.

To Struggle Historically, there exist many examples of artists coming together to organize themselves to demand not only the betterment of their working conditions (wages, social security) but also the transformation of the entire system of cultural production, therein suggesting that artists should cease to be artists in the privileged sense of the word. These collective struggles continue in today's reactionary time when artists' mobilization relates to more general demands for social and political change. In some cases, inspired by previous communes, coalitions, syndicates, and unions, some artist groups continue the struggle to smash the hegemonic system of cultural industry, however utopian this may sound.

Surveillance State A surveillance state describes the employ of a surveillance system by a government to watch over the majority or a substantial fraction of its population for monitoring purposes, such as the fight against terrorism or the protection of national security. However, laws on how the data gathered from these systems are used vary globally. Without consent from the people being monitored, the surveillance system invokes problems of privacy invasion. The surveillance state is the most distinguished trait of a totalitarian state.

On the Totality of Capitalism Today it is all the rage to say that there is nothing outside the contemporary world order. Capital and market relations are total, and, even if someone or something escapes this logic, this does not in any way negate it. This is a trait of moderately progressive consciousness: such is the opinion of leftist theorists, and the capitalists have no real objections to their equitable claim. We should play the idiot and simply declare this thesis a lie. We know quite well whose interests are served by it.

Works cited

Apostol, Corina L., and Chto Delat?. "From the Chto Delat? Lexicon." *Time Capsule. Artistic Report on Catastrophes and Utopia*. Secession and Revolver Verlag, 2014, pp. 4–5.

de Saint-Simon, Claude-Henri. *Opinions littéraires, Philosophiques Et Industrielles*, Galerie De Bossange-Père, 1825, p. 341.

Foucault, Michel. *The History of Sexuality*. Éditions Gallimard, 1976.

Hardt, Michael, and Antonio Negri. *Assembly*. Oxford University Press, 2017.

Herzfeld, Michael. "The Absence Presence: Discourses of Crypto-Colonialism." *The South Atlantic Quarterly*, vol. 101 no. 4, 2002, pp. 899–926. *Project MUSE*, muse.jhu.edu/article/39112. Accessed 31 July 2019.

Little, Daniel. "Methodological Nationalism." *Understanding Society*, 15 July 2010, understandingsociety. blogspot.com/2010/07/methodological-nationalism.html. Accessed 31 July 2019.

Muñoz José, Esteban. "Feeling Utopia." *Cruising Utopia: The Then and There of Queer Futurity*, New York University Press, 2009, pp. 1–2.

Sholette, Gregory. "The Missing Mass." *Dark Matter: Art and Politics in the Age of Enterprise Culture*, Pluto Press, 2011, pp. 1–22.

Wimmer, Andreas, and Nina Glick Schiller. "Methodological Nationalism and beyond: Nation-State Building, Migration and the Social Sciences." *Global Networks*, vol. 2, no. 4, 2002, pp. 301–334. doi:10.1111/1471–0374.00043.

INDEX

Note: Page numbers in *italics* refer to figures.